Monet
Renoir and the
Impressionist
Landscape

Monet
Renoir and the
Impressionist
Landscape

George T. M. Shackelford

Fronia E. Wissman

WITH CONTRIBUTIONS BY

Erika M. Swanson

NATIONAL GALLERY OF CANADA, OTTAWA / MUSEUM OF FINE ARTS, BOSTON

Published in conjunction with the exhibition *Monet, Renoir, and the Impressionist Landscape*, organized by the Museum of Fine Arts, Boston, in collaboration with the Nagoya/Boston Museum of Fine Arts in Nagoya, Japan. A slightly different version of this exhibition was shown at the Nagoya/Boston Museum of Fine Arts from April 17 to September 26, 1999.

National Gallery of Canada, Ottawa
June 2–August 27, 2000

Virginia Museum of Fine Arts, Richmond
September 19–December 10, 2000

The Museum of Fine Arts, Houston
January 21–April 15, 2001

Catalogue produced by the National Gallery of Canada in collaboration with the Museum of Fine Arts, Boston.

National Gallery of Canada
Chief, Publications Division: Serge Thériault
Editor: Usher Caplan
Picture Editor: Colleen Evans

Museum of Fine Arts, Boston
Manager of Exhibitions: Jennifer Bose
Curatorial Planning and Project Manager, Art of Europe: Deanna M. Griffin

Designed and typeset by Aerographics, Ottawa
Printed by MOM Printing, Ottawa

PRINTED IN CANADA

Copies of this publication are available at The Bookstore, National Gallery of Canada, 380 Sussex Drive, Box 427, Station A, Ottawa K1N 9N4.
Mail orders: (613) 990-0962, ngcbook@gallery.ca

Canadian Cataloguing in Publication Data

Shackelford, George T. M.
Monet, Renoir, and the impressionist landscape.

Exhibition catalogue.
Issued also in French under title: Monet, Renoir et le paysage impressionniste.
Includes bibliographical references: p.
ISBN 0-88884-713-0

1. Landscape painting, French—Exhibitions. 2. Painting, Modern—
19th century—France—Exhibitions. 3. Impressionism (Art)—France—
Exhibitions. 4. Museum of Fine Arts, Boston—Catalogs.
I. Wissman, Fronia E. II. National Gallery of Canada. III. Title.

ND547.5 I4 S53 2000 758'.144'0903407471384
 C00-986001-0

Cover: Claude Monet, *Grainstack (Sunset)*, cat. no. 49 (detail)

Monet
Renoir and the
Impressionist
Landscape

Contents

Message from the Sponsor

In a different time, a different place, the world was bursting forth with images and colours that caught the eye and the canvas of a new kind of artistic master. Never before had the French countryside been captured with such subtlety, such brilliance, as with the Impressionists of the late nineteenth century.

Monet, Renoir, and the Impressionist Landscape features some seventy masterworks in an exclusive Canadian engagement at the National Gallery of Canada. Organized by the Museum of Fine Arts, Boston, this breathtaking exhibition follows the evolution of the Realist and Impressionist landscape styles as interpreted by Camille Corot, Théodore Rousseau, Gustave Courbet, Camille Pissarro, Alfred Sisley, Pierre-Auguste Renoir, Claude Monet, Paul Cézanne, Vincent van Gogh, and Paul Gauguin. It also examines the profound influence that these visionaries had on artists who followed.

Investors Group is very proud to present this exhibition of masterpieces as part of our *Sharing Culture with Canadians* program. Our company has been advising Canadians of the benefits of long-term financial planning for more than seventy years. And in that time, we have developed a strong tradition of supporting arts and cultural programs across Canada. We have done this because we believe in making a meaningful contribution to the communities where we live and work.

As a Canadian company, we are especially pleased to be able to partner with the National Gallery of Canada in support of its mandate to "further knowledge, understanding, and enjoyment of art in general among all Canadians." For many, this exhibition will provide a rare opportunity to discover the groundbreaking works of some of the most cherished artists of the nineteenth century. And for all who experience it, *Monet, Renoir, and the Impressionist Landscape* will forever change their way of seeing the world.

H. Sanford Riley
President and Chief Executive Officer
Investors Group Inc.

Foreword

"It breaks my heart to see all of my paintings leave for America," confided Monet, with wry exaggeration, to his dealer Paul Durand-Ruel, in April 1888. Impressionism came to Canada, in the most modest of ways, early in the following decade, when Sir George Drummond and Sir William Van Horne, two great Montreal collectors, began to look beyond the Barbizon masters who had previously held their attention. In 1891, Drummond acquired Degas's *Artist in His Studio*, now one of the glories of the Calouste Gulbenkian Museum, Lisbon; the following year, Van Horne purchased Monet's recently painted *Two Grainstacks, Autumn*, today in the Art Institute of Chicago.

Before 1900, Impressionism was unseen in either Toronto or Ottawa, and it was only after Durand-Ruel sent a large and eclectic group of modern French paintings to Montreal in 1909 that the National Gallery of Canada made its first acquisitions in this field (works by a younger generation of "Impressionists," sponsored by Durand-Ruel, many of whom are largely forgotten today). Before the First World War, the Gallery made only two ambitious purchases of Impressionist paintings: Monet's splendid *Waterloo Bridge* and Sisley's *Washerwomen, near Champagne*, acquired in 1914 for $6,000 and $3,000 respectively.

With the advent of the war and the closure of the Gallery for several years, few works of any period entered the collection: most notable among the modern paintings was Degas's *Dancers at the Barre*, acquired in 1921, and Pissarro's *Stone Bridge in Rouen, Dull Weather*, acquired in 1923. While a new generation of Canadian collectors now began to look to later nineteenth-century painting – Frank Wood and Mrs. Wilmot Matthews in Toronto, Philip Osler in Montreal, Gordon Edwards and Harry Southam in Ottawa – the Gallery itself was inactive in this field throughout the decade of the Great Depression. Only in the 1940s would it acquire significant works by Renoir and Gauguin; and two of its finest Cézannes were acquired from the Vollard collection in 1950.

Ottawa cannot boast the pioneering commitment and courage of Boston's early collectors of Impressionism. Its collection of later nineteenth-century painting, while fine indeed, also lacks the range and depth of the great American museums in Boston, New York, Philadelphia, Washington, and Chicago. However, particularly since its move in 1988 to Moshe Safdie's handsome new building, the National Gallery of Canada has established itself as a *lieu de pèlerinage* for all those interested in Impressionism. Its outstanding exhibitions and publications devoted to Degas, Corot, and Renoir testify to a continuing scholarly engagement with the New Painting in its various manifestations.

For all these reasons, we are delighted to be the first North American venue for a touring exhibition of some seventy works from the permanent collection of the Museum of Fine Arts, Boston, that charts the development of French landscape painting between 1840 and 1900, with particular emphasis on the achievements of the founding members of the Impressionist brotherhood. These limpid, audacious, life-affirming views of the French countryside have in their turn influenced the way we look at nature today. And while we are now used to the Impressionists' flickering brushwork, bright colours, and seemingly unmediated compositions, this exhibition reminds us that such a vital and spontaneous vision – achieved only after much struggle and great hardship – had its origins in the flowering of French landscape painting of the 1840s and 1850s.

The National Gallery of Canada is especially thankful to our presenting sponsor, Investors Group, a Canadian company that has set a high standard for others to follow in its deep and unswerving commitment to supporting the arts. Their vision of the role that culture plays in shaping who we are is one that we proudly share.

Pierre Théberge, C.Q.
Director
National Gallery of Canada

Acknowledgments

The organizers of *Monet, Renoir, and the Impressionist Landscape* would like to thank some of the many individuals who have contributed significantly to the exhibition and its catalogue.

At the Museum of Fine Arts, Boston, we wish to thank Nancy Allen, Jennifer Bose, Leane Delgaizo, Catherine East, Katherine Getchell, Andrew Haines, Tsugumi Maki Joiner, Irene Konefal, Thomas Lang, Patricia Loiko, Amy Lucker, Nicole Luongo, Rhona MacBeth, Maureen Melton, Kim Pashko, Cynthia Purvis, Gary Ruuska, David Sturtevant, Lydia Vagts, John Woolf, Jean Woodward, Jim Wright, as well as the MFA Facilities staff. Special thanks to contributors in the department of the Art of Europe: Deanna M. Griffin, Alexandra Ames Lawrence, Kathleen A. McDonald, George T. M. Shackelford, and Erika M. Swanson.

At the National Gallery of Canada we wish to thank, first of all, Colin B. Bailey, Deputy Director and Chief Curator, and Daniel Amadei, Director of Exhibitions and Installations. Dr. Bailey has overseen the installation and related programming in Ottawa, and has been ably assisted by Michael Pantazzi and Stephen Borys in Collections and Research, Anne Newlands, Monique Baker-Wishart, and Jean-François Léger in Education and Public Programs, and Ellen Treciokas in Design Services. Production of the catalogue to accompany the North American tour of the exhibition was overseen by Serge Thériault and members of his Publications staff, Myriam Afriat, Usher Caplan, and Colleen Evans.

Additional thanks are due to Franck Giraud, Polly J. Sartori, Marc Simpson, and Fronia E. Wissman. Finally, we are grateful to our colleagues at the Nagoya/Boston Museum of Fine Arts, who provided the original impetus for this exhibition.

Note to the Reader

All of the paintings in the exhibition are from the collection of the Museum of Fine Arts, Boston.

The order of the catalogue is chronological, first by date of birth of the artist and then by date of the work. A list of works and their catalogue numbers, indexed alphabetically by artist, can be found on page 211.

Further information on each painting, including a capsule biography of the artist, provenance, exhibition history, and selected references, appears in the Documentation section of the catalogue, starting on page 164.

The individual texts on each of the works in the exhibition were written by Fronia E. Wissman, with the exception of the following by Erika M. Swanson: numbers 28, 32, 40, 51, 52, 53, 56, 61, 64, and 70.

Throughout the catalogue, dates of birth and death are mentioned only in the case of artists who are not represented in the exhibition.

A bibliographic listing of works cited in abbreviated form (in footnotes and under Selected References) appears on pages 204–210.

The following exhibitions, drawn extensively or entirely from the collections of the Museum of Fine Arts, Boston, are cited in abbreviated form (under Selected Exhibitions):

1939–40 Juliana Cheney Edwards Collection
Boston, Museum of Fine Arts, December 1, 1939–January 15, 1940, *Juliana Cheney Edwards Collection.*

1973 Impressionism: French and American
Boston, Museum of Fine Arts, June 15–October 14, 1973, *Impressionism: French and American* (catalogue by Alexandra R. Murphy).

1977–78 Monet Unveiled
Boston, Museum of Fine Arts, November 22, 1977–February 22, 1978, *Monet Unveiled: A New Look at Boston's Paintings* (catalogue by Alexandra R. Murphy, Lucretia H. Giese, and Elizabeth H. Jones).

1979–80 Corot to Braque
Atlanta, High Museum of Art, April 20–June 17, 1979; Tokyo, Seibu Art Museum, July 28–September 19, 1979; Nagoya, Nagoya City Art Museum, September 29–October 31, 1979; Kyoto, National Museum of Modern Art, November 13, 1979– January 15, 1980; Denver, Denver Art Museum, February 13– April 20, 1980; Tulsa, The Philbrook Art Center, May 25– July 25, 1980; Phoenix, Phoenix Art Museum, September 19– November 23, 1980, *Corot to Braque: French Paintings from the Museum of Fine Arts, Boston* (catalogue by Anne L. Poulet and Alexandra R. Murphy).

1983–84 Masterpieces of European Painting
Tokyo, Isetan Museum of Art, October 21–December 4, 1983; Fukuoka, Fukuoka Art Museum, January 6–29, 1984; Kyoto, Kyoto Municipal Museum of Art, February 25–April 8, 1984, *Masterpieces of European Painting from the Museum of Fine Arts, Boston* (catalogue by Pamela S. Tabbaa).

1984–85 Jean-François Millet
Boston, Museum of Fine Arts, March 28–July 1, 1984; Tokyo, Takashimaya Art Gallery, Nihonbashi, August 9–September 30, 1984; Sapporo, Hokkaido Museum of Modern Art, October 9– November 11, 1984; Yamaguchi, Yamaguchi Prefectural Museum of Art, November 22–December 23, 1984; Nagoya, Matsuzakaya Museum of Art, January 4–29, 1985; Kyoto, Kyoto Municipal Museum of Art, February 28–April 14, 1985; Kofu, Yamanashi Prefectural Museum of Art, April 23–May 19, 1985; New York, IBM Gallery of Science and Art, June 11–July 27, 1985, *Jean-François Millet: Seeds of Impressionism* (catalogue by Alexandra R. Murphy).

1989 From Neoclassicism to Impressionism
Kyoto, Kyoto Municipal Museum of Art, May 30–July 2; Sapporo, Hokkaido Museum of Modern Art, July 15–August 20; Yokohama, Sogo Museum of Art, August 30–October 10, *From Neoclassicism to Impressionism: French Paintings from the Museum of Fine Arts, Boston* (catalogue by Lucy MacClintock).

1991–92 Claude Monet: Impressionist Masterpieces
Baltimore, The Baltimore Museum of Art, September 21, 1991– January 19, 1992, *Claude Monet: Impressionist Masterpieces from the Museum of Fine Arts, Boston.*

1992 Crosscurrents
Boston, Museum of Fine Arts, February 19–May 17, 1992, *European and American Impressionism: Crosscurrents.*

1992–93 Monet and His Contemporaries
Tokyo, Bunkamura Museum, October 17, 1992–January 17, 1993; Kobe, Hyogo Prefectural Museum of Modern Art, January 23–March 22, 1993, *Monet and His Contemporaries: Masterpieces from the Museum of Fine Arts, Boston* (catalogue by Eric M. Zafran and Robert J. Boardingham).

1995 The Real World
Yokohama, Yokohama Sogo Museum of Art, April 27–July 24; Chiba, Chiba Sogo Museum of Art, August 4–September 17; Nara, Nara Sogo Museum of Art, September 27–November 5, *The Real World: Nineteenth-Century European Paintings from the Museum of Fine Arts, Boston* (catalogue by Eric M. Zafran and Anna Piussi).

Monet Renoir and the Impressionist Landscape

George T. M. Shackelford

Monet, Renoir, and the Impressionist Landscape presents a selection of seventy paintings by Claude Monet, Pierre-Auguste Renoir, and their contemporaries, as well as by painters of the generation before and after them who inspired the Impressionists or who were inspired by them. This exhibition is a rich survey of French landscape painting from the time of its great rise to prominence during the 1850s through to the end of the nineteenth century. It begins with the roots of the Impressionist landscape in the art of Camille Corot and the Barbizon School and extends as far as the Post-Impressionist landscapes of Paul Gauguin and Vincent van Gogh.

The exhibition is drawn entirely from the great collection of paintings at the Museum of Fine Arts, Boston, and showcases some of its most famous Impressionist works: Monet's *Grainstack (Sunset)* (cat. no. 49), Renoir's *Rocky Crags at L'Estaque* (cat. no. 57), Degas's *At the Races in the Countryside* (cat. no. 32), Cézanne's *Turn in the Road* (cat. no. 35), and van Gogh's *Houses at Auvers* (cat. no. 66). But the exhibition also features astonishing works, newly brought to light from Boston's collection, by artists whose fame in the late twentieth century has been overshadowed by that of the Impressionist generation, such as Paul Huet's *Landscape in the South of France* (cat. no. 4), Théodore Rousseau's *Gathering Wood in the Forest of Fontainebleau* (cat. no. 10), and Antoine Chintreuil's *Peasants in a Field* (cat. no. 11).

The development of the Impressionist landscape forms a complex story, yet too often it has been reduced to a simple and direct trajectory: from the plein-air cloud studies of John Constable to the freely painted compositions of the Barbizon School; from Monet's *Impression: Sunrise* to the sunstruck landscapes of van Gogh at Arles, Saint-Rémy, and Auvers. This story recognizes the fact that the Impressionists rejected the fussy, overly finished effects of paintings intended for exhibition at the official Salons and that they opted instead to paint sketchlike compositions in the open air and to exhibit these "impressions" as finished works, thus forging a modern landscape style, much to the consternation of the critics as well as the public.

It is a story that is undoubtedly true, but it describes only one of the many ways in which the art of landscape emerged from the achievements of the Men of 1830, as Corot and his contemporaries were called; and its development in the 1860s, 1870s, and 1880s was not a simple linear progression away from the preoccupations of an official style and toward a modernist idiom. This exhibition and its catalogue attempt to trace some of the major paths of that development. By including not only the works of the indisputably Impressionist landscape painters – Monet and Renoir, with Cézanne, Degas, Pissarro, and Sisley – but also works by some of their more traditionalist contemporaries – François-Louis Français and Henri-Joseph Harpignies, for example – the exhibition seeks to enrich the story of the Impressionist landscape, pointing out interesting byways that intersect or branch off from those paths.

The story of the Impressionist landscape is intimately tied to the career of Claude Monet, its most famous, most steadfast, and arguably most innovative practitioner. In 1857, when he was sixteen, Monet met the marine painter Eugène Boudin, who took an interest in the young man and invited him along to paint in the open air. Later, Monet said that the experience was a revelatory one for him: "Boudin, with untiring kindness, undertook my education. My eyes were finally opened and I really understood nature; I learned at the same time to love it."[1] Boudin became Monet's unofficial teacher for several years, and his gift for painting skies was matched by the talents of the younger artist.

In May 1859 Monet went to Paris to see the Salon exhibition, which had opened on April 15, and to try his hand at learning more about painting landscape. In that year, writing to Boudin from the capital, Monet singled out for praise the landscapes he saw at the Salon by Charles-François Daubigny, Constant Troyon, Théodore Rousseau, and Camille Corot. Troyon's paintings – *Return to the Farm* and *View Taken from the Heights of Suresnes* (Musée d'Orsay and Musée du Louvre, Paris) – were particularly attractive to Monet, who greatly admired the older artist's ability to capture the fleeting effects of clouds, sunlight, and atmosphere. "A magnificent sky," he

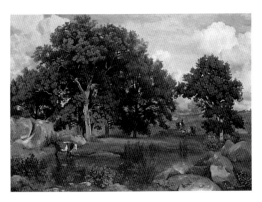

Fig. 1. Camille Corot, *Forest of Fontainebleau*, 1846, oil on canvas, 90.2 × 128.8 cm. Museum of Fine Arts, Boston, Gift of Mrs. Samuel Dennis Warren (90.199)

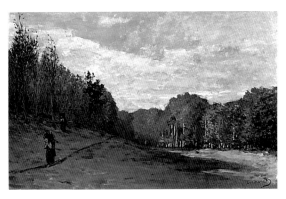

Fig. 2. Claude Monet, *Woodgatherers at the Edge of the Forest*, c. 1864, oil on panel, 59.7 × 90.2 cm. Museum of Fine Arts, Boston, Henry H. and Zoë Oliver Sherman Fund (1974.325)

wrote, "a stormy sky. There is a lot of movement, of wind in these clouds."[2] Earlier, Monet had visited Troyon in his studio, and he immediately recognized Troyon's skill. "I could not begin to describe all the lovely things I saw there," he wrote to Boudin. Looking at Monet's canvases, Troyon advised the young man to learn how to draw by studying the human figure, at that time the foundation of every artist's education. "Don't neglect painting," he nevertheless told Monet, "go to the country from time to time and make studies, and above all develop them."[3] Monet might have seen in Troyon's studio the kind of sketches made in the open air, such as *Fields outside Paris* (cat. no. 7), which Troyon would develop and refine into easel paintings for the Paris art market – for example, *Sheep and Shepherd in a Landscape* (cat. no. 8) – and which also lay behind the large-scale pictures he painted for the official Salon exhibitions.

In the Salon, still controlled by the Academy, as well as in the more informal market of picture dealers, landscape had taken the place of history painting in the public imagination and in the minds and hearts of critics. Monet, recognizing the hegemony of landscape painting, was determined to follow the path on which he had set out under Boudin. Still, taking Troyon's advice, in 1860 he embarked on a course of study to learn to draw the human figure, entering an informal art school – the Académie Suisse. In 1862 he entered the studio of Charles Gleyre, a history painter, where he met Pierre-Auguste Renoir, James McNeill Whistler, and Frédéric Bazille, each of whom practiced not only figure painting but also landscape, and Alfred Sisley, who was to devote himself to pure landscape. In addition to his study from the model, Monet continued to paint landscape during excursions to the countryside near Paris, notably at the village of Chailly, near Barbizon, in the Forest of Fontainebleau.

The most important painters of the landscape vanguard had practiced their craft in this region since the 1840s, among them Corot, Rousseau, Troyon, Narcisse Virgile Diaz de la Peña, Jean-François Millet, and Gustave Courbet. Corot's *Forest of Fontainebleau*, of 1846 (fig. 1), shows one of the clearings, bordered by great trees, that characterized the semi-wilderness

that attracted tourists from Paris. In the years before and after the Revolution of 1848, the rise of Realism in French painting had given forth not only the heroic figural compositions of Millet and Courbet but also a new notion of how landscape should be interpreted. Painters such as Corot and Rousseau sought to depict commonplace settings – ordinary meadows, fields, or woodlands – and to invest these simple landscapes with both a sense of poetry and a sense of the quiet dignity of the earth itself.

Aware of the special associations of the Fontainebleau landscape, Monet spent much of the spring of 1863 in Chailly. He returned in the following year, when he probably painted *Woodgatherers at the Edge of the Forest* (fig. 2), whose subject derived from those of artists of the Realist generation, such as Rousseau (see cat. nos. 9 and 10) and Millet. At this period in his development, most of Monet's subjects and compositions reflected his awareness of the art of these masters, as well as the continuing importance of Boudin and of Johan Barthold Jongkind, a Dutch marine painter whom Monet had met on the Normandy coast in 1862 (see cat. nos. 20 and 21).

Boudin's influence on Monet, however strong, was by no means exclusive, even in the early 1860s. Although his masterly views of Normandy's ports and beaches (see cat. nos. 22–26) depicted light in the fractured manner that Monet was to perfect later in his career, *Woodgatherers at the Edge of the Forest* is greatly simplified, its effects flattened and almost schematic. Monet used choppy broad strokes of color and juxtaposed warm browns and greens against the blue of the sky, thus recalling the boldly painted landscapes of Gustave Courbet, whose *Stream in the Forest* (cat. no. 17) was painted at about the same time. Courbet's earthy palette and his preference for dense, boldly painted canvases may have inspired Monet again when, about 1864, he took his easel into the streets of Honfleur, near Le Havre, to paint on site a view of the Rue de la Bavolle (cat. no. 39).[4] Perhaps following Troyon's advice to "develop" his studies, Monet used this plein-air canvas as the basis for a later version (fig. 24), in which the effects he studied before the motif were further refined.[5]

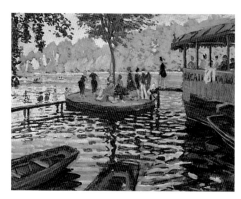

Fig. 3. Claude Monet, *La Grenouillère*, 1869, oil on canvas, 74.6 × 99.7 cm. The Metropolitan Museum of Art, New York, H. O. Havemeyer Collection, Bequest of Mrs. H. O. Havemeyer, 1929

Monet's experience had its parallels in that of his future Impressionist colleagues Renoir, Pissarro, and Sisley, each of whom experienced the strong pull of Barbizon style in the mid-1860s. Renoir painted both sober portraits inspired by Realist genre scenes, such as *The Cabaret of Mother Anthony* (1866, National Museum, Stockholm), and large-scale nudes, such as *Diana the Huntress* (1867, National Gallery of Art, Washington, D.C.), both redolent of Courbet's subject matter and style. Pissarro, at the Salons of 1864, 1865, and 1866, exhibited riverbank landscapes in the tradition of Daubigny (Glasgow Art Gallery and Museum, Kelvingrove; National Gallery of Scotland, Edinburgh; The Art Institute of Chicago). In 1866 Sisley exhibited *A Street at Marlotte: Environs of Fontainebleau*, a painting that recalls Corot in its massing of farm buildings and both Daubigny and Courbet in its sober palette (1866, Albright-Knox Art Gallery, Buffalo, N.Y.). Degas, at the same Salon, exhibited a large-scale scene of a *Steeplechase* (Collection of Mr. and Mrs. Paul Mellon, Upperville, Va.). An amalgam of Realist landscape and figure painting, Degas's ambitious composition nodded to Courbet's dramatic scenes of the hunt, as well as to the images of figures in the landscape painted by his mentor Édouard Manet. By the end of the 1860s, however, the young artists of the nascent Impressionist movement were advancing in uncharted directions, beyond the idiom of Barbizon painting. In 1869, working side by side at the fashionable boating place of La Grenouillère, Monet and Renoir began to paint works in which the optical experience of sunlight falling on the rippling water was recorded on canvas with a new vocabulary of brushstrokes, inspired by Courbet and Manet but aiming toward the invention of an altogether new pictorial language.

These paintings marked a turning point in the history of the Impressionist landscape, but they flow from the experiments that Monet had conducted in the middle years of the decade. His careful, deliberate technique, particularly evident in the handling of the alternating lights and shadows in his views of the river (see fig. 3), recalls the thick brushstrokes he used to paint the Rue de la Bavolle at Honfleur. It seems, moreover,

that Monet again intended to use these riverside paintings to develop other canvases in the studio. In late September 1869 he wrote to Bazille from a village near the Seine: "I do have a dream, of a picture, the bathing place at La Grenouillère, for which I have made a few bad sketches, but it's only a dream. Renoir, who has just passed two months here, would also like to paint this picture."[6]

A conventionally ambitious, large-scale Salon composition that derived from these studies never materialized; it seems likely, however, that Monet sent a more developed version of one of the *pochades*, as he called them, to the Salon of 1870, along with an interior. The jury rejected both works.[7] Renoir shrewdly ignored his new landscapes and exhibited at the same Salon two magnificent, but less innovative, figure paintings: a Courbet-like *Bather with a Griffin* (Museu de Arte de São Paulo Assis Chateaubriand), nearly life-size, and *Woman of Algiers* (National Gallery of Art, Washington, D.C.), manifestly inspired by Eugène Delacroix's Orientalist subjects. In the wake of Monet's exclusion from the Salon, both Daubigny (long a defender of the young painter) and Corot resigned from the Salon jury in protest. But despite his absence in the exhibition, much was made of Monet's being at the vanguard of painting. Arsène Houssaye wrote: "The two real masters of this school which, instead of saying art for art's sake, says nature for nature's sake, are MM. Monet (not to be confused with Manet) and Renoir, two real masters, like Courbet of Ornans, through the brutal frankness of their brush."[8]

Although his first attempt at exhibiting one of his "bad sketches" of La Grenouillere was rebuffed, Monet was to exhibit another work of this type in the second Impressionist exhibition, in 1876. By that time, he had already presented to the public the famously sketchy *Impression: Sunrise* (Musée Marmottan–Claude Monet, Paris), the lightly worked view of the port at Le Havre that gave the Impressionist movement its name. That picture was initially shown at the first exhibition of the newly founded Société Anonyme Coopérative d'Artistes-peintres, Sculpteurs, etc., held in the former studio of the photographer Nadar on a busy commercial street in Paris. It

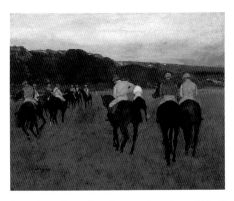

Fig. 4. Edgar Degas, *Race Horses at Longchamp*, 1871–75,
oil on canvas, 34.1 × 48.1 cm. Museum of Fine Arts, Boston,
S. A. Denio Collection (03.1034)

opened on April 15, 1874. Writing ten days later, the satirist
Louis Leroy presented the comments of two fictional visitors to
the Salon:

> – … What does that painting represent? Look in the
> catalogue.
> – IMPRESSION, *Sunrise*.
> – *Impression*, I was sure of it. I said to myself, too, because
> I am impressed, there must be some impression in it….
> And what freedom, what ease in the facture! An embryonic
> wallpaper is still more finished than that seascape there! [9]

Leroy's humorous exchange aside, the critics' response to
the newly named Impressionists was generally favorable, and
on the whole they praised the Impressionists' desire to exhibit
free from the strictures of the Salon system. [10] Recognizing that
the group assembled artists from a wide variety of backgrounds,
critics such as Armand Silvestre made an attempt to understand
the painters' common motivations and to help his readers
distinguish one participant from another:

> At their head are three artists whom I have spoken of
> several times and who have, at least, the merit of being
> immutable in their goals. This immutability even touches
> on an aspect common to all three, which gives priority
> above all to the processes of their painting. At first glance,
> one is hard pressed to distinguish what differentiates the
> paintings of M. Monet from those of M. Sisley and the
> manner of the latter from that of M. Pissarro. A bit of
> study will soon teach you that M. Monet is the most able
> and the most daring, M. Sisley is the most harmonious
> and timid, M. Pissarro is, in the end, the inventor of this
> painting, the most real and the most naive…. What is
> sure is that the vision of things that these three landscape
> painters affect does not resemble in the least that of any
> earlier master; that it has its plausible side; and that it
> affirms itself with a character of conviction that does not
> admit the possibility of disdain. [11]

By the mid-1870s, in spite of the critics' recognition of
close affinities between them, each artist had evolved a mature
vision of how landscape might be painted. Both Renoir and
Monet had formulated a wholly individual manner of painting
in the open air. Renoir's *Woman with a Parasol and Small Child
on a Sunlit Hillside* (cat. no. 55), painted about 1874–76, shows
his distinctive feathered brushstroke, with which he suggests
both the sheer white fabric of the reclining woman's dress and
the soft tufts of grass on which she reclines; sharp contrasts
between the foreground shadows of deep emerald green and
the background highlights of bright yellow and white convey
the sense of brilliant sunshine. Monet's 1875 depiction of his
wife Camille sewing in a garden while a child is playing at her
feet (cat. no. 41) employs a characteristic flickering pattern of
small daubed or curved brushstrokes. Here, dark greens and
reds are juxtaposed with brighter, lighter versions of the same
hues. This has the result of conveying the action of the light
on the bed of dahlias and the grassy verge that make up the
background of the picture, while the figures are set off from
the vegetation by their blue and white clothing.

The overall effect of these treatments of the figure set in a
landscape is a sense of freedom and improvisation, contrasting
sharply with the more classically refined surfaces of such works
as Degas's *Race Horses at Longchamp* (fig. 4), probably begun
about 1871 and reworked in the mid-1870s. Degas, who in
the 1850s had painted pure landscapes in Italy and had used
landscape backgrounds in his early history paintings, in the
1860s specialized in painting people in everyday scenes, mostly
indoors – at home, in a café, or at the opera. He rarely turned
to landscape at this period except as background for his racing
pictures. Unlike Monet and Renoir, he painted such landscapes
entirely in the studio, reproducing or adapting from memory
scenes he had witnessed in the suburbs of Paris. The seemingly
careless arrangement of horses in the open air is misleading, for
Degas rearranged the elements of the picture more than once
before settling on a final pattern of jockeys and mounts.

A middle ground between the sense of improvisation that
Monet and Renoir cherished and the calculated strategies of

Fig. 5. Paul Cézanne, *Landscape, Auvers*, c. 1874, oil on canvas, 46.3 × 55.2 cm. Philadelphia Museum of Art, The Samuel S. White III and Vera White Collection (1967-30-16)

Degas can be found in the paintings of Pissarro and Cézanne. Working together in the environs of Pontoise and nearby Auvers in the 1870s, these friends evolved a more geometrically structured response to the landscape. Pissarro, who in these years turned to themes taken from the lives of the agricultural workers in his district, often chose to order his paintings by introducing straight lines or geometrical shapes, as in *Sunlight on the Road, Pontoise*, of 1874 (cat. no. 28), or *The Côte des Boeufs, L'Hermitage*, of 1877 (fig. 22). Likewise, Cézanne, in *Landscape, Auvers* (fig. 5), also painted about 1874, employed the rhythmic architectural forms of walls and houses both to animate and to anchor his composition. In the middle years of the decade, both artists, along with Sisley, adopted a lightened palette in which the deeper shades of green and brown were softened by the admixture of whites and grays. And all three artists, particularly Cézanne, employed opaque, layered paint structures that together with their carefully shaped compositions confirm the studied processes by which these ordinary views were elaborated.

As the loosely affiliated artists explored different manners of depicting the landscape, each member of the group chose his sites and themes according to his particular temperament. On the whole, however, they shared a preference for motifs that veered away from the conspicuously picturesque, avoiding the hackneyed compositional formats that they scorned in the work of Salon painters. Thus, Monet painted an uneventful section of the road outside Vétheuil (cat. no. 42), Pissarro painted an equally uninspiring street in Pontoise on a dingy, snowy day (cat. no. 27), and Sisley, who might have chosen to paint a fountain in the park at Versailles, preferred to paint the pumping station at the Marly reservoir (cat. no. 36). By choosing subjects and points of view that seemed to contemporary audiences not only unimportant but somehow undignified, the Impressionists emphasized the distinction between their landscapes and those of the Barbizon School and its adherents at the Salon.

In line with their avoidance of conventional motifs, the Impressionists' compositions typically are free of apparent sentiment or evident meaning, especially when compared with

the landscape paintings being shown at the Salon in the 1870s. For example, Chintreuil's *Peasants in a Field* (cat. no. 11) makes use of pyrotechnic cloud effects above the bowed heads of the harvesters praying in the field. This painting, exhibited at the Salon of 1870, romanticizes and glorifies France's fertile landscape and traditional agrarian economy. The Impressionists tended to avoid such easily recognized interpretations: although Pissarro often returned to similar themes of rural labor, which Millet had made famous a generation earlier, his scenes of peasants or villagers in the fields are, in contrast to Chintreuil's dramatic vision, notably matter-of-fact (see cat. no. 29).

During the 1870s, the Impressionists concentrated on depicting places close to Paris, along the Seine or its tributaries downstream from the capital, in such towns as Argenteuil, Bougival, and Pontoise. In the 1880s Monet abandoned the villages along the Seine frequented by Parisians, in favor of sites – some equally touristic, others more remote in character – on the coasts of France. Monet typically avoided the views that Boudin had painted at the height of the Second Empire in such works as *Fashionable Figures on the Beach* (cat. no. 23), which exploited the relationship between sea and sky; instead he turned to painting the sea in juxtaposition with the land.

Monet's works of the early 1880s attest to his love for the rough Normandy coasts, where Delacroix, Courbet, and Millet had painted in the previous generation. There, at Pourville, Fécamp, and Étretat, Monet explored motifs that he had first treated in the late 1860s and early 1870s. His 1881 *Sea Coast at Trouville* (cat. no. 43) seems to equate the windswept form of a tree beside the sea with a watchful human presence, just as Millet had done in his 1866 *End of the Hamlet of Gruchy* (cat. no. 13), a depiction of his native village. His *Fisherman's Cottage on the Cliffs at Varengeville*, of 1882 (cat. no. 44), resembles not only that village view but also another by Millet showing a group of stone buildings perched on the sea, the 1872–74 *Priory at Vauville, Normandy* (cat. no. 14). Monet, like Millet, felt a profound connection to the Normandy landscape: "The countryside is very beautiful and I am very sorry I did not come here earlier," he wrote to his companion

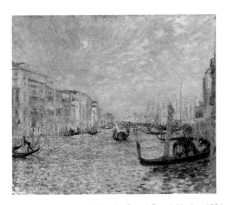

Fig. 6. Pierre-Auguste Renoir, *Grand Canal, Venice*, 1881, oil on canvas, 54.0 × 65.0 cm. Museum of Fine Arts, Boston, Bequest of Alexander Cochrane (19.173)

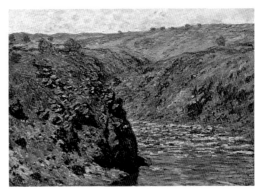

Fig. 7. Claude Monet, *Ravine of the Creuse in Sunlight*, 1889, oil on canvas, 65.0 × 92.4 cm. Museum of Fine Arts, Boston, Juliana Cheney Edwards Collection (25.107)

Alice Hoschedé from Pourville in February 1882. "One could not be any closer to the sea than I am, on the shingle itself, and the waves beat at the foot of the house."[12]

A group of these Normandy landscapes by Monet were presented at the Impressionist exhibition of 1882, where just under a third of Monet's paintings showed such cliffside views, sometimes stormy, sometimes sunny – among them the *Sea Coast at Trouville*. Although both Monet and Renoir remained largely unconcerned with its organization, the 1882 exhibition was heralded by critics as a great moment for the Impressionist landscape painters, who one by one had dropped out of the most recent group shows but had now returned to the fold.[13] However, not all the Impressionists shared Monet's passion for coastal scenery. At the same exhibition, Sisley presented *Overcast Day at Saint-Mammès* (cat. no. 37), named after the village on the Seine near Moret-sur-Loing, the town where he had settled in 1880; he was to make this humble landscape the subject of much of his painting for the rest of his life (see cat. nos. 36–38). Renoir was represented by a group of paintings lent by his dealer Paul Durand-Ruel. These included not only a large group of figure paintings but also views taken along the Seine and his new views of Venice (see fig. 6), which he had painted during a trip to Italy in the autumn of 1881.

Renoir's contact with the Mediterranean world was to have lasting consequences for his art as well as for the history of Impressionist landscape painting. In late January 1882, on his return from Italy, Renoir stopped to pay a visit to Cézanne in Provence, and there he painted the sun-drenched rock cliffs of L'Estaque (see cat. no. 57), above the bay of Marseilles, cliffs that Cézanne himself had painted just a few years earlier (see fig. 33). For many years Cézanne had divided his time between the region around Paris and the land between Aix and the port of Marseilles, and by the 1880s he was spending more time in the warmer light of his native Provence. In 1883, inspired by Renoir's enthusiasm for the Mediterranean, Monet forsook the Atlantic coast and returned with Renoir to Italy; on that trip, Renoir painted his *Landscape on the Coast, near Menton* (cat. no. 58). Monet went back to the Riviera alone early in the

following year and painted both in Bordighera, on the Italian coast, and on the Côte d'Azur, producing his own view of the Menton coastline (fig. 34).

In Italy and the South of France Monet found the warm golden light that had attracted artists there for centuries, a light that had clearly marked the work of a previous generation, most notably Corot (see cat. nos. 1–3) and his contemporaries, including Paul Huet (cat. no. 4). After several years, Monet again returned to the South, this time to Antibes, where in the spring of 1888 he painted yet another group of canvases.[14] "I can see what I want to do quite clearly but I'm not there yet," he wrote to Alice on February 1. "I've fourteen canvases under way, so you see how preoccupied I've become." Three weeks later, the painter wrote to her about his frustrations: "Everything's against me, it's unbearable and I'm so feverish and bad-tempered I feel quite ill … it's a miracle that I can work at all with all these worries, but I'm beginning to earn a reputation here as a ferocious and terrible person."[15] *Cap d'Antibes, Mistral* (cat. no. 48), which shows the snow-capped Alps beyond the Bay of Antibes, reveals the energetic and even ferocious brushwork that Monet adopted during this trip to paint the most agitated motifs that he discovered on the Mediterranean coast.

It was in Antibes, too, that Monet was to refine his practice of painting a fixed motif under changing conditions of light at different times of day, a practice that he was to develop almost into a system over the next decade. Monet had often painted multiple views of a particularly interesting motif, and he had already presented to the public groups of paintings of related subjects. In 1876 he had painted twelve views in and around the Gare Saint-Lazare, six of which he exhibited at the third Impressionist exhibition, in 1877.[16] In 1882 closely related views of the Normandy coast had constituted a kind of series within the group of paintings that Durand-Ruel selected to represent Monet at the Impressionist exhibition. As the decade drew to a close, in the early spring of 1889, Monet painted a group of landscapes in the valley of the river Creuse in a remote region of central France. Setting up his easel high above

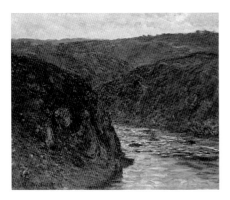

Fig. 8. Claude Monet, *Valley of the Creuse (Grey Day)*, 1889, oil on canvas, 65.5 × 81.2 cm. Museum of Fine Arts, Boston, Denman Waldo Ross Collection (06.115)

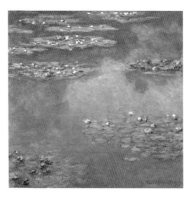

Fig. 9. Claude Monet, *Water Lilies*, 1907, oil on canvas, 89.3 × 93.4 cm. Museum of Fine Arts, Boston, Bequest of Alexander Cochrane (19.170)

the spot where two small rivers converged, he painted the valley in vivid sunlight (fig. 7) and in the gloom of twilight (fig. 8). These, following the paintings of Antibes, were steps in the process toward Monet's fully developed serial method, which he explored more deeply in the 1890s with such series as his 1890–91 Grainstacks (see cat. no. 49) and 1897 Mornings on the Seine (see cat. no. 50), and in the first decade of the twentieth century with his triumphant series of Water Lilies of 1903–8, exhibited as a group in 1909 (see fig. 9).

In making these groups of paintings, Monet was also seeking opportunities for independent solo exhibitions. He not only wished to be free of the constraints of the Salon but also hoped to create bodies of work that would set him apart from his former colleagues among the Impressionists. In 1886, once again, he was absent from the exhibition of the Impressionists. Like Renoir, he turned to Durand-Ruel, and to such galleries as Georges Petit and Boussod-Valadon, for exhibition opportunities. Durand-Ruel, for his part, sought to expand the market for the Impressionists beyond Paris, organizing commercial exhibitions of their works in New York and Boston.[17]

"It breaks my heart to see all of my paintings leave for America," Monet wrote to Durand-Ruel as early as 1888.[18] And although the Impressionists' works won the enthusiasm of at least a number of collectors in every part of the United States, they were nevertheless an easy target for satirists: "The Impressionists have been exhibiting here in force lately," wrote the critic of the Boston *Art Amateur* in May 1891.

Curious paintings by young Bostonian disciples of Monet, or Manet, with unconventional, prismatic reddish hues for fields and trees, and streets and houses in pinks and yellows respectively, have appeared from time to time for a year or two. But these were ascribed to the enthusiasm and indiscretion of apostleship.... But at last the news is circulated that leading Boston buyers of paintings – the first buyers, in other days of Millets, Corots, Diazes and Daubignys – are now sending to Paris for this sort of thing, and Impressionism becomes the fashion. Some of

our leading landscape artists praise it and preach it; many of the younger painters practice it…. The old favorites, sticking to their own styles, take back seats, and one almost wonders if all the pictures of the past are going to be taken out into Copley Square and burned. Titian and Veronese and the old masters have faded, we are told; Rembrandt is brown; even Corot is stuffy, and as for Daubigny and the rest of the modern French school of landscape, they are virtually black-and-white. Courbet and [the Boston painter William Morris] Hunt couldn't see color in nature as it really is. Tone, so much prized and labored for in the past, must go; Motley and Monet are your only wear.[19]

But the novelty of the Impressionists' style could not, of course, last forever. In the late 1880s Paul Gauguin, Georges Seurat, and Paul Signac (see cat. nos. 62, 63, 69, and 70), who had exhibited with the Impressionist circle, and Vincent van Gogh (see cat. nos. 65 and 66), whose brother Theo had sold Monet's works, rejected the Impressionists' methods, which they saw as overly dependent on optical effects, and searched for some new stylistic means. Gauguin gradually abandoned the broken brushstrokes that he had used in the early 1880s in favor of a new, radically simplified style. Seurat and Signac, likewise, left Impressionism behind to evolve a method of painting with small dots of color, which a critic would term "Neo-Impressionism."[20] And van Gogh, who recognized Monet as the great master of contemporary landscape painting, ended up rejecting the Impressionists' delicately nuanced palette in favor of an emphatically drawn, boldly colored style, which he believed expressed his deep emotions.

Partly because of these challenges, Monet, Renoir, and Pissarro themselves altered their landscape styles in the final decade of the century. Monet evolved his famous series as a way of expressing his continuing belief in the power of visual sensation and in the validity of representing these sensations as a means of artistic expression (see cat. nos. 49 and 50). Renoir, who in the late 1880s had expressed his dissatisfaction with the

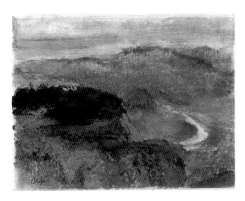

Fig. 10. Edgar Degas, *Landscape*, c. 1890–93, pastel over monotype on paper, 25.4 × 34.0 cm (plate). Museum of Fine Arts, Boston, Denman Waldo Ross Collection (09.295)

modes of traditional Impressionism, in the 1890s approached a manner that associated his art with the great traditions of French painting, deliberately referencing such painters of the eighteenth century as Jean-Antoine Watteau and Jean-Honoré Fragonard. Thus, many of his late landscapes, peopled by beautiful young women (see cat. no. 60), seem like fictions, as he reduced "the setting to little more than a freely brushed colored backdrop, with only the merest hints of natural features."[21] Pissarro, who in the mid-1880s had briefly adopted the Neo-Impressionist style advocated by Seurat and his disciple Signac, returned to his structured compositions of the 1870s in such paintings as *Morning Sunlight on the Snow, Éragny-sur-Epte* (see cat. no. 30 and fig. 22). At the end of the decade he embarked on a series of Parisian street scenes that seemed to bring his art back to the views of urban life that Monet, Renoir, and even Gustave Caillebotte had pioneered in the late 1860s and early 1870s. And, most remarkably, the figure painter Degas, who had once commented, "if I were the government I would have a special brigade of gendarmes to keep an eye on artists who paint landscapes from nature," took up landscape once again in the 1890s, even holding a solo exhibition of his imaginative landscape pastels in 1892 (see fig. 10).[22]

By the first years of the twentieth century, the artists of the Impressionist vanguard were internationally renowned. Their paintings were shown in exhibitions and collected enthusiastically throughout Europe and North America, and a growing appreciation of their achievements was felt in Japan. The work of Cézanne, by contrast, had received little public recognition during his lifetime, except perhaps from a handful of critics and from other painters: it is interesting to note that Cézanne's *Pond* (cat. no. 34) was owned by the painter Caillebotte, while his *Turn in the Road* (cat. no. 35) passed from the collection of the critic Théodore Duret to the painter Paul-César Helleu and eventually to Cézanne's friend Monet. After the turn of the century, however, a young generation of painters – in which were counted Henri Matisse, Pierre Bonnard, Pablo Picasso, and Georges Braque – found in the works of Cézanne, as well as in the works of Gauguin and van Gogh, the inspiration for

their vivid experiments with color and the radical distortion of form.

But the lessons of Monet and Renoir were not forgotten, for these artists had discovered, in their youth, a new direction for landscape painting. Respecting the genius of past art while at the same time breaking with its corrupted conventions, they sought throughout their lives to renew and reinvent their ways of seeing the natural world. Their art inspired not only their colleagues and contemporaries, but also generations after them; and today, museum-goers and art lovers everywhere cherish the enduring pleasures of the world that they find in the art of Monet and Renoir, delighting in the dazzling visual sensations that these painters brought to the Impressionist landscape.

Notes

1. Monet to the journalist Thiébault-Sisson, 1900, quoted in Rewald 1973, p. 38.
2. Monet to Boudin, June 3, 1859, quoted in Wildenstein 1974–91, vol. 1, p. 419.
3. Monet to Boudin, May 19, 1859, quoted in Kendall 1989, p. 18.
4. See House 1995, p. 178.
5. Wildenstein 1974–91, no. 34. See also House 1995, p. 178.
6. Wildenstein 1974–91, vol. 1, p. 427.
7. See Tinterow and Loyrette 1994, pp. 436–38 (the rejected view of *La Grenouillère* is probably Wildenstein 1974–91, no. 136 [formerly Arnhold Collection, Berlin, presumed destroyed]), and Stuckey 1995, p. 194.
8. Houssaye to Karl Bertrand, in "Salon de 1870," in *L'Artiste*, 1870, p. 319, quoted in Loyrette and Tinterow 1994, p. 438.
9. Leroy 1874, pp. 79–80, quoted in Berson 1996, vol. 1, p. 26.
10. For a critical review of the exhibition see Paul Hayes Tucker, "The First Impressionist Exhibition in Context," in Moffett et al. 1986, pp. 93–117, especially pp. 106–110.
11. Silvestre 1874, pp. 2–3, quoted in Berson 1996, vol. 1, p. 39.
12. Monet to Hoschedé, February 15, 1882, quoted in Kendall 1989, p. 100.
13. For an extended discussion of the seventh Impressionist exhibition, of 1882, see Joel Isaacson, "The Painters Called Impressionists," in Moffett et al. 1986, pp. 373–93.
14. For a discussion of both of Monet's 1880s campaigns on the Riviera, see Pissarro 1996.
15. Monet to Hoschedé, February 1 and February 24, 1888, quoted in Kendall 1989, p. 126.
16. For a discussion of Monet's paintings of the Gare Saint-Lazare in the context of Manet's work, see Bareau 1998.
17. For a discussion of the early Impressionist exhibitions in the United States, see Huth 1946 and Weitzenhoffer 1986.
18. Monet to Durand-Ruel, April 11, 1888, quoted in Wildenstein 1974–91, vol. 3, p. 234.
19. "Art in Boston," *The Art Amateur*, vol. 24, no. 6 (May 1891), p. 141, quoted in Eric M. Zafran, "Monet in Boston," in Zafran and Boardingham 1992, p. 37 (from the English-language manuscript in the Art of Europe paintings files at the Museum of Fine Arts, Boston).
20. For a discussion of Neo-Impressionism, see Rewald 1978, pp. 73–132.
21. John House in House and Distel 1985, p. 257.
22. Degas to Ambroise Vollard, quoted in Kendall 1987, p. 308.

Monet
Renoir and the
Impressionist
Landscape

Catalogue

1 **Camille Corot**

French, 1796–1875

Morning near Beauvais c. 1855–65

Oil on canvas, 36.0 × 41.5 cm

Juliana Cheney Edwards Collection (39.668)

Looking at this picture of serene calm one can easily understand why such fresh, evocative works were in enormous demand at the end of Corot's life. A simple scene – on the right a stream with a red-roofed house on the far bank, an open meadow with scattered trees closed off in the middle distance by a screen of trees growing more thickly – it is painted in the palette typical of the artist's late career. The overall silvery gray tonality is made up of a range of soft greens for the foliage and light browns and grays for trunks and branches. The whole is unified by the white sky and the discrete flecks of white throughout. One senses the freshness of early morning, the promise of a new day symbolized by the bare trees of spring.

After 1857 Corot frequently visited the city of Beauvais, about sixty-five kilometers northwest of central Paris. He had several friends there, among them Pierre-Adolphe Badin, a painter he had met in Italy and the director of the State Tapestry Manufactory. In the early 1860s Corot stayed with Badin and beginning in 1866 with a collector named Wallet.[1] Whereas a modern visitor might go to Beauvais to see what remains of the cathedral (an overambitious building plan resulted in the collapse of a large part of the superstructure in 1284 and the lantern tower in 1573), Corot was attracted to outlying areas of woods and streams.[2] The house to the right and the fence at the base of the tree to the left proclaim the area to be domesticated, put to human use, although Corot was not concerned with exactly what that use was. A woman and small child sit on the grass, protected and safe, flanked by trees. *Morning near Beauvais* investigates the subtle interplay of shallow spaces divided laterally by a broken screen of trees. Our attention is directed entirely to the foreground and middle ground, where there is created a sense of intimacy, security, and well-being, all to be enjoyed in the fresh air and soft light of early spring.

Although one can accept the bare trees at the right as being species that come into leaf later than the trees on the left, they are perhaps better understood as a pictorial device by which Corot was contrasting linearity with mass, spareness with fullness. Such explorations of difference are in keeping with the juxtaposition of near and far. In this way, the painting functions as both evocation and artifice.

1. Tinterow et al. 1996, p. 222, under no. 98, and pp. 295–96, under no. 123.
2. Ibid., p. 296, under no. 123.

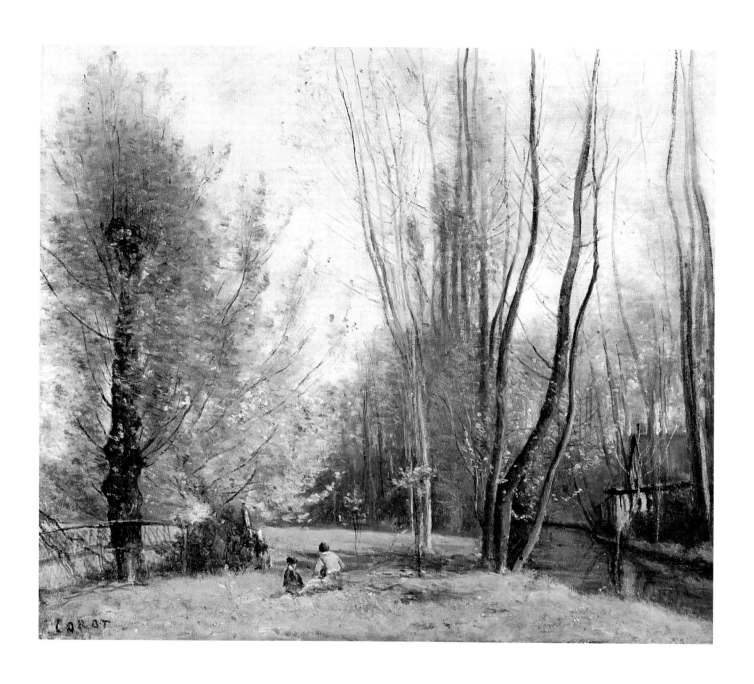

2 Camille Corot

French, 1796–1875

Souvenir of a Meadow at Brunoy c. 1855–65

Oil on canvas, 90.6 × 115.9 cm

Gift of Augustus Hemenway in Memory of Louis and Amy Hemenway Cabot (16.1)

After years of submitting to the Salon paintings with themes drawn from the Bible and from classical mythology, executed with crisply drawn contours and a clear light, Corot began, about 1850, to develop a looser touch, less precise and more atmospheric. *Souvenir of a Meadow at Brunoy* typifies this mature style. Through a screen of trees a denser forest is visible, beyond which rises a hill capped by the buildings of a town. Figures are scattered across the foreground and middle ground. In the foreground at the left, a woman, perhaps picking flowers, kneels; just above and to her right, a man walks deeper into the forest; two women, one holding the hand of a child, stop on a path to converse. A cow, at the right, looks out of the painting.

Corot produced many paintings similar to this one. They were popular in his day more for their evocation of mood than of place. The soft colors, green tending toward gray-brown, enlivened by spots of local color in the clothes the people wear and the pink-red flecks that sit on the surface, depict a scene that, despite its convincing sense of space and light, exists only in the imagination. The word *souvenir* in the title hints at the real subject of the picture: a recollection or remembrance of a meadow, not the meadow itself. Memories, more often than not, are pleasant, with their rough edges smoothed. In the latter part of his career Corot was interested, not in delineating the specifics of a given locale (which he did only in studies made on the spot, as exercises for eye and hand), but rather in conveying the feeling of being in the woods on a sunny spring day. Corot explained: "Beauty in art consists of truth, imbued with the impression we received from the contemplation of nature.... We must never forget to envelop reality in the atmosphere it first had when it burst upon our view. Whatever the site, whatever the object, the artist must submit to his first impression."[1]

The unpretentiousness and even insignificance of the scene – the people are not engaged in any specific activity – are belied by the painting's careful composition. Typical of Corot's later works is the shallow foreground. The light color of the meadow draws the eye into the painting, yet access to the meadow is mediated by the alternating forms of human figures, trees, and cow. Further recession into depth is denied by the edge of the woods beyond the meadow, and there is no visible way to get to the town on the hill, whose bright facets of masonry are the ultimate goal of the viewer's eye. The surface of the picture is covered by large, slightly textured shapes: the receding foreground, the diagonal wedge of woods, the lighter sky. Corot set up a sophisticated play of contrasts – surface versus depth, light versus dark, linear (the tree trunks) versus pattern (the foliage). In this configuration the figures are place markers, much as they are in many seventeenth-century landscapes, meant to guide the eye through the scene.

1. Courthion 1946, vol. 1, p. 89, translated in Clarke 1991, p. 107.

Camille Corot

French, 1796–1875

Bacchanal at the Spring: Souvenir of Marly-le-Roi 1872

Oil on canvas, 82.1 × 66.3 cm

Robert Dawson Evans Collection (17.3234)

Throughout his long career, which spanned the middle of the nineteenth century, Corot remained faithful to the classical tradition. Nymphs and bathers often animated his carefully observed landscapes, thereby linking antiquity with the nineteenth century's interest in optical verisimilitude and naturalism. Here, in a forest glade, a group of fictive figures disport themselves: in the foreground a woman reclines, leaning on a pitcher from which water flows. Farther back, a figure wearing a red cap (perhaps a satyr?) plays panpipes and a woman raises a tambourine. A woman in pink dances to the music of the pipes and tambourine, striking a pose in front of a child riding a leopard. To the right, a woman in blue watches. Surely this is not a scene from everyday life; this view makes visible the feeling that one is not alone in a forest. These figures are the animating spirits of the woods, embodying the freshness and renewal that nature was thought to offer the city-bound audience of Corot's art.

Such figures can be found throughout Corot's paintings, sometimes isolated and to monumental effect, as in *Bacchante with a Panther* (fig. 11), or else integrated, as in the Boston painting. The reclining figure with the pitcher can be traced to the seventeenth century, as in Nicolas Poussin's (1594–1665) *Amor omnia vincit* (The Cleveland Museum of Art), and still farther back to Poussin's source on antique sarcophagi. Some of Corot's contemporaries, more committed to the depiction of everyday life, however raw, were unsympathetic to his inclusion of the classical world. The novelist and journalist Émile Zola complained: "If M. Corot agreed to kill off, once and for all, the nymphs with which he populates his woods and replace them with peasant women I would like him beyond measure." Yet despite his grumbling, Zola seems to have understood Corot's aims, for he went on: "I know that for this light foliage, this humid and smiling dawn, one must have the diaphanous creatures, dreams clothed in vapours."[1] As Zola knew, such figures are crucial to an understanding of Corot's art, in which tradition played a large role.

The magic of Corot's *Bacchanal* stems from the way in which it combines a deep-seated regard for tradition with an extraordinarily sensitive rendering of light and atmosphere. At first glance the painting looks dark. The glade seems to be in semi-darkness, a protected, secluded spot for these mysterious goings-on. A blue sky and white clouds overhead signal clement weather. A patch of sky at the right gives form

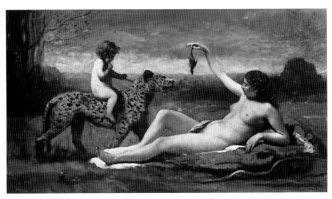

Fig. 11. Camille Corot, *Bacchante with a Panther*, 1860, reworked c. 1865–70, oil on canvas, 54.6 × 95.3 cm. Shelburne Museum, Shelburne, Vermont (27.1.1-226)

to the birch tree, which is more directly illuminated by a shaft of light striking it from the left. This light connects near and far, for the eye moves from the whitish bark to the sun-struck clearing beyond. The brightness of the farther glade and the light on the tree at the right serve to make the enclosing trees seem darker, and indeed the foliage is painted in dark greens tending to browns, enlivened by Corot's signature flecks of light-colored paint that sit sparklingly on the surface. Corot's subtle modulation of these hues, the product of a long life spent studying the effects of light outdoors, faithfully replicates the interior darkness of a forest.

1. Clarke 1991, p. 85, quoting from Zola 1974, p. 73.

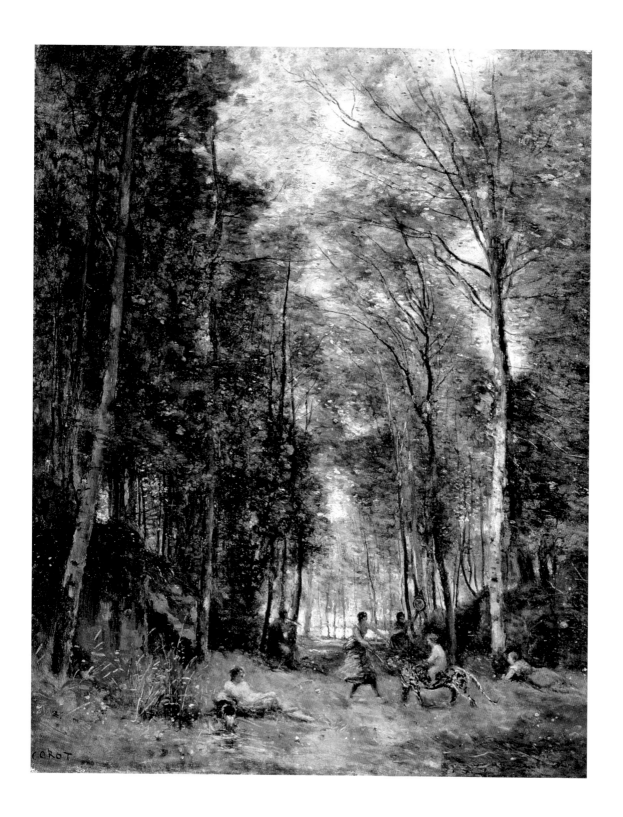

4 **Paul Huet**

French, 1803–1869

Landscape in the South of France c. 1838–39

Oil on paper mounted on panel, 35.6 × 51.7 cm

Fanny P. Mason Fund in Memory of Alice Thevin (1987.257)

This loosely rendered, luminous view of a river valley is a cunning blend of seventeenth-century compositional devices and open-air painting. Drenched in sunlight, the landscape is organized by the winding river zigzagging to the mist-filled background. With its careful progression into depth, punctuated by the darker V-shaped riverbank in the middle ground, the composition is not unlike examples by the seventeenth-century painter Claude Lorrain (1600–1682) (see fig. 12). Yet where Claude's paintings and prints were typically populated by shepherds and travelers – people using or moving through the landscape in a purposeful fashion – this small work by Huet shows naked children playing at the water's edge and two figures dancing. These people, in other words, are not working but playing, enjoying themselves in a beneficent climate. Their abandon finds material expression in Huet's fluid marks. The ability to paint in thinned-down, easy strokes was important to Huet, so he chose paper as his support. (The painting is now affixed to a panel.) Even a finely planed panel has texture, and canvas, no matter how carefully primed, has more, whereas paper is smooth. Such a surface allows a brush loaded with paint to glide over the surface easily, leaving a visible track of its movement.

Because Huet often painted pictures featuring monuments and scenery that fostered pride in the French nation, it is somewhat tempting to see in this work the germ of a large, finished canvas, such as his panoramas of Rouen (1831, Musée des Beaux-Arts, Rouen) and Dieppe (c. 1840, Musée des Beaux-Arts, Orléans). No such work has yet been identified, and Huet may well have painted this river valley for its own sake, as an *étude*, a study after nature, rather than as an *esquisse*, a compositional sketch. The topography suggests the South of France or perhaps northern Italy. Huet visited the area as early as 1833 and returned periodically as late as 1845. As happened often with artists from the North experiencing the light of the South for the first time, Huet despaired. "I am completely dazzled by this light, so keen and brilliant. I do not know if this glittering nature, well outside the bounds of my studies and my first affections, suits my talent." Without the softening and integrating humid light of the North, Huet explained to a friend in a letter, the landforms take on greater prominence: "Here the land is beautiful all on its own, and all its power, all

Fig. 12. Claude Lorrain, *Landscape with a Temple of Bacchus*, 1644, oil on canvas, 96.5 × 123.1 cm. National Gallery of Canada, Ottawa (4422)

its admirable delicacy of color, it draws from the sun and from the light."[1] Capturing this keen and brilliant light, which lends power to the landscape, was in no way beyond his means, as this painting admirably shows.

1. Huet 1911, p. 115.

5 **Eugène Isabey**

French, 1803–1886

Harbor View c. 1850

Oil on canvas, 33.3 × 47.9 cm

The Henry C. and Martha B. Angell Collection (19.101)

Isabey shows us an inlet that at high tide functions as a harbor. Now, however, at low tide, the local people take the opportunity to wash clothes and load the ships. This is a peaceful scene, showing everyday activities carried out according to the rhythms of nature. Tradition is emphasized through composition and color as well. The eye moves through the depicted space following a long zigzag course, starting at the lower left and ending at the high point of the eccentrically shaped steeple of the church. The dominant brown-blue tonality, sparked by the scattered reds of skirts, shirts, sail, and flags, is a subtle modulation of brown foreground, green middle ground, and blue background, a palette used by landscapists since the sixteenth century to indicate recession into depth. Isabey took obvious delight in applying paint to canvas. He thinned the paint with enough medium to allow him to paint wetly and rapidly, to make squiggles and flourishes, and to leave three-dimensional strokes of paint in the foreground, where his and the viewer's vision is clearest. This active brushwork functions as an analogue for the activity of washerwomen and laders but also, and more important, for the activity of light and its interaction with air, water, and objects. For all its adherence to convention, Isabey's *Harbor View* is a careful study of these essential elements of landscape painting, rendered with an understanding of how, for example, sunlight glinting off water and mud actually looks.

Isabey had painted on the Channel coast since the very beginning of his career, but it was his acquaintance in the mid-1820s with the English artist Richard Parkes Bonington (1801–1828) that proved decisive. Bonington's free, fluid, and light-saturated oils and watercolors electrified the young French artists who saw them. Isabey not only saw the works but also knew the artist and painted with him in 1825.[1] Isabey's composition is more complicated than Bonington's often are: the patterns made by the masts activate the space in a linear fashion that is inherently foreign to Bonington's emphasis on luminosity – even when compared with such a picture as Bonington's *Rouen* (fig. 13). Isabey's insistence on pattern can be seen in his repeated use of the same boat. Tipped at different angles or lined up one behind the other, the boats are compositional devices rather than portraits of individual vessels. Isabey's brushwork, too, is more detail-

Fig. 13. Richard Parkes Bonington, *Rouen*, before 1822, watercolor on paper, 18.1 × 23.8 cm. Wallace Collection, London (P704)

oriented than the Englishman's. Still, Isabey's picture is full of light, and it betrays an affection for the workaday scene that is akin to Bonington's fondness for the Channel scenes he painted.

Isabey played an important role in the development of nineteenth-century French landscape painting. He was, in effect, the conduit through which the English manner of seeing and painting the moist atmosphere of the northern French coast was transmitted to the younger generation of landscapists. He knew and instructed Boudin and Jongkind, who in turn were instrumental in the development of Monet's art.

1. Noon 1991, p. 11.

6 Narcisse Virgile Diaz de la Peña

French, 1808–1876

Bohemians Going to a Fête c. 1844

Oil on canvas, 101.0 × 81.3 cm

Bequest of Susan Cornelia Warren (03.600)

Trained as a porcelain painter, Diaz had enjoyed some moderate success with his small pictures of gypsies, nudes, and bandits. This picture, with its strong emphasis on the landscape setting, demonstrates his indebtedness to Rousseau, whom he had met in 1837 and who encouraged the slightly older Diaz to paint in the Forest of Fontainebleau. More specifically, *Bohemians Going to a Fête* was painted in homage to Rousseau's 1834–35 *Cattle Descending the Jura* (fig. 14).[1] Unlike Rousseau's canvas, which was rejected from the Salon of 1836, however, Diaz's was accepted in 1844, displayed to great acclaim, and bought by the distinguished collector Paul Périer. Rousseau's painting may have been deemed too truthful, too real, too harsh. Diaz's, a happy blend of his earlier genre pictures and naturalistic landscapes, offers an escape into a fantasy view.

The forest canopy breaks just enough and in just the right place to allow a brilliant shaft of light to enter from the left. It picks out the trunks of twin birch trees at the left and a few of the colorfully dressed figures – particularly the young woman in the pink-red skirt and her attentive companion – and bursts with detail-obliterating force on the right-hand bank, a chiaroscuro effect that looks back to Rembrandt.

Diaz's contemporaries saw it differently. One critic at the 1844 Salon wrote:

> Here we have Diaz. This man does not fear the most brilliant light. His pictures are like a pile of precious stones. The reds, blues, greens, and yellows, all [are] pure tones and all combined in a thousand different ways, their brilliance gleaming from every point in his pictures; it is like a bed of poppies, tulips, bouquets scattered under the sun; it is like the fantastic palette of a great colorist. It is impossible to risk more and to succeed better.[2]

A later commentator put the painting, and Diaz's oeuvre, in perspective:

> In his sun-gilt landscapes Diaz put such figures as offered, by their costumes, a pretext for the wealth of his palette. The *Descent of the Bohemians* is the fullest expression of this style; here is all life and air; the band is coming down a steep path; through the foliage the sun rains down its beams and floods the whole picture with a transparent and luminous half-light; it is a perfect dazzle to the eye, like all the works of this great colorist.[3]

Fig. 14. Théodore Rousseau, *Cattle Descending the Jura*, 1834–35, oil on canvas, 259.0 × 166.0 cm. Musée de Picardie, Amiens. © Photo R.M.N.

In their distance from the everyday world, with their mixture of Northern and Italian peasant-style costumes, Diaz's bohemians nonetheless were grounded in reality for the artist and his viewers. For centuries in France the term *bohémien* meant "gypsy," because these wandering peoples were thought to have come from Bohemia. At the time Diaz painted this picture, the term had evolved to refer to creative figures – artists, writers, musicians – and people on the fringe of society, such as vagabonds.[4] These gypsies, funneling "out of the woods, a spatial device that perfectly suits their legendary oneness with nature,"[5] can be seen as a kind of self-portrait – the artist, outside society, in the forest, reveling in color and light.

1. On Rousseau's painting, see Forges 1962, pp. 85–90.
2. Thoré 1844, p. 398.
3. Wolff 1886, p. 47.
4. Brown 1978, p. 4.
5. Ibid., p. 287.

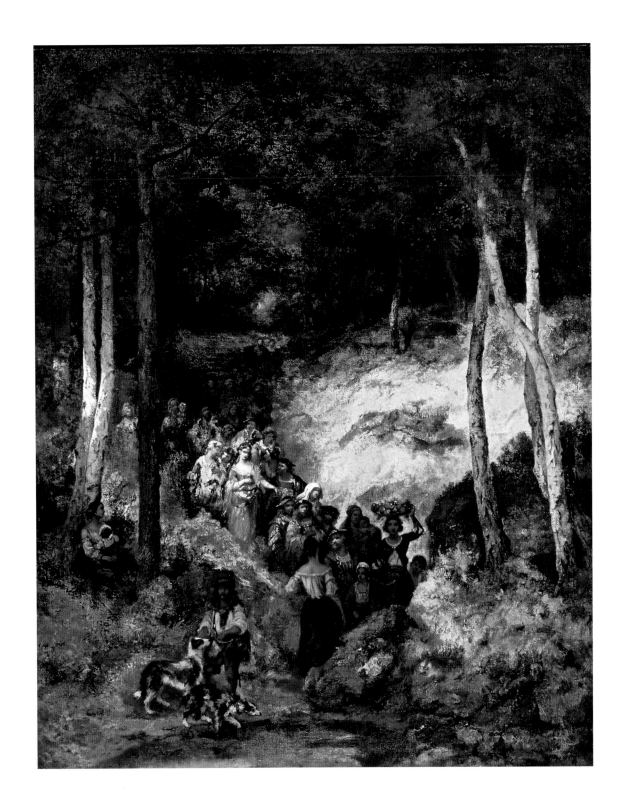

7 **Constant Troyon**
French, 1810–1865
Fields outside Paris 1845–51
Oil on paperboard, 27.0 × 45.5 cm
The Henry C. and Martha B. Angell Collection (19.117)

Landscape subjects could be found quite close to home, even for an urban dweller. In the middle of the nineteenth century a field outside Paris could be as near as eight or nine kilometers from Notre Dame or the Louvre. Visible in this painting by Troyon are low hills (perhaps those of Montmartre, at the northern edge of the city), poplars marking the boundaries of fields or properties, farmhouses and their outbuildings, three cows in the right middle ground, and two women to the left of the center foreground. Exactly what the women are doing cannot be determined, nor does it matter, for Troyon's primary interest is in the cloud-filled sky and in the establishment of a sense of place.

The low point of view taken by the artist heightens the immediacy of the scene. We are there, on the same plane as the women, in the middle of the field. This vantage point has the effect of breaking the composition into horizontal bands. These are variously differentiated by texture and color – a thin, scrubbed-on muddy green foreground; a fluid farther field, maybe newly harvested, wetly brushed on in long brown horizontals; a farther, greener field; the nervous, active, and brushy dark trees; and the blue hill, whose color announces its distance from the rest. The agrarian subject placed in a setting of horizontal bands mounting to a hill brings to mind later paintings by Camille Pissarro. Troyon's choice of paperboard as support suggests outdoor execution, since this material was more easily transportable than a stretched canvas.

8 **Constant Troyon**

French, 1810–1865

Sheep and Shepherd in a Landscape c. 1854

Oil on canvas, 34.8 × 45.1 cm

Bequest of Thomas Gold Appleton (84.276)

Although almost the same size as the other Troyon in this exhibition (cat. no. 7), *Sheep and Shepherd in a Landscape* differs in that it was painted on canvas. Troyon exploited the relative resistance of canvas to depict less immediate aspects of nature than in *Fields outside Paris*. The reeds edging the pool look as if they wafted onto the picture surface. In reality, Troyon's brush, dipped in thinned paint, merely touched the canvas in vertical strokes, and the combination of light touch, thin paint, and canvas weave conspired to create reeds. Elsewhere, dabs of paint, laid down in different directions, suggest but do not describe a rutted pathway, its dirt, and its vegetation.

In *Sheep and Shepherd in a Landscape* Troyon uses one of his favorite motifs, a flock of sheep (in other pictures a herd of cattle) being driven down a road and a peasant accompanying the animals, riding on a donkey loaded with panniers. This configuration allowed Troyon to experiment with light effects, depending on where the sun was and what kinds of clouds there were. Here, because of the clouds overhead, the peasants and donkey are in shadow, and some of the sheep are lit by bright sun. In a later painting, exhibited at the Salon of 1859, the sun is behind the figure and sheep, illuminating them with a halo-like effect; a smaller version of that work is illustrated here (fig. 15). The Boston painting is more casual, less hieratic, than the New York version, and its horizontality allows for a greater expanse of sky, with the fitful sun breaking through the cloud cover only in a few places.

Such pictures of animals were very popular with nineteenth-century audiences. Viewers understood that the subject was often a pretext for painterly effects. The august Larousse *Dictionnaire universel* described this kind of painting as follows:

> A *mise en scène*, picturesque, and often with a rare magnificence of effect; a color, sober, fine, distinguished, unfolding itself in sweet harmonies; a bold and original modeling, a quick instinct for light, the magic of shaded or radiant horizons, – these are the attractive charms, the exceptionable qualities, which assure this artist [Troyon] an eternal place among the masters of the [animal] genre.[1]

1. Translated in Clement and Hutton 1879, vol. 2, p. 302.

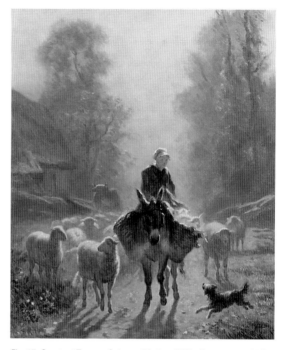

Fig. 15. Constant Troyon, *Going to Market*, 1860, oil on canvas, 41.0 × 32.7 cm. The Metropolitan Museum of Art, New York, Bequest of Isaac D. Fletcher, 1917 (17.120.220)

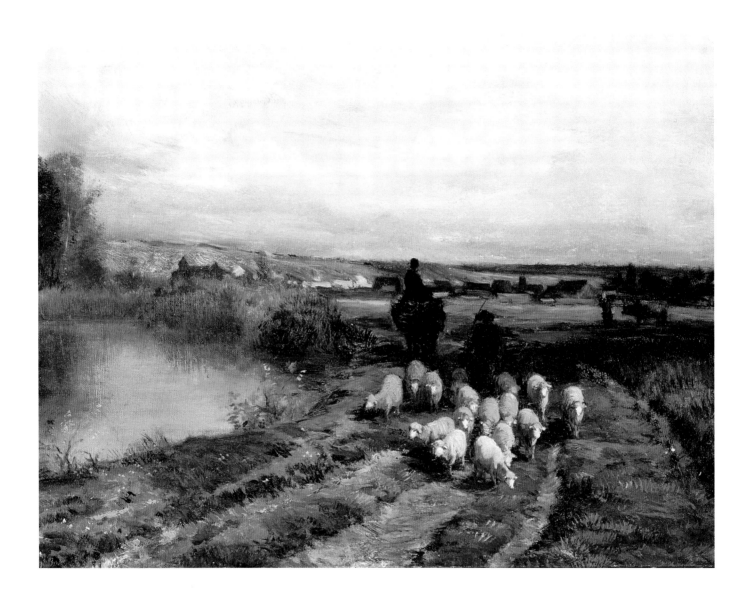

9 **Théodore Rousseau**
French, 1812–1867
Pool in the Forest early 1850s
Oil on canvas, 39.5 × 57.4 cm
Robert Dawson Evans Collection (17.3241)

Théodore Rousseau may have known the Forest of Fontaine-bleau better than any other painter. He began going to Barbizon in 1836 or 1837 and moved there soon after. He painted all aspects of the forest: the edge where it meets the surrounding plain, as in *Gathering Wood in the Forest of Fontainebleau* (cat. no. 10), trees isolated on the plain (*Group of Oaks, Apremont, Forest of Fontainebleau*, Musée du Louvre, Paris), and the forest interior, as in this painting.

In this serene picture, one looks beyond a dark foreground and past a screen of trees to a group of five cows and their herder enjoying the warmth of the sun. A palette of earth tones – especially the ochers and oranges – contributes to the feeling of warmth; this is perhaps one of the last days of summer. Despite the immediate attraction of the sunlit glade and the dark, insistent verticals of the tree trunks, the eye is led gradually through the composition, slowed by a series of gentle curves. The lower edge of the pool is defined by rocks whose curve echoes that of the water's far edge. The leaning ocher-colored tree at the left points the way to the branches that join in an arch at the center. The very shapes of the trees, full and rounded, are another voice in the symphony of curves.

Steven Adams, in his book *The Barbizon School and the Origins of Impressionism*, relates the device of a framed view (here, the glade seen through the screen of trees) to contemporaneous book illustration, "in which bright, centrally placed motifs gradually bleed off into dark, surrounding frames…. It marks a clear interface between print-making, popular imagery and landscape paintings."[1] As Adams notes, Rousseau was not alone in using this compositional device, and the increasing popularity of landscape paintings may be linked to the vogue for similarly composed, and more widely available, landscape views in prints.

Another source for the framed view was seventeenth-century Dutch landscape paintings, which at the time were widely known and valued for their perceived verisimilitude. Dutch landscape paintings, such as Meindert Hobbema's (1638–1709) *Pond in the Forest* (fig. 16), can be parsed into their conventions, just as surely as any painting by Claude or Poussin. But to nineteenth-century eyes, Dutch landscapes seemed almost haphazard; the artists, it was said, painted without selection or adjustment of what was in front of them. A picture like Rousseau's looked similarly casual to its audience, a glimpse of an otherwise overlooked corner of nature.

Fig. 16. Meindert Hobbema, *A Pond in the Forest*, 1668, oil on panel, 60.0 × 84.5 cm. Allen Memorial Art Museum, Oberlin College, Oberlin, Ohio, Bequest of Mrs. F. F. Prentiss, 1944 (44-52)

Despite immediate perceptions, *Pool in the Forest* is obviously carefully composed and equally carefully painted. The curves distributed throughout establish a slow, easy rhythm, allowing the viewer to discover, bit by bit, nature's beauties. This discovery is a hard-won prize, and the artist makes the process visible in his patient brushwork. Rousseau's fastidious handling of paint makes one feel his concentration on, his dedication to, and his love for the view he paints.

1. Adams 1994, p. 83.

10 Théodore Rousseau

French, 1812–1867

Gathering Wood in the Forest of Fontainebleau c. 1850–60

Oil on canvas, 54.7 × 65.3 cm

Bequest of Mrs. David P. Kimball (23.399)

Artists like Rousseau who went to the Forest of Fontainebleau to find subjects to paint were attracted to it for several reasons. Sixty-four kilometers southwest of Paris, it offered startlingly varied topography, from rocky gorges to open plains, from thick forests to paths and roadways. In addition, the forest was lived in and used by hardworking peasants, who animated and humanized the land. Rousseau and his colleagues painted what they saw in the forest, not idealizing but presenting the natural facts with a humble honesty. This humility allied them with seventeenth-century Dutch landscapists, whose paintings were seen in the nineteenth century to embody naturalism and truth.

Here Rousseau shows a typical activity in the forest: the gathering of wood. The location is most likely the Plain of Chailly, at the northwest edge of the forest. Women – destitute members of the community or wives of landless woodcutters – combed the forest for fallen branches, which they would then sell for a meager profit.[1] Rousseau's luminous painting shows faggot gathering as a group activity. A cart and horse in the middle ground seem to have some relation to the two women moving down the rain-soaked path in the direction of the viewer. The foremost woman rides a laden donkey, and the second one carries on her back a huge bundle of sticks.

But the depiction of laboring peasants is not what really interested Rousseau. The human figures are incidental to the delineation of the physiognomy of the forest, and especially the point at which the forest meets the plain. Taking his cue from seventeenth-century Dutch forest scenes, in which a concentration on elements in the foreground on one side of the painting is relieved by a view into the distance on the other side (see fig. 17), Rousseau contrasts the dense, intricate foliage on the right with the expanse of plain crowned by an overarching sky. The central towering tree blocks the sun, with the result that the tree is silhouetted against the light. Its dark branches seem to be given form by the light at the same time that they do battle with it. Rousseau here subsumes the figures into a radiant vision of nature's strength, variety, and vitality. His brush weaves a light-toned tapestry of color and texture, made visible by the light that shows at once the detail of the foreground and the seemingly endless plain stretching into the distance.

Fig. 17. Simon de Vlieger, *Sleeping Peasants near Fields* (*Parables of the Weeds*), 1650–53, oil on canvas, 90.4 × 130.4 cm. The Cleveland Museum of Art, Mr. and Mrs. William H. Marlatt Fund (1975.76)

1. For a fuller discussion of faggot gatherers, see Murphy 1984, pp. 26–27, no. 16, and pp. 88–89, no. 57.

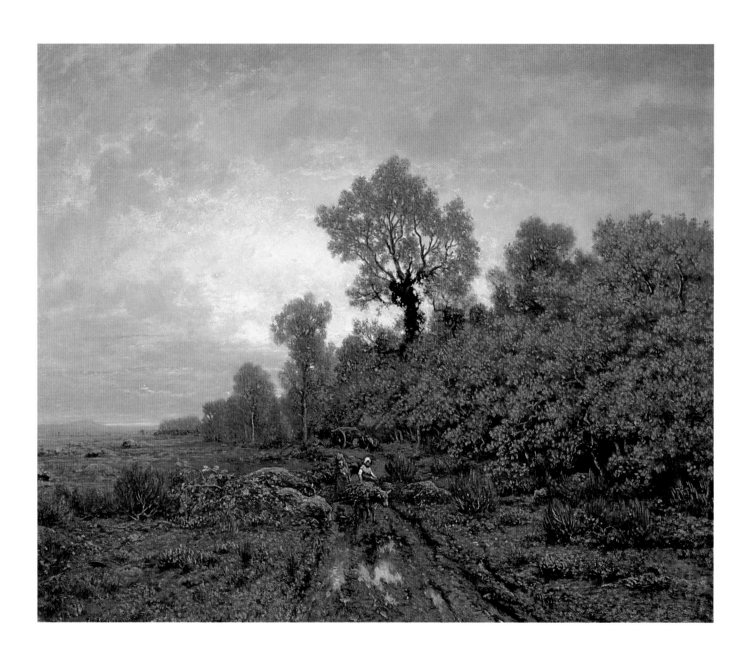

11 Antoine Chintreuil

French, 1814–1873

Peasants in a Field or *Last Rays of Sun on a Field of Sainfoin* c. 1870

Oil on canvas, 95.8 × 134.0 cm

Gift of Mrs. Charles G. Weld (22.78)

Chintreuil's landscape depicting peasants in a freshly harvested field is striking for its lurid yellow-orange sunset. More than four feet wide, the picture threatens to engulf the viewer by virtue of its size and luminosity. Chintreuil was attracted to sweeping vistas painted at large scale and dominated by strong light effects. (For the best-known example, see his *Expanse*, measuring 102.2 by 201.9 centimeters, in the Musée d'Orsay, Paris.) *Peasants in a Field* exemplifies this tendency. Here the field seems to stretch indefinitely to the low hills in the distance and more than half of the canvas is given over to the sky.

In his attention to a specific light effect, Chintreuil showed himself a faithful follower of Corot, having learned from the master the importance of capturing the overall impression of a scene and ignoring any potentially distracting details. Yet Chintreuil's effect could hardly be more different from Corot's soft, silvery light. Chintreuil's effulgent sky "is more consonant with a belated spirit of Romanticism, a resonant hymn of praise and wonder before the varied majesties of nature,"[1] than it is a careful naturalistic study. The hot light does two things. In the sky and at the horizon it seems to take on material form, much as does the light of the English painter J. M. W. Turner (1775–1851), although there is no evidence that Chintreuil had seen the latter's paintings. And like the animating light of the German Caspar David Friedrich (1774–1840) or of the mid-century American Luminist painters[2] such as Martin Johnson Heade (1819–1902), it makes the piles of the harvested crop glow eerily. This crop, mauve-colored and interspersed with pink flowers, is sainfoin, a perennial leguminous herb grown to feed livestock. Émile Zola trenchantly described Chintreuil's accomplishment: "One senses an artist who is striving to go beyond the leaders of the Naturalist school of landscape painting and who, although faithfully copying nature, attempted to catch her at a special moment difficult to transcribe."[3]

Chintreuil considered this an important painting. He exhibited it at the Salon of 1870, having to borrow it back from a M. Fassin, in Reims, to whom he had already sold it.

1. Rosenblum 1989, p. 118.
2. Ibid.
3. Zola 1959, p. 204.

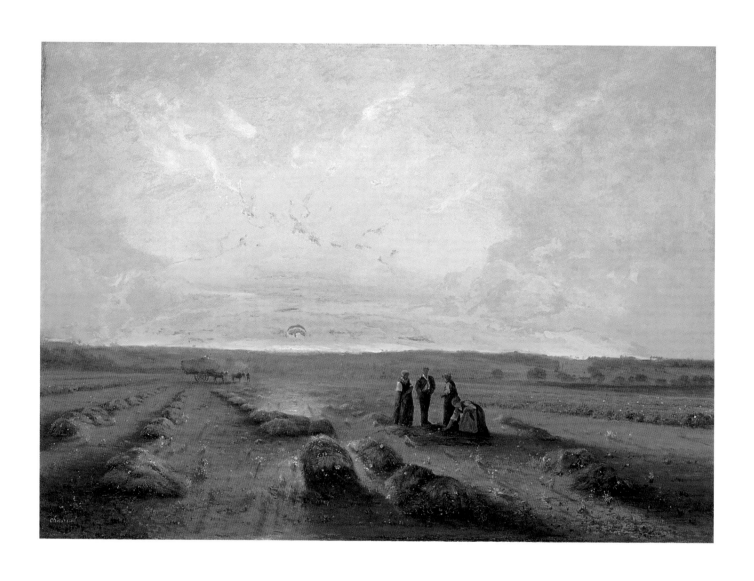

12 **François-Louis Français**

French, 1814–1897

Sunset 1878

Oil on canvas, 47.1 × 56.3 cm

Bequest of Ernest Wadsworth Longfellow (37.598)

The landforms in this painting fade into steel gray-blue and brownish black beneath a sky aflame with pinks, salmons, yellows, and oranges. Français deftly captures the different colors refracted through and reflected off clouds of various shapes and at different altitudes. These startling effects are visible to those who look for them, and by 1878, the date of this picture, Français had had a long career of working outdoors. In the early 1830s he painted in the environs of Paris with Huet; then, in the mid-1830s, he worked in the Forest of Fontainebleau, where he met Corot and Diaz. At mid-century he painted in various locations with Troyon, Corot, Courbet, Boudin, Jongkind, and Daubigny. Through these companions, Français probably became familiar with the practice of closely observing effects in nature. The slow-moving river may be the Saône; after 1873 Français summered at Plombières, on that river. In this painting he tackles the difficult and evanescent subject of the last moments of the setting sun, just before it sinks below the horizon completely, taking all light with it.

In contrast to Daubigny's *Château-Gaillard at Sunset* (cat. no. 16), whose titular focus is the ruined castle, Français's *Sunset* concentrates all attention on the sky. It was worked with very thin paint, swept across the canvas with large brushes to capture the broad effects. The trees marking the far bank were, if not an afterthought, then not integral to the painting's conception, for they were added on top of the colored sky as dabs and strokes of darkness.

This concentration on the evanescent effects of light and color, at the expense of the ground below, has few precedents in the history of art. The cloud studies of the English artist John Constable (1776–1837) come to mind, but Français would probably not have known of them. Similarly, a study Corot made on his first trip to Italy (fig. 18) shows a good deal of sky but was also a study exercise, not a work to be sold. By 1878 the study or sketch had come out of the studio. The painting's careful signature and date suggest that this medium-size canvas was made for sale, either directly to a collector or through a dealer. Its appeal to collectors is evident: the Bostonian Ernest Wadsworth Longfellow bought it as early as 1884.

Fig. 18. Camille Corot, *View of the Roman Campagna*, February 1826, oil on paper mounted on canvas, 26.0 × 46.0 cm. Fitzwilliam Museum, Cambridge, England (PD.1-1960)

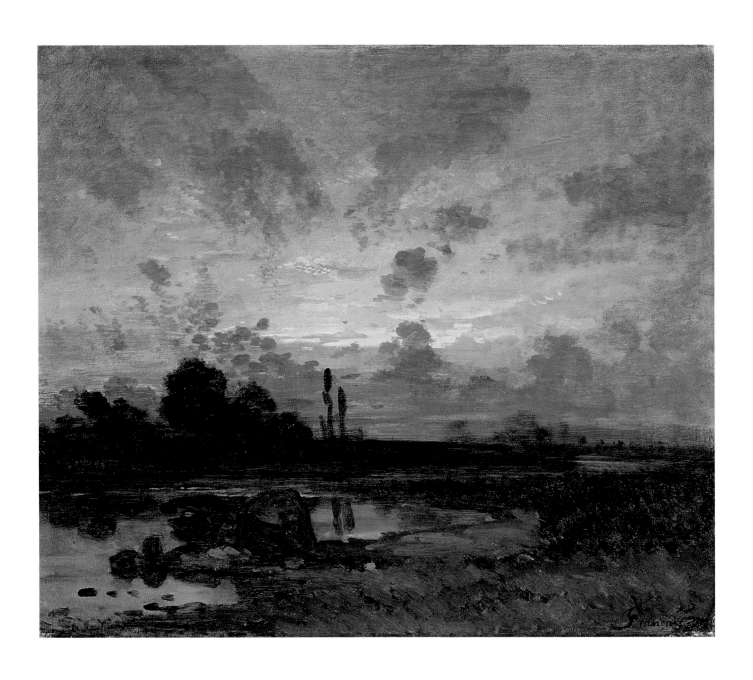

13 Jean-François Millet

French, 1814–1875

End of the Hamlet of Gruchy 1866

Oil on canvas, 81.5 × 100.5 cm

Gift of Quincy Adams Shaw through Quincy A. Shaw, Jr. and Mrs. Marian Shaw Haughton (17.1508)

Millet is so intimately associated with Barbizon (he moved his family there from Paris in 1849) that his attachment to his native Normandy is sometimes overlooked. He was born in the peasant community of Gruchy, on the coastal edge of the village of Gréville, almost eighteen kilometers west of Cherbourg,[1] in the northwest corner of Normandy that juts into the English Channel. This painting evinces a profound affection for the scene depicted, Millet's hometown, and in particular "the habitual peacefulness of the place, where each act, which would be nothing anywhere else, here becomes an event."[2] The stone house stands at the end of the single street of Gruchy, where land meets water. Domestic details abound: the two chairs by the spinning wheel, the family of ducks at the right, and the endearing procession of geese heading purposefully indoors, the last in line looking up as if to check the weather. Most poignant are the mother and child who have just vacated their chairs. In a letter, the artist described the scene. During a break from spinning, and to amuse the child, "the woman picked him up and sat him on the little wall where he plays…. I would like to have the power to express for the viewer the thoughts that must enter, for life, the mind of a young child who has never experienced anything other than what I have just described, and how this child, later in his life, will feel completely out of place in a city environment."[3] It is hard to avoid concluding that in this letter Millet is thinking of his own feelings when he lived in Paris.

The child reaches for the tree – an elm, Millet tells us – that clings to the coastal soil. A symbol of tenacity and strength, by 1866 it nonetheless succumbed to the winds coming off the Channel.[4] It lives on in the painting, perched at the edge of Normandy, its home, yet reaching out, its limbs anthropomorphized as if yearning for the unknown. In another letter Millet described the view to be had standing by the elm: "Suddenly one faces the great marine view and the boundless horizon…. Imagine the impressions that one can get from such a place. Clouds rushing through the sky, menacingly obscuring the horizon, boats sailing to faraway lands, tormented, beautiful, etc., etc."[5]

Millet's modifiers – "menacingly," "tormented," "beautiful" – betray an ambivalence about his home; perhaps he feels he should have stayed. Some of this ambivalence can be seen in the painting: the house is cast largely in shadow, and the geese are moving indoors (Millet told Silvestre that the house was the "constant goal" of the geese). The overwhelming impression, however, is one of contentment and delight in nature's beauty. Even this humble spot – "where each act, which would be nothing anywhere else, here becomes an event" – is beautiful. Millet lavishes color everywhere, from the flowers growing in the thatch of the roof to the blue-speckled stream to the lavenders and pinks in the sky and water. The entire scene sparkles with sunlight, evoking the clean, salty air of the sea.

1. This entry is indebted to Murphy 1984, no. 111.
2. Millet to Théophile Silvestre, April 20, 1868, quoted in Murphy 1984, p. 243.
3. Ibid.
4. Millet to Alfred Sensier, February 6, 1866, quoted ibid.
5. Millet to Silvestre, April 18, 1868, quoted ibid.

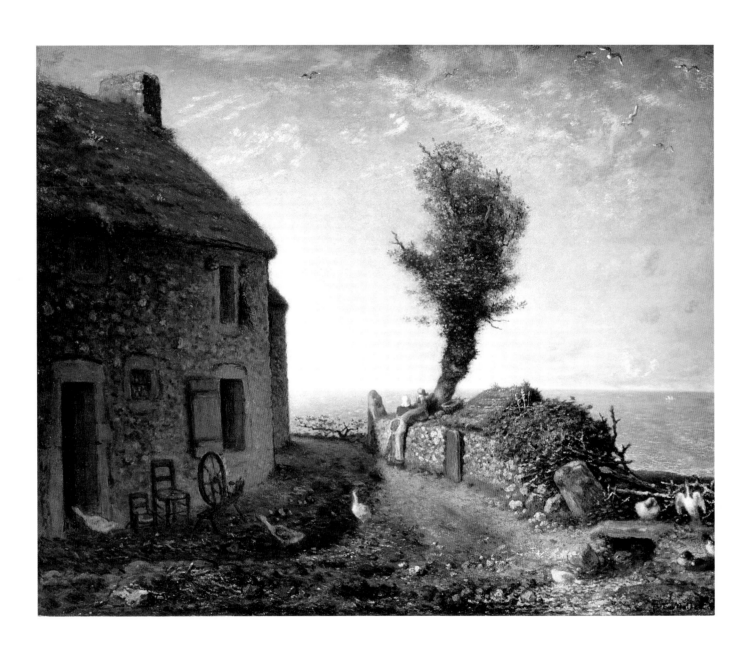

14 Jean-François Millet

French, 1814–1875

Priory at Vauville, Normandy 1872–74

Oil on canvas, 90.9 × 116.7 cm

Gift of Quincy Adams Shaw through Quincy A. Shaw, Jr. and Mrs. Marian Shaw Haughton (17.1532)

Millet's *Priory at Vauville, Normandy* shows the thriftiness of the rural French. The group of eleventh-century granite buildings seen here, built near the edge of cliffs overlooking the English Channel, formed a priory, a religious institution headed by a prior, a rank one step below an abbot. As with other religious buildings in France, it was removed from church control during the French Revolution. Not to let good buildings go to waste, local people converted the structures to the agricultural use Millet records here: the chapel was a barn for the farmer, who lived in another building.

Although only very little of the Channel waters can be seen (to the left and right of the central buildings), the presence of the open water is felt intensely. The rocky, rutted foreground, up to the stone boundary wall, takes up the bottom half of the picture. Because this foreground, despite its details of rocks and grass, is untended, formless land, our attention is directed more to the priory, with its horizontal lines of wall and roofs. This combination of unfocused space and horizontality powerfully suggests the expanse of sea beyond.

Millet is concerned with showing that these buildings and this land are being used. A woman opens the gate for the cows on their way to pasture along the cliffs; perhaps the man sitting to the left is waiting for them. Chickens are visible close to the largest building. The teeth of a harrow lying on the hillside outside the wall sparkle in the sunlight: even this unpromising soil can be made to yield crops.

Just as these farmers are able to make a living at the edge of the continent, so is Millet able to make a ravishing painting from the same scrap of land. Darker colors at the bottom gradually give way to lighter colors as the space moves back through the farm buildings, beyond to the sea, and up to the sky. Likewise, brushstrokes become smaller and more even, enlivened by spots of bright white representing highlights on cows, chickens, and clouds.

Millet must have been pleased with this painting, if the following anecdote can be trusted. A young Canadian-born American painter named Wyatt Eaton (1849–1896) befriended Millet at the end of the Frenchman's life. Eaton visited Millet at Barbizon in 1873 and saw *Priory at Vauville* on an easel. It is reported that "the evident admiration and delight of the young man pleased Millet, who called him nearer, and bade him notice the simplicity of his execution, and the infinite variety of effect that can be produced by a few touches."[1]

It is easy to agree with this assessment, particularly because the contrast of variety and simplicity is exactly what makes this painting so engaging.

1. Cartwright 1896, p. 339.

15 Charles-François Daubigny
French, 1817–1878
Road through the Forest c. 1865–70
Oil on canvas, 64.5 × 92.5 cm
Gift of Mrs. Samuel Dennis Warren (90.200)

During his lifetime Daubigny was criticized for his sketchy execution. The following quotation is typical: "It is truly a pity that M. Daubigny, this landscape-painter, with a sentiment so true, just, and natural, contents himself with a first impression, and neglects, at this point, the details. His pictures are no more than sketches, and sketches little advanced."[1] In this view of a rutted track leading into a forest, the broken brushstrokes lie as clumps of paint on the surface of the picture, almost destroying the illusion of depicted space. The materiality of the paint is all the more marked because of the large size of the canvas. The active brushwork and summary description of forms could be explained in traditional, academic circles if the painting were small and executed outdoors in preparation for a larger work to be finished in the studio. Yet, measuring more than a yard wide, *Road through the Forest* is a complete work unto itself, embodying Daubigny's belief in the primacy of an unmediated response to nature.

The motif of the road leading straight back into the composition recalls many similar scenes by Rousseau, such as his *Gathering Wood in the Forest of Fontainebleau* (cat. no. 10), and beyond Rousseau, to his sources in seventeenth-century Dutch landscape paintings. The differences between the Daubigny and the Rousseau, however, are instructive. First, Daubigny eschews the narrative supplied by the figures who are seen gathering wood in Rousseau's work. The motif of a road leading into a forest suffices for picture making. Allied to the notion that nature alone, unanimated by human figures, is a worthy subject for art is the way in which Daubigny paints the scene. Perhaps the most striking difference is his much freer handling of paint: witness the freely impasted sky, with its lowering gray clouds, spots of white struggling through, and the leaves of the apple trees at the left that melt into a single mass. Daubigny's ability to depict natural forms in such summary terms made him sympathetic to the younger artists who would become known as the Impressionists.

His approach was deplored by some and praised by others:

The art of this illustrious master consists in choosing well a bit of country and painting it as it is; enclosing in its frame all the simple and naïve poetry which it contains…. No, it is the real hospitable and familiar country, without display or disguise, in which one finds himself so well off, and in which one is wrong not to live longer when he is there, to which Daubigny transports me without jolting each time that I stop before one of his pictures.[2]

This painting by Daubigny came to the United States at a very early date, having been imported by Seth M. Vose, a dealer with galleries in Providence, Rhode Island, and Boston. Vose has the distinction of having introduced American audiences to progressive mid-century French landscape painting. The fact that this painting formed part of the important Beriah Wall collection proves that such a freely brushed scene appealed to American collectors. The collection was dispersed by auction in 1886, but the painting did not go homeless for long. It was bought at that sale by Mrs. Samuel Dennis Warren of Boston, another collector who appreciated the freshness of Daubigny's approach.[3]

1. Théophile Gautier, *Abécédaire du Salon de 1861*, translated in Clement and Hutton 1879, vol. 1, p. 185.
2. Edmond About, *Salon de 1864*, translated ibid.
3. For a succinct discussion of Vose and Boston collectors, see Poulet and Murphy 1979, p. xxxviii.

16 Charles-François Daubigny

French, 1817–1878

Château-Gaillard at Sunset c. 1873

Oil on canvas, 38.1 × 68.5 cm

Gift of Mrs. Josiah Bradlee (18.18)

This view from Château-Gaillard, perched high on chalk cliffs above the river Seine between Rouen and Paris, appealed to Daubigny. He painted it and its environs several times over a period of years beginning in 1869. The choice of a historic site is unusual for this artist. Château-Gaillard was built by the English king Richard I, the Lion-Hearted (1157–1199), in 1196 at Les Andelys in a futile attempt to protect Normandy (at that time under English rule) against a French invasion. In 1603 the castle was dismantled by order of the French king Henri IV. Any historical associations, however, are subsumed in the compositional possibilities the site offered: the ruins could as easily be a rock formation as a castle.

Daubigny was obviously drawn to this site at this time because the effects of the setting sun were so dramatic. Bright orange picks out a turret of the ruins, and violets and mauves fill the water and tint the sky. Landforms are drawn in with liquid brushstrokes of olive green and teal blue. Single strokes lie flat on the surface, tracing a contour of a hill or, alternatively, functioning as calligraphy, as in the squiggle in the foreground. The coloristic focus is the setting sun, with its hot hues of orange and yellow; the surrounding landscape serves mainly as a framework for the study of color and tone.

Château-Gaillard was one of many sites that Daubigny encountered on his trips on his *botin*, the studio-on-a-boat he launched in 1857. He traveled the rivers of France, notably the Seine, Marne, and Oise, in the summer months, studying the rivers and their moods. Daubigny's usual, more anonymous subjects are taken at the level of the river, which makes this panoramic view, in conjunction with its equally atypical historical site, singular in his oeuvre. Yet the elevated perspective allowed him to paint a bigger sky, vaulting as it does over the varied terrain.

This is one of four versions that Daubigny painted of the same prospect.[1] All are approximately the same size, and they present the elements – ruined castle, town below, and island in the river – with varying degrees of detail under different light conditions. For instance, the town that appears as a rather undifferentiated jumble here (decipherable only by the church spire) is legible in another version (Hellebranth 1976, no. 89) as orderly rows of buildings. The summary treatment of the Boston version shows Daubigny's willingness to forgo description in favor of capturing an effect. Because the four views overlooking the Seine from the height of the château were done over a period of years and not as a concerted campaign, they cannot be considered a series, unlike Monet's later investigations of early morning on the Seine and of grainstacks. Yet Daubigny's exploration of effects from the same vantage point is testimony to the same spirit of study that animates Monet's canvases.

The critic Albert Wolff, generally hostile to progressive trends in painting, was kindly disposed to these views of Château-Gaillard.

> [Daubigny] brought to landscape painting the realistic keynote in the best sense of the term – that is to say, the matching of real objects by a deeply felt stroke, so that, with each new sensation, freshly breathed in the presence of nature, he shifted his art;… where the artist has found himself astounded before the grandeur of a scene – as in the admirable view of the *Château-Gaillard* – he rises to the calm height of greatest art…. In this way the career of Daubigny is based on the simple and truthful art-theory that the handling of a picture ought to reflect the mood felt; that the painter can no more work perpetually in the same style than the writer can employ an unvarying form for the play of his thought.[2]

1. Hellebranth 1976, nos. 89–92.
2. Wolff 1886, p. 71.

17 Gustave Courbet

French, 1819–1877

Stream in the Forest c. 1862

Oil on canvas, 157.0 × 114.0 cm

Gift of Mrs. Samuel Parkman Oliver (55.982)

For this picture Courbet used virtually the same palette that Rousseau had used to paint his *Pool in the Forest* (cat. no. 9), and the subject – water in the form of a pool or stream in the forest – is also closely comparable, but there the similarities end. Whereas Rousseau's painting is small and intimate in feel, Courbet's is large and assertive. Rousseau applied his paint in careful, minute touches of a brush, while Courbet spread his onto the canvas with a painting knife, whose movement can be read in the long, tactile planes and ridges of paint.

Courbet has situated the point of view of the scene in mid-air, suspended over the stream. We look down on a young deer, turning to look at us, as if asking what we are doing in this secluded spot, and perhaps ready to defend the two younger deer in the underbrush behind. (This anecdotal touch, to which our attention is drawn by the splashes of red and white near the deer, argues for the picture's having been made for the market.) The point of view also offers a look down on the stream's surface. The light-blue streak to the right is especially arresting. Meant to be read as a reflection of the sky, it becomes a shape divorced from the tangible world. Because the reflections of the tree trunks converge on that side, it seems to point to the depths of the stream.

The sense of looking down is matched by a sense of looking up. This is a large painting, and its vertical format emphasizes the height of the slender trees. The trees seem especially lofty because their tops are cut off: even a five-foot-high canvas is not large enough to encompass their full height.

Courbet's approach was geared to satisfying his audience, people living in cities who could find visual respite in the cool colors and simple shapes of his scenes. In their quest for pictures of refreshing nature, his viewers were clearly able to accept the roughness of his technique. By insisting on the physicality of their surface, Courbet's landscapes, such as *Stream in the Forest*, balance delicately between the attempt to paint a fictive space that looks real and the urge to let the viewer see how the painting was made.[1]

1. Wagner 1981, pp. 410–31.

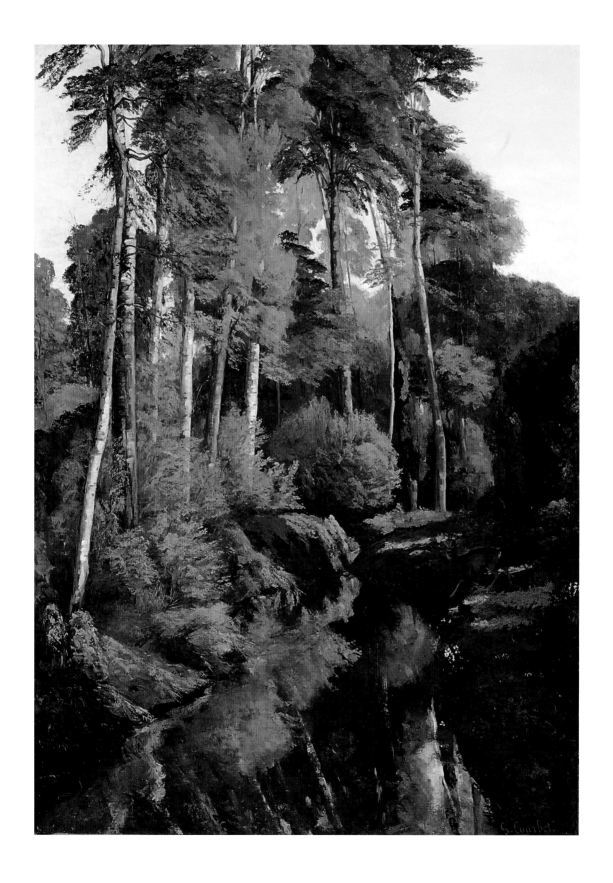

18 Henri-Joseph Harpignies

French, 1819–1916

Landscape with an Old Dam 1882

Oil on paperboard mounted on panel, 40.0 × 33.4 cm

Juliana Cheney Edwards Collection (39.650)

Harpignies steadfastly clung to a few compositions and motifs throughout his long career. His allegiance to the model of Corot is often cited, yet *Landscape with an Old Dam* is an ingratiating blend of Daubigny's palette of mid-to-dark greens and the English painter John Constable's (1776–1837) vertical compositions dominated by a stately tree. Careful draftsmanship and paint application combine with the modest rural subject to create a painting of profound stability and quietude.

The house and dam, their strict rectilinearity serving as a foil to the rounded or whip-like forms of the surrounding trees and reeds, announce that this land is used by humans. Unlike the contemporaneous Impressionists, who by 1882 were painting identifiable views of suburban Paris and beyond, Harpignies chose an anonymous spot, reminiscent of a way of life that had generally disappeared. Sisley's *Waterworks at Marly* (cat. no. 36), for example, may show the dams and pump stations built in the seventeenth century to supply water for Versailles, but it shows them in their present-day recreational use of 1876. Harpignies's dam, in contrast, was built for private use, perhaps to allow fish or eels to gather and be harvested by the inhabitants of the house a short distance from the stream.

Constable's impact on French landscape painting was most intensely felt in the 1820s, although prints after his works were widely circulated for many years. *Landscape with an Old Dam* recalls paintings by Constable such as *The Lock* (fig. 19), exhibited at the Royal Academy of Arts in London in 1824. Harpignies may have known the composition through the mezzotint made by David Lucas (1802–1881) and published on July 1, 1834. Constable's lock is more elaborate, and he included the necessary information on how the lock worked. In comparison with the Constable, the Harpignies seems all the more placid and even meditative, evocative of a time gone by.

Fig. 19. John Constable, *The Lock*, 1824, oil on canvas, 142.2 × 120.7 cm. Carmen Thyssen-Bornemisza Collection

19 **Henri-Joseph Harpignies**

French, 1819–1916

Evening at Saint-Privé 1890

Oil on canvas, 73.7 × 54.5 cm

Bequest of Ernest Wadsworth Longfellow (23.486)

At first glance, this painting appears to be a portrait of trees. The vertical orientation of the canvas, reminiscent of portraits, reinforces this impression. Yet the cropping of the composition – the tops of the trees are cut off by the upper edge of the canvas – emphasizes the decorative quality, in which patterns that lie flat on the picture's surface take precedence over description. A contemporary of the artist explained:

> While accepting the modern feeling for air and sunlight, he never forgot the primary rhythmical purpose of a picture – that it must before all else be a pattern. So in his paintings we always find this sense of rhythm and pattern accentuated with a true French love for clarity of expression, for gravity of mood, and for that logical, temperate balance, that love of proportion for its own sake.[1]

As true as these words are, this painting by Harpignies, done near his house at Saint-Privé, on the river Yonne southeast of Paris, conveys the effect of looking out from the relative darkness of a forest to a brighter area in the distance. With the sun hidden, the light picks out the tops and right sides of the trees on the far bank. The river itself is a smooth, reflective surface. The subtle nuancing of light throughout and the contrast of dark forms against a blue sky changing ever so slightly to rose are reminiscent of the artist's watercolors, in which luminosity is of prime importance.

1. Holmes 1909, pp. 76, 81.

20 **Johan Barthold Jongkind**

Dutch, 1819–1891

Harbor Scene in Holland 1868

Oil on canvas, 42.0 × 56.0 cm

Gift of Count Cecil Pecci-Blunt (61.1242)

The various ships and boats in Jongkind's paintings can be seen as a pretext for his experiments in translating the interactions of water, light, and atmosphere. Born a Dutchman but living and working in France, Jongkind carried his country's tradition of marine painting into the nineteenth century and updated it with his loose brushwork and attention to the fugitive effects of light.

Here, two brigantines (two-masted square-rigged sailing ships) are anchored on either side of a canal. Rowboats work the water between them. Judging from the brick houses at the right and the silhouettes of the drawbridge and windmill in the distance (a tug or barge is near the drawbridge), the scene is set in Holland. The date of 1868 suggests that the view could have been taken in Rotterdam or Dordrecht (Jongkind visited those two cities in the fall of that year). Yet it is most likely a generalized view rather than a portrait of a particular canal done at a particular time, for Jongkind is not known to have painted oils outdoors. His evocative scenes, whether sun-filled, overcast, or nocturnal, are based on memory and sketches.

Unlike seventeenth-century Dutch marines, in which the surface of the canvas is covered with a uniformly worked layer of paint, Jongkind varied his brushwork to represent different materials. The elements in this canal view – sky and clouds, trees, buildings, ships and boats, and water – are each rendered with their own kind of brushstroke. The blue sky and gray and white clouds are painted with large, buttery strokes. The canal, in contrast, is made up of tiny dabs of color – surprisingly, with almost no blue. These flecks of color, as well as the swirling strokes in the sky, stand for water and sky but also proclaim their physical presence on the canvas. In addition, Jongkind depicts a complicated light effect, with the sun hidden behind clouds. The windmill is obscured, and the brigs are backlit, their hulls appearing as dark masses.

Jongkind's importance for the younger generation of landscapists was immense. Boudin and Monet appreciated his free and spontaneous brushwork. Boudin emulated the older artist, despite the fact that many critics considered Jongkind's paintings unfinished. Boudin wrote: "Jongkind began to make the public swallow a sort of painting whose rather tough skin hid an excellent and very tasty fruit."[1] Monet misunderstood Jongkind's method but appreciated the effect. He believed that one had "always something to gain from studying Jongkind's landscapes because he paints what he sees and what he feels with sincerity."[2] The critic Théophile Thoré was more explicit in stating his praise: "M. Jongkind's manner does not appeal to everyone, but it delights all who love spontaneous painting, in which strong feelings are rendered with originality…. I have always maintained that true painters work at speed, under the influence of impressions."[3]

1. *L'Art* (1887), quoted in Jean-Aubry 1968, p. 116, translated in Cunningham 1976, p. 21.
2. Quoted in Cahen 1900, p. 41, translated in Hamilton 1992, p. 42.
3. Boime 1971, p. 21, quoted in Cunningham 1976, p. 14.

Johan Barthold Jongkind
Dutch, 1819–1891

Harbor by Moonlight 1871

Oil on canvas, 34.0 × 46.2 cm

The Henry C. and Martha B. Angell Collection (19.95)

Jongkind did not return to Holland, his homeland, in 1871, the date of this painting. But like Corot, who was able to recall the salient aspects of light and atmosphere of various locales when he painted his *souvenirs*, Jongkind did not need to see a Dutch canal to paint one. He seemed to relish making his task more difficult by choosing to depict a nighttime scene, full of mauves, grays, and blues. In this choice of subject he was consciously reviving a genre of landscape painting made popular in seventeenth-century Holland by Aert van der Neer (1603–1677) in works such as *Canal Landscape with Fishing Boats* (fig. 20). The earlier artist pointed the way for Jongkind in his minimization of local colors by the darkness and in his distribution of the reflected light over a basically monochrome painting.[1]

Like van der Neer, Jongkind concentrated the light in this painting in the middle, where the moon peeks through clouds and reflects off the surface of the canal. Unlike the earlier artist, however, Jongkind was not particularly concerned with physical description, and his brushwork was freer, which allowed him to flick bits of light-colored paint across the surface. These scattered highlights draw the eye to and fro, as if in imitation of dancing moonlight, falling fitfully through scudding clouds.

The painterly quality of Jongkind's scene is all the more evident when the two works are compared. Van der Neer fills his painting with anecdotal detail, such as men variously working the boats and riding by the side of the canal, and physical description, such as a bridge in the distance and the structure of the trees. In contrast, no people are visible in the Jongkind painting, the trees are mere blurs, and the outline of the building on the left is limned only by the diagonals of the roof. All detail is subsumed in the artist's insistent brushwork. As early as 1862 Jongkind's work appeared different from that of other painters. Monet looked back on his own career to the year in which he met Jongkind. "His painting," Monet said in an interview, "was too new and in far too artistic a strain to be then, in 1862, appreciated at its true worth…. From that time on, he was my real master, and it was to him that I owed the final education of my eye."[2]

Despite his innovative brushwork, Jongkind was mindful of exploiting the picturesque aspects of his native land. Van der Neer and other seventeenth-century Dutch landscapists had routinely included typically Dutch elements like canals and windmills in their paintings as a way to signal the Netherlands'

Fig. 20. Aert van der Neer, *Canal Landscape with Fishing Boats*, probably 1640s, oil on panel, 41.0 × 52.0 cm. Städelsche Kunstsammlung, Frankfurt (1092). Photograph: © Ursula Edelmann

economic status as a world power and to express pride in its newly constructed system of canals. Jongkind's canal, ships, and windmill are also used to symbolize the Netherlands, but now in a touristic fashion, as reminders of a more illustrious past. The linear configurations of rigging and windmill make decorative patterns against the brushy, atmospheric sky.

1. Stechow 1966, p. 178.
2. "Claude Monet: The Artist as a Young Man," *Art News Annual*, vol. 26 (1957), p. 128, translated from Thiébault-Sisson 1900, quoted in Cunningham 1976, p. 27.

22 Eugène Boudin

French, 1824–1898

Harbor at Honfleur 1865

Oil on panel, 20.3 × 26.8 cm

Anonymous Gift (1971.425)

Boudin dedicated himself to painting the sea, its coastline, and the human activities that take place in these locales. This concentration allowed him to study the ever-changing character of the seaside light and air and to develop painterly means to replicate these effects. Here he was attracted by the stark geometry of a pier seen at an angle. The atypical vantage point makes the pier spread out to fill the entire foreground of this tiny painting. It becomes almost abstract, a field for paint. Docked along two sides of the pier, the ships – a brig, a hermaphrodite brig, and a smaller coastal vessel[1] – instead of continuing the geometry, serve as a foil to it, their masts, spars, rigging, and sails offering an active alternative to the starkness of the wharf.

Boudin localizes this view by inscribing *Honfleur* in the lower left corner. Without the inscription, we would be at a loss to know which of the many English Channel ports this view represents. With it, we know that Boudin made the short trip from Le Havre, the large town on the northern shore of the Seine estuary, to the smaller town on the southern shore. The palette suggests that this is a summertime painting (Boudin often spent the summer months in his hometown). Light-colored paint gives the effect of being light-filled. A contemporary wrote of Boudin:

> In his color, he consistently adopted the luminous, all-over light-toned palette, pioneered by Corot, which in the 1850s and 1860s was known as *peinture claire* or *peinture grise*; this means of conveying the effects of outdoor light was, Boudin remembered later, very unfashionable in those years, in contrast to the more theatrical, artificial effects sought by most painters of seascapes. This *peinture claire* was to have a crucial influence on the emergence of Impressionism.[2]

Although Boudin never broke his brushstrokes into individual marks of color, as the Impressionists did, his distinctive touch – "gently feathered, blended, and succinctly articulated," in Peter Sutton's apt phrase[3] – suggests the movement of light through air. Here, the rapid brushwork animates the surface of the canvas. This makes the eye skip and hop from one stroke to another, a movement similar to that which the eye experiences in nature. It was this combination of *peinture claire* and active brushwork that so captivated the young Monet.

1. Sutton 1991, p. 40.
2. Leroi 1887, p. 32, translated by John House in Hamilton 1992, p. 17.
3. Sutton 1991, p. 20.

23 Eugène Boudin

French, 1824–1898

Fashionable Figures on the Beach 1865

Oil on panel, 35.5 × 57.5 cm

Gift of Mr. and Mrs. John J. Wilson (1974.565)

Boudin found that his horizontal pictures of fashionable tourists on the beach had a ready market. In them he combined always popular anecdote, a keen eye for costume (here a preponderance of white), and his acute sense of seaside weather to produce pictures that complemented and coincided with the growing taste for tourism among the French middle and upper classes.

Boudin took care to individualize the figures he painted just enough so that their actions could be discerned, but not so much that they assumed more importance than the bright blue sky and sunny enveloping atmosphere. Here the viewer notes a steamship on the horizon, a form of technology related to the trains that brought these visitors to the coast. The steamship contrasts with the rowboat, whose occupant appears to be telling a story to the people surrounding him. The people on the beach stand or sit in conversational groups. It is most likely a weekday, as there are relatively few men present (businessmen often would join their vacationing families only on weekends). Particularly engaging are the young girl and the dogs. The girl's dress is simply a small-scale version of the type worn by the adults. Her imperious gesture with the walking stick reinforces the unchildlike nature of her costume. The dogs, facing alertly to the left, evince more animation and interest in the world around them than any of the almost fifty people represented.

Boudin, who began painting fashionable people on the beach at Trouville in 1862, understood the public appeal of these depictions. Between 1864 and 1869 he showed eleven paintings at the annual Salon, nine of which were of this type.[1] He painted such pictures throughout his life, one as late as 1896,[2] yet in a letter of August 1867 he complained about the essential vapidity of the subject matter: "Must I admit it? This beach at Trouville that till recently so delighted me, now, on my return [from Brittany], seems merely a ghastly masquerade…. When … one comes back to this band of gilded parasites who look so triumphant, one pities them a little, and also feels a certain shame at painting their idle laziness."[3] As delightful as this painting is, Boudin's feelings help explain his later concentration on less detailed, more atmospheric scenes, as the other paintings in this exhibition demonstrate.

1. Tinterow and Loyrette 1994, p. 340.
2. Sutton 1991, p. 42.
3. Jean-Aubry and Schmit 1987, p. 90, translated by John House in Hamilton 1992, p. 20.

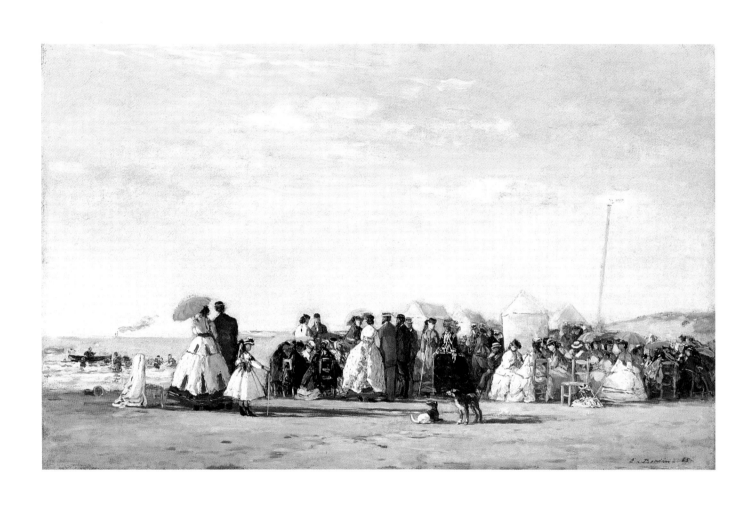

24 Eugène Boudin

French, 1824–1898

Beach Scene 1882

Oil on canvas, 54.5 × 75.0 cm

Bequest of Mrs. Stephen S. Fitzgerald (64.1905)

The precise date inscribed on this painting, July 16, 1882, allows us to identify the locale as Berck, a town of about five thousand inhabitants on the coast north of where the river Somme empties into the English Channel. Boudin spent several summers there, in 1881, 1882, and 1890. Still a working port, it was increasingly frequented by vacationers. Boudin eschewed the bright colors of the clothes worn by tourists for a muted palette of tans, grays, blues, and greens. This working side of Berck is characterized by a flat beach, the backs of houses, a few huts at the high-tide mark, and boats, both beached and in the water. From this unpromising material Boudin fashioned a deceptively rich painting.

Boudin was a master of the horizontal. Here the horizon stretches across almost three-quarters of the width of the painting, and where it is intercepted by a distant spit of land, horizontal streaks in the sky, above the farther buildings, continue the lateral movement. Although the scene is taken on the English Channel, which at this point is only about eighty kilometers wide, the sea seems limitless. Boudin achieves this effect in part by emphasizing the horizontal and in part by creating a deep, rushing recession into depth. A wedge that leads the eye toward the farther buildings is bounded at the top by the darker line of boats and huts and at the bottom by five unevenly spaced posts. This wedge activates the space and points to Boudin's true subject, the sky. Overcast but rich and mottled, it fills three-quarters of the canvas.

Corot called Boudin "the king of skies."[1] Boudin in turn acknowledged the compliment by dedicating to Corot a pastel study of a sky, which Corot kept all his life.[2] Boudin understood the importance to his paintings of the character of the skies. Invoking the precedent of seventeenth-century Dutch landscape painters, he is reported to have said to Troyon: "I must return to my original method which may have been more rigid but paid attention to form. Follow Van de Velde's example and emphasize the sky, put more energy into it."[3] Boudin could have been thinking of any of a number of beach scenes painted by the illustrious family of marine artists of that name. It is tempting to imagine that he was thinking of one particular painting by Adriaen van de Velde (1636–1672). *The Beach at Scheveningen with a Carriage* (fig. 21) had been in the French royal collection since 1784, and Boudin could easily have seen it and been impressed by its delineation of anecdotal activity under a vaulting sky.[4] Boudin's radical simplification of forms,

Fig. 21. Adriaen van de Velde, *The Beach at Scheveningen with a Carriage*, 1660, oil on panel, 37.0 × 49.0 cm. Musée du Louvre, Paris (1915)

accentuation of brushwork, and comparative dismissal of story-telling, however, distinguish his work from the Dutchman's and show how selective he was when he turned to earlier art for inspiration.

1. "Boudin, le roi des ciels," quoted in Meynell 1908, p. 272.
2. Hamilton 1992, p. 37.
3. Cahen 1900, p. 186, translated in Hamilton 1992, p. 80.
4. For Adriaen van de Velde, see Sutton 1987, pp. 493–94, no. 103.

25 Eugène Boudin

French, 1824–1898

Ships at Le Havre 1887

Oil on panel, 35.0 × 26.5 cm

Gift of Miss Amelia Peabody (37.1212)

Boudin painted the Normandy coast his entire life. He was attracted to "the changing states of atmosphere, the play of light on the beaches and wet rocks, hovering mists, cloudy skies, the indecision of marine horizons as well as the movement of ports and fishing villages, the picturesque effects of jetties, masts and spars, the work of dockyards and arrival of boats."[1] The tangible aspects of the Normandy coast, the ships and docks, are here very summarily treated, the background being merely blocked in and not distinguishable as buildings or hills. Boudin's brush moved quickly over the canvas, leaving clearly visible marks. In the sky these represent the maritime clouds, unpredictably moving and changing. Below, the brushstrokes represent gently lapping water, fairly smooth in the protected harbor. The water is the most richly painted passage here. A medley of colors – whites, creams, pinks, blues, and greens so dark that they look brown – combine to show the effect of reflections.

This painting is doubtless the product of outdoor work. Boudin felt that only outdoors could an artist capture on canvas what nature actually looked like. He wrote in his notebooks: "Everything that is painted directly and on the spot always has a strength, a power, a vivacity of touch that cannot be recovered in the studio" … "Three strokes of the brush in front of nature are worth more than two days' work at the easel [i.e., in the studio]."[2] By 1887, the date of this work, much had happened in French landscape painting. What scholars and the public came to call Impressionism had emerged, flowered, and evolved into other, related modes of expression. But Boudin, whose encounter with Monet in 1858 was crucial to Impressionism, continued on the same path he had established for himself early on. His subject matter remained the same, and his close attention to details of shipping and to anecdote – his figures are always legible – relates his paintings to older, topographic landscape traditions reaching back to the eighteenth century and the harbor scenes of Claude-Joseph Vernet (1714–1789). However much the colors and brushwork in paintings such as this one may look like the emphatic, colorful marks Monet used to indicate water, they remain distinctly Boudin's in their subtlety and finesse.

1. Gustave Geffroy, February 15, 1883, quoted in Jean-Aubry 1968, p. 236, translated in Cunningham 1976, p. 20.
2. Cahen 1900, pp. 181, 183, translated by John House in Hamilton 1992, p. 16.

26 **Eugène Boudin**

French, 1824–1898

Figures on the Beach 1893

Oil on canvas, 36.5 × 59.0 cm

Bequest of William A. Coolidge (1993.32)

A lifetime of careful study of the weather on the English Channel allowed Boudin to paint this subtly modulated scene. For an artist who had long been devoted to revising earlier conventions of marine painting, with its emphasis on details of shipping or the effects of storms, this work is shockingly minimal. Boudin constructs a panorama by stacking, one above the other, strips of the three seaside elements: sky, water, and land. The scene takes place at low tide, indicated by the luminous tidal pool in the foreground. Tourists, marked by the parasol, watch as a boy gathers shellfish. The pinkish beach is alive with activity: a boy walks by with a fishing rod, a man to the right works on a boat, people stroll, and horses pull a cart, perhaps bringing in a harvest of seaweed. Boats sail on the open water.

Yet all of this human activity is reduced in significance by the elements themselves. A rainstorm threatens on the horizon. The greenish cast of the sky and the Channel waters are sure tokens of inclement weather. One can almost smell the rain. Boudin has perfectly caught the look of an impending storm. He tried to be faithful to the specifics of a scene, which he understood to differ from its details. His term for what he wanted to paint was "un impression." In 1889 he wrote to Louis Braquaval, a student: "I have told you many times – an impression is gained in an instant but it then has to be condensed following the rules of art or rather your own feeling and that is the most difficult thing – to finish a painting without spoiling anything."[1] Boudin clearly considered this loose, sketchy painting finished, for he signed and dated it.

1. Translated in Hamilton 1992, p. 13.

27 Camille Pissarro

French (born in the Danish West Indies), 1830–1903

Pontoise, the Road to Gisors in Winter 1873

Oil on canvas, 59.8 × 73.8 cm

Bequest of John T. Spaulding (48.587)

The overcast winter sky in the village of Pontoise gave Pissarro the opportunity to focus, not on sharp contrasts of sunlight and shadow, but on the subtle color distinctions of plaster-fronted buildings. From January 1866 until 1884 Pissarro periodically lived with his growing family in Pontoise, on the river Oise twenty-four kilometers northwest of Paris (*Pontoise* means "bridge over the Oise"). Thus he is identified with the village and its surrounding countryside in the way that Corot is associated with Ville-d'Avray or Millet with Barbizon. More rural than Monet's Argenteuil, Pontoise was a provincial capital and market town, the place of transfer for the corn harvest from the Vexin to the northwest to the navigable Oise.[1] In some of his paintings of Pontoise Pissarro showed signs of its increasing modernization – smokestacks of a gas works, or a factory that distilled alcohol from sugar beets. In others he emphasized the hilliness of the area; Pontoise is built on a plateau above the river. This painting, in contrast, shows none of the particulars of the town – the view down a street could have been taken in any number of villages, perhaps even Honfleur (see Monet's *Rue de la Bavolle, Honfleur*, cat. no. 39). The street that we see here was, in fact, the widest road in Pontoise, leading from the river in a northwesterly direction toward Gisors, yet its relative anonymity freed Pissarro from depicting identifying characteristics in order to concentrate on the generic, traditional aspects of the town. A man pulls a cart without the aid of a horse, his head down and his shoulders hunched with the strain; a woman sweeps the walkway free of snow with a broom made of twigs. (The descendants of these brooms, with the twigs now replaced by plastic, can be seen in the streets of Paris today.)

The almost uniform color of the buildings and the gray light forced Pissarro to find pictorial equivalents for the smallest differences of hue and value. The view he chose resulted in an interlocking pattern of rectangles, some smaller, others larger, the rooflines forming an uneven series of steps. Apart from the rust-red and olive-green shutters, the brick chimneys, and a few touches of blues and greens, the painting is a study of pale, mid-range taupes, mushrooms, browns, beiges, and grays. The effect is that of a lightly tinted sepia photograph. The careful fitting together of parts and the rigorous geometry evident here were never far from Pissarro's sensibility, which was related to his admiration for Corot's work and to the similar predilections in Cézanne's emerging vision.

1. Brettell 1990 provides a complete discussion of Pissarro's activities in the town. See also Brettell's "Pissarro, Cézanne, and the School of Pontoise," in Brettell et al. 1984, pp. 175–205, especially pp. 175–82.

28 **Camille Pissarro**

French (born in the Danish West Indies), 1830–1903

Sunlight on the Road, Pontoise 1874

Oil on canvas, 52.3 × 81.5 cm

Juliana Cheney Edwards Collection (25.114)

Sunlight on the Road, Pontoise depicts a simple moment in the country. A woman and child walk hand-in-hand down a country road. A man on horseback looks back at the pair. A stand of trees occupies the foreground to the right, and slate-roofed cottages peek through the lush green foliage in the background. The composition makes use of a repeated horizontal pattern of blue, yellow, and green. The brushstrokes are similar to those of Cézanne of the same period: the two artists worked together in Auvers in 1872 (see cat. no. 34), and the interchange of styles between them is evident. Like Cézanne, Pissarro alternates soft, creamier textures with drier, sketch-like ones in order to assign mass and volume to objects such as the clouds.

The brushstrokes in this painting differ from those in the later Pissarros seen here (cat. nos. 29 and 30), which have a thicker impasto and are more roughly textured. Harmonious and well-ordered, Pissarro's *Sunlight on the Road, Pontoise* shows a rural scene imbued with a sense of naturalism. It reflects the moment in Pissarro's career when he abandoned explicitly contemporary, urban themes of Parisian life in favor of rustic French scenes, particularly of the agricultural life of the north-eastern edge of Pontoise, where he lived intermittently between 1866 and 1884. As a pastoral it is indebted to the traditions of seventeenth- and eighteenth-century French painting, but instead of depicting idealized classical figures romping in a landscape, or Parisians at leisure, Pissarro presents a quaint image of a mundane occurrence in the daily lives of country folk. He also makes stylistic and compositional references to Japanese prints of the eighteenth and early nineteenth centuries, where landscape and figures were often depicted through cropped leaves or branches near the foreground. Here the trees in the foreground also act as the framing device to set off the anecdotal moment. Pissarro collapses the traditional pastoral with Western and Oriental concepts of the genre scene, while investing his painting with a bright, sunny glow and the expression of a simple, singular moment.

29 **Camille Pissarro**

French (born in the Danish West Indies), 1830–1903

View from the Artist's Window, Éragny 1885

Oil on canvas, 54.5 × 65.0 cm

Juliana Cheney Edwards Collection (25.115)

In the spring of 1884 Pissarro moved with his family to Éragny, a village on the river Epte (a tributary of the Seine) three times farther from Paris than Pontoise. The area evidently pleased him, for he maintained it as his principal residence until his death. He painted several views of the fields surrounding his house from the vantage points of its ground-floor and upper-floor windows. This practice not only offered him an already framed view but also afforded him perspectives different from those he could get if his easel were outside. It was common for artists to take views of cities from windows (Pissarro himself would do so with his later series depicting Paris and Rouen, for example), but it was less usual to do so in the country.

Here, even from the ground-floor window, the view was slightly elevated, allowing the fields to be seen as a measured recession into the distance. A foreground field, cut by a fence, is bordered by a road. Beyond the road are an outbuilding and two farther fields. This is an orderly, tranquil scene: orderly because of the neat stepping back of the fields, demarcated by the soothing horizontals, first embodied in the fence rail in the foreground; tranquil because the only figures are passers-by – no labor is being done.

In addition to having new motifs to paint, Pissarro was experimenting with new ways of putting paint on canvas. For some years he had been using small curved brushstrokes that allowed him to create dense webs of color, seen to good advantage in *View from the Artist's Window, Éragny*. Within the overall texture, Pissarro still took pains to differentiate one surface from the next. The grass or field closest to the window, which was most clearly in focus, is painted with larger, rougher strokes, whereas the farther fields appear as a more uniform expanse, and the tree trunks and fence posts and rails are traced in a line with the brush. The sense of spaciousness evident here is unusual in Pissarro's work; often his paintings focus on the figure, or the view is interrupted by a screen of trees or cut off by a far hill. Even the compromised perspective of the fence rail to the left and the uncertain alignment of chimney, tree, and corner of house do not detract from the feeling of tranquility this scene evokes.

Pissarro evidently liked this particular view, because he painted it again four years later.[1] It is a different season: crops are visible in the fields on both sides of the foreground fence, and the staffage is different – cows graze in the middle distance, and there are no figures walking along the road. Pissarro seldom repeated a scene so exactly; perhaps the room in which he sat to paint it was his favorite.

1. Pissarro and Venturi 1939, no. 733.

30 Camille Pissarro

French (born in the Danish West Indies), 1830–1903

Morning Sunlight on the Snow, Éragny-sur-Epte 1894–95

Oil on canvas, 82.3 × 61.5 cm

John Pickering Lyman Collection (19.1321)

Snow scenes continually intrigued Pissarro. Here the artist has translated to canvas with perfect accuracy the sparkle, crispness, and crustiness of an early morning in winter. Pissarro probably painted the scene from inside his house and was thus protected from the cold, but he nonetheless knew how to convey the way light looks when its effect is magnified by reflection off snow and by refraction through ice- and frost-covered branches. Pastel pinks and blues dominate the canvas; only up close are purples, oranges, and greens visible. The woman carrying a bucket is understandably transfixed by the myriad colors, glancing light, and spiky textures.

Tempering the prettiness of the painting is its linear structure of screens of trees. Pissarro had long been fascinated with the complex spatial problems presented by a mediating screen of trees. Corot, too, had explored the problem, as can be seen in two of the Corots in this exhibition, *Morning near Beauvais* (cat. no. 1) and *Souvenir of a Meadow at Brunoy* (cat. no. 2). Pissarro may have adopted the motif from his early teacher. Pissarro, however, made the screen of trees a principal motif, both in paintings and in prints.[1] It is seen to particularly good effect here, where the trees are bare and the palette is pale. *The Côte des Boeufs at L'Hermitage* (fig. 22) is similarly constructed, though its browner palette and blocked view into the distance seem to clog the picture's surface. The orientation of these two canvases emphasizes the verticality of the trees, making them seem impossibly tall and thin. The screen of trees, by affording a glimpse of the distance yet denying immediate access to it, weaves foreground and distance together into a single two-dimensional pattern: the background becomes the interstices between the trees.

The intricate and textured surface of the painting testifies to the extended labor Pissarro lavished on the canvas. Tiny flecks of paint were placed quickly but deliberately. Pinks are balanced with blues, and optically heavier purples, oxbloods, and greens are clustered toward the bottom of the canvas, echoing the colors worn by the lone figure. Glancing out the window and deciding to paint the scene may have been an instantaneous decision, but the planning and execution surely constituted a plotted-out intellectual exercise.

1. Isaacson 1992, pp. 320–24.

Fig. 22. Camille Pissarro, *The Côte des Bœufs at L'Hermitage*, 1877, oil on canvas, 115.0 × 87.5 cm. National Gallery, London (NG4197)

31 **Antoine Vollon**
French, 1833–1900
Meadows and Low Hills
Oil on panel, 28.0 × 46.2 cm
Bequest of Ernest Wadsworth Longfellow (37.602)

The composition of this view of meadows and low hills could hardly be simpler. More than half of the small panel is given over to a cloud-filled sky, painted so thinly that the grain of the wood shows through. The landforms below are painted more thickly. In places the paint stands up in relief, as if mimicking the solidity of the ground and trees, in the same way that the thinness of the paint in the sky is analogous to the immateriality of that element.

The evident rapidity of execution and the fact that the painting was done on an easily portable panel attest to its having been made outdoors. Vollon was interested not so much in capturing color and light as in exploring the effect of depth and recession. The expanse of the meadow is indicated by the tiny size and indistinct anatomy of the grazing cows (and perhaps sheep) and the tinier farm buildings farther away. The place at the far end of the meadow at which the land starts to rise is marked by a line of dark trees, which perhaps signal the presence of a stream or simply serve as boundary markers. The trees climbing the hill – their crowns progressively silhouetted against the sky – indicate increasing distance, and those at the top of the hill are so far away that the artist registered them as mere puffs against the sky.

Vollon, best known as a still-life painter, chose an overcast day on which to paint his small but expansive scene. Devoid of strong contrasts of sunlight and shadow, the field shows itself in a dark, rich palette of greens and browns, colors similar to those the artist used in his kitchen interiors and arrangements of armor. As in those paintings, too, the brushwork in the darker areas is fluid and loose. In his still lifes Vollon was not interested in microscopic detail; rather, he preferred to juxtapose larger masses of simplified textures, a predilection he transferred to his work outdoors.

32 Edgar Degas

French, 1834–1917

At the Races in the Countryside 1869

Oil on canvas, 36.5 × 55.9 cm

1931 Purchase Fund (26.790)

At the Races in the Countryside is a casual record of an informal day of racing at Argentan, a racecourse along the Normandy coast about fifteen kilometers from the Ménil-Hubert estate. Using the family of his friend Paul Valpinçon as his subject, Degas presents us with a moment of upper-class leisure.[1] The picturesque family scene in the foreground is off-center. The parents and family dog turn their attention to the baby, who has fallen asleep at the breast of his nursemaid. The horses are alert and ready for departure. In the distance we can see the track where a few jockeys are racing before a small gathering of spectators. The writer and critic Edmond Duranty stressed the importance of painting subjects that "accurately express the everyday life of a country," and Degas's choice of subject and asymmetrical composition exemplify his determination not only to paint explicitly contemporary subjects but also depict them in a distinctly modern style.[2] The work was purchased by Durand-Ruel in 1872. That same year, it was shown in London at the *Fifth Exhibition of the Society of French Artists*.

With the exception of the carriage and its riders in the foreground, the forms in the painting are created with minimal modeling, and as a result the composition is flat.[3] The emphasis on the picture plane, the sharply rising background, and the simplification in the background elements are compositional devices that were evident in Degas's earlier work and can also be seen in *Race Horses at Longchamp* of 1871–75 (fig. 4).[4] The flattened composition and bold blocks of color also suggest the influence of Japanese *Ukiyo-e* prints, which Degas avidly collected.[5] While *At the Races* was surely completed in the studio, it may very well have been inspired by a plein-air sketch, and if so it shows Degas as less disaffiliated from his contemporaries and their methods than one might have supposed.[6] The off-center placement of the figures in the foreground and the cropping of the black horse on the right and small carriage on the left are compositional devices that suggest an awareness of photography, though the long-exposure photographs of the 1860s did not, in fact, often capture such fleeting effects. The painting is a product of the artist's imagination, and it is his genius for distilling the anecdotal that here gives the impression of an instantaneous, captured moment.

1.　See Boggs 1998, p. 79, and Dunlop 1979, p. 93.
2.　Moffett et al. 1986, p. 42.
3.　Moffett et al. 1974, p. 84.
4.　Ibid., p. 86.
5.　Ibid., p. 84.
6.　Boggs 1998, p. 80.

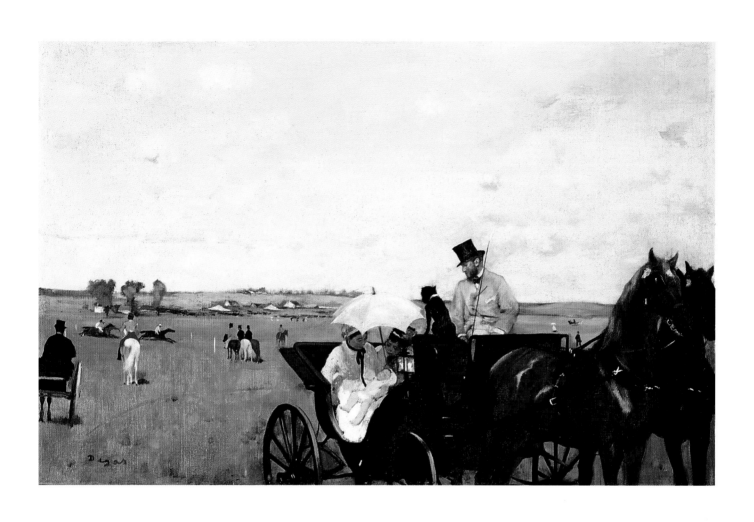

85

33 Paul-Camille Guigou
French, 1834–1871
View of Triel 1865
Oil on panel, 28.5 × 45.7 cm
Gift of Ananda K. Coomaraswamy (22.669)

In 1862 Guigou moved to Paris so that he could be at the center of the art world, yet he continued to paint scenes of his native Provence. At the Salon, where he made his public reputation, he showed only scenes of the South of France. He seems to have done very few paintings of the Île-de-France, the area around Paris, and it is unlikely that anyone outside his immediate circle knew of them. This view near Triel, a small village on the Seine about forty kilometers northwest of Paris, near where the Oise empties into the Seine, is one of five known paintings he made of the area.[1]

Guigou, used to the southern coastal plains terminated by inland mountains, chose a vantage point on the bank of the Seine that made northern France look as much as possible like southern France. A certain indistinctness in the middle ground, beyond the darker clumps of reeds, renders the course of the river somewhat illegible, but the line of low hills indicates that the river bends to the left. This very indistinctness allows the mind to imagine that the spaces represented are vast, akin to those Guigou showed in his depictions of the South. The critic Théodore Duret, a champion of Guigou, wrote about the painter's Provençal landscapes in a review of the Salon of 1870: "Guigou excels in extending the vista and in disposing the planes in a dexterously arranged distance…. Guigou, who in Provence most often does not have trees and foliage, paints space and expanse and makes horizons on the canvas flee to the farthest reaches."[2] Painted by other hands – Daubigny's or Sisley's, for example – the banks of the Seine would appear lush with vegetation. Guigou's southern eyes, however, did not see what they saw. His penchant for firm contours and strong colors finds an outlet in the carefully delineated reeds in the water and grasses on the bank.

Guigou shared with the young artists who would become known as the Impressionists a firm belief in the importance of painting outdoors, and this painting was most likely done on the spot. Unlike Monet, however, Guigou did not paint in small, prismatic strokes; such an approach was antithetical to his vision of deep spaces and hard light. Yet Guigou's insistence on rendering what he saw in the way that he saw it, and not following a formula devised by someone else, allied him and his art with the emerging sensibility of Impressionism.

1. Bonnici 1989, nos. 109, 114, 115, 134 (the Boston painting), and 269. A preparatory drawing for no. 115 is in the collection of the Pierpont Morgan Library, New York, and was given to the library by John Rewald.
2. Duret, "Le Salon de 1870," quoted in Bonnici 1989, p. 48.

34 Paul Cézanne
French, 1839–1906
The Pond c. 1877–79
Oil on canvas, 47.0 × 56.2 cm
Tompkins Collection (48.244)

Six people – two couples and two men by themselves – relax by the side of a pond or river. It is an enigmatic scene. The couple at the far left appears to have come from the city; the woman's square-necked, puff-sleeved blue dress and the man's light-colored top hat and jacket contrast with the simpler clothes worn by the others, setting them apart. One man naps as if lost to exhaustion; another, in a straw hat, sits in a boat. No food is present, so these people are not on a picnic, yet the man at the left makes a half-hearted attempt to fish.

This unsatisfactory attempt to read a narrative into the painting demonstrates how beside the point such a narrative is. Cézanne was certainly capable of painting a story, as *Picnic on a River* (fig. 23) demonstrates. There the woman is in a prettier dress and has brought a parasol and a straw hat trimmed with a black ribbon. The sleeping figure is more realistically portrayed (his body actually takes up space, rather than simply tracing a two-dimensional pattern on the grass), and a wine bottle in the lower right may explain the cause of the nap. Three of the four people are clustered together, as if sharing a common purpose. Mary Tompkins Lewis has explained how paintings such as *Picnic on a River* derive from eighteenth-century *fêtes galantes* in the manner of Antoine Watteau (1684–1721).[1]

Although vestiges of a Provençal rococo revival may remain in *The Pond*,[2] Cézanne's brushstrokes here have moved beyond description or a careful delineation of form to become almost independent marks. From early 1872 until the spring of 1874, Cézanne, under Pissarro's watchful eye, stayed in Auvers and began to paint outdoors. He used lighter and brighter colors and adopted Pissarro's technique of placing small strokes of pure color next to each other. Cézanne's version of the broken brushstroke – patches of parallel strokes, here predominantly blue and green – calls attention to itself and hence to the fiction of the scene, and not only to the fiction of the depicted scene but to the fiction of any painted space. The saturated colors chosen may convey a sense of lush, verdant summertime, but there is no question that Cézanne is really interested in exploring how to depict volumes in space. He has not yet figured out exactly how to do so – the painting has awkward and confusing passages and inconsistencies of scale. *The Pond* is not a failed picture, however. It allows us to watch Cézanne as he tries to meld a newly learned technique with traditional iconography and realizes that the technique is more important to him than the story.

Fig. 23. Paul Cézanne, *Picnic on a River*, c. 1872–75, oil on canvas, 26.4 × 34.0 cm. Yale University Art Gallery, Gift of Mr. and Mrs. Paul Mellon, B.A. 1929 (1983.7.6)

1. Lewis 1989, pp. 88–112.
2. The painting was given the title *Scène champêtre* in the list of Gustave Caillebotte's paintings that were bequeathed to the French State at his death in 1894. It did not go to the State, either because it was refused or the family retained it. See Poulet and Murphy 1979, p. 85, no. 43.

35 Paul Cézanne

French, 1839–1906

Turn in the Road 1882
Oil on canvas, 60.5 × 73.5 cm
Bequest of John T. Spaulding (48.525)

A signal event in the Parisian art world of 1907 was the Salon d'Automne, which featured two rooms of paintings by Cézanne. Among the visitors to that exhibition was the German poet Rainer Maria Rilke, who brought with him a friend, Mathilde Vollmoeller. Deeply impressed by the Cézannes, Vollmoeller described how she imagined the artist at work, seated in front of his subject "like a dog, without any nervousness, without any ulterior motive."[1] Expanding on his friend's remark, Rilke noted that Cézanne's work as a painter

> so … reduced a reality to its color content that it resumed a new existence in a beyond of color, without any previous memories…. [People] accept, without realizing it, that he represented apples, onions, and oranges purely by means of color (which they still regard as a subordinate means of painterly expression), but as soon as he turns to landscape they start missing the interpretation, the judgment, the superiority.[2]

Turn in the Road shows just what its title says, an unpaved road in the country, curving along a wall behind which are clustered the houses of a village, probably Valhermay, between Auvers and Pontoise.[3] Cézanne takes nothing on faith. Intuitively, he knows the road stays the same width in the course of its curve; empirically, he does not, and so he paints what he sees, the road disappearing as it makes the bend. Likewise, Cézanne makes no attempt to rationalize the houses behind the wall. No pattern of roads or even passageways can be read from the jumble of roofs and walls. What, for example, is happening behind the three taller trees to the right? Space is flattened so that the wall surface with windows and a door is in a continuous plane with the wall that belongs to the ocher roof second from the right, but our experience of the world tells us that that cannot be so. Such inconsistencies did not trouble Cézanne. His colors, bereft of "previous memories," make up a world seen afresh.

Cézanne's world, as lush and verdant as it is, nonetheless seems a deserted and somewhat forbidding place. We are to look at this village, but not enter it. The tree trunks in the foreground form a screen, through which we gain only a partial view of the village. The wall keeps us out, and even if we were to hop over it, only one house has a door. There are no people with whom to identify. Rilke understood that Cézanne sought

to represent the physical world "purely by means of color." Rilke's perception – that Cézanne found chromatic equivalents for the phenomenal world – succinctly explains the painter's approach to his art. *Turn in the Road* first startles and then seduces with its color, its white houses, its tawny road, and its brilliant and nuanced greens.

1. Rilke 1985, p. 46.
2. Ibid., p. 65.
3. See Brettell et al. 1984, pp. 194, 200, no. 72.

36 **Alfred Sisley**
British (worked in France), 1839–1899
Waterworks at Marly 1876
Oil on canvas, 46.5 × 61.8 cm
Gift of Miss Olive Simes (45.662)

In relation to the other major landscape artists associated with the Impressionist movement – Monet, Pissarro, and Renoir – Sisley stands apart on several counts. Relatively little is known about his private life; more than the others he concentrated on landscape, and generally not the landscape of modern life and leisure; and he painted in an Impressionist style throughout his career.

The waterworks at Marly were originally built in the late seventeenth century to lift water from the Seine to the aqueduct at Louveciennes. The aqueduct carried the water to the parks at nearby Versailles and Marly (another royal residence), where it filled the famous fountains. Sisley did not depict the historic waterworks, however, for they were replaced between 1855 and 1859 by a new system, and it is the end of the brick building containing six iron wheels and twelve forcing pumps that Sisley painted here. The site clearly intrigued him, for he painted at least six other views of it.[1] Sisley used the structure provided by the architecture and walkways to lay out his painting in large, bold shapes. The horizontals of the building and especially the walkway and row of posts reaching across the water give order to the trees with their autumn foliage; although they actually recede at a diagonal along the river, they appear as a uniform screen across the painting, blocking the view and concentrating attention on the foreground. Horizontal lines convey a sense of peace, an evenness of temperament, which here is reinforced by the presence of the recreational fishermen. At right and left, the fishermen take matter-of-fact advantage of the combination at Marly of the vestiges of the Ancien Régime and Napoleon III's recent empire and the technology that served both reigns.

Sisley's palette, particularly in his early career, was often blond in tonality. Pale grays, blues, greens, and ochers frequently dominate his scenes of water and sky. Here the foliage, touched with yellows and pinks, harmonizes with the pink of the bricks, and the colors are carried throughout the bottom of the painting in the reflections in the water. The frankly pretty color scheme calls to mind paintings of the previous century, suggesting that *Waterworks at Marly* is Sisley's tribute to a past age.

1. "La Celle-Saint-Cloud to Louveciennes, 1865–1875," in Stevens 1992, no. 20.

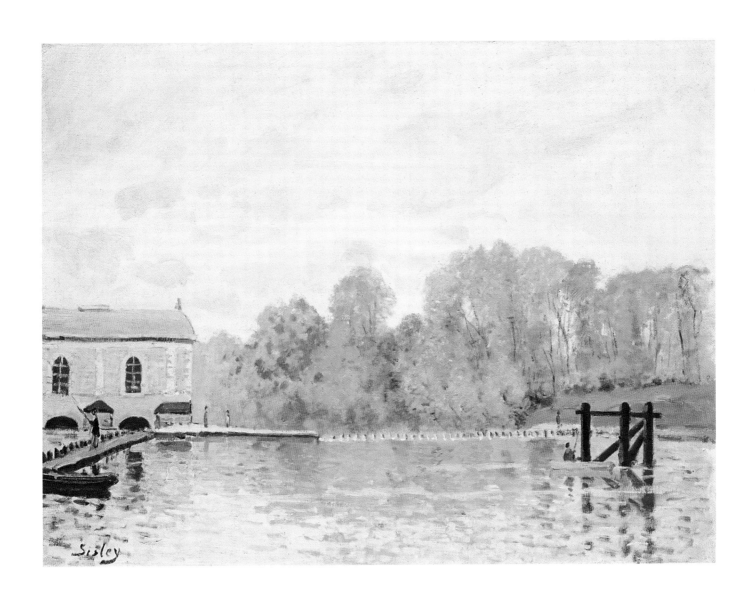

37 Alfred Sisley

British (worked in France), 1839–1899
Overcast Day at Saint-Mammès c. 1880
Oil on canvas, 54.8 × 74.0 cm
Juliana Cheney Edwards Collection (39.679)

Sisley rarely strayed far from the Seine for his subject matter. Unlike most of the other painters whose works are featured in this exhibition, however, Sisley spent most of his life painting the Seine upriver from Paris, not downriver toward the coast. In 1880 he moved his family to Veneux-Nadon, not far from Moret-sur-Loing. There, in the region where he had first begun painting outdoors, in the footsteps of Corot and Rousseau, he studied the moods of the river.

Here he shows us the banks of the Seine at Saint-Mammès, where the Loing empties into the Seine. Whereas *Waterworks at Marly* (cat. no. 36) is arranged in horizontals, *Overcast Day at Saint-Mammès* is a fan of triangles, their widest edge placed in the foreground and tapering to and converging at the point where the stone part of the bridge meets the shore. This crucial point, however, is blocked by the row of trees still in leaf, a masking device that removes the painting's construction from the realm of the obviously formulaic. Sisley's concentration on motifs drawn from a small region allowed him to experiment with both composition and paint handling. Here, his brush has left visible traces: dabs of color to stand for leaves, clothes, and undefined road surfaces. The sky, the focus of the painting, is worked with larger strokes of blues, grays, and creamy whites, colors that establish the tonality of the painting as a whole. Sisley has described the changing weather and scudding clouds of a typical autumn day in northern France.

Sisley included the painting among the twenty-seven he showed in the seventh Impressionist group exhibition, in 1882. Of the eight group shows, this one had the greatest number of views of the Seine: nineteen out of two hundred and ten works.[1] Sisley's views were generally well received. Ernest Chesneau could have been describing this picture when he wrote in the *Paris-Journal*: "Sisley has masterfully taken possession of the banks and waters of the Seine where the breeze, like a moving mirror, splinters into a thousand pieces the gold of autumn leaves and scatters the opal reflections of light, fleecy clouds, their soft gray drenched with melancholy."[2] Sisley painted the working river. Paddlewheel barges and logs being loaded or unloaded speak of daily life and work. It is a vision that is accommodating and generous, not critical or censorious. Technology in the form of the barges and the iron bridge is subsumed in the whole; it has become part of the landscape.

1. Richard R. Brettell, "The River Seine: Subject and Symbol in Nineteenth-Century French Art and Literature," in Rathbone et al. 1996, p. 123. See Brettell's entire essay for an enlightening discussion of the river.
2. Translated in Moffett et al. 1986, p. 418.

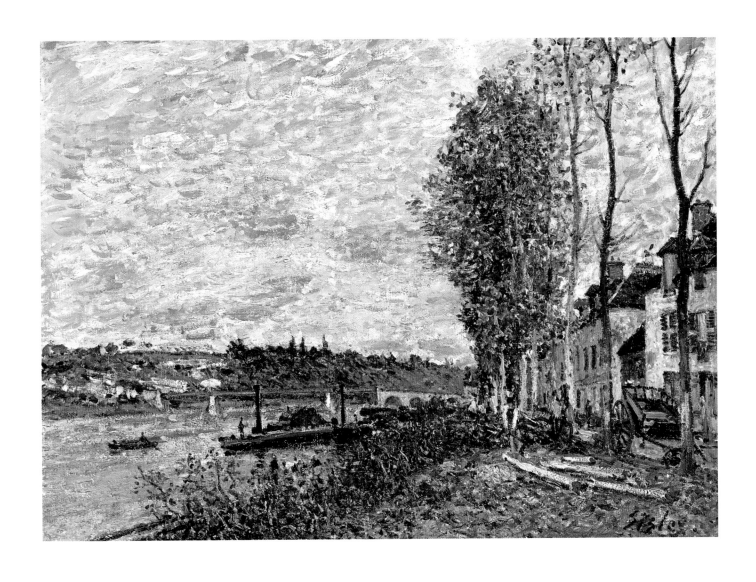

38 Alfred Sisley

British (worked in France), 1839–1899
The Loing at Saint-Mammès 1882
Oil on canvas, 49.8 × 65.0 cm
Bequest of William A. Coolidge (1993.44)

As the years passed, Sisley painted in an ever broader manner and with more daring colors. In *The Loing at Saint-Mammès*, magenta, orange, and lime-green poplars stand against an evening sky of pinks, blues, and purples; below lies the river, marked by the streaks of reflected trees. The trees and sky are rendered with long, loose brushstrokes. In the trees the brushstrokes trace thin trunks and clumps of foliage, whereas in the sky they thicken and overlap to create a textured ceiling of clouds. Underpinning these experiments in color and surface is the sweep of the river. Sisley's point of view along the Loing looking toward the Paris-Lyons railroad viaduct was cleverly chosen. From his vantage point the barge on the opposite bank bulks large, dwarfing the rowboats in the middle of the river. The wooden railing on the right rushes away in extreme foreshortening. Any movement implied by the various diagonals, however, is stopped short by the viaduct. Its wide double spans crossing the river and its series of arches marching off to the right are seen head-on, as it were, not at an angle; they create a barrier that halts the recession of the picture.

It is in paintings such as this one – views of unremarkable places seen under equally unremarkable but quite specific atmospheric conditions (the day was clear and sunny) – that Sisley proved himself to be the painter who remained most faithful to the principles of Impressionism as it was practiced in the early 1870s. Small, varied touches of pure color describe different textures: the sky with clouds, the broken surfaces of the river, the smooth fronts of the houses. All of this was in the service of replicating, as honestly as possible, the way nature, and objects in nature, looked. Gustave Geffroy, writing in the newspaper *La Justice* on June 23, 1883, described Sisley as an "analytical painter … subtle and delightful in the indication of aerial perspective and atmospheric transparencies."[1] Sisley was able to leave discrete marks on the canvas because he, like the other painters who showed together outside the official Salon, used paints that were manufactured with poppy oil rather than linseed oil. Poppy oil dries slowly enough to allow an artist to work wet paint on top of or next to paint that has not dried (wet-in-wet). In addition, its texture is buttery and retains the mark of the brush.[2] Sisley exploited these characteristics – we can see how his brush moved – to show how this particular stretch of river looked at this particular time: nothing dramatic, simply a slice of riverine life preserved.

1. Quoted in William R. Johnston, "Alfred Sisley and the Early Interest in Impressionism in America, 1865–1913," p. 56, in Stevens 1992.
2. Callen 1982, p. 23.

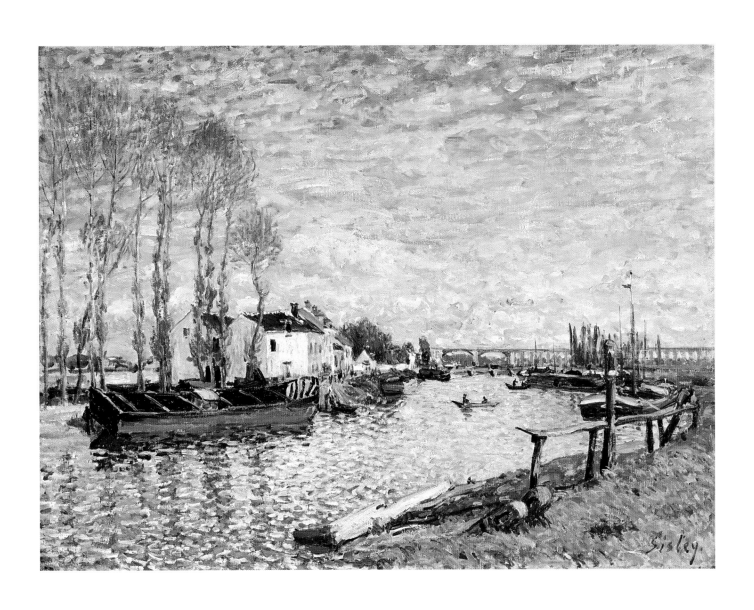

39 Claude Monet

French, 1840–1926
Rue de la Bavolle, Honfleur c. 1864
Oil on canvas, 55.9 × 61.0 cm
Bequest of John T. Spaulding (48.580)

The bold patterns and sharp contrasts make Monet's street view, showing the Norman town of Honfleur, immediately appealing. House fronts in shadow on the left focus, if not force, attention to the right-hand portion of the painting. As in *Woodgatherers at the Edge of the Forest* (fig. 2), the lines forming the composition are in the shape of a large X. Because the subject matter here is a built environment, the lines of the X are much more strongly delineated than could be the case with the irregular shapes of trees and uneven ground. The eye easily leaps across the void of the street from the roofline on the left to the edge of the road in sunlight on the right; the invisible crossing of the X lies just above the man's head. Such a structure locks the pictorial elements firmly in place and gives the picture a sense of solidity and assurance.

This sense of solidity can also be found in the way Monet has painted the picture. The colors – browns, grays, ochers, and even blacks – recall the palettes of older painters such as Boudin and Corot. Broad, smooth strokes of ocher and gray mimic the effect of the sun falling directly on the siding and plaster of the houses, and architectural details are firmly drawn in. Yet careful attention to subtler effects of light can also be found. Edges of roofs, dormers, and shutters sparkle against their more sober background. The dust and cobblestones of the street are rendered with shorter strokes applied with a smaller brush. The ivy so quivers with light that it looks as if it might detach itself from the wall.[1]

Monet painted in Honfleur during his summer trips to Normandy from Paris, where he had lived since 1862. Small streets like this one would have been familiar to him from his boyhood in Le Havre, which lies to the north of Honfleur, across the estuary of the Seine. Like its palette, the subject matter of this painting ties it to the tradition of townscapes. Anecdotal details abound – a cloth hangs out a window to air, a man peeks out of a doorway, a woman sitting outdoors is kept company by a black cat. Monet's interest in anecdote, in recording what he sees, is also evident in another painting of the same street (fig. 24). The differences between the two are noticeable in the shadows and clouds and in the figures. The man in the doorway to the left in the Boston painting is replaced by a bolder woman in the Mannheim version, staring as if she were watching the painter at work; the man in the middle of the street cedes to a woman and child nearer the

Fig. 24. Claude Monet, *Rue de la Bavolle, Honfleur*, c. 1864, oil on canvas, 58.0 × 63.0 cm. Städtische Kunsthalle, Mannheim (299). © Margitta Wickenhäuser

viewer. Monet records these changes – "imaginable but not truly predictable," like changes in weather – dispassionately, as if he were a camera installed in the middle of the street.[2]

1. Murphy et al. 1977, no. 2.
2. Isaacson 1984, pp. 20–21.

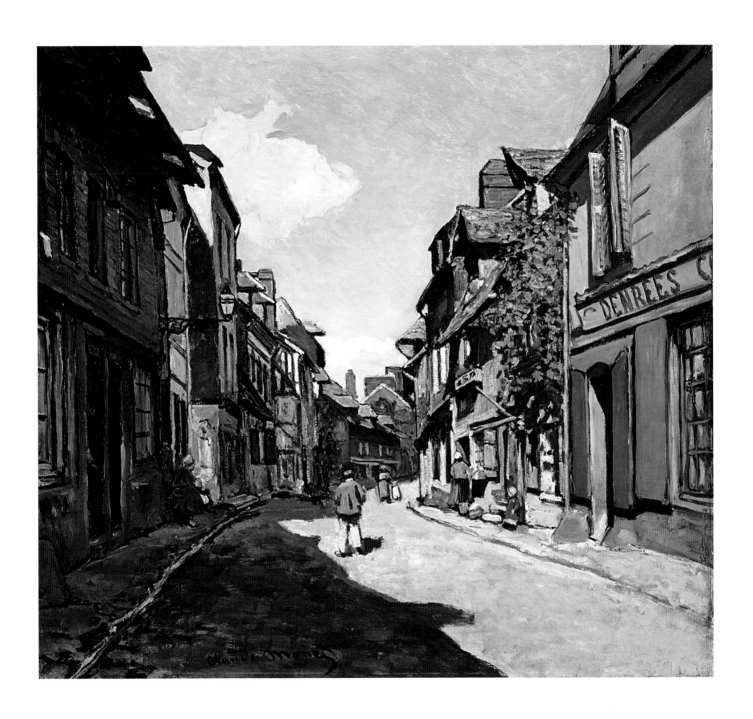

40 Claude Monet

French, 1840–1926

Snow at Argenteuil c. 1874

Oil on canvas, 54.6 × 73.8 cm

Bequest of Anna Perkins Rogers (21.1329)

The first snow of the season falls rapidly. The trees have yet to fully discard their leaves, and grass still peeks through in the snow-covered meadow and along the side of the path. Painted not far from his house in Argenteuil, and likely begun outdoors, this work shows Monet's concern for rendering the *feeling* of a snowfall.[1] It demonstrates his commitment to depicting the changing effects of light, weather, and atmospheric conditions.[2] Primed with a light-gray ground, the canvas can be seen through some of the thinly applied brushstrokes, while quick dabs of pigment and larger sweeps of color define the objects and the people. A balanced and harmonious composition is created by the path that leads us into town and is hemmed in by the trees and meadow on the right and more trees, houses, and a wall on the left. The snow-speckled meadow is set off by the lightly covered path and the varying-hued brown objects on the left. A backdrop of gray hangs behind the town, while a white veil of snow falls over it.

The path situates the viewer in the scene. The fence and meadow act as a framing device, so that like the pedestrians (and like the artist himself, as he painted) we can feel the cold, damp air and falling snow. Seemingly parallel to the picture plane, between the foreground and our viewing space, the snow-flakes are a curtain of quick dabs of paint. Monet's decision to depict a snowfall in progress, and not simply a winter scene of fallen snow, reflects the influence of Japanese *Ukiyo-e* prints. Eliza Rathbone notes that while there are very few examples in Western art of falling rain or snow, Japanese artists sought to "suggest nature in every aspect and every season."[3] By evoking the palpable immediacy of the weather in this *effet de neige*, Monet invites us to respond with all of our senses.

1. Moffett et al. 1998, p. 96.
2. Ibid.
3. Eliza E. Rathbone, "Monet, Japonisme and *Effets de Neige*," in Moffett et al. 1998, p. 32.

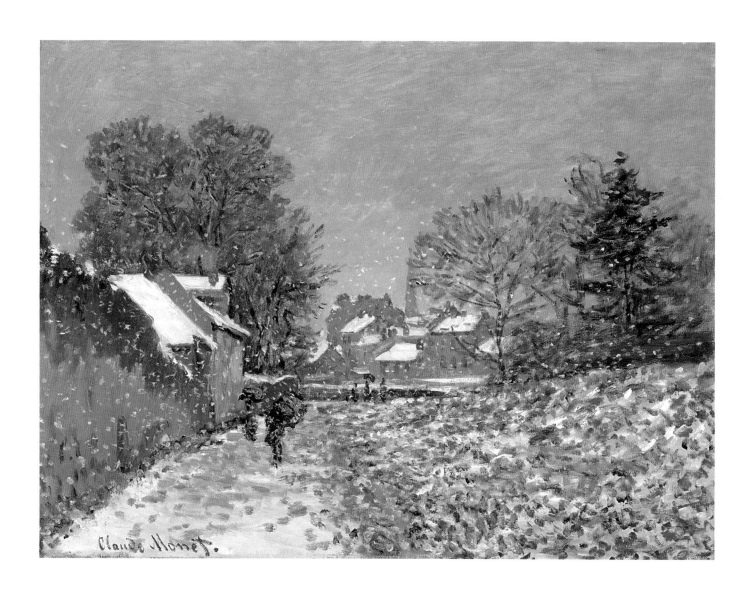

41 Claude Monet

French, 1840–1926

Camille Monet and a Child in the Artist's Garden in Argenteuil 1875

Oil on canvas, 55.3 × 64.7 cm

Anonymous Gift in Memory of Mr. and Mrs. Edwin S. Webster (1976.833)

This painting is one of the most popular of the Monets in the collection of the Museum of Fine Arts, Boston. The subject is immediately appealing. A pretty young woman in a fashionable striped dress sits in a lush garden, sewing. At her feet sits a small child, engagingly adorned with a pink ribbon that holds back his blond hair, looking at a picture book. A toy horse, wearing a green collar, waits its turn for attention. The day is sunny, the air soft and warm. It is a picture of secluded domesticity.

A pictorial rigor underlies the peacefulness of this scene. Monet's insistence on pattern making, so evident in the earlier *Rue de la Bavolle, Honfleur* (cat. no. 39), is no less marked here. The picture is composed simply. Horizontal bands of flowers, grass, and pathway establish the pictorial space. Over these bands are painted the triangles of the two figures. A geometric order has been imposed on the seeming vagaries of nature. Yet a curious tension reigns in this garden. Because blue is a cool color and therefore gives the effect of receding from the eye, the figures, despite their position in front of the flowers, seem to sink back into them. And because pink and red are warm colors and seem to advance toward the eye, the flowers appear to collapse the intervening space, enveloping the young woman and making her part of the garden.

The painting testifies to the flight of middle-class Parisians to the suburbs after mid-century. Paul Hayes Tucker has amply discussed this trend and Monet's part in it in his book *Monet at Argenteuil*.[1] The figures seen here are indeed urban people transposed to a suburban setting. The young woman, Monet's first wife, Camille, wears urban, not country, clothes. The toy horse came from a shop in Paris, not a father's workbench. The garden belonged to the second house Monet rented in Argenteuil, on the Boulevard Saint-Denis, a road that runs a block away from and parallel to the railway line to Paris. The seclusion and quiet that pervade this painting are exactly the qualities city dwellers sought in their suburban retreats, yet one wonders, with the train tracks a short block away, how peaceful the garden really was.

Such a question, however, is altogether beside the point, for Monet painted exactly what he wanted us to see. The simple composition evokes a sense of permanence and stability. The combination of young woman and child (who is too young to be the Monets' first son, Jean, born in 1867) proclaims both domesticity and the promise of future generations. Yet, while this painting is resolutely of its time, the imagery recalls the medieval convention of the *hortus conclusus*, an enclosed garden in which the Virgin and Child sit at their ease. This association is underscored by the blue color of Camille's striped dress, for the Virgin is traditionally depicted wearing a blue mantle. A deceptively simple painting, *Camille Monet and a Child in the Artist's Garden in Argenteuil* is at once ingratiating and manipulative, seamlessly blending tradition and the present in a careful tapestry of flickering brushstrokes, evocative of a perfect summer's day.

1. Tucker 1982, pp. 125–53.

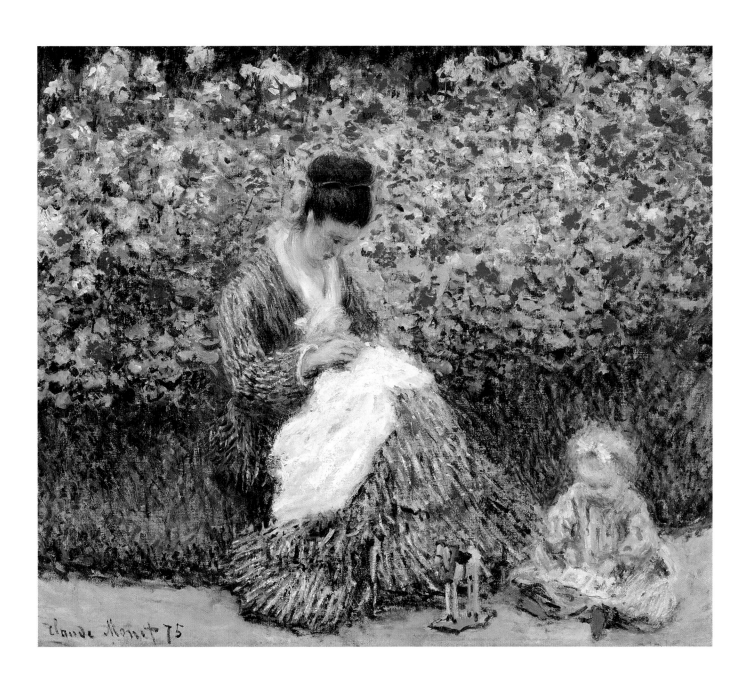

42 Claude Monet

French, 1840–1926

Entrance to the Village of Vétheuil in Winter 1879

Oil on canvas, 60.6 × 81.0 cm

Gift of Julia C. Prendergast in Memory of her brother, James Maurice Prendergast (21.7)

In northern France, winter poses particular problems for the landscape painter. Without foliage, trees and bushes stand spare and lean; grasses are dead and brown; flowers are gone. The air is duller, often bluer, than it is in warmer seasons. The moist air of the region, so soft in the summer, in the winter shrouds forms in alienating whiteness. Even the built environment looks different, as if buildings shrink into themselves to keep warm. Such conditions intrigued Monet, especially when he and his family moved to Vétheuil, a town farther down the Seine than Argenteuil and hence still untouched by signs of modernity.

In Vétheuil Monet painted no suburban gardens or sailboat regattas. A sweep of country road leading into the village, bordered by messy stretches of grasses and weeds sodden with melting snow, takes up the bottom half of the picture. The edges of the road materialize out of dabs and flicks of the brush, and Monet has found myriad colors in the unpromising terrain – various blues and greens, reds and oxbloods, whites and ochers. All are unified by the medium light-brown color of the canvas priming, left visible in places just as the grasses and ground peek through the melting snow. The eye is not held by the colors and texture present in the foreground but rushes past, only to be stopped by the phalanx of houses constituting the village, their rectilinear forms hastily sketched in blue. The outlines of plowed fields on the hill beyond subtly continue the architectural forms, in their turn terminated by the great curve of the hill, even more lightly drawn in with long, thin strokes, like those of a pastel.

The rushing perspective to the middle ground is not new to Monet's oeuvre; it was present in *Rue de la Bavolle, Honfleur* (cat. no. 39). It replicates lived experience: we look where we are going, at the goal of our journey, rather than examine the weeds along the way. Yet here the perspective is exaggerated, with the point of view chosen so that the roadway covers what seems a disproportionate area of the canvas. Monet could have seen such a composition in nineteenth-century Japanese woodblock prints that were being imported into France in large numbers. Ando Hiroshige's (1797–1858?) *Five Pines along the Onagi River*, from the *One Hundred Views of Famous Places in Edo* series, is one such example (fig. 25). Its effect is to direct the viewer's eye immediately to the middle and background, more or less skipping over the foreground, so that the picture as a whole is perceived at a glance. In a circular pattern of

Fig. 25. Ando Hiroshige, *Five Pines along the Onagi River*, in *One Hundred Views of Famous Places in Edo*, 1856, colored woodcut, 34.0 × 22.2 cm. Philadelphia Museum of Art, Gift of Mrs. Anne Archbold

borrowing, Hiroshige used an exaggerated form of European one-point perspective, initially introduced to Japan via Dutch landscape prints. When Monet used Hiroshige's foreshortened foreground, he was able to retain the atmospheric qualities – the *enveloppe* of air – that were so important to him.[1]

1. Gerald Needham, "Japanese Influence on French Painting, 1854–1910," in Weisberg et al. 1975, p. 117.

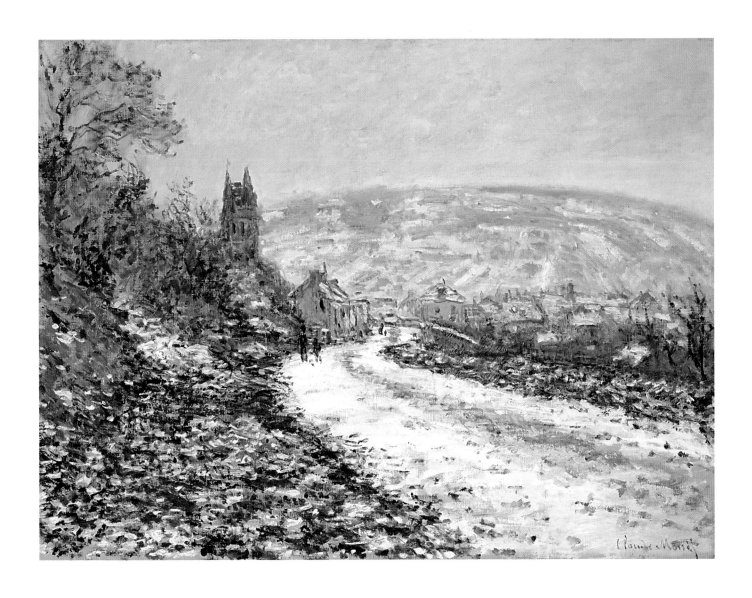

43 Claude Monet
French, 1840–1926
Sea Coast at Trouville 1881
Oil on canvas, 60.7 × 81.4 cm
John Pickering Lyman Collection (19.1314)

A single tree, deformed by the constant buffeting of onshore winds, is the central motif of this painting by Monet. The artist has focused so intently on it that the rest of the canvas serves as a mere backdrop. Because the horizon line is effaced in a haze of creamy blue strokes, there is no sense of recession into the distance. Such an abstract field behind the tree deprives it of volume, so that it reads as a flat pattern on the surface. This pattern is so dominant that its outline determines the shapes of other forms in the painting. Not only do the low blue bushes that extend from one edge of the canvas to the other echo the general form of the tree's foliage, but the very ground answers the bending motion in low hillocks parallel or related to the tree's angle. Although the tree's form is dominant and determines so many other shapes in the painting, the tree in itself is almost ephemeral, for it is barely rooted in the soil. The wind on the Channel coast is so strong that it seems to be able to pry tree roots from the ground, and this tree looks as if it is about to be blown away.

The painting is thus an exercise in pattern making rather than a naturalistic description of a place. What is lacking here – because Monet had no intention of including it – is the personality and even sentimentality that an earlier artist such as Théodore Rousseau invested in his portraits of isolated trees (fig. 26).[1] Rousseau made heroes of his trees. They become massive, overwhelming presences, reducing to insignificance the humans or animals taking shelter under their spreading branches. The other forms in the landscape – trees, cows, and people – appear very small, as if seen from a great distance, the distance being determined by how far back the artist had to go in order to see all of the central trees. Could trees be so big? As naturalistic as Rousseau's scene is, in its careful description of light, shadow, and plants it is informed by the artist's awe-struck wonder in the face of nature's majesty. No such humility underpins Monet's picture. He sees natural forms as a starting point, elements to be manipulated to serve optical and pictorial ends. The artist's personality, not the natural world, is primary.

1. Gary Tinterow, "Realist Landscape," in Tinterow and Loyrette 1994, pp. 71, 73.

Fig. 26. Théodore Rousseau, *Oak Trees in the Gorge of Apremont*, c. 1850–52, oil on canvas, 63.5 × 99.5 cm. Musée du Louvre, Paris, Département des Peintures, Bequest of Thomy Thiéry, 1902 (RF 1447). © Photo R.M.N.

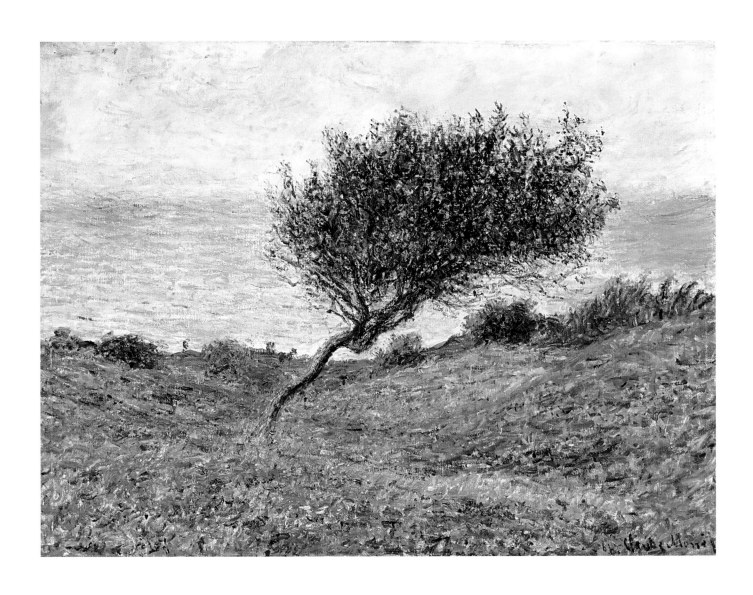

44 Claude Monet

French, 1840–1926

Fisherman's Cottage on the Cliffs at Varengeville 1882

Oil on canvas, 60.5 × 81.5 cm

Bequest of Anna Perkins Rogers (21.1331)

Monet was a restless man. Summertime often drew him to the English Channel coast, and in 1881 and 1882 he explored the area around Dieppe, situated about ninety-six kilometers to the east along the coast from Le Havre. He liked Pourville and Varengeville, west of Dieppe, because they were smaller and less pretentious, and, most important, their cliffs offered more compelling motifs.[1] It is impossible to know whether the motifs Monet painted were in one or the other town – what mattered was his confrontation with nature, not the built environment.

Still, it is sometimes useful to give focus to a scene. For this purpose, Monet particularly liked the stone cabins that had been built during the Napoleonic era as posts from which to observe coastal traffic. In Monet's day they were used by fishermen for storage. The door and flanking windows anthropomorphize the cottage, giving it a nose and two eyes. In this sunny picture (Monet was in the Dieppe area from mid-June to early October) the cottage turns into a teasing redhead, playing a game of hide-and-seek.

We may see the cottage, but we cannot reach it, for there is no path. Indeed, all we can do is admire the view out to sea (on which the cottage seems to turn its back). The Channel, dotted with recreational yachts, sparkles in the distance. The cottage, especially its roof, is given an orange hue, which it may truly have possessed but which makes a striking contrast of complementaries with the blue of the water on the horizon. The tangle of high-summer vegetation is created with layers of brushstrokes – myriad greens, salmons, blues, and turquoises – so complex that Monet could not have completed the canvas on site but must have taken it back to the studio. The vegetation is enlivened and simultaneously grounded and brought forward by the red of the poppies, the only plant species that can be guessed at. The lush vegetation offers no purchase for the eye, so we look out to the water, where our vision is directed to the horizon by the diagonal line formed by three of the boats. In contrast to the flickering brushwork of the vegetation, the sails are made of comparatively large, flat strokes of creamy white paint that lie flat on the canvas, thwarting to some extent the expected sense of recession.

A complicated painting, *Fisherman's Cottage on the Cliffs at Varengeville* was made for the market, specifically for the dealer Durand-Ruel. Monet and his dealer found that these pictures sold easily, especially after the success of similar subjects at the seventh Impressionist group exhibition, in March 1882.

1. Herbert 1994, p. 44.

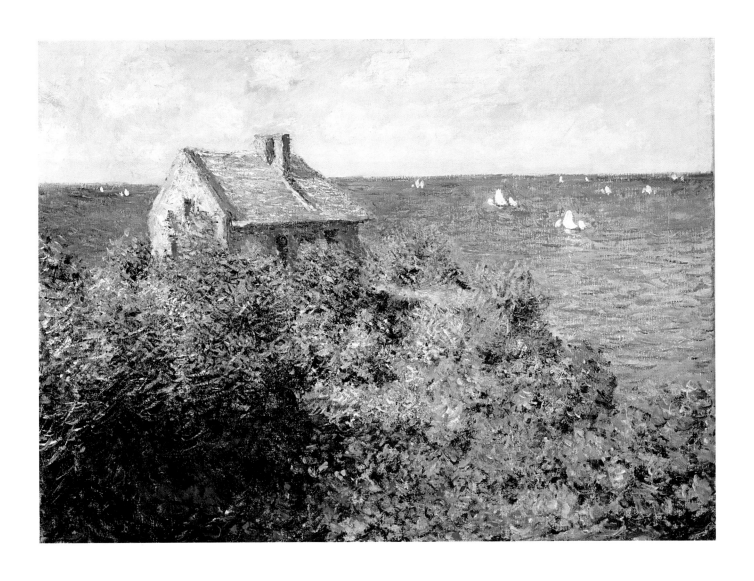

Monet had begun to experiment with X-shaped compositions as early as 1863–64. Here, almost twenty years later, he has refined the schema and simultaneously clothed it in an active surface pattern of indescribable subtlety. A grass-tufted path leads between hills to dip below, or turn to skirt, a wall of trees. The darker foliage of the trees separates the light-toned regions of foreground grasses and distant water and also denies access to the shore: the path must lead there, but how?

The large, simple triangle shapes and the softened rectangle of the foliage serve as suitably bland containers for the welter of colored marks. One of the great joys of looking at Monet's paintings is being able to trace the activity of his brush, the various ways in which he applied paint, and the many different colors of paint he applied. The pastel pinks, mauves, greens, and blues, so soft that they look as if they have been wafted onto the canvas, make the coarse seaside grasses seem pliant to the touch, almost silky.

Despite the uncertain continuance of the path, this is a welcoming, pleasant place. The path nestles between two soft mounds. In the Western tradition, landforms are often discussed in sensuous terms in relation to the human body. The topos of Mother Earth is evoked, and the import can be nurturing, or sexual, or both. By this date Monet's paintings only rarely included the human figure. If one were present here, as in the much more straightforward *Sheltered Path* of 1873 (fig. 27), the scene would take on an anecdotal air, and the force of the geometry and suggestiveness of the landforms would be diminished. Without a figure, *Road at La Cavée, Pourville* invites, seduces, comforts, and promises, on an optical as well as an animal level, the component parts of which are impossible to disentangle.

Fig. 27. Claude Monet, *The Sheltered Path*, 1873, oil on canvas, 54.5 × 65.5 cm. Philadelphia Museum of Art, Given by Mr. and Mrs. Hughes Norment in honor of William H. Donner (1972-227-001)

46 **Claude Monet**

French, 1840–1926

Meadow with Haystacks near Giverny 1885

Oil on canvas, 74.0 × 93.5 cm

Bequest of Arthur Tracy Cabot (42.541)

In this painting of primarily blue, green, and violet hues, the eye is drawn to the lighter and brighter streaks of yellow. These represent sunlight that has broken through the trees on the right, trees that glow from within with captured light. Color and light had always been Monet's primary interests; at Giverny in the mid-1880s, he began to give himself up entirely to their exploration. This could well be the same meadow that he painted in *Meadow at Giverny* (cat. no. 47), but here the view takes in haystacks, which have turned pink in the late afternoon light. Not an untended expanse filled with wildflowers, the land is put to human and animal use. But Monet is more interested in the haystacks for their formal properties, and he has carefully cropped the one farthest to the left and aligned it with two others in a diagonal recession.

Texture, too, is seen as an integral component of color and light. Blues, greens, oranges, and yellows appear haphazardly scattered on the ground to simulate the effect of light bouncing off the unevenness of the cut stubble; in fact, close observation reveals a careful manipulation of paint to create texture that is then colored – a painstaking rather than spontaneous process.[1] Texture of a different kind can be seen in the diagonal brushstrokes that unify the upper half of the painting, moving from the blue-green foliage through the smoother creamy white sky.

Monet wanted the public to believe that his paintings represented solitary confrontations with nature. A painting by the American artist John Singer Sargent (1856–1925), however, proves that this was not always the case (fig. 28). It is evident that Monet went to the meadow accompanied not only by a professional colleague, Sargent, but also by a woman, variously identified as Blanche or Suzanne Hoschedé, the daughter of Monet's mistress, Alice. The trio may have brought a picnic lunch, so domestic does Sargent's scene appear, with the woman absorbed in needlework or a book. Monet's letters written in the summer of 1885 describe his progress on this painting from late June to late August,[2] proof that he returned to it away from the motif. The sense of companionship evinced by Sargent's painting – although the painters did not talk with one another, each was aware of the other – makes the intellectual, formal, and aesthetic rigor of Monet's work all the more impressive.

Fig. 28. John Singer Sargent, *Claude Monet Painting at the Edge of a Wood*, 1885, oil on canvas, 54.0 × 64.8 cm. Tate Gallery, London, Presented by Miss Emily Sargent and Mrs. Ormond through the National Art Collections Fund, 1925. Photo: Tate Gallery, London / Art Resource, New York

1. Herbert 1979, pp. 92, 94, figures 1 and 2, and passim.
2. Wildenstein 1974–91, vol. 2, letters 578 and 581. The date of Sargent's painting, much discussed in the literature on the artist, was first conclusively given as 1885 in Simpson 1993, vol. 1, pp. 314–16.

47 Claude Monet

French, 1840–1926
Meadow at Giverny 1886
Oil on canvas, 92.0 × 81.5 cm
Juliana Cheney Edwards Collection (39.670)

Horizontal bands of color undulate across the vertical canvas – purplish green alternating with greenish yellow in the lower half, and pinkish yellow and pinkish white in the upper half. Two vertical elements interrupt the gentle waves. These colored bands describe a meadow bordered by trees at Giverny, the hamlet between Paris and Rouen where Monet made his home after April 1883. The countryside in that part of Normandy is tame and rolling, having been smoothed and shaped by the Seine. There Monet found a combination of motifs, light, and foliage that challenged his vision of nature and his changing notion of art.

It is difficult to describe adequately a painting of such visual complexity and sophistication. Purchase on the observed world is offered by the trees that break free of the prismatic waves, mimicking the human posture, and by the horizon line, the break between meadow and farther trees, which is placed relatively high on the picture plane. This high placement frustrates the attempt to read the picture as a naturalistic scene with recession into depth, for it tips up the picture plane and forces us to read the colored bands as adhering to the surface. The colored bands – the meadow itself – are a hypnotic field of carefully planned strokes. Blues and lavenders are layered on top of greens and spill over onto hotter yellows. The darker bands, we come to realize, are to be read as shadows of trees. Thus the cooler lavenders and blues are shadows, not springtime flowers. The pink-mauve color of the trees – poplars can be inferred from the long, thin shadows – betokens autumn foliage. Colors are placed one on top of another, creating a built-up, crusty surface in the foreground and a wispy, tracery-like effect against the sky. The painting is the result, not of a single outing, but of a premeditated, thought-out campaign.[1]

Meadow at Giverny does not have an obvious focal point: no figure, structure, or natural feature attracts the viewer's attention. The high-keyed palette and, especially, the insistence on pattern further contribute to our sense of it as a decorative painting, in the best sense of the term – as a work concerned, above all, with the very qualities of color and pattern. It is also a painting of loneliness. The only element that breaks from the pattern of horizontals is the tree in the background that frees itself from its neighbors. Were the tree a human figure, it could be described as displaying itself against the sky in a gesture of defiance or triumph. A tree is not a human being, of course,

yet the temptation to read the one for the other is strong. This tree is isolated, mirroring the position of the viewer looking at this deserted, if colorful, meadow.

1. For an analytical and thoughtful explanation of Monet's method, see Herbert 1979, pp. 90–108.

48 Claude Monet

French, 1840–1926

Cap d'Antibes, Mistral 1888

Oil on canvas, 66.0 × 81.3 cm

Bequest of Arthur Tracy Cabot (42.542)

As Monet grew older, his paintings became simpler. He began to focus on a single, isolated motif, the better to record the changes in color and light wrought on it by different times of day and fluctuations in weather. *Cap d'Antibes, Mistral* is one of three paintings of these very same trees that Monet made during his four-month sojourn in Antibes, from January through May 1888. (He made thirty-nine paintings during this period.) This was Monet's third visit to the Riviera. He went first with Renoir, in December 1883; then alone to Bordighera, in northwest Italy, for about ten weeks in 1884; and finally with his second wife, Alice, to Venice, from October through December 1908. These repeated visits are evidence of Monet's fascination with the region, which afforded, among other things, a comfortable distance from family, friends, and dealers.[1]

The component parts of *Cap d'Antibes, Mistral*, like those of its two companion pieces,[2] are easily itemized: a narrow strip of pink foreground on which grow grasses and trees of pink, green, and purple; a strip of blue-green water dotted with pleasure craft; the snowy maritime Alps terminating the expanse of water; and a strip of sky. Each of the three is distinguished by color tonalities, by brushwork, and, in the Boston example, by its windblown effect caused by the mistral – the strong, cold, northerly wind of southern France. The long, loose brushstrokes that depict the foliage are carried over into the water, mountains, and sky, as if to suggest that the wind is capable of smoothing the large surfaces of those different elements as easily as it agitates the more pliable grasses and leaves.

In painting similar versions of a subject over time, Monet sought to record the distinguishing atmospheric conditions of each moment. And as the atmospheric conditions changed, so did the perceptions of the painter. In Joachim Pissarro's words: "Seriality [the painting of more than one version of a single subject] emphasizes the natural uniqueness of painting, not only in its subject matter (representing a fragment of the real that is constantly under flux) but also in its temporality (reflecting a moment of the creative individuality that cannot be repeated)."[3]

Underlying the fluctuation of color and light that so riveted Monet, however, is the rigorous horizontal structure of strips piled one on top of the other. Monet's reduction looks forward to the sparer, starker vision of Ferdinand Hodler's (1853–1918) late views of the Lake of Geneva (fig. 29). Hodler, like Monet, painted many scenes of an expanse of water terminated by

Fig. 29. Ferdinand Hodler, *Lake of Geneva and the Range of Mont-Blanc, at Dawn*, 1918, oil on canvas, 61.2 × 128.0 cm. Musée d'Art et d'Histoire, Ville de Genève (1918-25)

a range of mountains, seen at different times of day. Hodler, concerned with recording psychic rather than atmospheric nuances, eliminated all but the narrowest strip of foreground and showed no boats on the lake. In contrast to the later Hodler, Monet, rooted in the nineteenth century, supposed that a view must have a viewer, and made the trees, with their wind-tossed foliage, stand in as surrogates for that viewer.

1. For a thorough discussion of Monet and his activities on the Mediterranean, see Pissarro 1996.
2. Ibid., no. 63 (Hill-Stead Museum, Farmington, Conn.) and no. 65 (private collection, France).
3. Ibid., p. 20.

49 Claude Monet

French, 1840–1926

Grainstack (Sunset) 1891

Oil on canvas, 73.3 × 92.6 cm

Juliana Cheney Edwards Collection (25.112)

Grainstack (Sunset) belongs to a series of at least twenty-five canvases that Monet painted of the subject (some with one stack and others with two) in 1890–91. The artist showed fifteen of them at the Durand-Ruel Gallery in May 1891, and the same number were also brought together in a recent exhibition.[1] The cumulative effect of seeing so many at once can be exhilarating. The variety of light, colors, and textures wrested from a single motif is astounding, producing a sensation somewhat like the calm induced by a group of paintings by Mark Rothko (1903–1970) or Clyfford Still (1904–1980). Seeing a single painting of a grainstack, as here, has its own rewards, however. In isolation from its relatives vying for attention, it can be studied at leisure, its various aspects noted with care.

The painting shows a stack of grain, carefully constructed and thatched to protect the precious harvest from moisture and rodents. Its upright sides and conical roof tower to a height of fifteen or twenty feet and relate it formally to the buildings stretching across the middle of the canvas, whose roofs were similarly thatched. The relation between the constructed forms goes beyond their shape, however. The stack represents the wealth of the people who live in the distant buildings and the prosperity and security of the country at large, for France continued to identify itself as an agrarian nation. The left edge of the purplish roof of the stack intersects the largest house, as if to underscore the connection.

This particular example from the series is aflame. Despite a palette that includes pale pastels of yellows, pinks, blues, and purples, it is the hot oranges, reds, and burning yellows that seem to predominate. The yellows in particular have a tangible presence; yellow paint is thickest along the contour of the stack's cone, as if the sunlight were caught in the thatch and had piled up there. The materiality of the sunlight is emphasized by the much smoother surface of the conical roof facing the viewer. There the brushstrokes are long and disjunctive and make up the darkest part of the picture. The contrast is startling – and distinctly anti-naturalistic. The upright wall of the stack that the viewer sees could not possibly be the hot orange Monet painted it; it was, after all, in shadow. Likewise, the ends of the buildings glow with bluish white under the light-orange roofs; they, too, face away from the sun. These color choices and textures – much of the canvas is covered with a thick crust of brushstrokes – have more to do with picture making than with capturing the scene before the artist. Monet used the

grainstacks as a vehicle through which his emotions would have an outlet. "In short," he wrote on October 7, 1890, "I am more and more driven by the need to render what I feel."[2] Monet achieved his goal: this fulgent grainstack, shown alone in a field, is emotion made visible.

1. Paul Hayes Tucker, "Of Hay and Oats and Stacks of Grain: Monet's Paintings of Agrarian France in 1890–91," in Tucker 1989, pp. 65–105. Tucker's discussion is the basis of much of this entry.
2. Geffroy 1924, translated in Stuckey 1985, p. 157.

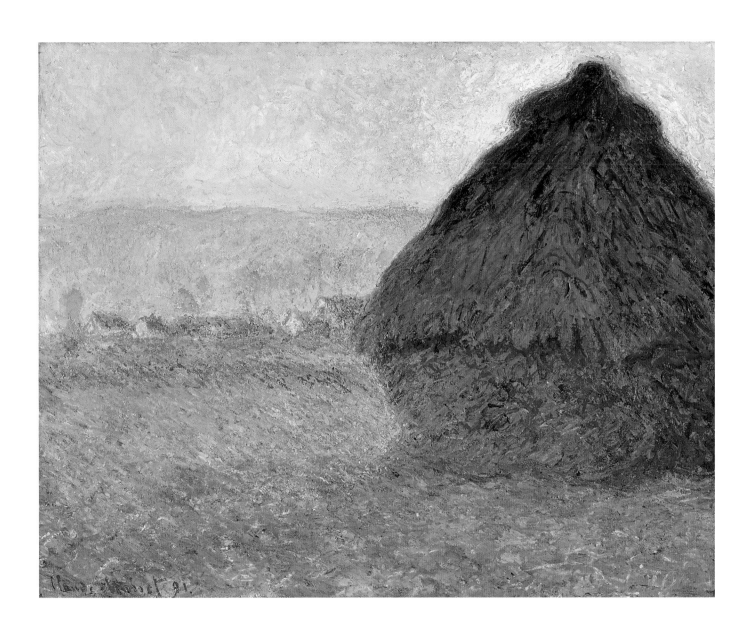

50 Claude Monet

French, 1840–1926

Morning on the Seine, near Giverny 1897

Oil on canvas, 81.4 × 92.7 cm

Gift of Mrs. W. Scott Fitz (11.1261)

Monet traveled as far north as Norway and as far south as Venice to look for different motifs, but he always returned to the places he knew best. He painted the river Seine in Paris, Argenteuil, Vétheuil, and where it emptied into the English Channel. He turned to it again in 1896 and 1897 for his series of canvases showing how it looked at dawn.

This version is notable for its softness. Its colors of pinkish mauve, cool blues, and greens are matched with large, simple, and rounded shapes. With the point of view suspended over the water, we are made to feel weightless, perhaps even bodiless. Almost symmetrical reflections threaten to disorient us, but Monet has left enough clues to let us know which way is up.

Lilla Cabot Perry (1848–1933), an American painter and journalist who met Monet in 1889 when she and her husband began spending their summers in Giverny, remembered the series when she wrote about Monet after his death: "They were painted from a boat, many of them before dawn, which gave them a certain Corot-like effect, Corot having been fond of painting at that hour."[1] In one of the many eulogies written after Corot's death, his early-morning habits were extolled. René Ménard explained that "Corot is *par excellence* the painter of morning. He can render with more felicity than anybody else the silvery light on dewy fields, the vague foliage of trees mirrored in calm water. He was not fond of the noonday light, and it was always in the earliest morning that he went out to paint from nature." Ménard quoted from a letter written by the artist himself:

> A landscape-painter's day is delightful. He gets up early, at three in the morning, before sunrise; he goes to sit under a tree, and watches and waits. There is not much to be seen at first. Nature is like a white veil, upon which some masses are vaguely sketched in profile…. The chilly leaves are moved by the morning air. One sees nothing: everything is there. The landscape lies entirely behind the transparent gauze of the ascending mist, gradually sucked by the sun, and permits us to see, as it ascends the silver-striped river, the meadows, the cottages, the far-receding distance. At last you can see what you imagined at first.[2]

When Perry evoked Corot, she was doubtless thinking of his *Souvenir of Mortefontaine* (fig. 30), which has been in the collection of the Louvre since 1889. Monet too must have

Fig. 30. Jean-Baptiste Camille Corot, *Souvenir of Mortefontaine*, c. 1864, oil on canvas, 65.0 × 89.0 cm. Musée du Louvre, Paris (MI 692 bis). © Photo R.M.N.

been thinking of this painting, and Ménard's words describe the later work perhaps better than the earlier one. We can imagine no greater homage.

1. Perry 1927, p. 120, quoted in Stuckey 1985, p. 184, and Tucker 1989, p. 231. Tucker's chapter is the most sensitive treatment of the Morning on the Seine series.
2. René Ménard, in *Portfolio*, October 1875, translated in Clement and Hutton 1879, vol. 1, p. 161.

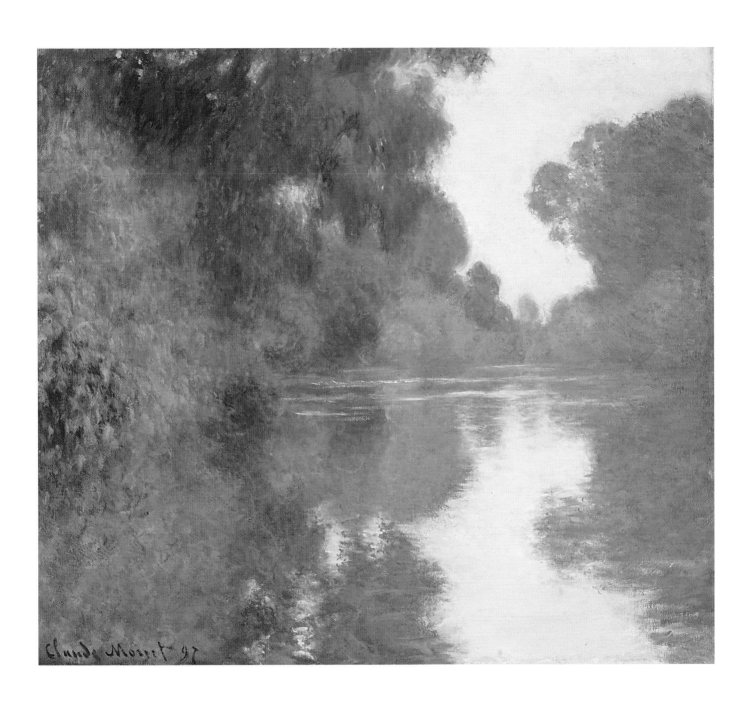

51 **Claude Monet**

French, 1840–1926

The Water Lily Pond 1900

Oil on canvas, 90.0 × 92.0 cm

Given in Memory of Governor Alvan T. Fuller by the Fuller Foundation (61.959)

The Water Lily Pond is one of Monet's numerous examinations of the pond at his estate at Giverny. Unlike his earlier series paintings such as the Grainstacks (see cat. no. 49), which were representations of a single object under varying atmospheric conditions, the Water Lily paintings are details of a larger subject. In his depictions of water, Monet's concern shifts from light and color (as in his earlier works) to the varying reflective properties of the ever-changing surface of a pond. For Monet, water was the face of nature itself.[1]

This landscape which at first glance seems static is charged with animation. The complementary greens and reds enliven the scene as reflections dance in the water between clusters of lilies. A musical rhythm is created: harmonies of color and geometric counterpoints form the overall composition. The bridge creates a crescendo and decrescendo as it balances the horizontal surface of the water and the cascading verticals of the willow boughs.

The pond is covered in a striated carpet of alternating water lilies and reflections of the surrounding vegetation. Placed before a curtain of weeping willow trees the bridge stretches across the pond between two banks obscured by lush vegetation. Enveloped in color and foliage, the scene has no horizon and no vanishing point; the glimpse of a pink twilight sky at the upper left of the canvas is the only indication of a space beyond this fertile cove. The arching bridge and the lack of Western perspective recall Japanese prints, of which Monet was an avid collector. In his effort to capture the sense of nature's abundance, Monet here begins to abandon traditional Western painting conventions, foreshadowing a stylistic shift that will not be fully realized until later in his career.

1. Georgel 1999, p. 10.

52 Stanislas Henri Jean-Charles Cazin

French, 1841–1901

Cottage in the Dunes c. 1890

Oil on canvas, 46.0 × 55.5 cm

William R. Wilson Donation (15.882)

Two stone cottages with red clay roofs stand at the center of a landscape dominated by an overcast sky with dark-gray clouds rolling in from the right. To the left, a woman walks down a path, our view of her partially eclipsed by the tall grasses in the foreground. Two figures move in the distance near another stone building, and a small cluster of yellow flowers flickers in the foreground at left.

Through this combination of details, Cazin creates a sense of physical and temporal movement. While this painting has the elements of a genre scene and depicts a moment in time, it is not primarily an anecdote of daily rural life, in the beauty of nature – as is Millet's *End of the Hamlet at Gruchy* (cat. no. 13). And although it shares a compositional and stylistic affinity with Millet's *Priory at Vauville, Normandy* (cat. no. 14), which links the buildings of a community with the rugged landscape they inhabit, this painting emphasizes atmospheric conditions, light, and texture, as conveyed by Cazin's rapid brushstrokes and subdued, warm palette. One can also see the influence of the young Monet, whose technique of juxtaposing separate unblended touches of color Cazin modified. Cazin's varying brushstrokes – some are quick and apparent, others smooth, even, and almost undetectable – serve, in one critic's words, "to emphasize the form and texture of objects rather than decompose them."[1]

The composition is reminiscent of seventeenth-century Dutch landscapes, with which Cazin may have become familiar in 1872 when he sketched in Holland together with Monet and Daubigny.[2] The prominence of the sky in relation to the rest of the painting is a Dutch leitmotif, as is the stature of the cottages. Just as windmills were a testament to Dutch national and civic pride in works by artists such as Jacob van Ruisdael (1628/29–1682), the cottages in this painting also serve as reminders of the dignity and permanence of life in rural France.

1. MacClintock 1989, no. 43 (from the English-language manuscript in the library of the Museum of Fine Arts, Boston).
2. Ibid.

53 **Stanislas Henri Jean-Charles Cazin**
French, 1841–1901
Farm beside an Old Road c. 1890
Oil on canvas, 65.1 × 81.6 cm
Bequest of Anna Perkins Rogers (21.1330)

At first glance, the eye can discern only a few simple forms in
this painting: the image appears to be composed mainly of
swatches and dabs of color. Easily perceptible are the path,
fields, farmhouses, distant hills, and a pinkish overcast sky.
Thick clouds cover hints of blue sky as day gives way to night.
It is twilight. A thin, quick brushstroke of red peeks through
the clouds just above the horizon, suggesting the final rays
of the setting sun. Lingering, the eye adjusts, and even more
forms are discerned. Certain colors – the whites and light
greens – become more prominent through Cazin's luminescent
undertones. Two forms that seem to be grainstacks become
apparent in the distance, and to the left across the valley are
two squiggly brushstrokes representing smoke from smoldering
fires (perhaps a field had been burned earlier in the day in order
to render it fallow). The tilled areas of dirt represented by
patches of color suggest autumn or late summer after harvest
time. Cazin captures the peace of early evening, with its still,
crisp air, and records the atmosphere and light.

There are no figures in this painting, but a human presence
is evident. Like *Cottage in the Dunes* (cat. no. 52), it is an image
of rural France, but here Cazin is more concerned with evoking
stillness, through his masterful rendering of color and light and
varying hues and tonalities, than with painting a heroic image
of country life. And whereas *Cottage in the Dunes* reveals the
influence of Monet, here we see the influence of Daubigny,
with his broader, more calligraphic brushstrokes. In *Farm beside
an Old Road*, Cazin uses color rather than line to sculpt his
forms. Almost every element of the composition is a suggestion
or an impression created by color: twisting, white lines denote
smoke; a thin orange line, strategically placed, indicates the
setting sun; large, expansive brushstrokes embody fields. The
artist's technique in this painting is truly Impressionist, as the
placement of color indicates and expresses forms, mood, and
atmospheric conditions.

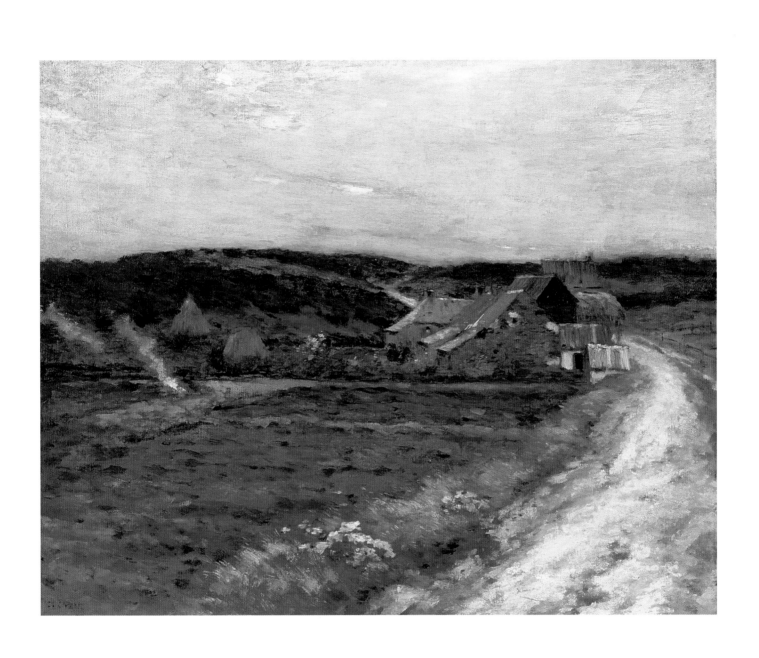

54 **Armand Guillaumin**
French, 1841–1927
Bridge in the Mountains 1889
Oil on canvas, 65.5 × 81.8 cm
Bequest of John T. Spaulding (48.560)

A riot of color threatens to overwhelm both the geological and man-made forms in this painting, as if a box of paint at the top of the hill had broken and the colors had flowed downhill, clinging in patches to outcroppings and pooling in hollows. Purples, pinks, oranges, greens, turquoises, mauves, blues, and lavenders cascade.

Guillaumin found this rugged countryside in central France while visiting his mother's family at Pontgibaud, in the Auvergne Mountains, in the summer and fall of 1889. The bridge is near the small village of Peschadoire. Guillaumin responded to the landscape, which is dramatically different from the gentle hills and softer colors of the area around Paris (where he had been living for thirty-two years). To simulate the rocky terrain, he adopted a brushstroke that is choppy and rough. The colors, seemingly unnaturalistic, were chosen in response to the hue of the heather that covers the mountains in late summer.[1]

Guillaumin's palette had always been highly charged, but the explosion of color seen here may also owe something to the strong hues of younger artists such as Gauguin and van Gogh, with whom he was friendly in Paris. Van Gogh saw in him a determined sense of purpose, a devotion to his particular vision. The Dutchman wrote in response to a comment his brother had made about Guillaumin: "What you say of Guillaumin is very true, he has found one true thing and contents himself with what he has found, without going off at random after divergent things, and in that way he will keep straight and become stronger on these same simple subjects."[2] Here the simple subject is the relation between natural and man-made forms: how the rectangular stones of the bridge gradually erode to resemble the irregular rocks of the valley, and how the slender thread of the path hardly seems to warrant the construction of a bridge. In short, the torrent of colors, which here is the stuff of nature, seems poised to overrun people's attempt to use the world around them.

1. Gray 1972, pp. 40–41.
2. Van Gogh 1958, vol. 3, p. 225, no. 611.

55 **Pierre-Auguste Renoir**

French, 1841–1919

Woman with a Parasol and Small Child on a Sunlit Hillside 1874–76

Oil on canvas, 47.0 × 56.2 cm

Bequest of John T. Spaulding (48.593)

Of all the paintings produced by the artists associated with the Impressionist movement, Renoir's are the most immediately ingratiating. His scenes more often include people – frequently young women and children – with whom we, as viewers, can identify. Here, the pretty, dark-haired young woman smiles welcomingly under her pink parasol. If it were possible to step into a painting, such an invitation would be hard to resist. Renoir's depiction of a hillside in summer conveys a sense of fullness and ease that can be complete only with the inclusion of the human figure: without the young woman and child – the one relaxing, the other exploring – the scene would hold no interest for us and would pictorially not exist.

Renoir's rapid yellow and green brushstrokes mimic the lushness of summer grasses so tall that the woman sinks into them (notice the blades curving over her right arm holding the parasol). The small child toddling off on a mission of his own is equally enveloped by the grasses. The unconcern evinced by the woman for the child's whereabouts is a sign, not of her inattention, but of the evident security of the surroundings. A beautiful summer's day holds no dangers. What it does hold is what Renoir shows us: color and light combining inextricably, color as light and light as color. Renoir took special care with the dress, which is not so much the white it initially appears as it is blues and grays, yellows and pinks – all the colors, that is, that he saw in the shadow in which the woman is reclining. As though this were a portrait, Renoir flatters the sitter's fashion sense by detailing the narrow black ribbon and ruffle trimming neckline and cuff.

Yet, despite the sunny nature of the picture, there seem to be some unresolved questions and tensions. The pose of the woman, propped as she is on one elbow, with that arm holding the parasol, seems awkward and perhaps finally painful. The movement of the child toward the upper right of the canvas, continuing the diagonal that begins in the lower left corner, opens the pictorial space into the unknown, symbolized by the dark, indeterminate corner. It is the country equivalent of Manet's (1832–1883) *Railway* (fig. 31). Both paintings feature a young woman whose gaze out of the picture establishes a relationship with the viewer, and a child whose attention is so intently directed toward an obscure goal that it turns its back. Although the woman in the Renoir clearly establishes that the spot where she reclines is soft and agreeable, a small segment of *pays doux*, the child's movement shows that there is more to see and explore beyond the confines of the picture space.

Fig. 31. Édouard Manet, *The Railway*, 1873, oil on canvas, 93.3 × 111.5 cm. National Gallery of Art, Washington, D.C., Gift of Horace Havemeyer in memory of his mother, Louisine W. Havemeyer (1956.10.1)

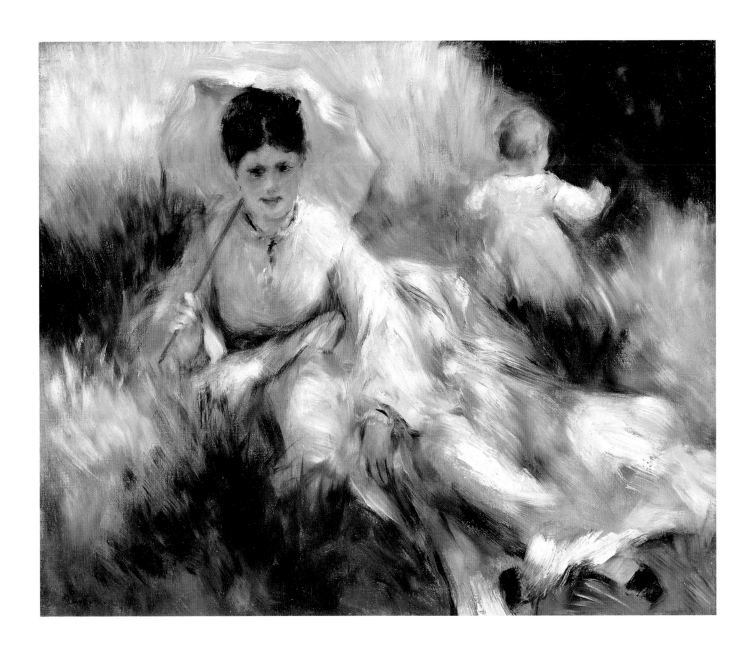

56 **Pierre Auguste Renoir**
French, 1841–1919
The Seine at Chatou 1881
Oil on canvas, 73.5 × 92.5 cm
Gift of Arthur Brewster Emmons (19.771)

Painted in April or May 1881, after Renoir's return from Algeria and before his second trip to Italy, this painting places the viewer amidst grasses and pink-flowering trees on the banks of the Seine near Chatou, a small town about sixteen kilometers west of Paris and a short distance north of Bougival. The Seine was a popular subject for writers, painters, and photographers alike, who often depicted it as a favored locus of Parisian and provincial leisure activity.[1] This painting, however, is not solely about people and their activities. It is about the landscape, the weather, and the atmosphere, all bursting with the color and vitality of spring.

Both banks of the river are filled with lush foliage, and the hillsides are dotted with houses and cottages whose colored roofs seem to be budding flowers amidst greenery. The surface of the canvas is replete with both human and natural activity. Even the little bit of sky is animated with full, moving, fair-weather clouds. While there is considerable activity on the surface of the canvas, Renoir offers some respite by leading the viewer into the painting with two strong diagonals. The first diagonal draws the viewer from the left along the path where a young woman stands. A second diagonal is composed of an alignment of complementary colors, from the red-orange brim of the woman's hat, to the orange hulls of the boats set against the water, to the green grasses that take us further into the painting and ultimately toward the group of poplars on the far bank.

Around 1872, Renoir had painted an image of the same location in *contre-jour*, focusing on some villas across the river (fig. 32). A quiet scene, it is characterized by bold, loose, sketch-like brushstrokes reminiscent of the work of Daubigny. Renoir is more concerned with the reflection and refraction of light in the earlier painting, whereas in the Boston *Seine at Chatou* his goal is to demonstrate nature's fecundity and vitality. He uses varying textures built one upon another: in the corners the paint is so thin that we can see the weave of the canvas, while in other areas it has been applied with a heavily loaded brush. Where the earlier painting is of a still moment, the 1881 image is charged with the activity of Renoir's rapid brushstrokes and changing hues and colors. Lush and abundant, and intoxicating in its execution, *The Seine at Chatou* evokes the sights, and even the sounds and smells, of springtime.

1. See Richard R. Brettell, "The River Seine: Subject and Symbol in Nineteenth-Century French Art and Literature," in Rathbone et al. 1996, pp. 81–130.

Fig. 32. Pierre-Auguste Renoir, *La Seine à Chatou*, c. 1872, oil on canvas, 45.7 × 55.9 cm. Art Gallery of Ontario, Toronto, Purchase, 1935

57 Pierre-Auguste Renoir

French, 1841–1919

Rocky Crags at L'Estaque 1882

Oil on canvas, 66.5 × 81.0 cm

Juliana Cheney Edwards Collection (39.678)

Rocky Crags at L'Estaque documents an important point in the development of Renoir's art. At the end of the 1870s, Renoir, along with his independent-minded colleagues, was becoming dissatisfied with the techniques of Impressionism.[1] Looking for greater compositional structure, and realizing that firm outlines were not anathema to him, he went to Italy in October 1881. "I am in a fever to see the Raphaels," he wrote.[2] A few months later, in mid-January 1882, he was with Cézanne at L'Estaque, west of Marseilles. There they worked together. In a letter, he described his excitement at experiencing the strong sun of southern France.:

> I am in the process of learning a lot.... I have perpetual sunshine and I can scrape off and begin again as much as I like. This is the only way to learn, and in Paris one is obliged to be satisfied with little ... am staying in the sun ... while warming myself and observing a great deal, I shall, I believe, have acquired the simplicity and grandeur of the ancient painters.... Thus as a result of seeing the out-of-doors, I have ended up by not bothering any more with the small details that extinguish rather than kindle the sun.[3]

Rocky Crags at L'Estaque testifies to what Renoir was learning. Painted in bold strokes of creamy white, the rocks are given form by the intervening ochers and greens of vegetation. Set off against the brilliant blue of the sky, the whites advance visually and constitute the most solid part of the picture. The grassy lower slopes and the trees are painted with comparatively small, parallel strokes, a technique Renoir was learning from Cézanne, although he clings to a naturalistic vision by making the brush follow the contours of the forms depicted. Here, in the areas of most active brushwork, we observe Renoir "not bothering any more with the small details." In this "perpetual sunshine" Renoir painted how the sun obliterates details in a way that he did not see in the moister air of the environs of Paris. Still, underlying the trees and grasses exploded into tiny, regular strokes, there is a firm sense of geology, of how the flatlands rise gently to the grassy hillside and how the hillside abruptly meets the towering crags.

Renoir's vision of these rocks is easier to understand than Cézanne's version of a similar scene (fig. 33). Cézanne's forms are more schematic, less naturalistic; his palette is less varied,

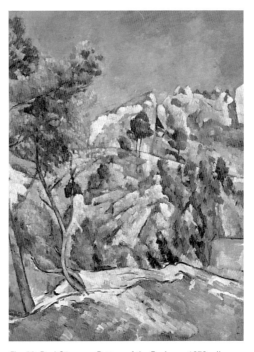

Fig. 33. Paul Cézanne, *Bottom of the Ravine*, c. 1879, oil on canvas, 73.0 × 54.0 cm. The Museum of Fine Arts, Houston, John A. and Audrey Jones Beck Collection (TR:79–78)

less ingratiating. The blue of his sky is deeper, more insistent. Yet Cézanne's influence is palpable in Renoir's painting, from the concentration devoted to a small slice of nature to the patient building-block approach to painting. Later landscapes by Renoir do not have so firm a structure, nor so keen an appreciation for the solidity of the earth.

1. Isaacson 1980.
2. House and Distel 1985, p. 300.
3. Renoir to Mme Charpentier, quoted in Florisoone 1938b, p. 36, translated in Rewald 1973, pp. 463–64.

French, 1841–1919

Landscape on the Coast, near Menton 1883

Oil on canvas, 65.8 × 81.3 cm

Bequest of John T. Spaulding (48.596)

Renoir made this painting when he and Monet traveled together on the Riviera coast from Marseilles to Genoa in the last two weeks of December 1883. Renoir's long, fluid brushstrokes in mid-to-dark greens are analogues for the individual leaves and blades of grass, set in motion by the wind, just as the yellow-green color used throughout is an analogue for the hot southern sun. In order to give some visual snap to the picture, he used the chromatic complementaries of dark red and green (as well as smaller touches of blue and orange), a technique he could have borrowed from the colorful canvases of Eugène Delacroix (1798–1863), an artist he greatly admired. This time in the South of France, with Monet rather than with Cézanne, Renoir seems to have been somewhat less interested in the structure of his painting; certainly, compared with *Rocky Crags at L'Estaque* (cat. no. 57), the recession into depth in *Landscape on the Coast, near Menton* is less clearly delineated. The movement of foliage, light, and water overwhelmed all other considerations, with the result that the viewer can imagine the feel of hot air and wind ruffling hair and clothes.

In this insistence on movement and air, Renoir's view of the Mediterranean coast stands in sharp contrast to Monet's. Although *Cap Martin, near Menton* (fig. 34) was painted not on the trip with Renoir but on Monet's next trip to the South, which he made alone beginning the following month, it shows well enough the differences between the sensibilities of the two artists. Monet's large brushstrokes, among the loosest he would use on any of his trips to the Mediterranean, flatten volumes so that they appear as patterns on the surface. This is particularly true where the trees at the left form a kind of window onto the mountains. The view to the right shows clearly that the mountains are at a distance, yet the abstracted brushstrokes through the aperture read like a backdrop, compressing the intervening space to nothing. In Renoir's view, in contrast, the distance reads as distance. *Landscape on the Coast, near Menton*, acknowledges that humans are part of the landscape. Renoir has painted his view in such a way that it allows us into the scene, and once we are there, it provides the sensory pleasures of heat and moving air. Renoir was concerned with aspects of picture making, to be sure, but he was also concerned with the human element in his art, even when it is not overtly expressed.

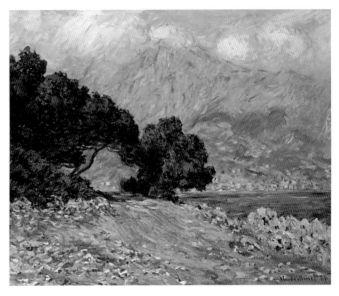

Fig. 34. Claude Monet, *Cap Martin, near Menton*, 1884, oil on canvas, 65.5 × 81.0 cm. Museum of Fine Arts, Boston, Juliana Cheney Edwards Collection (25.128)

59 Pierre-Auguste Renoir

French, 1841–1919

Children on the Seashore, Guernsey c. 1883

Oil on canvas, 91.5 × 66.5 cm

Bequest of John T. Spaulding (48.594)

Renoir took special delight in painting children. Here he has posed three girls of various ages and one small boy in front of a colorful scene of people bathing in the sea. In September 1883 he was inspired by what he saw while visiting Guernsey, an island sixteen kilometers off the coast of France in the English Channel, between the arms of Normandy and Brittany. Judging from this painting, however, he was as charmed by the finery worn by the children as he was by the landscape. Pink and white ruffles and flounces, smart feathers adorning a black hat, and the boy's dark-blue sailor suit are sufficiently delineated for the viewer to know that these young people are wearing city clothes. They are visitors to the island, perhaps making their first foray to the beach before taking a plunge into the sea. The artificiality of their stances, too, proclaims their foreignness. Renoir has arranged the four into a casual pyramid, grounded in the dark, right-angle figure of the boy and animated by the children's interaction with each other. The focus of the painting is the central, tallest, and oldest girl, whose stylish hat draws attention to itself and to her smooth, finely painted face. The effect of the whole is similar to that of an early photograph, in which objects near at hand are in focus but not those in the distance. The emphasis on costume and the seeming inappropriateness of it to the setting – especially in contrast to the naked bathers in the background – call to mind the artificiality of fashion plates; these young people could be modeling summer clothes for an advertisement.

Because the landscape background has been left unresolved (and unfinished in places along the edges) – the water and the bathers in particular are extremely sketchy, and the relation of water to land is unclear – the disjunction between the figures and the landscape setting is especially strong. Such an emphasis on foreground figures at the expense of an articulated background is common in Renoir's work, particularly in paintings of bathers, whose models would have posed in the studio, not in the open air. A piecemeal composition is suggested here, too, but with an important difference: the background, which is almost scribbled in with bright blues and greens, enhances the outdoorsy feeling, the loose brushwork standing in for a fresh ocean breeze and bracing water.

139

60 Pierre-Auguste Renoir

French, 1841–1919
Girls Picking Flowers in a Meadow c. 1890
Oil on canvas, 65.0 × 81.0 cm
Juliana Cheney Edwards Collection (39.675)

A vision of springtime: two girls in a meadow, picking flowers. Renoir's painting is so soft, in touch and color, that the viewer can be excused for not seeing at first how strictly composed it is. Set against an expanse of green and yellow (so unarticulated as to recession that it looks like a backdrop), the two girls form a triangle. This stable geometric shape has been used in figure compositions in the West since the Renaissance as a means of suggesting permanence. Just as Raphael (1484–1520) did in his many depictions of the Madonna that used this shape, Renoir knits the outline of the triangle together by pairing the girls' profiles and posing their arms in such a way that they form an echoing smaller triangle within the larger enclosing shape. The geometric form finds greater materiality in the strict vertical of the curiously short tree trunk. Such is the chromatic as well as emotional harmony of the whole, however, that logical questions – how could the tree be so short? why are there no flowers left in the meadow? – seem out of place.

Renoir also found a way to paint scenes from modern life that linked them to the history of art. *Girls Picking Flowers in a Meadow* recalls imagery from eighteenth-century France, such as the girls outdoors in François Boucher's (1703–1770) *Spring* (fig. 35). Through juxtaposition and gesture Renoir relates the sexuality of the adolescent girls to the flowering sapling. Renoir's version, with its clothed figures, may be more innocent than Boucher's, but the meaning of the season – a time of rebirth and regrowth – is still legible. Perhaps the hats the girls wear are an additional homage to the eighteenth century. Whereas the girls' dresses are simple, everyday wear, the hats are quite extraordinary. The straw hat with blue ribbons (on the left) is a complicated affair, bent and crimped into a fantastic shape, and the ruffles on the pink hat turn it into a cloud around the dark-haired girl's head. The hats are not necessarily ones that the girls themselves would have worn – Renoir may have had them made expressly for his models to pose in.[1] They suit well the atmosphere of charm and youth that the painting evokes.

1. House and Distel 1985, p. 251.

Fig. 35. François Boucher, *Spring*, 1745, oil on canvas, 100.3 × 135.6 cm. Wallace Collection, London (P445)

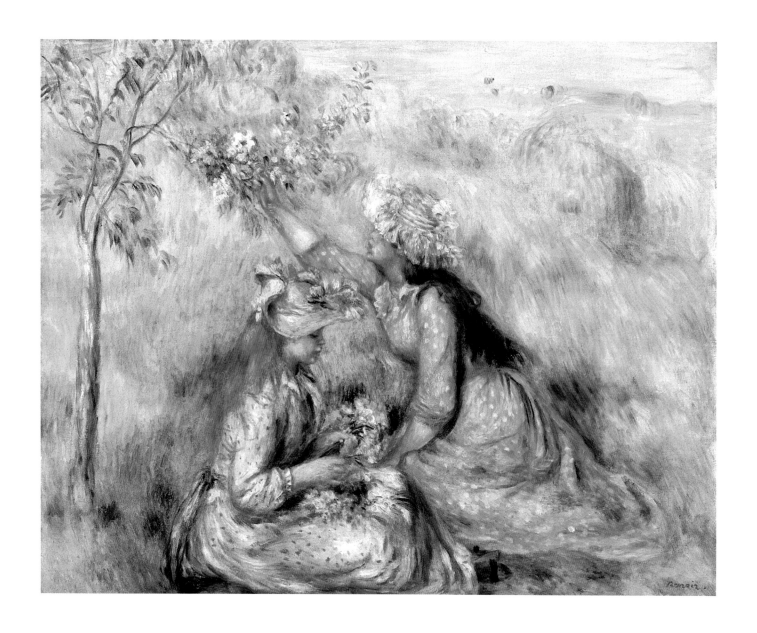

61 **Léon Augustin Lhermitte**

French, 1844–1925

Wheatfield (Noonday Rest) 1890

Oil on canvas, 53.2 × 77.5 cm

Bequest of Julia C. Prendergast in Memory of her brother, James Maurice Prendergast (44.38)

A man and a woman, exhausted from work in the wheatfields, take refuge from the sun, while a young girl brings them a canteen of water. The subdued tones of warm yellows, browns, and greens convey the day's warmth. The cool blues and grays of the shadow and the young woman's apron counter these hues. Like the Impressionists, Lhermitte painted out-of-doors. His interest in light and his use of visible unmixed brushstrokes were similar to theirs, but his primary concerns were different: he employed light as a means of defining contour and space.[1] Lhermitte uses quick, alternating brushstrokes and varies the texture of the paint. The pyramidal elements in the stacks of hay and the poses of the figures remind us of the work of his contemporaries. The loose brushwork may show an indebtedness to the Impressionists, but the asymmetrical composition and strong diagonals also recall photography, which by this date had become an accepted art form. Set in a theatrical tableau, with allusions to traditional history paintings, this scene has an implied narrative, conveyed through the emotive gestures and expressions of the figures and also by means of the anecdotal lunch pail placed in the immediate foreground.

As nineteenth-century industrialization and urban sprawl increasingly threatened the rural landscape and agrarian roots of France, such images of an unchanging countryside became increasingly nostalgic.[2] Lhermitte's painting is reminiscent of Millet's images of working and resting peasants. The elder artist's *Noonday Rest* (fig. 36), for example, shows a peasant couple sleeping in the shade of a stack of wheat. Noontime was one of the few intervals of respite in a workday that lasted from before dawn until close to sunset. Millet's depiction of a quiet, intimate moment shared by a peasant couple contains references to his own earlier pastoral compositions with mythological figures, harking back in turn to Arcadian images by Giorgione (1477/78–1510) and Titian (1488/89–1576) but renewing their themes by substituting agricultural workers for idealized figures.[3] Millet's works had a decisive influence on Lhermitte, and while Lhermitte's view of country life is more nostalgic, both artists heroize agrarian laborers and reinforce a certain bourgeois idealization of the lost innocence and healthy simplicity of rural living.[4]

Fig. 36. Jean-François Millet, *Noonday Rest*, 1866, pastel and black conté crayon on buff woven paper, 28.2 × 42.0 cm. Museum of Fine Arts, Boston, Gift of Quincy Adams Shaw through Quincy A. Shaw, Jr. and Mrs. Marian Shaw Haughton (17.1511)

1. Zafran and Piussi 1995 (from the English-language manuscript in the Art of Europe paintings files at the Museum of Fine Arts, Boston.)
2. Ibid.
3. Murphy 1984, p. 169.
4. Poulet and Murphy 1979, p. 120.

62 Paul Gauguin

French, 1848–1903

Entrance to the Village of Osny 1883

Oil on canvas, 60.0 × 72.6 cm

Bequest of John T. Spaulding (48.545)

Between the time Pissarro left Pontoise, in December 1882, and the time he settled at Éragny, in April 1884, he and his family lived in Osny, a village on the northwestern edge of Pontoise. Gauguin visited him there from June 15 to July 5, 1883, and it is likely that this painting was at least started and perhaps even finished at that time. The painting was found among Pissarro's effects after his death, when the dealer Durand-Ruel bought some canvases from Mme Pissarro. Durand-Ruel explained to John T. Spaulding, the donor of the picture to the Boston museum, that among them was "one that was unsigned which we knew was not by Pissarro but resembled a cross between Pissarro and Guillaumin."[1] Mme Pissarro made the identification. It is not surprising that the sophisticated dealer Durand-Ruel did not recognize this work as one by Gauguin, because the artist himself was very reluctant to acknowledge his early works.[2] While Pissarro was still in Pontoise, in the summer of 1881, Cézanne (who lived there at the time), Gauguin, and Guillaumin all visited him. Gauguin, as the most inexperienced of the group and an amateur (he was employed at the time by a brokerage firm), could easily have absorbed techniques from the other artists.

Entrance to the Village of Osny shows a road plunging into the village, which, like van Gogh's *Houses at Auvers* (cat. no. 66), is a mix of tile- and thatch-roofed houses. Tilled fields cover the slopes of the surrounding hills. The subject, a farming village with no discernible narrative, is very much like those Pissarro favored. The treatment, however, is not. Gauguin used a very rough canvas, which he did not cover completely with paint, evidently because he liked the resulting uneven effect. The road, which stretches the full width of the canvas, peters out; it is not clear where the figures are going. With no goal, the eye lifts to the jumble of roofs, where there is no order or design. So, too, with the fields and line of boundary trees. Gauguin's patches of color do not read as the equivalents of elements in the natural world.

Despite its weaknesses and its dependence on others' art (Guillaumin's brash color, Pissarro's small, rhythmic brushstroke), this painting by Gauguin nonetheless contains certain marks of bravado, including the unwillingness to create a legible space. The pinkish thatched roof jumps out from the overall dark green-brown and blue palette. The pink color brings out the other pinks and purples scattered throughout, colors Gauguin would use almost as signature hues in his

paintings of the South Seas. The road is a bold stroke – a wide swath of many colors. A rhythm across the canvas is established by the chimney rising from the thatched roof almost like a flame, the skinny poplar to right of center, and the mass of greenery at the right edge. These verticals, in concert with the strong horizontal of the hillcrest, keep the color patches in check and presage Gauguin's extreme pattern-making in his later works.

1. Durand-Ruel to Spaulding, January 9, 1933, Art of Europe paintings files at the Museum of Fine Arts, Boston..
2. Charles F. Stuckey, "The Impressionist Years," in Brettell et al. 1988.

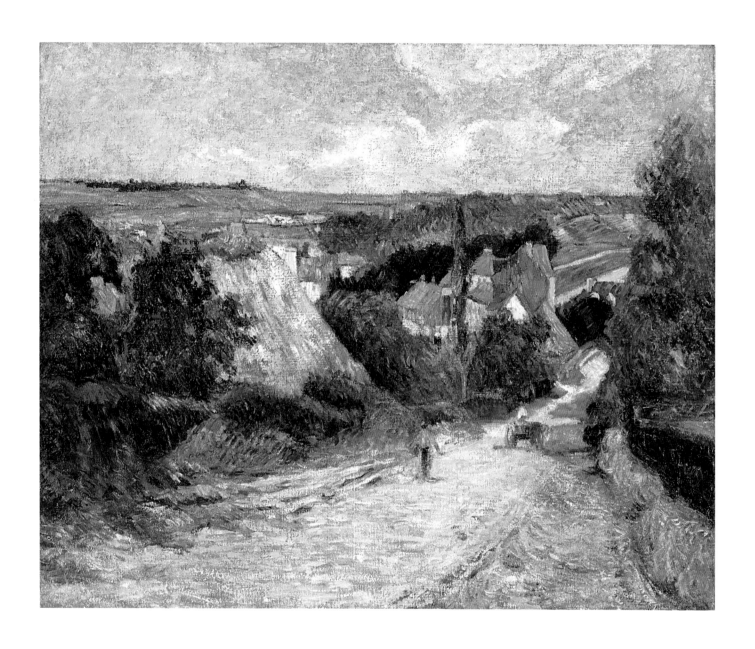

63 Paul Gauguin

French, 1848–1903

Forest Interior (Sous-Bois) 1884

Oil on canvas, 55.5 × 46.1 cm

Gift of Laurence K. and Lorna J. Marshall (64.2205)

In 1884 Gauguin moved his family to Rouen, where he hoped the cost of living would be lower than in Paris. He explored the countryside around the provincial city and found a glade in the forest, bordered by a path and a retaining wall. Tall, skinny trees, some sheathed in vines, rise from the forest floor and are framed by softer tree forms at the sides. The dark-green trees in the clearing combine with the softer forms to lend the glade a feeling of seclusion. Hot-orange pools of sunlight on the forest floor alternate with purple shadows. A peasant woman walks on the path.

Just as Monet and the other Impressionists modified the motifs and compositions of earlier artists to accord with their aesthetic goals, so did Gauguin base his early works on models of the Impressionists. *Forest Interior* can be compared with Pissarro's *Edge of the Woods* (fig. 37), a painting that had been included in the fourth Impressionist exhibition, in 1879, in which Gauguin also participated. Pissarro's palette of lush greens, enlivened by the red of roofs and bits of blue in the sky and in the clothing of the man asleep in the foreground, is tame when juxtaposed with Gauguin's vibrant greens, hot yellows and oranges, and purples. Likewise, Pissarro's brushwork – minute and fractured – seems fussy next to Gauguin's longer, fuller, and bolder strokes. The origin of Gauguin's diagonal strokes most certainly lies in the more careful facture of Pissarro and Cézanne (perhaps, in this instance, more that of Cézanne). Yet the younger artist was willing to forgo the kind of description possible with specific color, inherent in Pissarro's approach, in favor of a more decorative, unified effect. Even with the screen of trees, knitting together foreground and background, Pissarro was still careful to show how the two realms relate to one another. Not only did Gauguin not do so, but he made the break between far and near complete by using two different perspectives: one for the lower section, with the woman and the path, the other for the clearing, which rises sharply. In fact, the forest floor rises so steeply that it is almost transformed into a two-dimensional tapestry of an abstract design. Without the grounding the path provides, it would be difficult to read the painting as a depiction of the natural world.

Fig. 37. Camille Pissarro, *Edge of the Woods*, 1879, oil on canvas, 126.0 × 162.0 cm. The Cleveland Museum of Art, Gift of the Hanna Fund (51.356)

64 **Pascal Adolphe Jean Dagnan-Bouveret**
French, 1852–1929
Willows by a Stream c. 1885
Oil on canvas, 65.4 × 81.4 cm
Gift of Robert Jordan from the Collection of Eben D. Jordan (24.216)

Dagnan-Bouveret is better known for his portraits and genre scenes than for his landscapes, but this pristine, calm scene proves his ability to render nature. The painting's composition and subject matter demonstrate the influence of Corot, of whom he was a pupil. The artist depicts a solitary retreat from urban noise, waste, and industry, a setting that seems to be untouched by man. The trees cast long shadows as a final burst of warmth from the setting sun floods the left side of the image. A group of ducks frolic and feed in the water; one is upturned, perhaps nibbling beneath the surface. Nearby, butterflies flutter in a cluster. These details contribute to the sense of a suspended moment in time and lend to the work an affinity with Corot's *Souvenirs* and the idyllic scenes of other Barbizon painters such as Diaz. In *Willows by the Stream*, the animals take the place of the peasants and mythological figures that populate Corot's and Diaz's canvases.

Willows by a Stream is painted with Dagnan-Bouveret's characteristic delicacy and precision, which resulted from his special interest in optical verisimilitude and a kind of photographic naturalism. Perhaps in response to modern theories of color – which in turn derived from the theories of Eugène Delacroix – Dagnan-Bouveret juxtaposes hues of yellow-green and reddish-brown, and adds strokes of pigment mixed with red or white to increase the warmth of the scene. The painter's interest is in recording light and time and in juxtaposing a variety of values and tones, hues and textures. In spite of these modern influences, however, the painting remains an evocation of unspoiled nature, richly poetic.

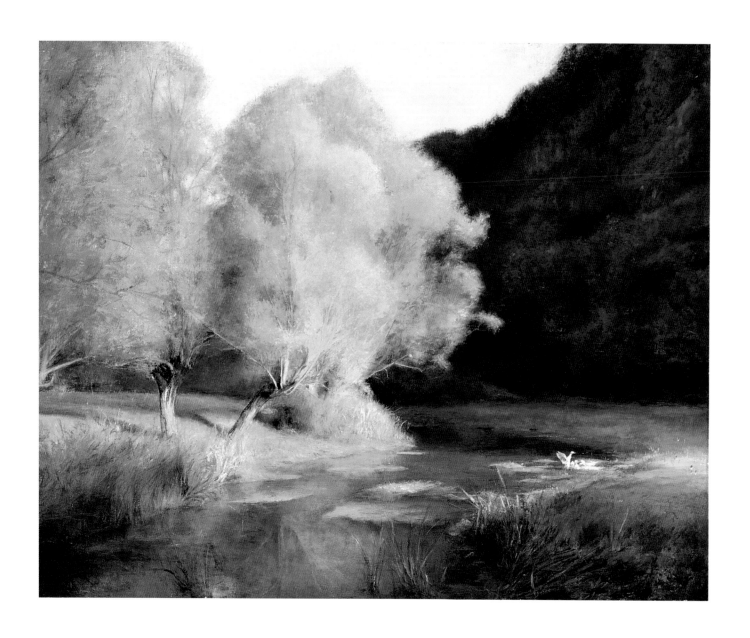

65 Vincent van Gogh

Dutch (worked in France), 1853–90

Enclosed Field with Ploughman October 1889

Oil on canvas, 53.93 × 64.51 cm

Bequest of William A. Coolidge (1993.37)

In the context of nineteenth-century French landscape painting, the subject of this scene is unremarkable – a man plowing a field with the aid of two horses. This painting's agrarian theme allies it to a long line of similar works that extol the virtue of hard, honest labor and the simplicity and integrity that come from living close to the land.[1] Although van Gogh's awareness of the tradition informs his work, the specific circumstances of the genesis of this painting are also important.

At the end of February 1889, following a public protest over the artist's increasingly erratic behavior, van Gogh was taken to an asylum outside Saint-Rémy, near Arles, in the South of France. After a short interval on his own, he asked to be readmitted. During most of the period that he spent in the asylum, until May 1890, he did not suffer from the terrifying and debilitating epileptic seizures that occasioned his hospitalization. From time to time he was allowed outside the grounds to paint, and painting, he felt sure, would help him get well. He told his brother Theo: "Work distracts me infinitely better than anything else, and if I could once really throw myself into it with all my energy, possibly that would be the best remedy."[2]

Van Gogh also worked inside the asylum. *Enclosed Field with Ploughman* shows the view from the artist's room (though the windmills seem to have been imported from nearby Arles). Writing to Theo in late August or early September, he reported the beginnings of the painting: "Yesterday I began to work a little again – on a thing that I see from my window – a field of yellow stubble that they are plowing, the contrast of the violet-tinted plowed earth with the strips of yellow stubble, background of hills."[3] The view onto the field from the window is, of course, elevated. Looking down yet also out at it has the effect of giving the picture at least two perspectives. The foreground, in taupes, browns, and light blues, with the bright green in the lower right, has more varied brushstrokes. Lines intersect at different angles and there are squiggles and circles interspersed, as if to describe the various textures to be seen close at hand.[4] The field, farther away, smooths out into long, parallel, and striated ribbons of yellows and ochers, blues and yellows.

While van Gogh was at the asylum at Saint-Rémy, he was increasingly intrigued by the work of earlier artists. He collected reproductions after drawings by his hero, Jean-François Millet, as well as works by Eugène Delacroix (1798–1863), Honoré Daumier (1808–1879), and Rembrandt van Rijn (1606–1669). It is the spirit of Millet that informs this painting of a peasant working. Van Gogh explained his affinity for people who work the land: "Though I saw Paris and other big cities for many years, I keep looking more or less like a peasant … and sometimes I imagine I also feel and think like them, only peasants are of more use in the world…. Well, I am plowing on my canvases as they do on their fields."[5]

1. See Rosa Bonheur's *Ploughing in the Nivernais,* 1849 (Musée d'Orsay, Paris).
2. Van Gogh 1958, vol. 3, p. 195.
3. Ibid.
4. A similar effect is seen in Millet's *Priory at Vauville, Normandy* (cat. no. 14).
5. Van Gogh 1958, vol. 3, p. 226, as quoted in Debora Silverman, "Weaving Paintings: Religious and Social Origins of Vincent van Gogh's Pictorial Labor," in Roth 1994, p. 164.

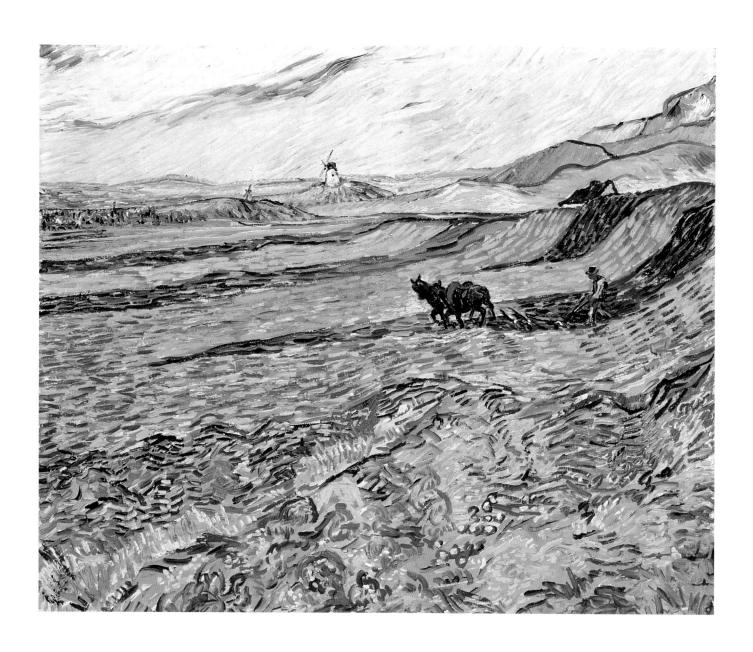

66 Vincent van Gogh

Dutch (worked in France), 1853–90

Houses at Auvers 1890

Oil on canvas, 75.5 × 61.8 cm

Bequest of John T. Spaulding (48.549)

Van Gogh left the South of France in May 1890. He settled in Auvers, near the river Oise, where Dr. Gachet, an eccentric physician and art collector, lived. At Pissarro's urging, Gachet promised van Gogh's brother Theo that he would look after the painter. Van Gogh was not the first artist to paint in Auvers. Auvers is close to Pontoise, an area in which Pissarro had worked happily some years earlier; Cézanne visited Pissarro there and was encouraged by him to paint outdoors. The region's artistic heritage was therefore rich, but van Gogh may have valued it more for its proximity to his brother and young family in Paris and for its enabling him to live on his own. There was much to interest the artist, including the older cottages and newer houses, the surrounding rich fields, the flowers, the church (mentioned in guidebooks of the time), and the sympathetic Dr. Gachet himself.

Van Gogh has painted a sunny day in June or July, with puffy white clouds in a blue sky. Like paintings by Pissarro, this one shows a peaceful village integrated into the surrounding countryside: the thatched roofs help tie together the man-made and natural worlds. In his very first letter to Theo from Auvers van Gogh noted that thatched roofs were "getting rare."[1] His concentration on the roof in the left foreground evinces his fondness for the old-fashioned material. Certainly compared with the red and green tiled roofs, the thatched one is richer, nuanced, and more subtle.

The thick strokes of paint overall, but particularly in the thatched roof, can be likened to colored threads. Van Gogh had a box containing balls of yarn that he manipulated to create and observe the resulting color harmonies. He thought of himself as an artisan, a craftsman.[2] His careful application of paint was an attempt to ally his work with that of other craftspeople. His color and touch were put at the service of suggesting surfaces; tile roofs are painted differently from thatch, bricks differently from plaster. Likewise, puffy clouds receive individual treatment, and fields are differentiated from trees. Van Gogh gave each motif its due.

1. Van Gogh 1958, vol. 3, p. 273.
2. See Debora Silverman, "Weaving Paintings: Religious and Social Origins of Vincent van Gogh's Pictorial Labor," in Roth 1994, pp. 137–68, 465–73, especially pp. 163–68.

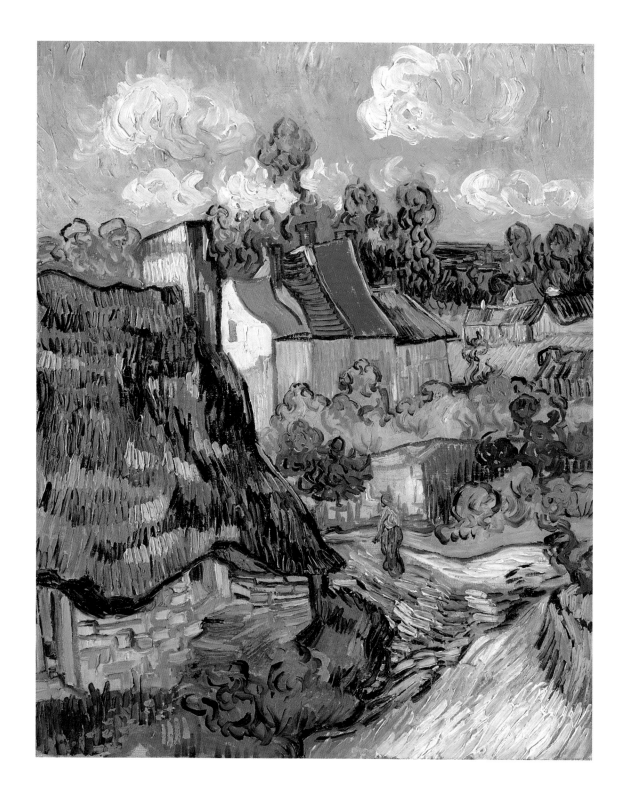

67 Maxime Maufra

French, 1861–1918

Departure of Fishing Boats, Yport 1900

Oil on canvas, 54.1 × 65.2 cm

John Pickering Lyman Collection (19.1316)

Maufra, like many other artists in this exhibition, was attracted to the simple but always challenging genre of the seascape. Here he painted Yport, between Étretat and Fécamp in Normandy, an area that had already been explored by Isabey, Monet, and Jongkind, among others. Maufra tried to distill the essence of a scene when painting; catching a fleeting impression was not his goal. Rather, as he explained in a letter to a friend: "I seek the broad horizons, the skies! Then too I would like landscapes to be classic, simple, and immense; but all of that is so difficult. Drawing, drawing, that's everything; color needs to be naturally instinctual, that is to say harmonious."[1] The rocky grass-covered cliff looming up from the strip of beach has been simplified to a rounded, benign shape. Like the cliff, the boats have been firmly drawn in, black hulls with bright stripes of pink, yellow, and green. The English Channel seems immense, its size hinted at by the gradual smoothing of its waters toward the distant horizon, which appears as the simplest line of all, drawn to separate the elements. Closer to the French shore, the water is depicted with discrete marks into whose interstices are fitted the darker strokes that demarcate the reflections of the boats.

From 1896, Maufra was under contract to Durand-Ruel, who was able to find buyers for the hundreds of pictures that Maufra painted. For instance, the dealer bought this example in 1900, the year it was made, and sold it from the New York office in 1906. By that date the public had become accustomed to the bright colors and visible brushwork used so defiantly by Monet and his contemporaries forty years earlier. Maufra's essentially synthetic style blended these now common aspects of Impressionism with the stylizations favored by Gauguin's followers, seen here in the arabesques traced by the blue-violet clouds in the yellow-orange sky. In addition, the comparatively large amount of canvas left uncovered by paint, particularly in the soft-green water, adds a pleasing element of texture and depth.

1. Maufra to Victor-Émile Michelet, Saint-Michel-en-Grève, c. 1897, quoted in Michelet 1908, p. 48.

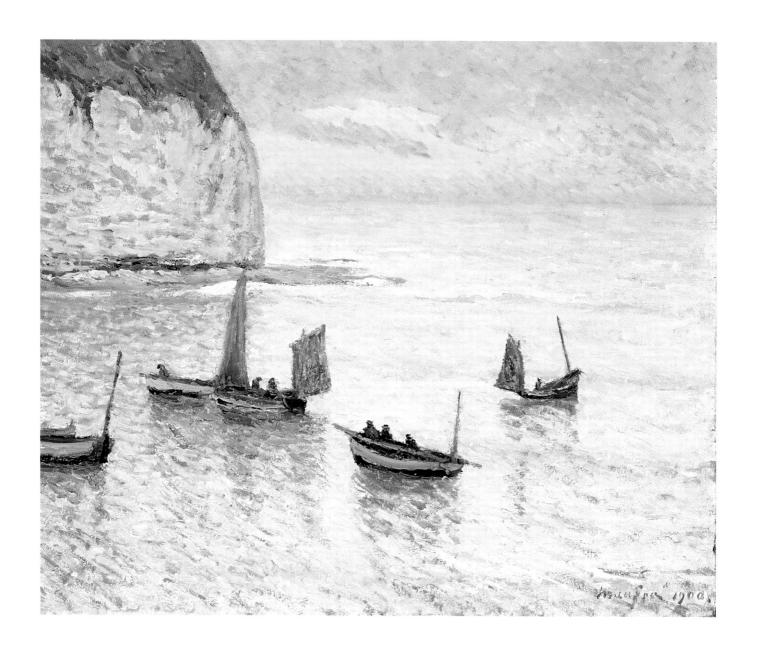

68 **Henri Le Sidaner**

French, 1862–1939

Grand Trianon c. 1905

Oil on canvas, 70.5 × 94.5 cm

Bequest of Katherine Dexter McCormick (68.567)

An unearthly quiet emanates from this painting by Le Sidaner. It shows, simply, the Grand Trianon in the gardens of the palace at Versailles and the basin of a fountain. The park is merely suggested at the right. The time is dusk. The setting sun strikes the windows and the capitals of the pilasters, making them glow. In mysterious response, the spaces between the balustrades on the roof also glow. Rounded forms – the arches of the windows, the three bushes, and the basin's curve – balance the linearity of the architecture with its insistent cornice, while the greens, blues, and purples in the water complement the hotter pink-mauve of the building. Le Sidaner's close focus on the building and his simplification of the fenestration (there are in fact eight rows of panes below the crowning arch) force the viewer to concentrate on the surface of the painting, the play of straight and curved lines, the variegated brushwork.

Le Sidaner often went to Versailles to paint. He chose as his subjects the smaller structures of the park rather than the overwhelming main palace. Although the Grand Trianon is not small, Le Sidaner has made it seem so by painting only one end of it. Built by Jules Hardouin-Mansart for Louis XIV in 1687 – of white stone and pink marble – it was used for festivities to honor the royal family. After a century of neglect, Napoleon had it restored in 1805 (the furnishings had been sold during the French Revolution). Louis-Philippe, during his reign from 1830 to 1848, often stayed there with his family. It was not used again until 1962, when Charles de Gaulle undertook a massive renovation so that he could honor foreign heads of state in the magnificent rooms. When Le Sidaner painted the Grand Trianon, the building had not seen life for more than fifty years.

Many of Le Sidaner's paintings assume the character of portraits of buildings, devoid of humans but, by their very essence as made objects, testimony to the human hand. The windows and doors are portals through which one may look, whether from the outside in, as here, or from the inside out. Yet the view from the outside is often blocked – by reflections, acute angles, or darkness – so that the viewer is shut out. The windows' nacreous gleam arouses the feeling that something – the building, or some spirit or memory inhabiting it – is alive. A contemporary of the artist described the mood Le Sidaner's paintings evoke:

[Le Sidaner] may be described as a mystic who views the world with an air of detachment, standing aloof from the distractions of its inhabitants. He prefers an environment breathing some vague and undefined sorrow. The joy of life does not course through his veins.[1]

1. Dewhurst 1904, p. 81. The same lonely mood can be found in the contemporaneous works of the Danish painter Vilhelm Hammershøi (1864–1916).

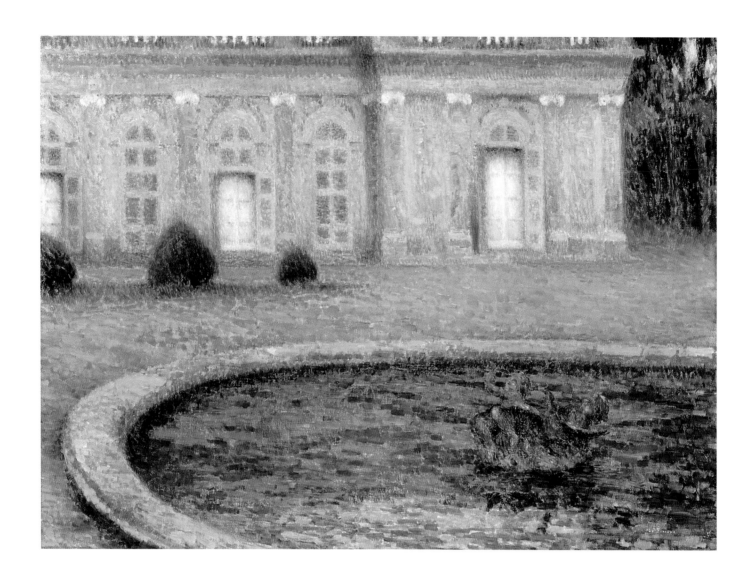

69 **Paul Signac**

French, 1863–1935

View of the Seine at Herblay late 1880s

Oil on canvas, 33.2 × 46.4 cm

Gift of Julia Appleton Bird (1980.367)

Signac was an admirer of Monet's paintings, and like Monet he was attracted to sites on the water. Yet he did not live at Herblay, close to where the Seine meets the Oise, nor did he map the region in a series of paintings, as Sisley did with Saint-Mammès and Monet did with Argenteuil, Giverny, and Vétheuil. The configuration of the town is seen more clearly in a panoramic view (fig. 38). Rising in steps are bathhouses or washhouses, moored in the river; houses looking out over the water; and, thrusting above the crest of the hill, the tower of a church.[1] In the Boston painting the view is seen from a position under a tree whose branches hang over the water. The village seems to dissolve in color and light. Barely articulated, it looks bleached and isolated.[2]

Signac's divisionism, or pointillism, a method of painting in small, separate dots of color, which he adopted from his friend Georges Seurat (1859–1891), is put to good use here. Divisionism was developed as a way of applying the scientific analysis of color to painting, so that color would have as much brilliance as possible. An example can be seen in the reflection of the foliage, where orange and blue, opposites on the color wheel, are juxtaposed so that they vibrate to best advantage. Paintings done in this manner often look as though a veil has been dropped over the scene. Each small touch of color, no matter how vivid, necessarily denies the possibility of large areas of hue. Even in this painting, with its fairly large oblong strokes and concentration of midnight blue in the overhanging foliage and its reflection, the individual brushstrokes make the scene scintillate before our eyes.

It was thought that in its application of scientific principles to painting divisionism would depersonalize art, removing from it the subjective, expressive element. This was not to be. Signac's brushwork, appearing in some places as dots and in others as oblongs or sketchy strokes, shows how he responded in different ways to the light reflecting off various surfaces. A particularly lovely passage is in the foliage, where blossoms shimmer against the dark-blue leaves – or is it sunlight that has coagulated there, quivering? The brushwork in *The Seine at Herblay* (fig. 38) is more controlled, less spontaneous, and more truly divisionist. This is not to say that the painting in Boston is an unmediated response to nature; pencil lines carefully demarcate the shoreline and the crest of the hill. But despite the pencil lines, the premeditated use of color opposites, and the light-gray priming left bare to provide a sense of transparency and depth as well as

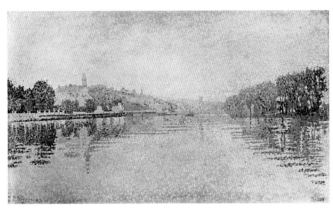

Fig. 38. Paul Signac, *The Seine at Herblay*, 1889, oil on canvas, 33.0 × 55.0 cm. Musée d'Orsay, Paris. © Photo R.M.N.

a mid-tone that mutes the contrast of colors, Signac allowed himself the luxury of painterly touches. These are in evidence in the already mentioned brushy reflection and in the more thickly painted farther hill, where no dots can be seen. Perhaps the Boston picture was done on the spot, and *The Seine at Herblay* indoors, where the relative freedom of plein-air work was replaced by the intellectual rigor of the studio.

1. For another view of Herblay by Signac, see *Sunset at Herblay* (1889–90, oil on canvas, 58.5 × 90.0 cm, Glasgow Art Gallery and Museum).
2. The painting was identified by Murphy (1985, p. 263) as showing Vétheuil, undoubtedly because the church tower so closely resembles that at Vétheuil. However, the church at Vétheuil is on a level with the riverbank, not on a slope, as at Herblay.

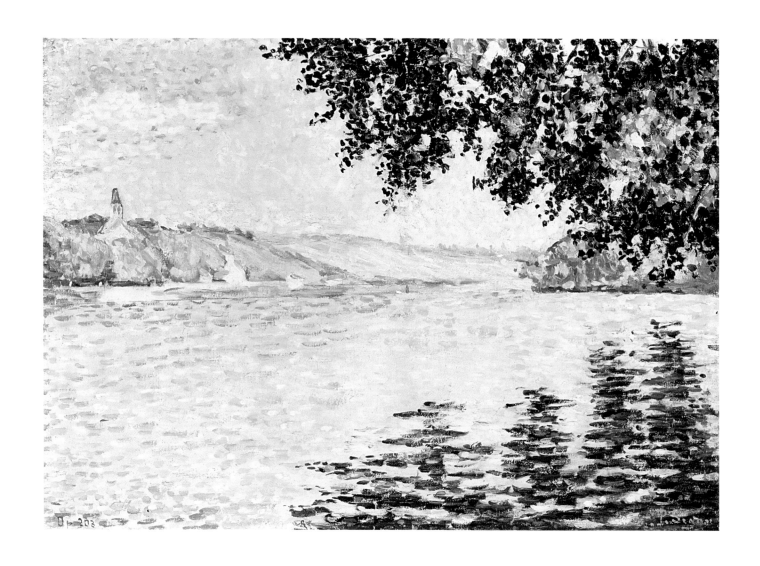

70 Paul Signac

French, 1863–1935

Port of Saint-Cast 1890

Oil on canvas, 66.0 × 82.5 cm

Gift of William A. Coolidge (1991.584)

Port of Saint-Cast belongs to one of two series, each consisting of four paintings, that were exhibited in 1891 in Brussels and Paris under the group titles "Le Fleuve" (The River) and "La Mer" (The Sea). Claude Monet, who earlier had begun working on his Creuse Valley and Belle Isle series, may have provided the inspiration for these landscapes by Signac.[1]

Geometric order and mathematical harmony are embedded in the painting. Signac makes use of color, points of light, and gradations of tonality to reduce the natural world to pattern within the pictorial world. Yet while he adheres to a traditional nature-based subject, the pictorial representation in Signac's divisionist style borders on the abstract. In *D'Eugène Delacroix au néo-impressionnisme*, the artist stated:

> The Neo-Impressionist does not paint with dots. He divides … [which] is a way of securing all the benefits of brightness, color, and harmony by the optical mixture of … pure pigments (all the hues of the prism and all their tones); by the separation of the … elements; and the balance and proportion of these elements in accordance with the laws of the contrast, gradation, and irradiation; [and] by the choice of brushstroke which fits to the size of the painting.[2]

Signac also adhered to the theories propounded by Michel Eugène Chevreul (1786–1889) on the scientific use of colors. Chief among these was Chevreul's law of simultaneous contrast of colors: the contrast of entire areas of opposing hues, the juxtaposition of dabs of complementary colors, or the placement of another color on an area of a pure color in order to produce a visual vibration.[3] Signac's use of all three of these methods is demonstrated in *Port of Saint-Cast*. The systematically organized composition is as contrived as the technique. Several diagonals take the viewer through the painting: from the lower left, the shoreline leads to the reflection of the hill, which in turn leads to the bluff; together with the sliver of a promontory on the left, the tip of the large hill points toward the sailing vessels, whose forms rhyme with those of the town on the far shore.

The small, meticulously placed brushstrokes, juxtaposing primary and secondary colors, result in a fluctuating visual resonance and evoke the physical and visual textures found in nature, from the graininess of the sand to the shimmering reflections on the water. The influence of Japanese woodblock prints is detectable in the flattened picture plane and in the expansive areas that give the appearance of being unified colors. Signac, along with others who were dissecting the visual world into its fundamental components of color and light, would come to influence the modernist theories of the Fauves, championed by his friend and follower Henri Matisse (1869–1954).

1. Sutton 1995, p. 98.
2. Paul Signac, "From Delacroix to Neo-Impressionism," translated in Ratcliff 1992, p. 207.
3. See Michel Eugène Chevreul, *The Principles of Harmony and Contrast of Colors, and Their Applications to the Arts*, 3rd. ed., translated by Charles Martel (London, 1870, 1899).

P. Signac 30 Op. 203

Monet Renoir and the Impressionist Landscape

Documentation

Camille Corot

Paris 1796–1875 Paris

After showing a lack of interest in being a businessman, Corot was given money by his parents to devote himself to painting. He studied in the ateliers of Jean-Victor Bertin (1767–1842) and Achille-Etna Michallon (1796–1822). From 1825 to 1828 he visited Italy. There he painted small studies out-of-doors, something he had already been doing in France. He enjoyed a successful Salon career, showing in every exhibition from 1827, ending with the posthumous presentation of his works at the Salon of 1875. Until about 1850 he showed composed landscapes, often with subjects drawn from the Bible or classical mythology. After mid-century he developed a softer style, with diaphanous foliage and indeterminate subject matter. This poetic or lyrical style, as it was often characterized, became extremely popular.

Corot was an inveterate traveler, returning to Italy in 1834 and again in 1843, and visiting Switzerland, the Netherlands, and England. During the winter months he stayed in Paris, working in his studio, but in the summers he crisscrossed northern France, staying with his many friends and painting out-of-doors. He was a close friend of Jean-François Millet and of Charles-François Daubigny. Antoine Chintreuil and François-Louis Français considered themselves his pupils, and he counseled Camille Pissarro and Berthe Morisot (1841–1895). Being of an older generation, and with a classical bent, Corot never understood the painterly means of the Impressionists, although his insistence on transferring to canvas his impressions of nature allied him to the younger painters.

1 *Morning near Beauvais* c. 1855–65
Oil on canvas, 36.0 × 41.5 cm
Juliana Cheney Edwards Collection (39.668)

Provenance
John Saulinier, Bordeaux, until 1886; Saulinier sale, Escribe, Hôtel Drouot, Paris, June 5, 1886, no. 21, called *Paysage: Matinée environs de Beauvais*; Boussod Valadon et Cie., Paris, 1886, no. 2717; Knoedler & Co., London, June 1, 1901, no. 9546, called *Prairie boisée près ruisseau*; F. Isman, Philadelphia, July 31, 1903; Knoedler & Co., New York, December 1903; Robert J. Edwards (d. 1924), Boston, December 31, 1906, called *The Brook in the Woods*; Hannah Marcy Edwards (d. 1931), Boston, 1906; Grace M. Edwards (d. 1939), Boston, 1931; bequeathed by Hannah Marcy Edwards to the Museum of Fine Arts, Boston, October 11, 1939.

Selected Exhibitions
1886 Paris, *Maîtres du siècle*, no. 45.
1939–40 *Juliana Cheney Edwards Collection*, no. 4.
1972 Providence, R.I., Rhode Island School of Design, February 3–March 5, *To Look on Nature*, no. 35.
1979–80 *Corot to Braque*, no. 7.
1989 *From Neoclassicism to Impressionism*, no. 18.
1992 *Crosscurrents*.
1992–93 *Monet and His Contemporaries*, no. 2.

Selected References
Bulletin of the Museum of Fine Arts (Boston), vol. 37, no. 224 (December 1939), p. 98, no. 4; Murphy 1985, p. 60; Robaut 1905, vol. 2, p. 310, no. 1012.

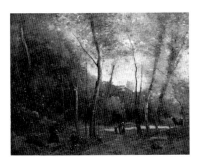

2 *Souvenir of a Meadow at Brunoy* c. 1855–65
Oil on canvas, 90.6 × 115.9 cm
Gift of Augustus Hemenway in Memory of Louis and
Amy Hemenway Cabot (16.1)

Provenance
Louis Latouche, Paris, by 1875, called *Chemin de village*; Seth M. Vose,
Westminster Gallery, Providence, R.I., by 1882 (?); Mrs. Augustus Hemenway,
Boston, by 1887; Louis and Amy Hemenway Cabot, Boston; Augustus
Hemenway, Milton, Mass.; given by Augustus Hemenway to the Museum of
Fine Arts, Boston, 1916.

Selected Exhibitions

1875	Paris, École Nationale des Beaux-Arts, *Corot*, no. 193, called *Chemin de Village*.
1878	Paris, Durand-Ruel, *Maîtres Modernes*, no. 120.
1890	Boston, Museum of Fine Arts, *Loan Exhibition*.
1915	Boston, Museum of Fine Arts, from February 3, *Evans Memorial Galleries Opening Exhibition*.
1940	San Francisco, *Golden Gate International Exhibition*, no. 245.
1953–54	New Orleans, Isaac Delgado Museum of Art, October 17, 1953–January 10, 1954, *Masterpieces of French Painting through Five Centuries, 1400–1900*, no. 63.

Selected References
Bulletin of the Museum of Fine Arts (Boston), vol. 14, no. 81 (February 1916),
p. 4; Durand-Gréville 1887, p. 67; Edgell 1949, p. 11; Murphy 1985, p. 58;
New England Magazine 1892, no. 6, p. 700; Robaut 1905, vol. 3, p. 380,
no. 2417, vol. 4, pp. 276, 281.

3 *Bacchanal at the Spring: Souvenir of Marly-le-Roi* 1872
Oil on canvas, 82.1 × 66.3 cm
Robert Dawson Evans Collection (17.3234)

Provenance
Émile Gavet, Paris, 1872; Brun, Paris, by 1875; Marquis Fressinet de Bellanger,
Paris, no. 79; Galeries Georges Petit, Paris, 1875 (?); Arthur Tooth and Sons,
London and New York, 1875; H. S. Henry, Philadelphia, March 1898; Henry
sale, *Paintings of the Men of 1830*, American Art Association, New York,
January 25, 1907, no. 4; Robert Dawson Evans (d. 1909), Boston, January 25,
1907; Mrs. Robert Dawson Evans (Maria Antoinette Hunt, d. 1917), Boston,
1909; Abby Hunt and Belle Hunt, Boston, 1917; bequeathed by Mrs. Robert
Dawson Evans to the Museum of Fine Arts, Boston, November 1, 1917.

Selected Exhibitions

1875	Paris, École Nationale des Beaux-Arts, *Corot*, no. 12.
1895	Paris, Palais Galliéra, *Centenaire de Corot*, no. 79.
1908	Boston, Copley Society, *French School of 1830*, no. 15.
1914	New York, *The Men of 1830* (catalogue by Robert J. Wickenden), no. 4.
1915	Boston, Museum of Fine Arts, from February 3, *Evans Memorial Galleries Opening Exhibition*.
1916	Cleveland, The Cleveland Museum of Art, *Inaugural Exhibition*, no. 9.
1940	New London, Conn., Lyman Allen Museum, Connecticut College, November 17–December 15.
1942	New York, Wildenstein Galleries, *The Serene World of Corot*, no. 68.
1946	Philadelphia, Philadelphia Museum of Art, *Corot*, no. 74.
1960	Chicago, The Art Institute of Chicago, October 5–November 13, *Corot*, no. 135.
1962–63	San Francisco, Palace of the Legion of Honor, September 24–November 4, 1962; Toledo, Ohio, The Toledo Museum of Art, November 20–December 27, 1962; Cleveland, The Cleveland Museum of Art, January 15–February 24, 1963; Boston, Museum of Fine Arts, March 15–April 28, 1963, *Barbizon Revisited* (catalogue by Robert L. Herbert), no. 18.
1972	New York, Shepherd Gallery, April 21–June 10, *The Forest of Fontainebleau: Refuge of Reality*.

Selected References
Fosca 1930, no. 87; Moreau-Nélaton 1924, vol. 2, p. 53, fig. 227; Murphy
1985, p. 59; Robaut 1905, vol. 2, pp. 53–54, no. 97, vol. 3, p. 330, no. 2201,
vol. 4, pp. 269, 291; Roger-Milès 1896, no. 39.

Paul Huet

Paris 1803–1869 Paris

Huet was apprenticed at a young age to a painter (some sources give his name as Deltil) who taught him about landscape. He learned portraiture and history painting from Pierre-Narcisse Guérin (1774–1833), with whom he studied in 1818, and from Baron Antoine-Jean Gros (1771–1835), who was his teacher from 1819 to 1822. He cast aside traditional teachings in favor of the color and freshness of the English painter Richard Parkes Bonington (1802–1828), whom he met in 1820 and with whom he worked in Normandy. About the time he met Eugène Delacroix (1798–1863), in 1822, he made his first studies in the Forest of Compiègne. An exponent of the emotive strain of landscape painting, Huet was known for his dramatic scenes, often with stormy skies and with structures symbolic of France's past, such as the château at Pierrefonds.

Poor health, both his wife's and his own, was the reason for repeated visits to the South of France (1833, 1838–41, 1844–45) and Italy (1841–43). He also traveled elsewhere, notably to London (1862) and the Low Countries (1864–65). He first exhibited at the Salon in 1827 and won medals in 1833, 1848, and 1855. Despite his republican leanings, the State made regular purchases of Huet's somewhat old-fashioned landscapes. The artist's less public works, made on the English Channel coast or in the forests of Compiègne and Fontainebleau, demonstrate his alliance with such painters as Théodore Rousseau, Constant Troyon, and Camille Corot.

4 *Landscape in the South of France* c. 1838–39
Oil on paper mounted on panel, 35.6 × 51.7 cm
Fanny P. Mason Fund in Memory of Alice Thevin (1987.257)

Provenance
Paul Huet collection, Paris, until April 15, 1878; Huet sale, Paris, April 15–16, 1878; Durand-Ruel, Paris, 1878; private collection, Paris (?), after 1878; Galerie de la Scala, Paris, by 1986; purchased from Galerie de la Scala by the Museum of Fine Arts, Boston, 1987.

Eugène Isabey

Paris 1803–1886 Montévrain (Seine-et-Marne)

The son of Jean-Baptiste Isabey (1767–1855), a miniaturist and court painter to Napoleon, Eugène Isabey began exhibiting at the Salon in 1824, when he won a first-class medal. This auspicious beginning set the stage for his career. He exhibited regularly at the Salon until 1878 and was, in his turn, a court painter to Louis-Philippe (reigned 1830–48). In this role Isabey commemorated historical and diplomatic events. As a painter of landscape, he was drawn to the Normandy coast, traveling its length and painting its various ports his whole life. It is likely that in 1825 he went to England with Eugène Delacroix (1798–1863) and Richard Parkes Bonington (1802–1828), from whom he adopted fresh colors and easy brushwork in his depiction of marine subjects. In 1828 he painted in Normandy with Paul Huet. The mid-1840s were important years for the future of French landscape painting, and Isabey was a crucial participant in the changes that took place at that time. In 1844 he met Eugène Boudin, who exhibited Isabey's work in his frame shop in Le Havre. In 1846, on a trip to the Netherlands, Isabey met Johan Barthold Jongkind, who became his pupil when the Dutchman moved to Paris later that year. Isabey is also known for his lithographs (on which he concentrated from 1828 to 1835) and for his luminous watercolors.

5 *Harbor View* c. 1850
Oil on canvas, 33.3 × 47.9 cm
The Henry C. and Martha B. Angell Collection (19.101)

Provenance
Doll and Richards, Inc., Boston, until 1882; Doll and Richards, Inc., sale, Boston, March 23–24, 1882, no. 35, called *Entrance to a Port*; Louis Ralston, Boston, until 1904; Dr. Henry C. Angell (d. 1911), Boston, 1904; Martha B. Angell (d. 1919), Boston, 1911; given by Martha B. Angell to the Museum of Fine Arts, Boston, May 5, 1919.

Selected Exhibitions
1952 Hartford, Conn., Wadsworth Atheneum, *The Romantic Circle*.
1967 Cambridge, Mass., Fogg Art Museum, Harvard University, *Eugène Isabey*, no. 4.
1989 *From Neoclassicism to Impressionism*, no. 13.
1990 Boston, Museum of Fine Arts, *Boudin in Boston*.
1991 Salem, Mass., Peabody Museum, May 17–September 16, *Eugène Boudin* (catalogue by Peter C. Sutton), no. 1.
1992–93 *Monet and His Contemporaries*, no. 4.

Selected References
Miquel 1980, no. 540; Murphy 1985, p. 136.

Narcisse Virgile Diaz de la Peña

Bordeaux 1808–1876 Menton

Diaz's began his career working in a porcelain factory, and he soon left the factory to establish himself as an independent painter. His orientalizing genre subjects were very popular, and he painted many works that he sold for small sums. The mid-to-late 1830s were decisive years in his development: he began painting in the Forest of Fontainebleau, where he met Théodore Rousseau, whose style influenced him greatly. Diaz combined his natural tendency toward the depiction of genre figures such as gypsies, bathers, and mythological characters with a devotion to the honest depiction of landscape. He won great popularity, received medals, and was elected to the Légion d'Honneur. He was able to sell everything he painted, and his economic success allowed him to help less fortunate colleagues, including Rousseau, Jean-François Millet, and Johan Barthold Jongkind.

Diaz represents an important link in the history of French art. The subject matter of his figural works looks back to the eighteenth century and the *fête galante*. He was particularly fond of Pierre-Paul Prud'hon (1758–1823) and the Renaissance master Correggio (Antonio Allegri, c.1489–1534), and their softened contours can be seen in his work. He brought scenes of the Forest of Fontainebleau to the Salon and made them available for popular consumption. And he met Alfred Sisley, Claude Monet, Pierre-Auguste Renoir, and Frédéric Bazille (1841–1870) near Barbizon in 1863. The younger artists understood the importance of his warm colors and individual brushstrokes. After years of living in Barbizon, he moved to Menton, on the Riviera, where he died.

Provenance

Paul Périer collection, Paris, until 1846; Périer sale, Bonnefons, Paris, December 19, 1846, no. 4; M. A. Mosselman collection, Paris, December 19, 1846; Mosselman sale, Rolin, Paris, December 4, 1849, no. 86; Getting; Mme André Édouard; with Arnold and Tripp, Paris; with Laurent-Richard, Paris, 1868–73; Laurent-Richard sale, Paris, April 7, 1873; Viot, Paris, 1873; Viot sale, Paris, 1886; Mrs. Samuel Dennis Warren (d. 1901), Boston, by 1893; Miss Susan Cornelia Warren, Boston, 1901; Warren sale, American Art Association, New York, January 8, 1903, no. 113; Samuel Putnam Avery (d. 1904), New York, January 8, 1903 (purchased from the Warren sale on behalf of the Museum of Fine Arts); purchased by the Museum of Fine Arts, Boston, June 13, 1903.

Selected Exhibitions

1844	Paris, *Salon*, no. 553.
1871	Paris, École Nationale des Beaux-Arts, *Diaz de la Peña*, no. 6.
1893	Chicago, *World Columbian Exposition*, no. 2913.
1897	Boston, Copley Society, *One Hundred Masterpieces*, no. 24.
1901	Boston, St. Botolph Club, no. 17.
1902	Boston, Museum of Fine Arts, *Special Exhibition of Paintings from the Collection of the Late Mrs. Samuel Dennis Warren*, no. 35.
1962–63	San Francisco, Palace of the Legion of Honor, September 24–November 4, 1962; Toledo, Ohio, The Toledo Museum of Art, November 20–December 27, 1962; Cleveland, The Cleveland Museum of Art, January 15–February 24, 1963; Boston, Museum of Fine Arts, March 15–April 28, 1963, *Barbizon Revisited* (catalogue by Robert L. Herbert), no. 38.
1965	Indianapolis, Herron Museum of Art, February 21–April 11, *The Romantic Era: Birth and Flowering, 1750–1850*, no. 48.
1979–80	*Corot to Braque*, no. 10.
1995	*The Real World*, no. 10.

Selected References

Ballu 1977, pp. 294, 298; Boston 1921, p. 96; Bouret 1972, p. 105; Bouret 1973, pp. 105, 122; *Charivari* 1844, pp. 1–2; Claretie 1875, p. 17; Claretie 1876, pp. 26–27; Constable 1955, p. 19; Durbe and Damigella 1967, p. 19, no. 28; Grate 1959, p. 207; La Farge 1903, pp. 128–29; La Farge 1908, p. 119; Mollet 1890, pp. 97, 124, appendix; Murphy 1985, p. 82; Silvestre 1856, p. 225; Silvestre 1878, p. 219; Stranahan 1888, p. 253; Tomson 1905, pp. 161–62; Wolff 1883, p. 35.

6 *Bohemians Going to a Fête* c. 1844
Oil on canvas, 101.0 × 81.3 cm
Bequest of Susan Cornelia Warren (03.600)

Constant Troyon

Sèvres 1810–1865 Paris

Troyon was one of many nineteenth-century painters who was trained as a porcelain decorator (Narcisse Virgile Diaz de la Peña and Pierre-Auguste Renoir were others). Although he exhibited successfully at the Salon from 1833 with conventional landscape subjects, he was encouraged by Théodore Rousseau and Paul Huet, whom he met in 1843, to paint more directly. Since Troyon had already been painting out-of-doors, this advice was validation. Critical to Troyon's career was a trip he made to the Netherlands in 1847. In Amsterdam he saw the animal paintings of Albert Cuyp (1620–1691) and Paulus Potter (1625–1654), and he began to add animals to his landscapes. These became very popular with the public not only in France but also in England, the Netherlands, Germany, and Austria. In order to meet the demand, Troyon hired assistants to fill in the backgrounds so that he could concentrate on the animals. He also painted pure landscapes, and in his later years frequently visited the Normandy coast. There, freed from market demands, he painted in a more exploratory fashion, recording variations in light. He was the first of the artists associated with Barbizon and rural French subjects to be awarded the cross of the Légion d'Honneur, in 1849.

7 *Fields outside Paris* 1845–51
Oil on paperboard, 27.0 × 45.5 cm
The Henry C. and Martha B. Angell Collection (19.117)

Provenance
Thomas Robinson, Providence, R.I., until 1886; Robinson sale, Moore's Art Galleries, New York, November 16, 1886, no. 117; Vose Galleries, Providence, R.I., and Boston, November 16, 1886; Dr. Henry C. Angell (d. 1911), Boston, 1886; Martha B. Angell (d. 1919), Boston, 1911; given by Martha B. Angell to the Museum of Fine Arts, Boston, March 20, 1919.

Selected Exhibitions
1946–47 Cambridge, Mass., Fogg Art Museum, Harvard University, September 1946–September 1947.
1959 Deerfield, Mass., Hilson Gallery, *Landscape through Time.*
1962–63 San Francisco, Palace of the Legion of Honor, September 24–November 4, 1962; Toledo, Ohio, The Toledo Museum of Art, November 20–December 27, 1962; Cleveland, The Cleveland Museum of Art, January 15–February 24, 1963; Boston, Museum of Fine Arts, March 15–April 28, 1963, *Barbizon Revisited* (catalogue by Robert L. Herbert), no. 104.
1978 Chapel Hill, N.C., William Hayes Ackland Memorial Art Center, University of North Carolina, March 15–April 30, *French Nineteenth-Century Oil Sketches: David to Degas* (catalogue), no. 60.

Selected References
Bouret 1972, p. 111; Cormack 1986, pp. 164–65, fig. 160; Goldstein 1979, p. 233; Murphy 1985, p. 283.

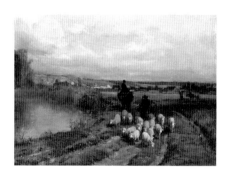

8 *Sheep and Shepherd in a Landscape* c. 1854
Oil on canvas, 34.8 × 45.1 cm
Bequest of Thomas Gold Appleton (84.276)

Provenance
Auguste de Charlière, Paris, until 1854; Charlière sale, Paris, October 17, 1854; Thomas Gold Appleton, Boston, until June 1884; bequeathed by Thomas Gold Appleton to the Museum of Fine Arts, Boston, June 1884.

Selected Exhibitions
1858 Hartford, Conn., Wadsworth Atheneum, *Thirty-second Exhibition*, no. 94.
1871 Hartford, Conn., Wadsworth Atheneum, *Exhibition for the Benefit of the French*, no. 23.
1871–72 Hartford, Conn., Wadsworth Atheneum, *Forty-seventh Exhibition*, no. 84.
1872 Hartford, Conn., Wadsworth Atheneum, *Forty-eighth Exhibition*, no. 192.
1872–73 Hartford, Conn., Wadsworth Atheneum, *Forty-ninth Exhibition*.
1873 Hartford, Conn., Wadsworth Atheneum, *Fiftieth Exhibition*, no. 203.
1912 Indianapolis, John Herron Art Institute.
1940 Boston, St. Botolph Club.
1940 Colorado Springs, Colorado Springs Fine Arts Center.

Selected References
Murphy 1985, p. 282.

Théodore Rousseau

Paris 1812–1867 Barbizon

Rousseau received traditional training first from a cousin and then from Jean-Charles-Joseph Rémond (1795–1875) and Guillaume Guillon-Lethière (1760–1832). He was already painting in the Forest of Fontainebleau in the late 1820s and traveled to the Auvergne, Normandy, Switzerland, and the Jura. His work was first accepted at the Salon in 1831. Rousseau visited Barbizon in 1836, which was also the year that the Salon jury began rejecting his submissions; he was again rejected in 1838, 1839, and 1840. In the following years Rousseau chose not to submit to the jury, showing next only in the unjuried Salon of 1849, when he won a first-class medal. By that time his work had attracted the attention of the writers Charles Baudelaire and George Sand and, most important, the critic Théophile Thoré. Rousseau divided his time between Barbizon, where Jean-François Millet was his closest friend, and Paris, where he kept a studio and where he could remain involved in the art world. Barbizon and its environs became his chief subject matter, and his compositions often resemble seventeenth-century Dutch landscapes and Japanese prints. In 1866 the dealers Durand-Ruel and Brame bought his early sketches, which gave him sufficient money on which to live. He was appointed president of the jury for the Exposition Universelle of 1867.

Selected Exhibitions

1938–39 Springfield, Mass., Springfield Museum of Fine Arts, December 6, 1938–January 2, 1939.

1954 New Orleans, Isaac Delgado Museum of Art, October 17,1953–January 10, 1954, *Masterpieces of French Painting through Five Centuries, 1400–1900*, no. 66.

1967 Wellesley, Mass., Wellesley College Art Museum, for use in study, November 1–December 4.

1979–80 *Corot to Braque*, no. 14.

1983–84 *Masterpieces of European Painting*, no. 39.

1989 *From Neoclassicism to Impressionism*, no. 22.

1992–93 *Monet and His Contemporaries*, no. 7.

Selected References

Murphy 1985, p. 251.

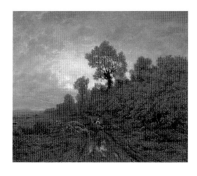

10 *Gathering Wood in the Forest of Fontainebleau* c. 1850–60
Oil on canvas, 54.7 × 65.3 cm
Bequest of Mrs. David P. Kimball (23.399)

Provenance

Samuel Putnam Avery collection (d. 1904), New York, until 1921; David P. Kimball collection, Boston, 1921; bequeathed by Mrs. David P. Kimball to the Museum of Fine Arts, Boston, September 6, 1923.

Selected Exhibitions

1940 Colorado Springs, Colorado Springs Fine Arts Center; Boston, St. Botolph Club; New London, Conn., Lyman Allen Museum, Connecticut College.

1942 Norfolk, Va., Norfolk Museum of Arts and Sciences.

Selected References

Murphy 1985, p. 251.

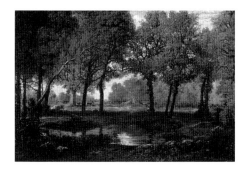

9 *Pool in the Forest* early 1850s
Oil on canvas, 39.5 × 57.4 cm
Robert Dawson Evans Collection (17.3241)

Provenance

M. Garnier collection, Paris; Robert Dawson Evans collection, Boston, until 1909; Mrs. Robert Dawson Evans (Maria Antoinette Hunt, d. 1917), Boston, 1909; bequeathed by Mrs. Robert Dawson Evans to the Museum of Fine Arts, Boston, November 1, 1917.

Antoine Chintreuil

Point-de-Vaux (Ain) 1814–1873 Septeuil (Seine-et-Oise)

After arriving in Paris in 1838, Chintreuil worked first as a bookseller. The primary influence on his painting was Camille Corot, whom he met in the 1840s; he listed himself as "a pupil of Corot" in the Salon catalogues until the end of his life, but he was probably mainly self-taught. Chintreuil was dogged in his pursuit of an artistic career, weathering repeated rejections by the Salon jury in the mid-1840s. The years of the Second Republic and Second Empire were good to him, however: in the course of the 1850s, several of his paintings were bought by the State. His most productive period began in 1857, when he settled at Septeuil, near Mantes. From 1863, when he showed at the Salon des Refusés three paintings that had been rejected by the Salon jury, his reputation grew. He received a medal at the Salon of 1867 and the Légion d'Honneur in 1870. He was especially known for his unusual depictions of light effects and weather. Georges Lafenestre wrote in the July 1873 issue of the *Gazette des Beaux-Arts*: "M. Chintreuil loves to seize that which appears unseizable, to express that which seems inexpressible; the vegetable, geological, atmospheric complications attract him inevitably; his curious mind and his skillful brush are only at ease in the midst of the strange and unexpected; when he succeeds he creates prodigies."[1]

1. Translated in Clement and Hutton 1879, vol. 1, p. 136.

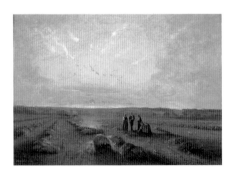

11 *Peasants in a Field* or *Last Rays of Sun on a Field of Sainfoin* c. 1870
Oil on canvas, 95.8 × 134.0 cm
Gift of Mrs. Charles G. Weld (22.78)

Provenance
M. Fassin, Reims, before 1870; Charles G. Weld, Boston, by 1891; bequeathed by Mrs. Charles G. Weld to the Museum of Fine Arts, Boston, February 2, 1922.

Selected Exhibitions
1870 Paris, Salon.
1874 Paris, École Nationale des Beaux-Arts, April 25–May 15, *Tableaux, études et dessins de Chintreuil, exposés à l'École des Beaux-Arts* (catalogue), no. 208.

Selected References
De la Fizelière et al. 1874, p. 66, no. 408; Murphy 1985, p. 51.

François-Louis Français

Plombières (Vosges) 1814–1897 Paris

Français began his career in Paris in 1829 as an errand boy to the publisher Paulin. In 1834 he studied drawing and print-making in the atelier of Jean Gigoux (1806–1894). For many years Français produced lithographs and wood engravings for a wide range of books, from Bernardin de Saint-Pierre's popular romantic novel *Paul et Virginie* to La Fontaine's fables to novels by George Sand and Honoré de Balzac. Also in 1834, he began going to Barbizon. He became a pupil of Camille Corot in 1836. Français's sympathy for the works of Corot and other mid-century landscapists informed his many lithographs done after their paintings. Français enjoyed a long and successful career, exhibiting both paintings and lithographs at the Salon, beginning in 1837. He received his first medal in 1841, and in 1853 was named *chevalier* of the Légion d'Honneur. His landscapes trace a record of far-flung travels – the Italian countryside (1846–49, 1851, 1858–59, 1864–66, 1869, and 1873), the French provinces (from 1870 he wintered on the Riviera), and the Île-de-France. Français's work was essentially a hybrid that combined the calculated compositions of the Neoclassical landscape with a freshness of vision derived from the direct study of nature.

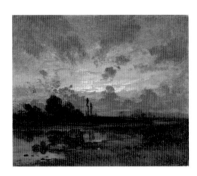

12 *Sunset* 1878
Oil on canvas, 47.1 × 56.3 cm
Bequest of Ernest Wadsworth Longfellow (37.598)

Provenance
Ernest Wasdsworth Longfellow, Boston, by 1884 (?); bequeathed by Ernest Wadsworth Longfellow to the Museum of Fine Arts, Boston, 1937.

Selected Exhibitions
1989 *From Neoclassicism to Impressionism*, no. 36.

Selected References
Murphy 1985, p. 101.

Jean-François Millet

Gruchy, near Cherbourg (Manche) 1814–1875 Barbizon

Millet took lessons in Cherbourg from the portrait painter Bon Du Mouchel (1807–1846) as well as the history painter Lucien-Théophile Langlois (1803–1845). A municipal stipend from Cherbourg underwrote his study in Paris in the studio of Paul Delaroche (1797–1856) in 1837, but Cherbourg withdrew Millet's stipend when he left that studio following his failure in the Prix de Rome competition. Millet spent the 1840s painting portraits and genre and pastoral scenes. In 1847 he met the collector Alfred Sensier, who became the artist's most constant supporter and, later, biographer. Millet used the money from a government commission to flee the cholera epidemic of 1849; he settled in Barbizon, a village in the Forest of Fontainebleau. There he concentrated on the agricultural themes that brought him fame. In Barbizon he was closely associated with Théodore Rousseau, Constant Troyon, and Narcisse Virgile Diaz de la Peña. Rousseau encouraged Millet to paint landscapes, which he did increasingly after 1863. His paintings sold well in the last decade of his life, and he received both public and private commissions. Although he was portrayed as a peasant-painter, Millet's early schooling with two village priests inculcated in him a thorough knowledge of Latin literature and a love of reading. A deep sense of tradition is palpable in his works, allied to a sincere love of the countryside.

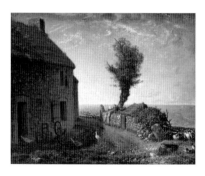

13 *End of the Hamlet of Gruchy* 1866
Oil on canvas, 81.5 × 100.5 cm
Gift of Quincy Adams Shaw through Quincy A. Shaw, Jr. and
Mrs. Marian Shaw Haughton (17.1508)

Provenance
Paul Marmontel, Paris, 1868; Marmontel sale, Hôtel Drouot, Paris, May 11, 1868, no. 55; Hector Henri Clement Brame, Paris, 1868; Jean-Baptiste Faure collection, Paris, until 1873; Faure sale, Galeries Georges Petit, Paris, June 7, 1873, no. 26; with Durand-Ruel, Paris, by 1879; Quincy Adams Shaw, Boston, 1879; Quincy A. Shaw, Jr. and Mrs. Marian Shaw Haughton, Boston, 1908; given by Quincy A. Shaw, Jr. and Mrs. Marian Shaw Haughton to the Museum of Fine Arts, Boston, 1917.

Selected Exhibitions
1866 Paris, *Salon*, no. 1376.
1890 New York, American Art Association, *Barge Monument Fund*, no. 553.
1918 Boston, Museum of Fine Arts, *Quincy Adams Shaw Collection*, no. 2.
1975–76 Paris, Grand Palais, October 1, 1975–January 5, 1976; London, Hayward Gallery, January 20–March 20, 1976, *Millet* (catalogue by Robert L. Herbert), no. 193.
1984–85 *Jean-François Millet*, no. 111.
1995–96 London, Hayward Gallery, May 18–August 28, 1995; Boston, Museum of Fine Arts, October 4, 1995–January 14, 1996, *Impressions of France: Monet, Renoir, Pissarro, and Their Rivals* (catalogue by John House), no. 12.

Selected References
About 1866; Buhler 1985, pp. 2551–56; Burty 1877, p. 281; Cartwright 1896, pp. 290–92, 309; Durand-Gréville 1887, p. 68; Edgell 1949, pp. 19–20; Fermigier 1977, p. 19; Gensel 1902, p. 58; Marcel 1901, pp. 74–78; Moreau-Nélaton 1921, vol. 2, p. 182, vol. 3, pp. 1, 2, 5, 53, 91, no. 214; Murphy 1985, p. 197; Peacock 1905, pp. 116–18; Piedgnel 1876, pp. 62, 80; Rolland 1902, p. 107; Sensier and Mantz 1881, pp. 290–94; Strahan 1879, vol. 3, p. 86; Tabarant 1942, p. 383.

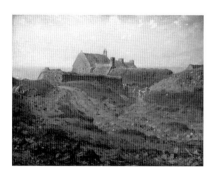

14 *Priory at Vauville, Normandy* 1872–74
Oil on canvas, 90.9 × 116.7 cm
Gift of Quincy Adams Shaw through Quincy A. Shaw, Jr. and
Mrs. Marian Shaw Haughton (17.1532)

Provenance
Quincy Adams Shaw, Boston, 1874; Quincy A. Shaw, Jr. and Mrs. Marian Shaw Haughton, Boston, 1908; given by Quincy A. Shaw, Jr. and Mrs. Marian Shaw Haughton to the Museum of Fine Arts, Boston, March 1917.

Selected Exhibitions
1918 Boston, Museum of Fine Arts, *Quincy Adams Shaw Collection*, no. 25.
1984–85 *Jean-François Millet*, no. 149.

Selected References
Cartwright 1896, pp. 331–32, 334, 339, 344; Durand-Gréville 1887, p. 68; Mantz 1887, p. 32; Moreau-Nélaton 1921, vol. 3, pp. 78–79, 84, 87, 102, 104, no. L72; Murphy 1985, p. 201; Peacock 1905, p. 132; Sensier and Mantz 1881, pp. 348–49, 352, 362, 363.

Charles-François Daubigny

Paris 1817–1878 Paris

Daubigny's father was a landscape painter who had studied with Jean-Victor Bertin (1767–1842), the first teacher of Camille Corot. Thus, unlike many other artists, Daubigny did not have to overcome parental opposition to his chosen career. He worked variously as a decorator of ornamental objects and a restorer, and went to Italy for six months in 1836. He had an active and respected career as a graphic illustrator beginning in 1838, the year he also started to exhibit at the Salon. In 1852 he met Corot, and the two remained close friends all their lives. In 1857 he launched his *botin*, or floating studio, which he piloted along the Seine, Marne, and Oise rivers, painting directly from nature. He settled in Auvers in 1860. By that time he was beginning to be criticized for the roughness and unfinished quality of his paintings. But despite some negative opinions, his works won medals and were purchased by the State. His direct approach to painting nature also found expression in his championing the work of Camille Pissarro, Paul Cézanne, and Pierre-Auguste Renoir when he was on the Salon jury in the late 1860s. Fleeing the Franco-Prussian War of 1870–71, he traveled in Holland and to London, where he met Claude Monet, thereby forging another link between the generations.

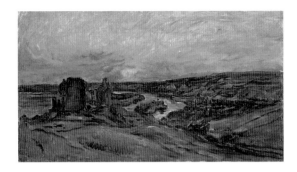

16 *Château-Gaillard at Sunset* c. 1873
Oil on canvas, 38.1 × 68.5 cm
Gift of Mrs. Josiah Bradlee (18.18)

Provenance
Mr. and Mrs. Josiah Bradlee, Boston; given by Mrs. Josiah Bradlee to the Museum of Fine Arts, Boston, February 17, 1918.

Selected References
Fidell-Beaufort and Bailly-Herzberg 1975, p. 202, no. 162; Hellebranth 1976, no. 90; Murphy 1985, p. 71; Sterling and Adhémar 1959, pl. 158, no. 523, p. 3.

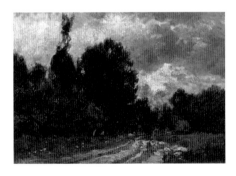

15 *Road through the Forest* c. 1865–70
Oil on canvas, 64.5 × 92.5 cm
Gift of Mrs. Samuel Dennis Warren (90.200)

Provenance
Seth M. Vose, Providence, R.I., between 1870 and 1884; Beriah Wall, Providence, R.I., by 1884; Wall-Brown collection sale, American Art Association, New York, March 30–April 1, 1886, no. 208, called *After the Storm*; Mrs. Samuel Dennis Warren, Boston, 1886; given by Mrs. Samuel Dennis Warren to the Museum of Fine Arts, Boston, December 20, 1890.

Selected Exhibitions
n.d. Providence, R.I., *Loan Exhibition in Aid of the First Light Infantry*.

Selected References
Hellebranth 1976, no 158; Murphy 1985, p. 71; Wall 1884, p. 16, no. 42.

Gustave Courbet

Ornans (Franche-Comté) 1819–1877 La Tour de Peilz (Switzerland)

Courbet went to Paris in 1839, ostensibly in order to take up law. He studied at the Académie Suisse, but he was essentially self-taught, having spent much time in the Louvre learning from the old masters, particularly of the Dutch, Venetian, and Spanish schools. His submissions to the Salon in the early 1850s, such as *Burial at Ornans* (Musée d'Orsay, Paris), gave rise to controversy because of their use of everyday subject matter on a heroic scale. In 1855 he erected his Pavilion of Realism within the grounds of the Exposition Universelle, a move that impressed younger artists for its independence from official sanction. In it he showed forty paintings and two drawings and accompanied them with a Realist manifesto; these actions made him the chief proponent of Realist painting.

From then on his art became less polemic, and he painted more nudes, portraits, and landscapes. The critic Edmond About, in *Nos artistes au Salon de 1857*, explained that Courbet "affects not to choose, but to paint all that he meets, without preferring one thing before another…. His theory may be thus given: all objects are equal before painting."[1] Courbet, like many other artists, painted on the Normandy coast, first going to Le Havre in 1859, where he met Eugène Boudin. Courbet's involvement with the Paris Commune and his alleged role in the destruction of the Vendôme Column led him to move to Switzerland in 1873.

1. Translated in Clement and Hutton 1879, vol. 1, p. 165.

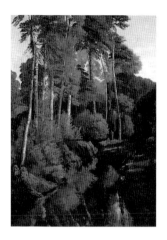

17 *Stream in the Forest* c. 1862
Oil on canvas, 157.0 × 114.0 cm
Gift of Mrs. Samuel Parkman Oliver (55.982)

Provenance
Potter Dekens, Brussels, after 1862; Galerie Allard (probably Joseph Allard), Paris; Meyer Goodfriend, New York (?), until January 4, 1923; Meyer Goodfriend sale, American Art Galleries, New York, January 4, 1923, no. 61, called *Paysage avec biches*; Paul Rosenberg and Co., London, New York, and Paris, 1923; Sir A. Chester Beatty, London, 1936; Paul Rosenberg and Co., New York, March 1955; purchased from Paul Rosenberg and Co., by the Museum of Fine Arts, Boston, March 1955.

Selected Exhibitions
1936 London, Anglo-French Art and Travel Society, *Masters of Nineteenth-Century Painting*, no. 29.
1937 Paris, Palais des Beaux-Arts, *Chefs-d'oeuvre de l'art français*, no. 280.
1939 Belgrade, Prince Paul Museum, *French Painting of the Nineteenth Century*, no. 26.
1957 New York, Paul Rosenberg and Co., *Benefit Exhibition*.
1959–60 Philadelphia, Philadelphia Museum of Art, December 16, 1959–February 14, 1960, *Gustave Courbet*, no. 68.
1979–80 *Corot to Braque*, no. 21.
1983–84 *Masterpieces of European Painting*, no. 40.
1988–89 Brooklyn, N.Y., Brooklyn Museum of Art; Minneapolis, Minneapolis Institute of Arts, November 1988–April 1989, *Courbet Reconsidered* (catalogue by Linda Nochlin), no. 37.
1992 *Crosscurrents*.
1992–93 *Monet and His Contemporaries*, no. 14.

Selected References
Adams 1994, pp. 6, 154, fig. 1; Murphy 1985, p. 64.

Henri-Joseph Harpignies

Valenciennes 1819–1916 Saint-Privé (Yonne)

After working for his father, Harpignies studied with the landscape painter Jean Achard (1807–1884). He and Achard visited the Netherlands and Belgium to avoid the Revolution of 1848, and then Harpignies traveled in Italy from 1849 to 1852. He returned there in 1863 and stayed until 1865. Harpignies had a successful career at the Salon from 1853 to 1912, winning medals in 1866, 1868, and 1869. He was named *chevalier* of the Légion d'Honneur in 1875, *officier* in 1883, *commandeur* in 1901, and *grand officier* in 1911. In 1883 the art dealers Arnold & Tripp began to commission and sell his works, an arrangement that freed Harpignies from money worries and increased his productivity.

In the mid-1850s Harpignies was particularly drawn to Camille Corot's work and adopted Corot's silvery tonalities until the early 1870s. His concurrent work in watercolor brightened his palette and gave it more individuality. After the mid-1880s he was increasingly influential as a watercolorist. From 1878 he lived in Saint-Privé, on the river Yonne, and he began wintering in Nice after 1885. Harpignies was unaffected by vanguard developments in landscape painting, ignoring the Impressionist vocabulary and remaining true to a mid-century aesthetic, marked by his own distinctive stylization.

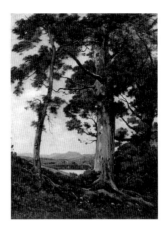

19 *Evening at Saint-Privé* 1890
Oil on canvas, 73.7 × 54.5 cm
Bequest of Ernest Wadsworth Longfellow (23.486)

Provenance
Obach and Co., London, until May 5, 1901; Obach sale, London, May 5, 1901; Knoedler & Co., London, until February 1903; Morris J. Hirsch, London (?), 1903; Knoedler & Co., London, until March 1904; Ernest Wadsworth Longfellow, Boston, March 1904; bequeathed by Ernest Wadsworth Longfellow to the Museum of Fine Arts, Boston, November 1, 1923.

Selected Exhibitions
1978–79 Memphis, Tenn., Dixon Gallery and Gardens, December 3, 1978–January 14, 1979, *Henri-Joseph Harpignies: Paintings and Watercolors and Loan Exhibition*, no. 7.
n.d. New York, Union League Club.

Selected References
Murphy 1985, p. 129.

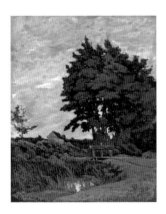

18 *Landscape with an Old Dam* 1882
Oil on paperboard mounted on panel, 40.0 × 33.4 cm
Juliana Cheney Edwards Collection (39.650)

Provenance
Grace M. Edwards (d. 1939), Boston, until 1939; bequeathed by Grace M. Edwards to the Museum of Fine Arts, Boston, 1939.

Selected Exhibitions
1939–40 *Juliana Cheney Edwards Collection*, no. 15.

Selected References
Murphy 1985, p. 129.

Johan Barthold Jongkind

Lattrop (Netherlands) 1819–1891 Côte Saint-André (Isère)

Jongkind's first teacher, with whom he studied in The Hague, was the foremost Dutch landscape painter of the time, Andreas Schelfhout (1787–1870). A government stipend enabled Jongkind to go to Paris in 1846 for further study under Eugène Isabey. Jongkind made watercolors and sketches in the outdoors, from which he composed his oil paintings in the studio. Early public success (acceptance at the Salon, a third-class medal in 1852, several purchases by the State, and support from the dealer Pierre Firmin-Martin) was cut short by the withdrawal of the Dutch stipend in 1853. Jongkind fell into debt, drank heavily, and was forced to return to the Netherlands in 1855.

A sale of works by Jongkind's artist friends in 1860 realized enough money to allow him to return to Paris. Once back, he met Mme Joséphine Fesser-Borrhée. Her friendship and the support of her family gave Jongkind a new lease on life. Together, they traveled frequently to the Normandy coast, where in 1862 he met the young Claude Monet. He also went back to the Netherlands and visited the South of France and the Dauphiné. Jongkind's art was a path-breaking combination of compositional structures taken from the landscape and seascape traditions of seventeenth-century Dutch art, the careful study of specific light conditions, and a free manner of painting.

20 *Harbor Scene in Holland* 1868
Oil on canvas, 42.0 × 56.0 cm
Gift of Count Cecil Pecci-Blunt (61.1242)

Provenance
Ferdinand Blumenthal, before 1920; Count Cecil Pecci-Blunt, Rome, 1920; given by Count Cecil Pecci-Blunt to the Museum of Fine Arts, Boston, December 1961.

Selected Exhibitions
1910 Paris, Galeries Georges Petit, May, *Exposition de chefs-d'oeuvre de l'école française*, no. 107.
1979–80 *Corot to Braque* (not in catalogue; Phoenix venue only).
1990 Boston, Museum of Fine Arts, *Boudin in Boston.*
1991 Salem, Mass., Peabody Museum, May 17–September 16, *Eugène Boudin: Impressionist Marine Paintings* (catalogue by Peter C. Sutton), no. 4.
1992 *Crosscurrents.*

Selected References
Hefting 1975, p. 198, no. 448; Murphy 1985, p. 153; Roger-Milès 1920, p. 105, plate following p. 104.

21 *Harbor by Moonlight* 1871
Oil on canvas, 34.0 × 46.2 cm
The Henry C. and Martha B. Angell Collection (19.95)

Provenance
Bernheim-Jeune, Paris; Aimé Diot, Paris, until 1888; Henry C. (d. 1911) and Martha B. Angell (d. 1919), Boston, 1888; given by Martha B. Angell to the Museum of Fine Arts, Boston, March 20, 1919.

Selected Exhibitions
1897 Boston, Copley Society, *One Hundred Masterpieces*, no. 45.
1969 Miami, Miami Art Center, March 20–April 18, *The Artist and the Sea*, no. 19.
1991 Salem, Mass., Peabody Museum, May 17–September 16, *Eugène Boudin: Impressionist Marine Paintings* (catalogue by Peter C. Sutton), no. 5.

Selected References
Murphy 1985, p. 153.

Eugène Boudin

Honfleur 1824–1898 Deauville

The son of a ship's captain, Boudin opened a stationery and framing shop with a partner in Le Havre in 1844. As was the custom before commercial art galleries were established, he exhibited in his window paintings by local artists. Constant Troyon and Jean-François Millet were two of these, and they convinced him to try painting himself. The local art society gave him a scholarship to study art in Paris. At its end, in 1854, he returned to the Normandy coast and painted directly from nature. He met the young painter Claude Monet in 1858 and convinced him, as he himself had been persuaded, to paint out-of-doors. In 1859 he became friends with Gustave Courbet, and in 1862 with Johan Barthold Jongkind, whose fresh vision of marine painting made a significant impact on him. Boudin's works were accepted regularly at the Salon beginning in 1859, and he showed several works at the first Impressionist exhibition in 1874. His reputation was secure after 1871, and he began to travel, visiting Belgium, the Netherlands, the South of France, and Venice. Despite his popular success and financial security (after 1883 the Parisian dealer Paul Durand-Ruel held exclusive rights to his output), Boudin received official honors only late in life – a third-class medal at the Salon of 1881, a gold medal at the 1889 Exposition Universelle, and the rank of *chevalier* of the Légion d'Honneur in 1892.

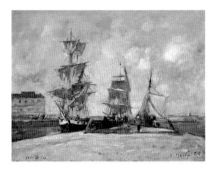

22 *Harbor at Honfleur* 1865
Oil on panel, 20.3 × 26.8 cm
Anonymous Gift (1971.425)

Provenance
Private collection, Paris, c. 1929; Rowland Burdon-Muller, Lausanne-Ouchyvaud and Boston, 1929; given anonymously to the Museum of Fine Arts, Boston, 1971.

Selected Exhibitions
1991 Salem, Mass., Peabody Museum, May 17–September 16, *Eugène Boudin: Impressionist Marine Paintings* (catalogue by Peter C. Sutton), no. 6.
1992–93 *Monet and His Contemporaries* (not in catalogue).

Selected References
Murphy 1985, p. 30; Schmit 1973, no. 339.

23 *Fashionable Figures on the Beach* 1865
Oil on panel, 35.5 × 57.5 cm
Gift of Mr. and Mrs. John J. Wilson (1974.565)

Provenance
Cadar and Luquet, Paris, after 1865; Galeries Georges Petit, Paris; Dr. Francisco Llobet, Buenos Aires, after 1930; Mme Inès Gowland de Llobet, Buenos Aires; Peter Nathan and Jacques Dubourg, Paris; Mr. and Mrs. John J. Wilson, Boston, 1974; given by Mr. and Mrs. John J. Wilson to the Museum of Fine Arts, Boston, December 1974.

Selected Exhibitions
1966 New York, Hirschl & Adler Galleries, *Eugène Boudin: 1824–1898: Retrospective Exhibition*, no. 7.
1990 Boston, Museum of Fine Arts, *Boudin in Boston*.
1991 Salem, Mass., Peabody Museum, May 17–September 16, *Eugène Boudin: Impressionist Marine Paintings* (catalogue by Peter C. Sutton), no. 7.
1995 *The Real World*, no. 37.

Selected References
Murphy 1985, p. 30; Schmit 1973, no. 345.

24 *Beach Scene* 1882
Oil on canvas, 54.5 × 75.0 cm
Bequest of Mrs. Stephen S. Fitzgerald (64.1905)

Provenance
Durand-Ruel; O'Doard, Paris, November 29, 1892; Durand-Ruel, Paris; M. Tavernier, Paris, March 8, 1900; Desmond Fitzgerald; Mrs. Stephen S. Fitzgerald, Weston, Mass., by 1962; bequeathed by Mrs. Stephen S. Fitzgerald to the Museum of Fine Arts, Boston, 1964.

Selected Exhibitions

Selected References

Murphy 1985, p. 29; Schmit 1973, no. 1658.

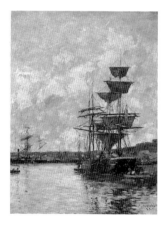

25 *Ships at Le Havre* 1887
Oil on panel, 35.0 × 26.5 cm
Gift of Miss Amelia Peabody (37.1212)

Provenance

Adrien Lacroix, Toulouse; Lacroix sale, Paris, Hôtel Drouot, April 12, 1902, no. 7; Chaine and Simonson, Paris, 1902; Vose Galleries, Boston, August 11, 1905; Frank Peabody, Boston, December 5, 1905; Amelia Peabody, Boston, 1937; bequeathed by Amelia Peabody to the Museum of Fine Arts, Boston, October 21, 1937.

Selected Exhibitions

Selected References

Murphy 1985, p. 29; Schmit 1973, no. 2196.

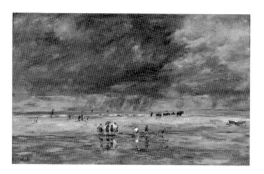

26 *Figures on the Beach* 1893
Oil on canvas, 36.5 × 59.0 cm
Bequest of William A. Coolidge (1993.32)

Provenance

Private collection, Paris, until December 2, 1952; sale of the collection of Princesse X, Galerie Charpentier, Paris, December 2, 1952, no. 33; Allard & Noël, Paris, 1952; Antique Porcelains Co., New York, 1975; William A. Coolidge, Boston, 1975; bequeathed by William A. Coolidge to the Museum of Fine Arts, Boston, 1993.

Selected Exhibitions

Selected References

Schmit 1973, no. 2338; Sutton 1995, pp. 79–81, no. 15.

Camille Pissarro

Saint-Thomas (Danish West Indies) 1830–1903 Paris

Pissarro learned to draw when his parents, in 1841, sent him to Paris for schooling. After an unsettled period during which he first worked in his father's store and then went to Venezuela with the Danish painter Fritz Melbye (1826–1896), Pissarro returned to Paris in 1855, in time to witness the Exposition Universelle. He enrolled in both the École des Beaux-Arts and the less regimented Académie Suisse. Pissarro asked Camille Corot for advice, and aspects of the older painter's style can be seen in Pissarro's silvery palette and soft touch through the mid-1860s. After that time the more assertive style of Gustave Courbet is evident. Sporadic success at the Salon encouraged Pissarro to find alternative exhibition venues. He was the only artist to participate in all eight of the Impressionist group shows. Pissarro preferred to live in the country rather than the city, and he settled in Pontoise as early as 1866, moving from there to increasingly rural locales. By all accounts a generous and kindly man, he counseled Paul Cézanne in the early 1870s and was himself influenced by the younger painters Georges Seurat (1859–1891) and Paul Signac in the later 1880s. Although success came late to Pissarro, he continued to find challenging motifs. Pissarro also left an impressive body of prints, many of which are technically innovative.

Selected References

Edgell 1949, p. 35; Murphy 1985, p. 229; Pepper 1948, p. 16, no. 64; Pissarro and Venturi 1939, vol. 1, p. 107, no. 202, vol. 2, nos. 41, 202; Pope 1930, pp. 98, 103; Rewald 1954, no. 19; Rewald 1963, p. 88, no. 202; Watson 1925, pp. 336, 344.

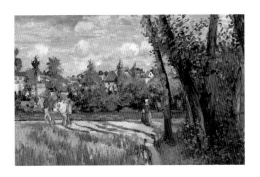

28 *Sunlight on the Road, Pontoise* 1874
Oil on canvas, 52.3 × 81.5 cm
Juliana Cheney Edwards Collection (25.114)

Provenance

Jean-Baptiste Faure, Paris, no. 87, called *En plein soleil*; Durand-Ruel, Paris and New York, no. 4258, by 1919; Robert J. Edwards (d. 1924), Boston, until 1924; Hannah Marcy Edwards (d. 1931) and Grace M. Edwards (d. 1939), Boston, by inheritance, 1924; bequeathed by Robert J. Edwards to the Museum of Fine Arts, Boston, 1925.

Selected Exhibitions

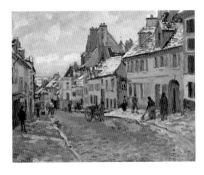

27 *Pontoise, the Road to Gisors in Winter* 1873
Oil on canvas, 59.8 × 73.8 cm
Bequest of John T. Spaulding (48.587)

Provenance

Durand-Ruel, Paris, until 1925; John T. Spaulding, Boston, 1925; bequeathed by John T. Spaulding to the Museum of Fine Arts, Boston, June 3, 1948.

Selected Exhibitions

1973 *Impressionism: French and American*, no. 63.
1979–80 *Corot to Braque*, no. 31.
1983–84 *Masterpieces of European Painting*, no. 45.
1985 Boston, Museum of Fine Arts, February 13–June 2, *The Great Boston Collectors: Paintings from the Museum of Fine Arts, Boston* (catalogue by Carol Troyen and Pamela S. Tabbaa), no. 45.
1992 *Crosscurrents.*
1996 Tokyo, Tobu Museum of Art, March 30–June 30, *The Birth of Impressionism.*

Selected References

Cunningham 1939a, p. 8; Edgell 1949, p. 33; "La Chronique des Arts" in *Supplément à la Gazette des Beaux-Arts*, no. 1261 (February 1974), pp. 32–33; Murphy 1985, p. 229; Venturi 1939, vol. 1, p. 15, no. 255, vol. 2, no. 255.

29 *View from the Artist's Window, Éragny* 1885
Oil on canvas, 54.5 × 65.0 cm
Juliana Cheney Edwards Collection (25.115)

Provenance

Camille Pissarro, Paris, until 1892; Durand-Ruel, Paris, 1892; Robert J. Edwards (d. 1924), Boston, 1914; Hannah Marcy Edwards (d. 1931) and Grace M. Edwards (d. 1939), Boston, 1924; bequeathed by Robert J. Edwards to the Museum of Fine Arts, Boston, April 2, 1925.

Selected Exhibitions

1893 Paris, Durand-Ruel, *Pissarro*, no. 33.
1939–40 *Juliana Cheney Edwards Collection*, no. 45.
1946 Pittsfield, Mass., Berkshire Museum.
1947 Wellesley, Mass., Wellesley College Art Museum.
1949 Boston, Symphony Hall.
1973 *Impressionism: French and American*, no. 65.
1974–75 Berkeley, Calif., University Art Museum, University of California, September 1974–September 1975, *One Year Loan Exhibition.*

Selected References

Edgell 1949; Murphy 1985, p. 229; Pissarro and Venturi 1939, vol. 1, p. 177, nos. 141, 678.

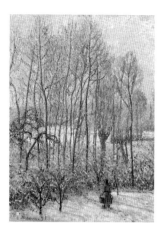

30 *Morning Sunlight on the Snow, Éragny-sur-Epte* 1894–95
Oil on canvas, 82.3 × 61.5 cm
John Pickering Lyman Collection (19.1321)

Provenance

Durand-Ruel, Paris, 1894; John Pickering Lyman (d. 1914), Portsmouth, N.H., 1910; Theodora Lyman (d. 1919), Portsmouth, N.H., 1914; given by Theodora Lyman to the Museum of Fine Arts, Boston, 1919.

Selected Exhibitions

1915 Boston, Museum of Fine Arts, from February 3, *Evans Memorial Galleries Opening Exhibition.*
1945 New London, Conn., Lyman Allen Museum, Connecticut College.
1945 New York, Wildenstein and Co., *Camille Pissarro and His Influence*, no. 32.
1946 Chicago, Arts Club of Chicago.
1949 Boston, Symphony Hall.
1956 South Hadley, Mass., Mount Holyoke College, *French and American Impressionism.*
1964 Iowa City, University of Iowa Gallery of Art, November 8–December 8, *Impressionism and Its Roots*, no. 39.
1973 *Impressionism: French and American*, no. 67.
1979–80 *Corot to Braque*, no. 30.
1980–81 London, Hayward Gallery, October 31, 1980–January 11, 1981; Paris, Grand Palais, January 30–April 27, 1981; Boston, Museum of Fine Arts, May 19–August 9, 1981, *Camille Pissarro: The Unexplored Impressionist*, no. 74.
1984 Tokyo, Isetan Museum of Art, March 8–April 10; Fukuoka, Fukuoka Art Museum, April 20–May 20; Kyoto, Kyoto Municipal Museum of Art, May 25–June 30, *Camille Pissarro Retrospective*, no. 49.
1990 Birmingham, England, Birmingham City Museum and Art Gallery, March 8–April 22; Glasgow, Burrell Collection, Pollock County Park, May 3–June 17, *Camille Pissarro.*
1992–93 *Monet and His Contemporaries*, no. 47.

Selected References

Murphy 1985, p. 229; Pissarro and Venturi 1939, vol. 1, p. 207, no. 911, vol. 2, no. 911.

Antoine Vollon

Lyons 1833–1900 Paris

Vollon began his career in his native Lyons in an enameling shop, copying eighteenth-century works onto decorative objects. He won awards in printmaking during his two-year period of study, from 1851 to 1852, at the École des Beaux-Arts in Lyons, and by 1858 was exhibiting oil paintings in his hometown. He moved to Paris in 1859 and first exhibited at the Salon in 1864. His paintings were regularly purchased from the Salon by the State (1864, 1868, 1870, and 1875), and he enjoyed a successful official career, marked by awards at the Salon in 1865, 1868, and 1869, and at the Expositions Universelles of 1878 and 1900. He was named *chevalier* of the Légion d'Honneur in 1870, *officier* in 1878, and *commandeur* in 1898. Associated with François Bonvin (1843–1866) and Théodule Ribot (1823–1891), Vollon was best known for his still lifes, primarily of kitchen subjects, yet he was also fond of painting armor. His works are characterized by heavily loaded brushstrokes and dramatic lighting. As the example in the Museum of Fine Arts, Boston, shows, however, he was equally adept at landscapes, often of farmyard subjects, and he also did portraits. Toward the end of his life he spent more time outside Paris, painting rural subjects.

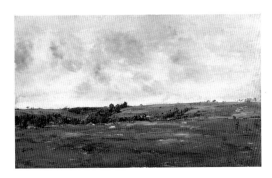

31 *Meadows and Low Hills*
Oil on panel, 28.0 × 46.2 cm
Bequest of Ernest Wadsworth Longfellow (37.602)

Provenance
Goupil and Co., London; Ernest Wadsworth Longfellow, Boston, before 1937; bequeathed by Ernest Wadsworth Longfellow to the Museum of Fine Arts, Boston, August 12, 1937.

Selected References
Murphy 1985, p. 297.

Edgar Degas

Paris 1834–1917 Paris

Degas's father, a banker interested in music and art, did not object very much when his son chose to pursue a career in art instead of the law. Degas first studied with Félix-Joseph Barrias (1841–1905) and then, more important, with Louis Lamothe (1822–1869), who had been a pupil of Jean-Auguste-Dominique Ingres (1780–1867). Ingres's supple draftsmanship and classical orientation were deciding factors in Degas's early development. From 1856 to 1859 Degas visited Italy, where he copied ancient and Renaissance works in Naples, Florence, and Rome. On his return to Paris he painted portraits and scenes from history and modern life and was accepted at the Salon from 1865 to 1870. Increasingly, however, Degas allied himself with independent-minded artists of a Realist or Naturalist aesthetic who gathered with his friend Édouard Manet (1832–1883) at the Café de la Nouvelle Athènes and the Café Guerbois. He exhibited with the group known as the Impressionists in all but one of their eight shows, sharing with them an interest in Japanese prints, subjects of modern life, and technical innovation. Degas distinguished himself by the combination of his devotion to the figure and his constant experimentation.

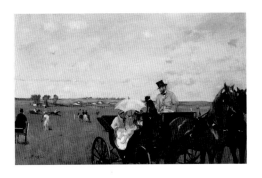

32 *At the Races in the Countryside* 1869
Oil on canvas, 36.5 × 55.9 cm
1931 Purchase Fund (26.790)

Provenance
Durand-Ruel, Paris, September 17, 1872; Jean-Baptiste Faure, Paris, April 25, 1873; Durand-Ruel, Paris, January 2, 1893; deposited with the Durand-Ruel family, Les Balans, March 29, 1918; purchased in New York by the Museum of Fine Arts, Boston, 1926.

Selected Exhibitions
1872 London, 168 New Bond Street, *Fifth Exhibition of the Society of French Artists*, no. 113.
1873 London, 168 New Bond Street, *Sixth Exhibition of the Society of French Artists*, no. 79, called *A Race-course in Normandy*.
1874 Paris, 35 Boulevard des Capucines, *Société Anonyme Coopérative d'Artistes-peintres, Sculpteurs, Graveurs, etc. …*, no. 63, called *Aux courses en Province*.
1903–4 *Vienna Secession*.
1922 Paris, Musée des Arts Décoratifs, May 27–July 10, *Le décor de la vie sous le second empire*, no. 57.

1924 Paris, Galeries Georges Petit, *Exposition Degas*, no. 40.
1929 Cambridge, Mass., Fogg Art Museum, Harvard University, March 6–April 6, *French Painting of the Nineteenth and Twentieth Centuries*, no. 25.
1933 Chicago, The Art Institute of Chicago, *A Century of Progress*, no. 282.
1936 Philadelphia, Philadelphia Museum of Art, *Degas 1834–1917*, no. 21.
1937 Paris, Musée de l'Orangerie, *Degas*, no. 14.
1937 Paris, Palais des Beaux-Arts, *Chefs-d'oeuvre de l'art français*, no. 301.
1938 Cambridge, Mass., Fogg Art Museum, Harvard University, *The Horse: Its Significance in Art*, no. 147.
1955 Paris, Musée de l'Orangerie, *Nineteenth-Century French Paintings from American Collections*, no. 20.
1958 Los Angeles, Los Angeles County Museum of Art, March 1958, *Edgar Degas*, no. 17.
1959 Brussels, Palais International des Beaux-Arts, August 8–October 19, 1959, *Man and Art*.
1973 *Impressionism: French and American*, no. 4.
1974–75 New York, The Metropolitan Museum of Art, December 12, 1974–February 10, 1975, *Impressionism: A Centenary Exhibition* (catalogue by Anne Dayes, Michel Hoog, and Charles S. Moffett), no. 13.
1983–84 *Masterpieces of European Painting*, no. 48.
1985 Boston, Museum of Fine Arts, February 13–June 2, *The Great Boston Collectors: Paintings from the Museum of Fine Arts, Boston* (catalogue by Carol Troyen and Pamela S. Tabbaa), no. 39.
1986 Washington, D.C., National Gallery of Art, January 17–April 6; San Francisco, Fine Arts Museums of San Francisco, M. H. de Young Memorial Museum, April 19–July 9, *The New Painting: Impressionism 1874–1886* (catalogue by Charles S. Moffett et al.), no. 4.
1988–89 Paris, Grand Palais, February 9–May 16, 1988; Ottawa, National Gallery of Canada, June 27–August 28, 1988; New York, The Metropolitan Museum of Art, September 27, 1988–January 8, 1989, *Degas* (catalogue by Jean Sutherland Boggs et al.), no. 95.
1992 *Crosscurrents*.
1994–95 Paris, Grand Palais, April 19–August 8, 1994; New York, The Metropolitan Museum of Art, September 19, 1994–January 8, 1995, *The Origins of Impressionism* (catalogue by Gary Tinterow and Henri Loyrette), no. 66.
1995 *The Real World*, no. 38.
1999 New Orleans, New Orleans Museum of Art, May 1–August 9; Copenhagen, Ordrupgaardsamlingen, September 16–November 28, *Degas and New Orleans: A French Impressionist in America* (catalogue by Jean Sutherland Boggs), no. 18.

Selected References
Boggs 1962, pp. 37, 92, note 6; Cabanne 1948, pp. 23, 27, 35, 97, 110; Clark 1973, p. 314; Coke 1964, pp. 15, 69, note 34; Colvin 1872; Cooper 1954, p. 22, note 1; Traz 1954, pp. 34–39; Dunlop 1979, p. 93; Grappe 1911, p. 18; Guerin ed. 1931, p. 65, note 1; Hertz 1929, p. 29; Jamot 1918, pp. 137–38; Jamot 1924, pp. 81, 141; Jenks 1927, pp. 2–3; Lafond 1918, vol. 1, p. 141; Lemoisne 1924, p. 27; Lemoisne 1946–49, vol. 1, pp. 70, 85, vol. 2, no. 281; Liebermann 1918, p. 6; Manson 1927, pp. 20, 46; Mauclair 1903, p. 35; McMullen 984, pp. 194–96; Meier-Graef 1923, p. 35; Murphy 1985, p. 75; Rewald 1946, p. 264; Rewald 1973, p. 311; Rich 1951, p. 52; Rivière 1935, p. 174; Russoli and Minervino 1970, no. 203; Scharf 1962, p. 191, fig. 7; Shinoda 1957, pp. 57–58, pl. 93; Sickert 1905, p. 101; Sutton 1984, p. 286, fig. 11; Waldman 1927, p. 95; Wolenski 1940, pp. 5, 9, 31.

Paul-Camille Guigou
Villars d'Apt (Vaucluse) 1834–1871 Paris

Guigou's first significant teacher, Émile Loubon (1809–1863), was the leader of the Provençal school of landscape painting and director of the École des Beaux-Arts at Marseilles, where Guigou's family settled in 1854. In Marseilles Guigou met the artist Adolphe Monticelli (1824–1886), with whom he remained close. Loubon and Monticelli encouraged Guigou to celebrate the landscape of his native Provence, which he painted with warm colors and in a hard light that makes sharp distinctions between forms. He visited Paris about 1855 and there admired the art of Gustave Courbet. In 1862, with his parents' approval, he stopped working as a notary and moved to the capital to pursue a career in art. In 1865 he painted at Moret and Triel, on the Seine, and also went to Algeria. He was befriended by the critic Théodore Duret, who took him to the Café Guerbois, where he met the artists who were to become the Impressionists. But Guigou kept his distance from Parisian trends, remaining true to his initial vision determined by the brilliant light of the South. His style and subject matter were established by the time he was twenty-eight, and although he exhibited each year at the Salon, beginning in 1863, he was not much noticed in the press and did not win prizes.

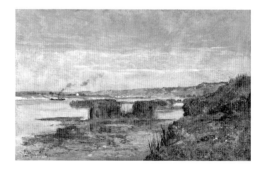

33 *View of Triel* 1865
Oil on panel, 28.5 × 45.7 cm
Gift of Ananda K. Coomaraswamy (22.669)

Provenance
Ananda K. Coomaraswamy, Boston, 1920 (?); given by Ananda K. Coomaraswamy to the Museum of Fine Arts, Boston, 1922.

Selected Exhibitions
1987 New York, W. Beadleston, Inc.; Columbus, Ohio, Columbus Museum of Art, 1987, *Paul Guigou 1834–1871*, no. 6.

Selected References
Bonnici 1989, no. 134; De Gail 1989, p. 92, no. 56; Murphy 1985, p. 127.

Paul Cézanne

Aix-en-Provence 1839–1906 Aix-en-Provence

Cézanne studied law for three years in his native Aix, and at the same time took lessons in the free municipal drawing school. His father finally relented and allowed him to go to Paris in the summer of 1861 to study art. Cézanne was unhappy there and returned to work in his father's bank. Restless, he was back in Paris in 1862. He enrolled again at the Académie Suisse, showed at the Salon des Refusés of 1863, and came to know, among others, Camille Pissarro, Claude Monet, and Pierre-Auguste Renoir. After 1864 Cézanne divided his time between Aix and Paris. Thanks to his prosperous family, he was able to devote himself entirely to his art.

Cézanne's early paintings are marked by romantic, violent, and erotic themes as well as a deep regard for the old masters. Pissarro introduced him to painting out-of-doors and to a new way of applying paint. Although Cézanne showed with Monet and his colleagues in their group exhibitions in 1874 and 1877, their emphasis on sensuousness and spontaneity was at odds with his vision of structure and solidity. He withdrew from them physically and artistically, living in Aix and no longer showing his work in the capital. Only in 1895 did Ambroise Vollard hold an exhibition of Cézanne's work in Paris, an event that galvanized young artists: the 1903 exhibition of more than thirty of his canvases at the Salon d'Automne established his reputation as a beacon for the twentieth-century vanguard.

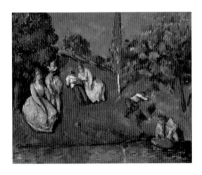

34 *The Pond* c. 1877–79
Oil on canvas, 47.0 × 56.2 cm
Tompkins Collection (48.244)

Provenance
Gustave Caillebotte (d. March 8, 1894), Paris, until 1894; Martial Caillebotte, Paris, c. 1894; Albert Chardeau, Paris; Matignon Art Galleries, Inc. (André Weil Gallery), Paris and New York, until 1948; purchased by the Museum of Fine Arts, Boston, February 12, 1948.

Selected Exhibitions
1905 Paris, Grand Palais, *Salon d'Automne*, no. 319 (?), called *Bord de rivière*.
1949 Manchester, N.H., Currier Gallery of Art, October–November, *Monet and the Beginnings of Impressionism*, no. 27.
1950 Richmond, Va., Museum of Fine Arts, October–November, *Impressionists and Post-Impressionists*.

1952 Montreal, Montreal Museum of Fine Arts, March 7–April 13, *Six Centuries of Landscape*, no. 55.
1956–57 The Hague, Gemeentemuseum, June–July 1956, no. 11; Zurich, Kunsthaus, no. 21; Cologne, Wallraf-Richartz Museum, December 1, 1956–January 31, 1957, *Cézanne*.
1970 New York, The Metropolitan Museum of Art, *One Hundred Paintings from the Boston Museum*, no. 64.
1971 Washington, D.C., The Phillips Collection; Chicago, The Art Institute of Chicago; Boston, Museum of Fine Arts, February 27–July 3, *Cézanne* (catalogue by John Rewald), no. 4.
1973 *Impressionism: French and American.*
1977 Cambridge, Mass., Fogg Art Museum, Harvard University, November.
1978 St. Petersburg, Fla., Museum of Fine Arts, September 30–November 5; Montgomery, Ala., Montgomery Museum of Art, November 17–December 31, *Symbolist Roots of Modern Painting*.
1979–80 *Corot to Braque*, no. 43.
1983–84 *Masterpieces of European Painting*, no. 53.
1992 *Crosscurrents.*
1996 Tokyo, Tobu Museum of Art, March 30–June 30, *The Birth of Impressionism.*
1997 Glasgow, McLellan Galleries, Burrell Collection, Glasgow Museums, May 22–September 7, *The Birth of Impressionism: From Constable to Monet*, pp. 24–25, 31.

Selected References
Berhaut 1978, p. 251; Bernard 1926, p. 32; Edgell 1949, p. 51; Geist 1975, p. 9; Kendall 1988, p. 108; Lewis 1989, p. 109, fig. 52; Lindsay 1969, fig. 32; Murphy 1985, p. 48; Rewald 1996, p. 172, fig. 244; Shiff 1984, fig. 24; Venturi 1936, vol. 1, p. 116, vol. 2, nos. 63, 232.

35 *Turn in the Road* 1882
Oil on canvas, 60.5 × 73.5 cm
Bequest of John T. Spaulding (48.525)

Provenance
Julien Tanguy, Paris (?); Théodore Duret, Paris, until 1894; Duret sale, Galeries Georges Petit, Paris, March 19, 1894, no. 3; Paul-César Helleu (d. 1927), Paris; Claude Monet, Giverny, until 1926; Michel Monet, Giverny, 1926–27; Paul Rosenberg and Co. (buying from Monet estate for Wildenstein), Paris, 1926–27; Wildenstein Galleries, Paris, 1926–27; John T. Spaulding, Boston, 1927; bequeathed by John T. Spaulding to the Museum of Fine Arts, Boston, June 3, 1948.

Selected Exhibitions
1928 New York, Wildenstein Galleries, *Paul Cézanne*, no. 14, called *Environs d'Aix-en-Provence.*
1929 Boston, Museum of Fine Arts.

Alfred Sisley

Paris 1839–1899 Moret-sur-Loing

Selected References

Andersen 1967, p. 139; Bizardel 1974, as no. 3 in the 1894 Duret sale; Bodelsen 1968, p. 345; Boisdeffre et al. 1966, p. 198; Cogniat 1939, p. 36; Cooper 1954, pp. 378–79; Edgell 1949, p. 51; Erpel 1958, pp. 20–21; Goldwater 1938, p. 149; Gowing 1956, pp. 185–92; Ikegame 1969, no. 18; Jewell 1944, p. 43; Lhôte 1939, no. 44; Lhôte 1958, no. 43; Murphy 1985, p. 48; Novotny 1937, p. 33; Pope 1930, p. 122; Rewald 1996, p. 330, no. 490; Raynal 1954, p. 55; Venturi 1978, p. 82; Vollard 1937, no. 30; Watson 1928, pp. 33, 35–36; Wilenski 1940, no. 15A.

Judging from his paintings, Sisley seems to have had a quieter personality than the other Impressionists. The son of British parents living in Paris, he retained his British citizenship his whole life. Sisley went to London in the late 1850s to prepare himself for a career in business. He used part of this time to visit museums, where he studied the work of British painters, particularly John Constable (1776–1837). On his return to Paris he found that his father was amenable to his studying art, and through an introduction from Frédéric Bazille (1841–1870) he entered Charles Gleyre's (1808–1874) studio in 1862. There he met Claude Monet and Pierre-Auguste Renoir and with them painted in the countryside around Paris, especially the Forest of Fontainebleau. He had limited success at the Salon in the late 1860s and participated in four of the eight Impressionist group exhibitions. He moved often in the 1870s, always close to Paris. In 1880 he settled in the area where the river Loing empties into the Seine, beyond Barbizon and Fontainebleau, and remained there until his death. The Franco-Prussian War ruined his father financially, and from 1871 Sisley had to support himself, his mistress, and their two sons solely on the sales of his paintings. Despite a coterie of collectors, the dealings of Durand-Ruel and Georges Petit, and inclusion in major exhibitions, Sisley did not enjoy financial success. He concentrated on landscapes of the region in which he lived, and his canvases are marked by a calmness of mood and a brightness of palette.

36 *Waterworks at Marly* 1876
Oil on canvas, 46.5 × 61.8 cm
Gift of Miss Olive Simes (45.662)

Provenance
Durand-Ruel, Paris and New York (?); William Simes, Boston, after 1910;
Olive Simes, Boston, 1945; given by Olive Simes to the Museum of Fine
Arts, Boston, September 13, 1945.

Selected Exhibitions
1973 *Impressionism: French and American*, no. 86.
1983–84 *Masterpieces of European Painting*, no. 51.
1992–93 London, Royal Academy of Arts, July 3–October 18, 1992; Paris,
 Musée d'Orsay, October 28, 1992–January 31, 1993; Baltimore,
 Walters Art Gallery, March 14–June 13, 1993, *Alfred Sisley*
 (catalogue edited by MaryAnne Stevens), no. 20.
1995–96 London, Hayward Gallery, May 18–August 28, 1995; Boston,
 Museum of Fine Arts, October 4, 1995–January 14, 1996,
 Impressions of France: Monet, Renoir, Pissarro, and Their Rivals
 (catalogue by John House), no. 83.
1996–97 Washington, D.C., The Phillips Collection, September 21, 1996–
 February 23, 1997, *Impressionists on the Seine: A Celebration of
 Renoir's "Luncheon of the Boating Party"* (catalogue by Charles S.
 Moffett et al.), no. 46.

Selected References
Bulletin of the Museum of Fine Arts (Boston), vol. 44, no. 255 (February 1946),
p. 30; Constable 1955, p. 61; Daulte 1959, no. 216; Murphy 1985, p. 264;
Stevens 1992, no 20.

37 *Overcast Day at Saint-Mammès* c. 1880
Oil on canvas, 54.8 × 74.0 cm
Juliana Cheney Edwards Collection (39.679)

Provenance
Durand-Ruel, Paris, October 28, 1880; Juliana Cheney Edwards, Boston,
1889; Hannah Marcy Edwards (d. 1931), Boston, until 1931; Grace M.
Edwards (d. 1939), Boston, 1931; bequeathed by Grace M. Edwards to
the Museum of Fine Arts, Boston, October 11, 1939.

Selected Exhibitions
1882 Paris, *Septième exposition des artistes indépendants*, no. 169.
1899 Paris, probably Durand-Ruel, *Monet, Pissarro, Renoir, Sisley*, no. 137.
1905 London, probably Grafton Galleries, *Paintings by Boudin, Cézanne,
 Degas, Manet, Monet, Morisot, Pissarro, Renoir, Sisley*, no. 292, called
 The rue du bord de l'eau at Saint-Mammès – Dull Weather.
1939–40 *Juliana Cheney Edwards Collection*, no. 54.
1945 New London, Conn., Lyman Allen Museum, Connecticut College.
1946 Pittsfield, Mass., Berkshire Museum.
1951 Providence, R.I., Rhode Island School of Design, *Paris in Paintings*.
1973 *Impressionism: French and American*, no. 88.
1979–80 *Corot to Braque*, no. 40.
1986 Washington, D.C., National Gallery of Art, January 17–April 6;
 San Francisco, Fine Arts Museums of San Francisco, M. H. de Young
 Memorial Museum, April 19–July 9, *The New Painting: Impressionism
 1874–1886* (catalogue by Charles S. Moffett et al.), no. 135.
1988 Springfield, Mass., Springfield Museum of Fine Arts, September 25–
 November 27, *Lasting Impressions: French and American Impressionism
 from New England Museums* (catalogue by Jean C. Harris, Steven
 Kern, and Bill Stern), no. 23.
1989 *From Neoclassicism to Impressionism*, no. 65.
1991 Nagoya, Matsuzakaya Museum of Art, March 21–April 28; Nara,
 Nara Prefectural Museum of Art, May 3–June 16; Hiroshima,
 Hiroshima Museum of Art, June 22–July 28, *World Impressionism
 and Pleinairism* (catalogue by R. J. Boyle and Herwig Todts), no. 19.
1992–93 *Monet and His Contemporaries*, no. 53.
1996 Copenhagen, Ordrupgaardsamlingen, September 6–December 1,
 Impressionism, the City, and Modern Life (catalogue by Anne-Birgitte
 Fonsmark), no. 36.

Selected References
Berson 1996, vol. 1, pp. 395, 400, vol. 2, pp. 212–13, no. VII-169;
Cunningham 1939b, pp. 107, 110, no. 54; Daulte 1959, no. 374; Edgell
1949, pp. 52–53; Murphy 1985, p. 264.

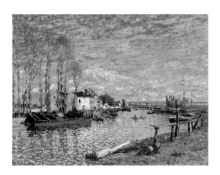

38 *The Loing at Saint-Mammès* 1882
Oil on canvas, 49.8 × 65.0 cm
Bequest of William A. Coolidge (1993.44)

Provenance
Durand-Ruel, Paris, until December 11, 1890; Coquelin Cadet, Paris, until May 27, 1893; Bernheim-Jeune, Paris, until November 15, 1934; Wildenstein and Co., Paris, November 15, 1934; William A. Coolidge, Boston, August 5, 1936; bequeathed by William A. Coolidge to the Museum of Fine Arts, Boston, 1993.

Selected Exhibitions
1966 New York, Wildenstein and Co., October 26–December 3, 1966, *Sisley*.

Selected References
Besson 1946, no. 37; Daulte 1959, no. 461; Stevens 1992, p 56; Sutton 1995, pp. 84–86, no. 17.

Claude Monet
Paris 1840–1926 Giverny

Monet's prodigious talent as an artist was first recognized by Eugène Boudin, whom he met in Le Havre in 1858. Boudin encouraged Monet to give up drawing caricatures and to paint out-of-doors, which he did in the company of both Boudin and Johan Barthold Jongkind. Monet's short tenure (1862–64) in the atelier of Charles Gleyre (1808–1874) was decisive, for not only did Gleyre encourage his students to go their own way, but it was there that Monet met Pierre-Auguste Renoir, Alfred Sisley, and Frédéric Bazille (1841–1870). After limited success at the Salon during the 1860s, Monet became a leader of the group that exhibited independently of the Salon; they came to be called the Impressionists, after the title of one of Monet's canvases. Monet chose to live not in Paris but in the suburbs ever farther from the art capital, drawing on his surroundings for motifs. For additional challenges he traveled to the coasts of France, as well as to Norway, London, and Venice. He was a canny businessman, playing dealers off one another and carefully orchestrating his exhibitions and their attendant publicity. In 1883 he moved to Giverny, some sixty kilometers northwest of Paris, and in 1890 bought property there. He worked on the grounds for decades, diverting streams and maintaining a water garden. The area around Giverny and his gardens provided the subjects for his series of paintings of single motifs.

39 *Rue de la Bavolle, Honfleur* c. 1864
Oil on canvas, 55.9 × 61.0 cm
Bequest of John T. Spaulding (48.580)

Provenance
Aimé Diot, Paris, until March 8–9, 1897; Diot sale, Hôtel Drouot, Paris, March 8–9, 1897, no. 102, called *Une rue*; Arthur Tooth and Sons, London, 1897; Durand-Ruel, Paris, 1902; Galerie Thannhauser, Munich, 1912; Oskar Schmitz collection, Dresden, 1915, no. 40; Wildenstein and Co., London, New York, and Paris, 1936; John T. Spaulding, Boston, 1940; bequeathed by John T. Spaulding to the Museum of Fine Arts, Boston, June 3, 1948.

Selected Exhibitions

1949 Cambridge, Mass., Fogg Art Museum, Harvard University.

1949 Manchester, N.H., Currier Gallery of Art, December 1, 1939–
 January 15, 1940, *Monet and the Beginnings of Impressionism*,
 no. 34.

1952 The Hague, Gemeentemuseum; Zurich, Kunsthaus, July 24–
 September 22, *Claude Monet*.

1953 Kansas City, Mo., William Rockhill Nelson Gallery of Art, *20th
 Anniversary Exhibition*.

1957 Edinburgh, Royal Scottish Academy, August 6–September 15;
 London, Tate Gallery, September 26–November 3, *An Exhibition
 of Paintings: Claude Monet*, no. 8.

1972 Providence, R.I., Rhode Island School of Design, February 3–
 March 5, *To Look on Nature* (not in catalogue).

1973 *Impressionism: French and American*, no. 26.

1975 Chicago, The Art Institute of Chicago, March 15–May 11,
 Paintings by Monet, no. 5.

1977–78 Boston, Museum of Fine Arts, November 8, 1977–January 15,
 1978, *The Second Greatest Show on Earth: The Making of a Museum*
 (organized by the Archives of American Art, Boston), no. 2.

1977–78 *Monet Unveiled*, no. 2.

1980 Paris, Grand Palais, February 8–May 5, *Monet*, no. 13.

1983–84 *Masterpieces of European Painting*, no. 56.

1985 Boston, Museum of Fine Arts, February 13–June 2, *The Great Boston
 Collectors: Paintings from the Museum of Fine Arts, Boston* (catalogue
 by Carol Troyen and Pamela S. Tabbaa), no. 52.

1985 Williamstown, Mass., Sterling and Francine Clark Art Institute,
 June 8–October 6, *Monet in Massachusetts* (catalogue by John H.
 Brooks).

1992 *Crosscurrents*.

1992–93 *Monet and His Contemporaries*, no. 21.

1994–95 Paris, Grand Palais, April 19–August 8, 1994; New York, The
 Metropolitan Museum of Art, September 19, 1994–January 4,
 1995, *The Origins of Impressionism* (catalogue by Gary Tinterow
 and Henri Loyrette), no. 124.

1996 Tokyo, Tobu Museum of Art, March 30–June 30, *The Birth of
 Impressionism.*.

Selected References

Bierman 1913, p. 325; Champa 1973, p. 5, fig. 5; Dormoy 1926, p. 342;
Isaacson 1978, pp. 55, 194, 195, fig. 7; Isaacson 1984, pp. 16–35; Katalog
1916, p. 21, no. 16; Malingue 1943, pp. 22, 33, 145, no. 33; Murphy 1985,
p. 209; Reuterswürd 1948, p. 281; Rewald 1961, p. 128; Scheffler 1921,
pp. 178, 186; Seitz 1960, pp. 19, 22, nos. 15, 16; Tucker 1982, pp. 27, 29,
fig. 12; Weisberg et al. 1975, p. 117, no. 31; Wildenstein 1974–91, no. 33;
Wildenstein 1996, no. 33.

40 *Snow at Argenteuil* c. 1874
Oil on canvas, 54.6 × 73.8 cm
Bequest of Anna Perkins Rogers (21.1329)

Provenance

Durand-Ruel, Paris, April 29, 1890, no. 305; Anna Perkins Rogers, Boston,
June 14, 1890; bequeathed by Anna Perkins Rogers to the Museum of Fine
Arts, Boston, 1921.

Selected Exhibitions

1879 Paris, Fourth Impressionist Exhibition, no. 159.

1892 Boston, St. Botolph Club, *Monet*, no. 19.

1899 Boston, St. Botolph Club, *Monet*, no. 6.

1903 Boston, Copley Society, *Old Masters*, no. A8.

1905 Boston, Copley Society, March, *Monet*, no. 6.

1911 Boston, Museum of Fine Arts, *Monet*, no. 38.

1927 Boston, Museum of Fine Arts, January 11–February 6, *Claude
 Monet Memorial Exhibition*, no. 3.

1940 San Francisco, *Golden Gate International Exhibition*, no. 286.

1949 Boston, Symphony Hall.

1957 Edinburgh, Royal Scottish Academy, August 6–September 15;
 London, Tate Gallery, September 26–November 3, *An Exhibition
 of Paintings: Claude Monet*, no. 41.

1973 *Impressionism: French and American*, no. 30.

1976 New York, Acquavella Galleries, October 27–November 28,
 Paintings by Claude Monet, no. 22.

1977–78 *Monet Unveiled*, no. 6.

1979–80 *Corot to Braque*, no. 46.

1985 Williamstown, Mass., Sterling and Francine Clark Art Institute,
 June 8–October 6, *Monet in Massachusetts* (catalogue by John H.
 Brooks).

1989 *From Neoclassicism to Impressionism*, no. 68.

1992 *Crosscurrents*.

1992–93 *Monet and His Contemporaries*, no. 22.

1996 Tokyo, Tobu Museum of Art, March 30–June 30, *The Birth of
 Impressionism.*

1998–99 Washington, D.C., The Phillips Collection, September 19, 1998–
 January 3, 1999; San Francisco, Fine Arts Museums of San Francisco
 at the Center for the Arts at Yerba Buena Gardens, January 30–
 May 2, 1999, *Impressionists in Winter: Effets de Neige* (catalogue by
 Charles S. Moffett et al.), no. 9.

Selected References

Gordon and Forge 1983, p. 64; House 1986, p. 168; Murphy 1985, p. 205;
Petrie 1979, p. 52; Reuterswürd 1948, p. 282; Seitz 1960, pp. 29, 100, 101;
Stuckey 1985, pp. 58, 104; Tucker 1982, pp. 48–49; Wildenstein 1974–91,
no. 348; Wildenstein 1996, no. 348.

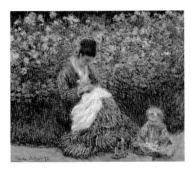

41 *Camille Monet and a Child in the Artist's Garden in Argenteuil* 1875
Oil on canvas, 55.3 × 64.7 cm
Anonymous Gift in Memory of Mr. and Mrs. Edwin S. Webster (1976.833)

Provenance
Clément Courtois, Paris, October 1875; Julius Oehme, Paris (?); Durand-Ruel, Paris and New York, 1900; Desmond Fitzgerald, Boston, 1905; Edwin S. Webster, Boston, April 21, 1927; private collection, New York, 1972; given by an anonymous donor to the Museum of Fine Arts, Boston, 1976.

Selected Exhibitions
1905 Boston, Copley Society, March, *Monet*, no. 29.
1911 Boston, Museum of Fine Arts, *Monet*, no. 36.
1914 Boston, Copley Society, *Portraits by Living Painters*, no. 46.
1939 Boston, Museum of Fine Arts, June 9–September 10, *Art in New England: Paintings, Drawings, and Prints from Private Collections in New England*, no. 82.
1945 New York, Wildenstein Galleries, *Monet*, no. 22.
1949 Manchester, N.H., Currier Gallery of Art, October–November, *Monet and the Beginnings of Impressionism*.
1977–78 *Monet Unveiled*, no. 8.
1978 Tokyo, National Museum of Western Art, April 25–June 11, *Boston Museum of Fine Arts: Human Figures in Fine Arts*, no. 35.
1979 Tokyo, Isetan Museum of Art, September 26–November 6; Kyoto, Kyoto Municipal Museum of Art, November 10–December 9, 1979, *Renoir*, no. 12.
1989 *From Neoclassicism to Impressionism*, no. 69.
1991–92 *Claude Monet: Impressionist Masterpieces*.
1992 *Crosscurrents*.
1992–93 *Monet and His Contemporaries*, no. 23.
1994 Tokyo, Bridgestone Museum of Art, February 11–April 7; Nagoya, Nagoya City Art Museum, April 16–June 12; Hiroshima, Hiroshima Museum of Art, June 18–July 31, *Monet: A Retrospective* (catalogue by Paul Hayes Tucker et al.), no. 25.
1995 *The Real World*, no. 42.

Selected References
Geffroy 1920, p. 68, no. 11; Murphy 1985, p. 209; Reuterswärd 1948, p. 87; Seitz 1960, p. 102; Tucker 1982, p. 149, fig. 121; Wildenstein 1974–91, no. 302; Wildenstein 1996, no. 302.

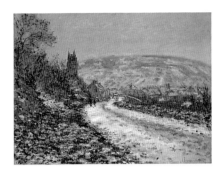

42 *Entrance to the Village of Vétheuil in Winter* 1879
Oil on canvas, 60.6 × 81.0 cm
Gift of Julia C. Prendergast in Memory of her brother, James Maurice Prendergast (21.7)

Provenance
Bascle, Paris, February 1880, called *Vue de Vétheuil*; Charles Bonnemaison-Bascle sale, Hôtel Drouot, Paris, May 3, 1890, no. 3; Williams and Everett, New York, May 3, 1890; James Maurice Prendergast (d. 1899), Boston, July 1891; Julia C. Prendergast, Boston, 1899; given by Julia C. Prendergast to the Museum of Fine Arts, Boston, January 18, 1921.

Selected Exhibitions
1899 Boston, St. Botolph Club, *Monet*, no. 7.
1905 Boston, Copley Society, March, *Monet*, no. 91.
1941 New London, Conn., Lyman Allen Museum, Connecticut College.
1945 New London, Conn., Lyman Allen Museum, Connecticut College.
1949 Boston, Symphony Hall.
1952 Boston, Simmons College, November 3–10, *Mid-Century Jubilee*.
1956 Binghamton, N.Y., Robertson Memorial Center, *Impressionist Painting*.
1957 St. Louis, Mo., City Art Museum of St. Louis, September 25–October 22; Minneapolis, Minneapolis Institute of Arts, *Claude Monet*.
1960 New York, The Museum of Modern Art, March 7–May 15; Los Angeles, Los Angeles County Museum of Art, June 14–August 7, *Claude Monet: Seasons and Moments* (catalogue by William C. Seitz), no. 20.
1960 Portland, Oreg., Portland Art Association, September 8–October 2, *Monet Exhibition*.
1973 *Impressionism: French and American*, no. 34.
1975 Chicago, The Art Institute of Chicago, March 15–May 11, *Paintings by Monet*, no. 50.
1977–78 *Monet Unveiled*, no. 10.
1991–92 *Claude Monet: Impressionist Masterpieces*.
1992–93 *Monet and His Contemporaries*, no. 26.
1995–96 London, Hayward Gallery, May 18–August 28, 1995; Boston, Museum of Fine Arts, October 4, 1995–January 14, 1996, *Impressions of France: Monet, Renoir, Pissarro, and Their Rivals* (catalogue by John House), no. 94.

Selected References
Isaacson 1978, p. 109, fig. 61; Murphy 1985, p. 205; Reuterswärd 1948, pp. 121, 283; Seiberling 1981, p. 52; Tucker 1982, p. 155, fig. 126; Wildenstein 1974–91, no. 509; Wildentsein 1996, no. 509.

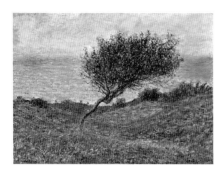

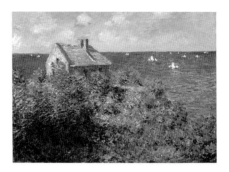

43 *Sea Coast at Trouville* 1881
Oil on canvas, 60.7 × 81.4 cm
John Pickering Lyman Collection (19.1314)

Provenance
Durand-Ruel, Paris, June 1882; Galeries Georges Petit, Paris; with Leroux, Paris, after August 1883; Leroux sale, Hôtel Drouot, Paris, February 27–28, 1888, no. 61; Durand-Ruel, Paris, 1888; Mrs. Catholina Lambert, Patterson, N.J., 1888 (?); Durand-Ruel, New York, February 28, 1899; John Pickering Lyman (d. 1914), Portsmouth, N.H., April 13, 1907; Theodora Lyman (d. 1919), Portsmouth, N.H., 1914; given by Theodora Lyman to the Museum of Fine Arts, Boston, 1919.

Selected Exhibitions
1882 Paris, *Septième exposition des artistes indépendants*, no. 84.
1886 Brussels, *Libre Esthétique des Vingtistes.*
1886 New York, American Art Association, *Impressions of Paris*, no. 268.
1907 New York, Durand-Ruel, *Monet*, no. 13.
1927 Boston, Museum of Fine Arts, January 11–February 6, *Claude Monet Memorial Exhibition*, no. 9.
1939 Williamstown, Mass., Williams College.
1941 Norfolk, Va., Norfolk Museum of Arts and Sciences, February 2–March 30; Colorado Springs, Colorado Springs Fine Arts Center, May 15–July 1, *French Impressionists*, no. 6.
1963 Wellesley, Mass., Wellesley College, Jewett Arts Center, January 1–May 1.
1965 Albuquerque, N. Mex., University of New Mexico Art Gallery, February 9–March 14; San Francisco, M. H. de Young Memorial Museum, March 30– May 5, *Impressionism in America*, p. 6.
1973 *Impressionism: French and American*, no. 36.
1977–78 *Monet Unveiled*, no. 13.
1979–80 *Corot to Braque*, no. 48.
1991–92 *Claude Monet: Impressionist Masterpieces.*
1992 *Crosscurrents.*
1992–93 *Monet and His Contemporaries*, no. 27.

Selected References
Alexandre 1908, p. 98; Berson 1996, vol. 2, pp. 206, 223, VII-84; Boston 1921, no. 361; "Collection de tableaux de M. Charles Leroux" 1888, p. 1; Murphy 1985, p. 205; Reuterswärd 1948, p. 289; Seitz 1960, p. 30; Wildenstein 1974–91, no. 687; Wildenstein 1996, no. 687.

44 *Fisherman's Cottage on the Cliffs at Varengeville* 1882
Oil on canvas, 60.5 × 81.5 cm
Bequest of Anna Perkins Rogers (21.1331)

Provenance
Durand-Ruel, Paris, October 1882; Galeries Georges Petit, Paris, August 1883; Porto Riche collection, Paris, until May 14, 1890; Durand-Ruel, Paris, 1890, no. 22; Anna Perkins Rogers, Boston, 1890; bequeathed by Anna Perkins Rogers to the Museum of Fine Arts, Boston, 1921.

Selected Exhibitions
1955 Atlanta, Atlanta Art Association; Birmingham, Ala., Birmingham Museum of Art, *French Painting*, no. 21.
1960 New York, The Museum of Modern Art, March 7–May 15; Los Angeles, Los Angeles County Museum of Art, June 14–August 7, *Claude Monet: Seasons and Moments* (catalogue by William C. Seitz).
1960 Portland, Oreg., Portland Art Association, September 8–October 2, *Monet Exhibition.*
1971 Hagerstown, Md., Washington County Museum, September, *Exhibition of the Works of Claude Monet.*
1973 *Impressionism: French and American*, no. 34.
1977–78 *Monet Unveiled*, no. 14.
1985 Auckland, Auckland City Art Gallery, April 29–June 9; Sydney, Art Gallery of New South Wales, June 21–August 4; Melbourne, National Gallery of Victoria, August 14–September 29, *Claude Monet: Painter of Light*, no. 12.
1989 *From Neoclassicism to Impressionism*, no. 70.
1991–92 *Claude Monet: Impressionist Masterpieces.*
1992–93 *Monet and His Contemporaries*, no. 29.
1995–96 London, Hayward Gallery, May 18–August 28, 1995; Boston, Museum of Fine Arts, October 4, 1995–January 14, 1996, *Impressions of France: Monet, Renoir, Pissarro, and Their Rivals* (catalogue by John House), no. 100.

Selected References
Herbert 1979, p. 108; Herbert 1988, p. 300, fig. 307; Herbert 1994, pp. 48, 54, figs. 1, 56, 57; House 1986, p. 120, no. 151; Murphy 1985, p. 205; Reuterswärd 1948, p. 284; Wildenstein 1974–91, no. 805; Wildenstein 1996, no. 805.

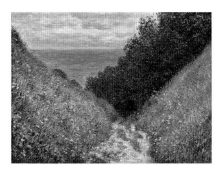

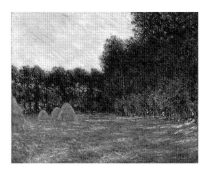

45 *Road at La Cavée, Pourville* 1882
Oil on canvas, 60.4 × 81.5 cm
Bequest of Mrs. Susan Mason Loring (24.1755)

46 *Meadow with Haystacks near Giverny* 1885
Oil on canvas, 74.0 × 93.5 cm
Bequest of Arthur Tracy Cabot (42.541)

Provenance
Durand-Ruel, Paris, October 1882; Williams & Everett, New York, 1882;
Charles Fairchild, New York, 1888; Durand-Ruel, Paris and New York,
December 3, 1898, no. 5765; William Caleb Loring, Boston, April 3, 1903;
Susan Mason Loring, Boston, 1924; bequeathed by Susan Mason Loring to the
Museum of Fine Arts, Boston, September 6, 1924.

Provenance
Durand-Ruel, Paris, December 1885; Bernheim-Jeune, Paris, 1886;
Durand-Ruel, Paris and New York, 1886, no. 792; Eastman Chase, Boston,
1897; Arthur Tracy Cabot, Boston, 1899; bequeathed by Arthur Tracy Cabot
to the Museum of Fine Arts, Boston, November 12, 1942.

Selected Exhibitions
1905 Boston, Copley Society, March, *Monet*, no. 35.
1957 Cambridge, Mass., Fogg Art Museum, Harvard University, *French
 Paintings*.
1960 Boston, Institute of Contemporary Art, May–August, *The Image
 Lost and Found*.
1973 *Impressionism: French and American*, no. 38.
1977–78 *Monet Unveiled*, no. 15.
1991–92 *Claude Monet: Impressionist Masterpieces*.
1992 *Crosscurrents*.
1992–93 *Monet and His Contemporaries*, no. 30.
1995–96 Boston, Museum of Fine Arts, October 4, 1995–January 14, 1996,
 Landscapes of France.
1998 Graz, Neue Galerie am Landesmuseum Joanneum, September 4–
 November 30, *Chemins de l'Impressionnisme: Normandy-Paris,
 1860–1910*.

Selected Exhibitions
1954 Cambridge, Mass., Busch-Reisinger Museum, Harvard University,
 February 12–March 20, *Impressionism and Expressionism*, no. 9.
1979–80 *Corot to Braque*, no. 107.
1986–87 Boston, Museum of Fine Arts, June 11–September 15, 1986;
 Denver, Denver Art Museum, October 25, 1986–January 18, 1987;
 Chicago, Terra Museum of American Art, March 13–May 10, 1987,
 The Bostonians: Painters of an Elegant Age (catalogue by Trevor J.
 Fairbrother), no. 17.
1991–92 *Claude Monet: Impressionist Masterpieces*.
1992–93 *Monet and His Contemporaries*, no. 32.
1995–96 London, Hayward Gallery, May 18–August 18, 1995; Boston,
 Museum of Fine Arts, October 4, 1995–January 14, 1996,
 Impressions of France: Monet, Renoir, Pissarro, and Their Rivals
 (catalogue by John House), no. 107.
1997–98 Norfolk, Va., Chrysler Museum of Art, July 15, 1997–January 15,
 1998.

Selected References
Geffroy 1922, p. 107; Gordon and Forge 1983, p. 138; Kendall 1989, p. 137;
Murphy 1985, p. 206; Stuckey 1985, pp. 95–97; Wildenstein 1974–91,
no. 762; Wildenstein 1996, no. 762.

Selected References
Herbert 1979, pp. 92, 94–95, figs. 1–2; Herbert 1994, p. 97, fig. 106; House
1986, pp. 94, 96, 238 note 30, fig. 132; Murphy 1985, p. 208; Reuterswärd
1948, p. 286; Seiberling 1981, p. 87; Stuckey 1985, p. 370; Wildenstein
1974–91, no. 995; Wildenstein 1996, no. 995.

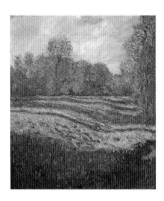

47 *Meadow at Giverny* 1886
Oil on canvas, 92.0 × 81.5 cm
Juliana Cheney Edwards Collection (39.670)

Provenance
Galeries Georges Petit, Bernheim-Jeune, and Montaignac, Paris, 1898; Jos. Hessel, Paris; Alexandre Barthier, Prince de Wagram, Paris, until April 14, 1914; Durand-Ruel, Paris, April 14, 1914, no. 10519; Durand-Ruel, New York, November 11, 1915, no. 3897; Hannah Marcy Edwards (d. 1931), Boston, March 20, 1916; Grace M. Edwards (d. 1939), Boston, 1931; bequeathed by Hannah Marcy Edwards to the Museum of Fine Arts, Boston, October 11, 1939.

Selected Exhibitions
1887　New York, National Academy of Design, May 25–June 30, *Celebrated Paintings by French Masters*, no. 156.
1891　Boston, Chase Gallery, *The Impressionists of Paris: Monet, Pissarro, Sisley*, no. 3.
1900　New York, Durand-Ruel, *Monet and Renoir*, no. 1.
1902　New York, Durand-Ruel, *Monet*, no. 21.
1919–20　Boston, Museum of Fine Arts, December 1919–January 1920, *Impressionist and Barbizon Schools*.
1927　Boston, Museum of Fine Arts, January 11–February 6, *Claude Monet Memorial Exhibition*, no. 41.
1939–40　*Juliana Cheney Edwards Collection*, no. 37.
1941　Norfolk, Va., Norfolk Museum of Arts and Sciences, February 2–March 30; Colorado Springs, Colorado Springs Fine Arts Center, May 15–July 1, *French Impressionists*.
1945　New York, Wildenstein Galleries, *Monet*, no. 52.
1949　Boston, Symphony Hall.
1971　Hagerstown, Md., Washington County Museum, September, *Exhibition of the Works of Claude Monet*.
1973　*Impressionism: French and American*, no. 42.
1974–75　Berkeley, Calif., University Art Museum, University of California.
1977–78　*Monet Unveiled*, no. 19.
1979–80　*Corot to Braque*, no. 50.
1984　Miami, Center for Fine Arts, January 12–April 22, *In Quest of Excellence* (catalogue by Jan van der Marck), no. 119.
1991–92　*Claude Monet: Impressionist Masterpieces.*
1992–93　*Monet and His Contemporaries*, no. 38.
1997–98　Norfolk, Va., Chrysler Museum of Art, July 15, 1997–January 15, 1998.

Selected References
Murphy 1985, p. 208; Reuterswärd 1948, p. 285; Wildenstein 1974–91, no. 1083; Wildenstein 1996, no. 1083.

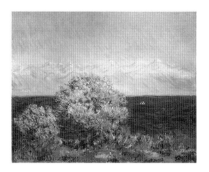

48 *Cap d'Antibes, Mistral* 1888
Oil on canvas, 66.0 × 81.3 cm
Bequest of Arthur Tracy Cabot (42.542)

Provenance
Durand-Ruel, Paris and New York, 1890; J. Eastman Chase, Boston, 1892; Mr. and Mrs. Arthur Tracy Cabot, Boston, 1903; bequeathed by Arthur Tracy Cabot to the Museum of Fine Arts, Boston, November 12, 1942.

Selected Exhibitions
1905　Boston, Copley Society, March, *Monet*, no. 37.
1945　Wellesley, Mass., Wellesley College, Farnsworth Museum.
1949　Boston, Symphony Hall.
1957　Edinburgh, Royal Scottish Academy, August 6–September 15; London, Tate Gallery, September 26–November 3, *An Exhibition of Paintings: Claude Monet*, no. 86.
1959–60　Cologne, Wallraf-Richartz Museum, November 1, 1959–May 1, 1960.
1973　*Impressionism: French and American*, no. 46.
1977–78　*Monet Unveiled*, no. 24.
1979–80　London, Royal Academy of Arts, November 17, 1979–March 16, 1980, no. 171; Washington, D.C., National Gallery of Art, May 25–September 1, 1980, *Post-Impressionism*, no. 25.
1985　Williamstown, Mass., Sterling and Francine Clark Art Institute, June 8–October 6, *Monet in Massachusetts* (catalogue by John H. Brooks).
1989–90　Paris, Musée Rodin, November 14, 1989–January 21, 1990, *Monet-Rodin, 1889–1989.*
1991–92　*Claude Monet: Impressionist Masterpieces.*
1992–93　*Monet and His Contemporaries*, no. 37.
1995–96　London, Hayward Gallery, May 18–August 28, 1995; Boston, Museum of Fine Arts, October 4, 1995–January 14, 1996, *Impressions of France: Monet, Renoir, Pissarro, and Their Rivals* (catalogue by John House), no. 112.
1997–98　Fort Worth, Tex., Kimbell Art Museum, June 8–September 7, 1997; Brooklyn, N.Y., Brooklyn Museum of Art, October 10, 1997–January 18, 1998, *Monet and the Mediterranean* (catalogue by Joachim Pissarro), no. 138.

Selected References
House 1986, p. 168, fig. 206; Küster 1992, no. 17; Murphy 1985, p. 208; Murphy et al. 1977, p. 37; Reuterswärd 1948, p. 285; Wildenstein 1974–91, no. 1176; Wildenstein 1996, no. 1176.

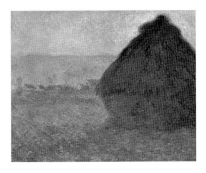

49 *Grainstack (Sunset)* 1891
Oil on canvas, 73.3 × 92.6 cm
Juliana Cheney Edwards Collection (25.112)

Provenance
Knoedler & Co., London, September 1891; James F. Sutton, New York, after
September 1891; Sutton sale, American Art Association, New York, January 17,
1917, no. 156; Durand-Ruel, New York, 1917; Robert J. Edwards (d. 1924),
Boston, 1917; Hannah Marcy Edwards (d. 1931) and Grace M. Edwards
(d. 1939), Boston, 1924; bequeathed by the Edwards sisters to the Museum
of Fine Arts, Boston, April 2, 1925.

Selected Exhibitions
1891 Paris, Durand-Ruel, *Monet: Les meules* (probably included in the
 series of grainstacks).
1905 Boston, Copley Society, March, *Monet*, no. 66.
1919–20 Boston, Museum of Fine Arts, December 1919–January 1920,
 Impressionist and Barbizon Schools.
1927 Boston, Museum of Fine Arts, January 11–February 6, *Claude
 Monet Memorial Exhibition*, no. 16.
1939–40 *Juliana Cheney Edwards Collection*, no. 38.
1942 Lubbock, Tex., Texas Technological College of Art Institute.
1942 Santa Barbara, Calif., Santa Barbara Museum of Art.
1949 Boston, Symphony Hall.
1950–51 Boston, School of the Museum of Fine Arts.
1954 Cambridge, Mass., Busch-Reisinger Museum, Harvard University,
 February 12–March 20, *Impressionism and Expressionism*, no. 8.
1955 Cambridge, Mass., Fogg Art Museum, Harvard University,
 May 2–31, *From Sisley to Signac*, no. 15.
1957 Cambridge, Mass., Fogg Art Museum, Harvard University, *French
 Painting.*
1957 Edinburgh, Royal Scottish Academy, August 6–September 15;
 London, Tate Gallery, September 26–November 3, *An Exhibition of
 Paintings: Claude Monet*, no. 93.
1960 New York, The Museum of Modern Art, March 7–May 15; Los
 Angeles, Los Angeles County Museum of Art, June 14–August 7,
 Claude Monet: Seasons and Moments (catalogue by William C. Seitz),
 no. 50.
1960 Portland, Oreg., Portland Art Association, September 8–October 2,
 Monet Exhibition.
1973 *Impressionism: French and American*, no. 50.
1977–78 *Monet Unveiled*, no. 29.

1978 New York, The Metropolitan Museum of Art, April 19–July 9;
 St. Louis, Mo., St. Louis Art Museum, late July–September 15,
 Monet's Years at Giverny: Beyond Impressionism, no. 14.
1979–80 Copenhagen, Ordrupgaardsamlingen, November 16, 1979–
 January 11, 1980, *Late Paintings by Monet*, no. 4.
1983 Paris, Centre Culturel du Marais, April 6–July 31, *Claude Monet
 au temps de Giverny*, no. 43.
1984–85 Los Angeles, Los Angeles County Museum of Art, June 28–
 September 9, 1984; Chicago, The Art Institute of Chicago,
 October 18, 1984–January 6, 1985; Paris, Grand Palais,
 February 4–April 22, 1985, *A Day in the Country: Impressionism
 and the French Landscape*, no. 104.
1985 Williamstown, Mass., Sterling and Francine Clark Art Institute,
 June 8–October 6, *Monet in Massachusetts* (catalogue by John H.
 Brooks).
1986 Madrid, Museo Español de Arte Contemporáneo, April 29–June 30,
 Claude Monet, no. 69.
1990 Boston, Museum of Fine Arts, February 7–April 29; Chicago, The
 Art Institute of Chicago, May 19–July 21; London, Royal Academy
 of Arts, September 7–December 9, *Monet in the '90s: The Series
 Paintings* (catalogue by Paul Hayes Tucker), no. 30.
1991–92 *Claude Monet: Impressionist Masterpieces.*
1992 *Crosscurrents.*
1992–93 *Monet and His Contemporaries*, no. 41.
1995–96 Dallas, Tex., Dallas Museum of Art, May 18, 1995–January 14,
 1996.
1997–98 Göteborg, Göteborg Konstmuseum, October 11, 1997–January 4,
 1998, *Monet.*

Selected References
"Claude Monet Exhibit Opens" 1905, p. 9; Geffroy 1922, p. 189; Gordon
and Forge 1983, p. 162; Greenberg 1961, pp. 37–46; Herbert 1979, p. 106,
fig. 18; House 1986, pp. 28, 98, 128, 176, 178, 197, 199, fig. 162; Murphy
1985, p. 207; Reuterswärd 1948, p. 286; Rewald and Weitzenhoffer 1984,
pp. 139–60, fig. 67; Seiberling 1981, pp. 94, 97, 360, figs. 14, 33; Seitz 1956,
pp. 141, 143; Seitz 1960, p. 138; Wildenstein 1974–91, no. 1289;
Wildenstein 1996, no. 1289.

50 *Morning on the Seine, near Giverny* 1897
Oil on canvas, 81.4 × 92.7 cm
Gift of Mrs. W. Scott Fitz (11.1261)

Provenance
Durand-Ruel, Paris, June 18, 1909; James Viles, Chicago, October 22, 1909; Durand-Ruel, Paris and New York, March 1, 1911; Mrs. Walter Scott Fitz, Boston, March 7, 1911; given by Mrs. Walter Scott Fitz to the Museum of Fine Arts, Boston, April 6, 1911.

Selected Exhibitions
1898	Paris, Galeries Georges Petit, *Monet*, no. 50.
1900	Paris, Durand-Ruel, *Monet*, no. 16.
1911	Boston, Museum of Fine Arts, *Monet*.
1919	Boston, Walter Kimball Galleries, *Monet*, no. 27.
1927	Boston, Museum of Fine Arts, January 11–February 6, *Claude Monet Memorial Exhibition*, no. 19.
1968	New York, Acquavella Galleries, *Important Impressionist Paintings*.
1970	Tokyo, Asahi Tokyo Shimbun Magasin; Osaka, Magasin Daimaru; Fukuoka, Magasin Iwataya, *Claude Monet*, no. 16.
1973	*Impressionism: French and American*, no. 55.
1977–78	*Monet Unveiled*, no. 34.
1978	New York, The Metropolitan Museum of Art, April 19–July 9; St. Louis, Mo., St. Louis Art Museum, late July–September 15, *Monet's Years at Giverny: Beyond Impressionism*, no. 27.
1983	Paris, Centre Culturel du Marais, April 6–July 31, *Claude Monet au temps de Giverny*, no. 36.
1985	Auckland, Auckland City Art Gallery, April 29–June 9; Sydney, Art Gallery of New South Wales, June 21–August 4; Melbourne, National Gallery of Victoria, August 14–September 29, *Claude Monet: Painter of Light*, no. 26.
1990	Boston, Museum of Fine Arts, February 7–April 29; Chicago, The Art Institute of Chicago, May 19–July 21; London, Royal Academy of Arts, September 7–December 9, *Monet in the '90s: The Series Paintings* (catalogue by Paul Hayes Tucker), no. 83.
1992–93	*Monet and His Contemporaries*, no. 43.
1998	Dallas, Tex., Dallas Museum of Art, March 28–May 17, *Monet: A Turning Point*.

Selected References
Alphant 1993, p. 578; Boston 1921, no. 363; Geffroy 1922, p. 260; Isaacson 1978, pp. 156, 224, fig. 111; Joyes et al. 1975, p. 59; Murphy 1985, p. 204; Reuterswärd 1948, p. 283; Rouart et al. 1972, pp. 58, 60; Seitz 1960, p. 144; Stuckey 1985, p. 196; Tucker 1982, p. 166, fig. 148; Wildenstein 1974–91, no. 1481; Wildenstein 1996, no. 1481.

51 *The Water Lily Pond* 1900
Oil on canvas, 90.0 × 92.0 cm
Given in Memory of Governor Alvan T. Fuller by the Fuller Foundation (61.959)

Provenance
Léonce Rosenberg, Paris, December 1900, purchased directly from Monet; Léon Orosdi, Paris, until May 25, 1923; Durand-Ruel, Paris, from Orosdi sale, May 25, 1923, Hôtel Drouot, no. 41; purchased from Durand-Ruel by Alvan T. Fuller, Boston, November 27, 1927; given by the Fuller Foundation to the Museum of Fine Arts, Boston, 1961, in memory of Governor Alvan T. Fuller.

Selected Exhibitions
1927	Boston, Museum of Fine Arts, January 11–February 6, *Claude Monet Memorial Exhibition*, no. 52.
1957	Boston, Museum of Fine Arts, January 9–February 19, *A Tribute to Claude Monet*.
1959	Boston, Museum of Fine Arts, February 6–March 22, *A Memorial Exhibition of the Collection of the Honorable Alvan T. Fuller*, no. 37.
1961	Palm Beach, Fla., *Paintings in the Collection of Alvan T. Fuller*, no. 28.
1977–78	*Monet Unveiled*, no. 35.
1985	Williamstown, Mass., Sterling and Francine Clark Art Institute, June 8–October 6, *Monet in Massachusetts* (catalogue by John H. Brooks).
1990	Boston, Museum of Fine Arts, February 7–April 29; Chicago, The Art Institute of Chicago, May 19–July 21; London, Royal Academy of Arts, September 7–December 9, *Monet in the '90s: The Series Paintings* (catalogue by Paul Hayes Tucker), no. 93.
1992–93	*Monet and His Contemporaries*, no. 45.
1994	Tokyo, Bridgestone Museum of Art, February 11–April 7; Nagoya, Nagoya City Art Museum, April 16–June 12; Hiroshima, Hiroshima Museum of Art, June 18–July 31, *Monet: A Retrospective* (catalogue by Paul Hayes Tucker et al.), no. 69.
1998–99	Boston, Museum of Fine Arts, September 20–December 27, 1998; London, Royal Academy of Arts, January 23–April 18, 1999, *Monet in the Twentieth Century* (catalogue by Paul Hayes Tucker, George T. M. Shackelford, and MaryAnne Stevens), no. 3.
1999	Paris, Musée de l'Orangerie, May 6–August 2, *Monet: Le cycle des nymphéas* (catalogue by Pierre Georgel), no. 8.

Selected References
Feuillet 1923; Georgel 1999, pp. 4–25; Murphy 1985, p. 209; Murphy et al. 1977, p. 52, no. 35; Reuterswärd 1948, p. 288; Rouart et al. 1972, p. 155; Seiberling 1981, p. 240; Tucker 1989, pp. 277, 280; Wildenstein 1974–91, no. 1630; Wildenstein 1996, no. 1630.

Stanislas Henri Jean-Charles Cazin

Samer (Pas-de-Calais) 1841–1901 Lavandon, near Toulon

Cazin studied under Horace Lecoq de Boisbaudran at the École des Arts Décoratifs in Paris. His early training was as a draftsman for prints, architectural projects, and designs for porcelain and other ceramics. In 1886 he became a professor of drawing at the École d'Architecture as well as director of the École des Beaux-Arts in Tours and curator of the Musée du Tours. Like other artists, he fled to England in 1871 at the onset of the Franco-Prussian War. Between 1871 and 1875 he traveled to Italy and Holland. In 1872 he sketched with Daubigny and Monet in Holland – a formative experience that made him decide to devote his efforts to painting. Returning to France in 1875, he concentrated mainly on history paintings. His works were highly acclaimed for the science and precision of their execution, no doubt a result of his early experiences as a draftsman. Cazin debuted at the Salon of 1876 and also exhibited at the Salon of 1879. He took part in the Expositions Universelles of 1889 and 1900 in Paris, where he received a gold medal and grand prize respectively. He was named *chevalier* of the Légion d'Honneur in 1882 and *officier* in 1889. Although critics and Salon judges praised his history paintings, it was his landscapes that were most popular with collectors.

53 *Farm beside an Old Road* c. 1890
Oil on canvas, 65.1 × 81.6 cm
Bequest of Anna Perkins Rogers (21.1330)

Provenance
Ernest May collection, Paris, until 1890; May sale, Paris, June 4, 1890, no. 6; Anna P. Rogers, Boston, June 4, 1890; bequeathed by Anna P. Rogers to the Museum of Fine Arts, Boston, 1921.

Selected Exhibitions
1889 Paris, *Exposition décennale de 1889.*
1903 Boston, Copley Society, *Old Masters*, no. A1.

Selected References
"A Boon for Cazin" 1890; *Chronique des Arts* 1890; "Cazin in America" 1893.

52 *Cottage in the Dunes* c. 1890
Oil on canvas, 46.0 × 55.5 cm
William R. Wilson Donation (15.882)

Provenance
With Georges Petit, Paris, 1894; sold to Knoedler & Co., New York, September 1894, inv. no. 7634; William R. Wilson, Boston, October 1894; donated by William R. Wilson to the Museum of Fine Arts, Boston, 1915.

Selected Exhibitions
1941 Norfolk, Va., Norfolk Museum of Arts and Sciences, February 2– March 30; Colorado Springs, Colorado Springs Fine Arts Center, May 15–July 1, *French Impressionists*, no. 2.
1989 *From Neoclassicism to Impressionism*, no. 43.
1992–93 *Monet and His Contemporaries*, no. 19.

Selected References
Murphy 1985, p. 47.

Armand Guillaumin

Paris 1841–1927 Paris

While working at municipal jobs, Guillaumin took drawing classes and enrolled at the Académie Suisse, where he met Paul Cézanne and Camille Pissarro in 1861. He painted with them around Pontoise in the early 1870s. Along with many artists who battled against the strictures of the state-run art establishment, Guillaumin took part in the Salon des Refusés of 1863 and showed in six of the eight Impressionist group exhibitions. Like many young painters, he was influenced by the materiality of Gustave Courbet's paintings, but he soon was using a lighter palette and broken brushwork. His color grew even more intense and subjective in the 1880s.

Thanks to his marriage to a teacher in a secondary school, Guillaumin had the means to travel to the South of France. His life changed decisively when, in 1891, a bond he held paid a special premium of 100,000 gold francs. Retiring from government service, he painted full-time and began to travel more extensively, particularly to the mountainous regions in the South of France. There, the rugged scenery encouraged him to use brighter colors and a vigorous style of brushwork, not unlike van Gogh's. During the time he lived in Paris he was friendly with van Gogh and other Post-Impressionists.

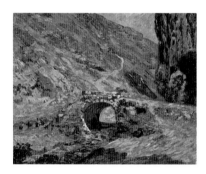

54 *Bridge in the Mountains* 1889
 Oil on canvas, 65.5 × 81.8 cm
 Bequest of John T. Spaulding (48.560)

Provenance
Tadamasa Hyashi, Tokyo, until 1913; Durand-Ruel, Paris and New York, January 8, 1913, no. 3608; John T. Spaulding, Boston, November 18, 1921; bequeathed by John T. Spaulding to the Museum of Fine Arts, Boston, June 3, 1948.

Selected Exhibitions
1961 New York, Hammer Galleries, January 9–21, *Guillaumin.*
1963 Cambridge, Mass., Laurence K. Marshall Gallery, February 1–April 28.
1973 *Impressionism: French and American*, no. 15.
1988 Springfield, Mass., Springfield Museum of Fine Arts, September 25–November 27, *Lasting Impressions: French and American Impressionism from New England Museums* (catalogue by Jean C. Harris, Steven Kern, and Bill Stern), no. 30.

Selected References
Edgell 1949, p. 67; Gray 1972, pp. 40–41, no. 39; Murphy 1985, p. 127.

Pierre-Auguste Renoir

Limoges 1841–1919 Cagnes

At age thirteen Renoir was apprenticed to porcelain painters in Paris, where his family had moved in 1844. He worked for a manufacturer of window blinds and other decorative objects in 1858, and in 1860 applied for and received permission to copy paintings in the Louvre. In 1862 he entered both the École des Beaux-Arts and the studio of Charles Gleyre (1808–1874), where he met other progressively minded painters, such as Alfred Sisley, Claude Monet, and Frédéric Bazille (1841–1870). They painted together during the summers in the Forest of Fontainebleau. Renoir showed in the Impressionist exhibitions of 1874, 1876, 1877, and 1882, but he was as well a faithful adherent of the classical tradition and submitted to the Salon regularly. His primary subject matter was the figure, and he experimented with portraits, genre-like scenes, and images of female bathers. In the early 1880s he traveled to Italy, North Africa, and the South of France. The Renaissance art and light he experienced there prompted him to adopt a brighter and more colorful palette, which he joined to an increased emphasis on line and structure. In poor health for some time, he wintered in the South of France. In 1907 he bought property in Cagnes and had a house built there, where he died.

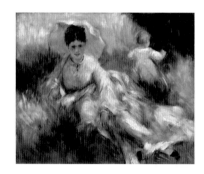

55 *Woman with a Parasol and Small Child on a Sunlit Hillside* 1874–76
 Oil on canvas, 47.0 × 56.2 cm
 Bequest of John T. Spaulding (48.593)

Provenance
Durand-Ruel, Paris, August 25, 1891; W. J. Stansky, New York, January 14, 1917; Duncan Phillips, Washington, D.C.; Durand-Ruel, Paris; John T. Spaulding, Boston, April 1926; bequeathed by John T. Spaulding to the Museum of Fine Arts, Boston, June 3, 1948.

Selected Exhibitions
1929 Cambridge, Mass., Fogg Art Museum, Harvard University, March 6–April 6, *French Painting of the Nineteenth and Twentieth Centuries*, no. 79.
1948 Boston, Museum of Fine Arts, May 26–November 7, *The Collections of John T. Spaulding, 1870–1948*, no. 70.
1950 Springfield, Mass., Springfield Museum of Fine Arts, January 15–February 19, *In Freedom's Search*, no. 6.
1953–54 Edinburgh, Royal Scottish Academy; London, Tate Gallery, *Renoir*, no. 9.
1973 *Impressionism: French and American*, no. 70.
1979–80 *Corot to Braque*, no. 57.

1985–86 London, Hayward Gallery, January 30–April 21, 1985; Paris, Grand
 Palais, May 14–September 2, 1985; Boston, Museum of Fine Arts,
 October 9, 1985–January 5, 1986, *Renoir*, no. 31.
1989 *From Neoclassicism to Impressionism*, no. 72.
1992 *Crosscurrents*.
1996 Tokyo, Tobu Museum of Art, March 30–June 30, *The Birth of
 Impressionism*.

Selected References
Constable 1955, p. 54; Daulte 1971, no. 260; Edgell 1949, p. 63; Kerr 1954,
p. 15; Meier-Graefe 1929, p. 61, no. 52; Murphy 1985, p. 240; Pepper 1948,
pp. 17, 25, no. 70; Pope 1930, pp. 97, 121.

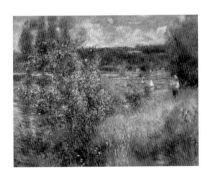

56 *The Seine at Chatou* 1881
Oil on canvas, 73.5 × 92.5 cm
Gift of Arthur Brewster Emmons (19.771)
Exhibited in Richmond

Provenance
Durand-Ruel, Paris, August 25, 1891; Mrs. Blair, New York, January 26, 1900;
Mr. Sehley, New York, by 1901; Durand-Ruel, New York, March 4, 1901;
Arthur Brewster Emmons, Newport, R.I., and Boston, March 5, 1906; given
by Arthur Brewster Emmons to the Museum of Fine Arts, Boston, 1919.

Selected Exhibitions
1882 Paris, *Septième exposition des artistes indépendants*, no. 154.
1937 New York, The Metropolitan Museum of Art, May 18–September 12,
 Renoir: A Special Exhibition of His Paintings, no. 28.
1958 New York, Durand-Ruel, May 30–October 15, *Hommage à Renoir*,
 no. 5.
1973 *Impressionism: French and American*, no. 71.
1978 Boston, Museum of Fine Arts, May 2–August 27, *French Paintings
 from the Storerooms and Some Recent Acquisitions*.
1979–80 *Corot to Braque*, no. 54.
1985–86 London, Hayward Gallery, January 30–April 21, 1985; Paris, Grand
 Palais, May 14–September 2, 1985; Boston, Museum of Fine Arts,
 October 9, 1985–January 5, 1986, *Renoir*, no. 57.
1989 *From Neoclassicism to Impressionism*, no. 73.
1992 *Crosscurrents*.
1992–93 *Monet and His Contemporaries*, no. 55.
1995–96 London, Hayward Gallery, May 18–August 28, 1995; Boston,
 Museum of Fine Arts, October 4, 1995–January 14, 1996,
 Impressions of France: Monet, Renoir, Pissarro, and Their Rivals
 (catalogue by John House), no. 98.

Selected References
Allen 1937, pp. 112–13; Bernard 1986, pp. 179, 259; Berson 1996, vol. 2,
pp. 211, 231, VII-154; Constable 1955, p. 54; Edgell 1949, p. 5; Feaver 1985,
p. 48; Fezzi 1972, no. 443; Florisoone 1938a, p. 120; Hawes 1919; Kapos 1991,
pl. 88; Langdon 1986, pp. 28–29; McBride 1937, p. 158; Murphy 1985, p. 239;
Updike 1989, p. 83; Wadley 1987, p. 226.

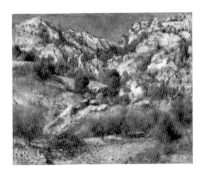

57 *Rocky Crags at L'Estaque* 1882
Oil on canvas, 66.5 × 81.0 cm
Juliana Cheney Edwards Collection (39.678)
Exhibited in Ottawa and Houston

Provenance
Durand-Ruel, Paris, 1891, no. 193; Caroline Lambert, Boston (?), February 25,
1892; Robert J. Edwards (d. 1924), Boston, by 1915; Hannah Marcy Edwards
(d. 1931) and Grace M. Edwards (d. 1939), Boston, 1924; bequeathed by the
Edwards sisters to the Museum of Fine Arts, Boston, October 11, 1939.

Selected Exhibitions
1887 New York, National Academy of Design, May 25–June 30,
 Celebrated Paintings by French Masters, no. 181.
1915 Boston, Museum of Fine Arts, from February 3, *Evans Memorial
 Galleries Opening Exhibition*.
1939–40 *Juliana Cheney Edwards Collection*, no. 48.
1942 Montreal, Art Association of Montreal, *Masterpieces of Painting*,
 no. 73.
1950 New York, Wildenstein Galleries, March 23–April 29, *Renoir*,
 no. 35.
1958 New York, Wildenstein Galleries, April 8–May 10, *Renoir*, no. 35.
1973 *Impressionism: French and American*, no. 77.
1975 Framingham, Mass., Danforth Museum, May 24–September 30,
 Inaugural Exhibition.
1979–80 London, Royal Academy of Arts, November 17, 1979–March 16,
 1980, no. 171; Washington, D.C., National Gallery of Art,
 May 25–September 1, 1980, *Post-Impressionism*, no. 34.
1985–86 London, Hayward Gallery, January 30–April 21, 1985; Paris, Grand
 Palais, May 12–September 2, 1985; Boston, Museum of Fine Arts,
 October 9, 1985–January 5, 1986, *Renoir*, no. 64.
1988–89 Nagoya, Nagoya City Art Museum, October 15–December 11,
 1988; Hiroshima, Hiroshima Museum of Art, December 17, 1988–
 February 12, 1989; Nara, Nara Prefectural Museum of Art,
 February 18–April 9, 1989, *Renoir Retrospective Exhibition*.
1990 Cologne, Wallraf-Richartz Museum, April 5–July; Zurich, August–
 October, *Landscape in the Light* (catalogue by Götz Czymmek),
 no. 151.
1992 *Crosscurrents*.
1992–93 *Monet and His Contemporaries*, no. 56.
1994 Glasgow, National Gallery of Scotland, August 11–October 23,
 From Monet to Matisse (catalogue by Richard Thompson), no. 98.

Selected References
Callen 1982, pp. 118–21; Cunningham 1939a, pp. 8, 16; Cunningham
1939b, pp. 96–110; Edgell 1949, pp. 64–65; Goldwater 1958, pp. 60–62;
Hoffmann 1958, p. 185; Keller 1987, pp. 91, 165, no. 66; Murphy 1985,
p. 239; Rewald 1946, p. 363; Schneider 1985, pp. 49–56; Thomas 1980,
p. 17; Venturi 1939, vol. 1, p. 61; White 1984, p. 120, fig. 123.

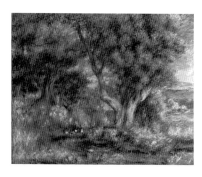

58 *Landscape on the Coast, near Menton* 1883
Oil on canvas, 65.8 × 81.3 cm
Bequest of John T. Spaulding (48.596)

Provenance
Durand-Ruel, Paris, 1884; Prince Alexandre Berthier de Wagram (d. 1918),
Paris; Durand-Ruel, Paris and New York, by 1918; John T. Spaulding, Beverly,
Mass., December 1924; bequeathed by John T. Spaulding to the Museum of
Fine Arts, Boston, June 3, 1948.

Selected Exhibitions
1931 Boston, Museum of Fine Arts, May 26–October 27, *Collection of
 Modern French Paintings, Lent by John T. Spaulding.*
1939 Boston, Museum of Fine Arts, June 9–September 10, *Art in New
 England: Paintings, Drawings, and Prints from Private Collections
 in New England,* no. 105.
1948 Boston, Museum of Fine Arts, May 26–November 7, *The
 Collections of John T. Spaulding, 1870–1948,* no. 73.
1973 *Impressionism: French and American,* no. 80.
1985 Boston, Museum of Fine Arts, February 13–June 2, *The Great Boston
 Collectors: Paintings from the Museum of Fine Arts, Boston* (catalogue
 by Carol Troyen and Pamela S. Tabbaa), no. 51.
1985–86 London, Hayward Gallery, January 30–April 21, 1985; Paris,
 Grand Palais, May 14–September 2, 1985; Boston, Museum of
 Fine Arts, October 9, 1985– January 5, 1986, *Renoir,* no. 71
 (Boston venue only).
1995–96 London, Hayward Gallery, May 18–August 28, 1995; Boston,
 Museum of Fine Arts, October 4, 1995–January 14, 1996,
 Impressions of France: Monet, Renoir, Pissarro, and Their Rivals
 (catalogue by John House), no. 105 (Boston venue only).

Selected References
Barnes 1990, p. 55; Barnes and de Mazia 1935, pp. 83, 455; Boston 1931,
p. 53, no. 173; Constable 1955, p. 54; Fell 1991, p. 19; Fezzi 1972, no. 591;
McBride 1937, p. 60; Meier-Graefe 1929, p. 194, no. 162; Murphy 1985,
p. 240; Orlando 1980, p. 83; Pepper 1948, p. 18; Pope 1930, pp. 98, 122;
Updike 1989, p. 83; Wadley 1987, p. 228; Watson 1925, p. 338; White 1984,
p. 135.

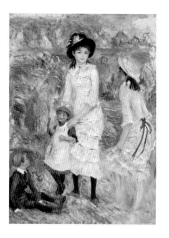

59 *Children on the Seashore, Guernsey* c. 1883
Oil on canvas, 91.5 × 66.5 cm
Bequest of John T. Spaulding (48.594)

Provenance
Galerie Barbazanges, Paris, 1919, no. 11756; Howard Young Galleries,
New York, until November 16, 1922, no. 2020; John T. Spaulding, Boston,
November 16, 1922; bequeathed by John T. Spaulding to the Museum of
Fine Arts, Boston, June 3, 1948.

Selected Exhibitions
1949 Cambridge, Mass., Fogg Art Museum, Harvard University.
1950 New York, Wildenstein Galleries, March 23–April 29, *Renoir,*
 no. 39.
1950 Springfield, Mass., Springfield Museum of Fine Arts, January 15–
 February 19, *In Freedom's Search,* no. 7.
1955 Hartford, Conn., Wadsworth Atheneum, *Holiday.*
1973 *Impressionism: French and American,* no. 79.
1991 Portland, Maine, Portland Museum of Art, August 1–October 13,
 Impressionist/Post-Impressionist.
1992 *Crosscurrents.*
1992–93 *Monet and His Contemporaries,* no. 57.
1994–95 Brisbane, Queensland Art Gallery, July 30–September 11, 1994;
 Melbourne, National Gallery of Victoria, September 19–
 October 30, 1994; Sydney, The Art Gallery of New South Wales,
 November 5, 1994–January 15, 1995, *Renoir: Master Impressionist*
 (catalogue by John House).

Selected References
André 1931, nos. 6, 12; Daulte 1971, no. 451; Edgell 1949, p. 4; Fosca
1961, p. 55; House 1988, pp. 11–13, 18, 21, no. 7; Meier-Graefe 1929,
p. 180, no. 151; Murphy 1985, p. 240; Pope 1930, p. 96; Raynal 1922,
p. 601; Sturrock 1955, pp. 2–6, no. 3; Watson 1925, p. 340; White 1984,
pp. 133–36.

Léon Augustin Lhermitte

Mont-Saint-Père (Aisne) 1844–1925 Paris

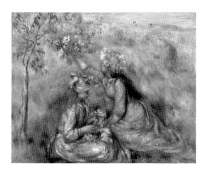

60 *Girls Picking Flowers in a Meadow* c. 1890
Oil on canvas, 65.0 × 81.0 cm
Juliana Cheney Edwards Collection (39.675)

Provenance
Durand-Ruel, Paris and New York, 1894; Palmer Potter, Chicago, 1912; Hannah Marcy Edwards (d. 1931), Boston, 1912; Grace M. Edwards (d. 1939), Boston, 1931; bequeathed by Grace M. Edwards to the Museum of Fine Arts, Boston, October 11, 1939.

Selected Exhibitions
1900 New York, Durand-Ruel, *Monet and Renoir*, no. 30.
1939–40 *Juliana Cheney Edwards Collection*, no. 49.
1941 New York, Duveen Galleries, *Renoir Centennial Loan Exhibition*, no. 60.
1946 Colorado Springs, Colorado Springs Fine Arts Center, *19th Century French Painters*.
1955 Los Angeles, Los Angeles County Museum of Art, July 14–August 21; San Francisco, M. H. de Young Museum of Art, September 1–October 2, *Renoir*, no. 38.
1973 *Impressionism: French and American*, no. 81.
1983–84 *Masterpieces of European Painting*, no. 59.
1985–86 London, Hayward Gallery, January 30–April 21, 1985; Paris, Grand Palais, May 14–September 2, 1985; Boston, Museum of Fine Arts, October 9, 1985–January 5, 1986, *Renoir*, no. 86.
1988 Springfield, Mass., Springfield Museum of Fine Arts, September 25–November 27, *Lasting Impressions: French and American Impressionism from New England Museums* (catalogue by Jean C. Harris, Steven Kern, and Bill Stern), no. 20.
1989 *From Neoclassicism to Impressionism*, no. 74.
1991 Nagoya, Matsuzakaya Museum of Art, March 21–May 6, *World Impressionism and Pleinairism* (catalogue by R. J. Boyle and Herwig Todts), no. 24.
1992–93 *Monet and His Contemporaries*, no. 58.
1994–95 Brisbane, Queensland Art Gallery, July 30–September 11, 1994; Melbourne, National Gallery of Victoria, September 18–October 30, 1994; Sydney, The Art Gallery of New South Wales, November 5, 1994–January 15, 1995, *Renoir: Master Impressionist* (catalogue by John House), no. 23.
1995 *The Real World*, no. 44.

Selected References
Cunningham 1939b, pp. 101, 110; Daulte 1971, no. 609; Edgell 1949, pp. 64–65; Meier-Graefe 1929, p. 199, no. 203; Murphy 1985, p. 239; White 1984, pp. 192, 195.

Lhermitte, like his lifelong friend Cazin, studied in Paris under Horace Lecoq de Boisbaudran, who stressed memory training as opposed to drawing from casts. The legacy of Boisbaudran's teaching can be seen in Lhermitte's fluid treatment of gesture and expression, ease in drawing the moving figure, and secure blocking of forms. Lhermitte debuted at the 1864 Salon with a charcoal drawing, and in 1866 a painting of his was accepted. During his early career he exhibited mostly landscapes and charcoal drawings, while earning an income as an illustrator of books and magazines. At the 1864 Salon he was praised for his profound depictions of nature, but as his work matured Lhermitte would specialize increasingly in rural genre scenes, alternating images of laboring peasants with depictions of pilgrimages and rural devotion. He had a high regard for and deep interest in the works of Jean-François Millet. While his works exhibit a style and working method akin to that of the Impressionists, he did not use all of their techniques. Lhermitte concentrated on the narrative content of his pictures rather than on formal innovation. His works have distinctly moral overtones, for he was interested in expressing his deeply held belief in the purifying value of rural labor. He won a third-class medal at the Salon of 1874, a second-class medal at the Salon of 1880, and a first-class medal at the Exposition Universelle in 1889. He was inducted into the Légion d'Honneur in 1884, and was named *officier* a decade later and *commandeur* in 1911. In 1905 he was elected as a member of the Institut de France. He was a founding member and vice-president of the Société Nationale des Beaux-Arts, and during his tenure he continued to paint mainly landscape and genre scenes in country settings. His tendency toward Realism and his reluctance to follow the lead of the Impressionists resulted in a temporary decline of his popularity. His work did, however, gain a new audience later in his career, and his engravings, especially his depictions of peasants, were particularly influential in France, England, and the United States.

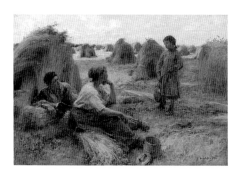

61 *Wheatfield (Noonday Rest)* 1890
Oil on canvas, 53.2 × 77.5 cm
Bequest of Julia C. Prendergast in Memory of her brother, James Maurice
Prendergast (44.38)

Provenance
Arnold and Tripp, London, 1890; with Williams and Everett, Boston, 1890;
James Maurice Prendergast (d. 1899), Boston; Julia C. Prendergast, Boston,
1899, by inheritance; bequeathed by Julia C. Prendergast to the Museum of
Fine Arts, Boston, 1944.

Selected Exhibitions
1958 Boston, First National Bank of Boston.
1974 Oshkosh, Wis., Paine Art Center and Arboretum, September 21–
 November 10, *Léon Lhermitte* (catalogue by Mary Michele Hamel),
 no. 23.
1979–80 *Corot to Braque*, no. 60.
1982–83 Omaha, Nebr., Joslyn Art Museum, November 5, 1982–January 2,
 1983; Memphis, Tenn., Dixon Gallery and Gardens, January 16–
 March 8, 1983; Williamstown, Mass., Sterling and Francine Clark
 Art Institute, April 2–June 5, 1983, *Jules Breton and the French
 Rural Tradition* (catalogue by Hollister Sturges), no. 90.
1992–93 *Monet and His Contemporaries*, no. 20.
1995 *The Real World*, no. 52.

Selected References
Fonteney 1991, p. 109, no. 52; Murphy 1984, pp. 169; Murphy 1985, p. 167.

Paul Gauguin
Paris 1848–1903 Atuana (Marquesas Islands)

Before working as a stockbroker in Paris, Gauguin had spent
four years in Lima, Peru, with his mother's family, and six years
as a sailor, putting in at ports around the world. While a stock-
broker, he collected Impressionist paintings and also began to
paint, exhibiting with the Impressionist group in 1879, 1880,
1881, and 1882. The collapse of the stock market in 1883 cost
him his job. Despite the responsibility of supporting a growing
family he turned to painting full time, selling his art collection
to raise money on which to live. The years between 1886 and
1890 were mostly spent at Pont-Aven, in Brittany, except for a
trip to Martinique in 1887 and another to Arles, together with
Vincent van Gogh, in 1888. In Brittany Gauguin was attracted
by the simple lives and rituals of the people. Away from Paris
he developed a different style of painting that was flatter, more
colorful, and more decorative. In 1891 he went to Tahiti, in
the hope of finding there a still simpler life. The desperate state
of his finances forced him back to Paris in 1893, but he found
France unbearable and in 1895 returned to Tahiti. Restless and
still searching, Gauguin moved to the more remote Marquesas
Islands in 1901. He continued to paint, despite illness, poverty,
and loneliness, producing works combining revolutionary color,
mysticism, and a personal mythology.

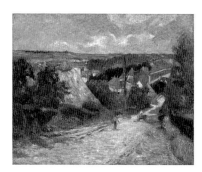

62 *Entrance to the Village of Osny* 1883
Oil on canvas, 60.0 × 72.6 cm
Bequest of John T. Spaulding (48.545)

Provenance
Camille Pissarro (d. 1903), Éragny-sur-Epte, July 1883; Jean-Baptiste Faure
(d. 1914), Paris, by 1903; Durand-Ruel, Paris, 1914, no. 4520; John T.
Spaulding, Boston, March 3, 1921; bequeathed by John T. Spaulding to
the Museum of Fine Arts, Boston, June 3, 1948.

Selected Exhibitions
1931 Boston, Museum of Fine Arts, May 26–October 27, *Collection of
 Modern French Paintings, Lent by John T. Spaulding.*
1950 Springfield, Mass., Springfield Museum of Fine Arts, January 15–
 February 19, *In Freedom's Search*, no. 8.
1954 Houston, Tex., The Houston Museum of Fine Arts, March 27–
 April 25, *Paul Gauguin: His Place in the Meeting of East and West*,
 no. 4.

1955 Cambridge, Mass., Fogg Art Museum, Harvard University, May 2–31, *From Sisley to Signac*, no. 7.

1960 Paris, Galerie Charpentier, January 7–February 28, *Gauguin*, no. 13.

1960 Munich, Haus der Kunst, April 1–May 29, no. 11; Vienna, Belvedere, June 1–July 31, no. 2, *Gauguin*.

1963 Hamburg, Kunstverein, May 1–July 15, *The Four Pioneers of Modern Art: Seurat, Cézanne, Van Gogh, and Gauguin*, no. 38.

1963 Berlin-Dahlem, Staatliche Museen, September 28–November 24, *Die Ile de France und ihre Maler*, no. 27.

1973 *Impressionism: French and American*, no. 13.

1979–80 *Corot to Braque* (not in catalogue).

1992 *Crosscurrents*.

1995–96 London, Hayward Gallery, May 18–August 28, 1995; Boston, Museum of Fine Arts, October 4, 1995–January 14, 1996, *Impressions of France: Monet, Renoir, Pissarro, and Their Rivals* (catalogue by John House), no. 104.

Selected References
Edgell 1949, p. 73; Estienne 1953a, p. 27; Hughé et al. 1960, p. 111; Malingue 1948, p. 76; Murphy 1985, p. 111; Reidemeister 1963, p. 82; Roskill 1970, pp. 16, 254, note 3, under "Impressionism"; Rostrup 1956, p. 64; Van Dovski 1950, p. 338, no. 9; Wildenstein 1964, no. 121.

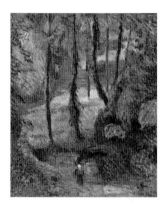

63 *Forest Interior (Sous-Bois)* 1884
Oil on canvas, 55.5 × 46.1 cm
Gift of Laurence K. and Lorna J. Marshall (64.2205)

Provenance
Georges Viau, Paris, until March 4, 1907; Marquis de Ganay, Paris, March 4, 1907; Laurence K. Marshall, Cambridge, Mass., by 1964 (?); given by Laurence K. and Lorna J. Marshall to the Museum of Fine Arts, Boston, December 9, 1964.

Selected Exhibitions
1973 *Impressionism: French and American*, no. 14.

1992–93 *Monet and His Contemporaries*, no. 60.

Selected References
Murphy 1985, p. 112; Wildenstein 1964, no. 110.

Pascal Adolphe Jean Dagnan-Bouveret

Paris 1852–1929 Quincey (Haute-Saône)

Dagnan-Bouveret was a student of Gérôme and Corot at the École des Beaux-Arts in Paris. Beginning as a painter of portraits and mythological scenes, he debuted at the Salon of 1876 with *Orphée et les Bacchantes* and *Bacchus enfant adoré*. He also took second place in the 1876 competition in Rome. He befriended the artist Bastien-Lepage (1848–1884), whose work influenced his style, making it more spirited, idyllic, and poetic. His 1879 painting *La noce chez le photographe* foreshadowed a change in subject matter. From then on he resigned himself to painting genre scenes and landscapes, as well as portraits of the Parisian aristocracy. He won a third-class medal at the Salon of 1878 and a first-class medal in 1880, and won the grand prize at the Exposition Universelle in 1889. In 1900 he was named *officier* of the Légion d'Honneur and a full member of the Institut de France. He received the medal of honor in 1889, and exhibited at the Salons of 1921 and 1922.

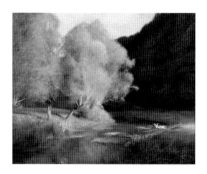

64 *Willows by a Stream* c. 1885
Oil on canvas, 65.4 × 81.4 cm
Gift of Robert Jordan from the Collection of Eben D. Jordan (24.216)

Provenance
Eben D. Jordan, Boston, before 1924; Robert Jordan, Boston, by inheritance, 1924; given by Robert Jordan to the Museum of Fine Arts, Boston, 1924.

Selected References
Murphy 1985, p. 70.

Vincent van Gogh

Zundert (Netherlands) 1853–1890 Auvers

Van Gogh was the son of a Protestant minister, and the importance of leading a moral, useful life was impressed on him at an early age. He tried several different professions – art dealer, teacher, minister, and missionary – before deciding in 1880 to become a painter. His training was spotty; he worked under his cousin Anton Mauve (1838–1888) in The Hague, on his own in the Dutch and Flemish countryside, and in Antwerp. He joined his brother Theo in Paris in the spring of 1886. There he met many of the progressive painters, including Camille Pissarro, Edgar Degas, Paul Gauguin, and Paul Signac, as well as Georges Seurat (1859–1891) and Henri de Toulouse-Lautrec (1864–1901). His art, previously dark in palette and moralistic in subject matter, changed dramatically as a result of the twin influences of Impressionism and Japanese prints, becoming light and bright. Van Gogh was emotionally unstable: when Paris became too much for him, he went to Arles, in the South of France. Gauguin joined him there for a while. After a year's internment in an asylum, during which he devoted himself to painting with great energy, he returned north, to Auvers, in May 1890. Always productive, van Gogh painted continuously until he killed himself in July. His work was little known until more than a decade after his death; he sold but one painting during his lifetime.

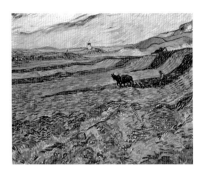

65 *Enclosed Field with Ploughman* October 1889
Oil on canvas, 53.93 × 64.51 cm
Bequest of William A. Coolidge (1993.37)

Provenance
Bernheim-Jeune, Paris; M. W. Boyd collection, West Jerry (near Dundee), Scotland, until 1920; Josse and Gaston collection, Bernheim-Jeune, Paris, 1920; Arthur Tooth and Sons, London, 1928; William A. Coolidge, Boston, August 26, 1936; bequeathed by William A. Coolidge to the Museum of Fine Arts, Boston, 1993.

Selected Exhibitions
1926 Norwich, England, *Museum Centenary Exhibition*, no. 64.
1986–87 New York, The Metropolitan Museum of Art, November 25, 1986– March 22, 1987, *Van Gogh in Saint-Rémy and Auvers* (catalogue by Ronald Pickvance), no. 21.
1988–89 Amsterdam, Rijksmuseum Vincent van Gogh, December 9, 1988– February 26, 1989, *Van Gogh and Millet* (catalogue edited by Louis van Tilbourgh, Sjraar van Heugten, and Philip Conisbee), no. 28.
1998–99 Paris, Musée d'Orsay, September 14, 1998–January 10, 1999, *Millet / van Gogh*, no. 21.

Selected References
De la Faille 1928, vol. 1, p. 201, no. 706, vol. 2, no. 99, called *Le laboureur*; De la Faille 1939, p. 498, nos. 706, 722, called *The Ploughman Lands at Fontvielle*; Duret 1916; Duret 1937, p. 39, no. 218; Hulsker 1980, no. 1794; Scherjon 1932; Sutton 1995, pp. 13, 92–96, no. 20; Van Gogh 1929, p. 364.

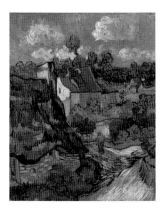

66 *Houses at Auvers* 1890
Oil on canvas, 75.5 × 61.8 cm
Bequest of John T. Spaulding (48.549)

Provenance
Mrs. J. van Gogh-Bonger, Amsterdam, after 1890; Tilla Durieux-Cassirer, Berlin; Paul Cassirer Art Gallery, Berlin; Galerie Tannhauser, Lucerne; Voss collection, Berlin; Wildenstein Galleries, New York, until October 18, 1926; John T. Spaulding, Boston, October 18, 1926; bequeathed by John T. Spaulding to the Museum of Fine Arts, Boston, June 3, 1948.

Selected Exhibitions
1912 Cologne, Kunsthalle, May–September, *International Exposition*, no. 105.
1929 Cambridge, Mass., Fogg Art Museum, Harvard University, March 6–April 6, *French Painting of the Nineteenth and Twentieth Centuries*, no. 95.
1929 New York, The Museum of Modern Art, *First Loan Exhibition: Cézanne, Seurat, Gauguin, Van Gogh*, no. 90.
1936 Boston, Museum of Fine Arts, February 18–March 15; New York, The Museum of Modern Art; San Francisco, Palace of the Legion of Honor; Philadelphia, Philadelphia Museum of Art; Cleveland, The Cleveland Museum of Art, *Vincent van Gogh*, no. 64
1939 Boston, Museum of Fine Arts, June 9–September 15, *Art in New England: Paintings, Drawings, and Prints from Private Collections in New England*, no. 58.
1951 Cambridge, Mass., Busch-Reisinger Museum, Harvard University, *Van Gogh.*
1975 Auckland, Auckland City Art Gallery, August 18–October 5, *Vincent van Gogh.*
1979–80 *Corot to Braque*, no. 63.
1983–84 *Masterpieces of European Painting*, no. 63.
1985 Boston, Museum of Fine Arts, February 13–June 2, *The Great Boston Collectors: Paintings from the Museum of Fine Arts, Boston* (catalogue by Carol Troyen and Pamela S. Tabbaa), no. 54.
1990–91 Essen, Museum Folkwang, August 10–November 4, 1990; Amsterdam, Rijksmuseum Vincent van Gogh, November 16, 1990–February 18, 1991, *Vincent van Gogh and Early Modern Art, 1890–1914*, no. 43.
1992 *Crosscurrents.*

Selected References
De la Faille 1928, vol. 1, p. 228, no. 805, vol. 2, no. 226; De la Faille 1939, p. 539, no. 789; Edgell 1949, p. 84; Estienne 1953b, p. 73; Hulsker 1980, no. 1989; Lecaldano 1977, p. 853; Malraux 1952, p. 15; Meier-Graefe 1921, vol. 2, no. 100; Mothe 1987, p. 160; Murphy 1985, p. 120; Naeling 1984, p. 4; Nemeczek 1981, p. 33; Reidemeister 1963, p. 164; Scherjon and De Gruyter 1938, p. 363..

Maxime Maufra
Nantes 1861–1918 Poncé (Sarthe)

Maufra studied painting in Nantes, first with Charles Le Roux (b. 1814) and then with the brothers Charles and Alfred Leduc (b. 1831; 1850–1913). He went to Liverpool, England, in 1880, to learn English and the business of commerce. On his way home, in 1883, he stopped in London, where he was deeply impressed by the paintings of John Constable (1776–1837), Thomas Gainsborough (1727–1788), and J. M. W. Turner (1775–1851). In 1886 he showed work both at Nantes and at the Salon in Paris. In 1890 he left business to devote himself entirely to art. He toured Brittany and met Paul Gauguin and his followers at Pont-Aven in July 1890. Maufra maintained his home and studio in Paris from 1892 while returning yearly to Brittany. Printmaking became an important form of expression for him. A contract with Durand-Ruel after 1896 granted him economic security. A prolific painter of landscapes and marines, Maufra traveled to Scotland, the Dauphiné, the Savoy, the South of France, and Algeria in search of new motifs, but is best known for his scenes of northern and particularly northwestern France.

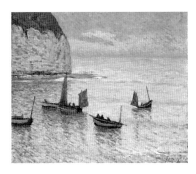

67 *Departure of Fishing Boats, Yport* 1900
Oil on canvas, 54.1 × 65.2 cm
John Pickering Lyman Collection (19.1316)

Provenance
Durand-Ruel, Paris, April 2, 1900, no. 5783; Durand-Ruel, New York, June 12, 1901, no. 2619; John Pickering Lyman (d. 1914), Portsmouth, N.H., January 13, 1906; Theodora Lyman (d. 1919), Portsmouth, N.H., 1914; given by Theodora Lyman to the Museum of Fine Arts, Boston, 1919.

Selected Exhibitions
1902 New York, Durand-Ruel, April 19–May 3, *André, d'Espagnat, Loiseau, Maufra, Monet*, no. 27.
1941 Norfolk, Va., Norfolk Museum of Arts and Sciences, February 2–March 30; Colorado Springs, Colorado Springs Fine Arts Center, May 15–July 1, *French Impressionists*, no. 5.
1941 New London, Conn., Lyman Allen Museum, Connecticut College, October 4–31, *Impressionist Paintings.*
1955 Poughkeepsie, N.Y., Vassar College Art Gallery, November 1–30, *Later Nineteenth-Century European and American Painting.*
1973 *Impressionism: French and American*, no. 25.

Selected References
Murphy 1985, p. 184

Henri Le Sidaner

Port-Louis (Mauritius) 1862–1939 Paris

In 1872 Le Sidaner's family returned to France from the West Indies, settling in Dunkirk. Le Sidaner studied art there, and then went to Paris in 1880, with the help of a stipend from the city of Dunkirk. Two years later he discovered the progressive painting of the Impressionists at the group's seventh exhibition. Le Sidaner chose to pursue more academic training: in 1884 he entered the École des Beaux-Arts and enrolled in the studio of Alexandre Cabanel (1823–1889), with whom he studied at least through 1888. Le Sidaner first submitted a painting to the Salon in 1887, and in 1897 he had a solo exhibition at the Galerie Mancini. In 1899 he formalized an exclusive contract with the prestigious Galeries Georges Petit. After this time he traveled widely, going often to London, Venice, Bruges, and even the United States, where he participated in the Carnegie International exhibition in Pittsburgh, Pennsylvania. In 1904 he bought a house and garden in Gerberoy, where he created a flowery retreat. He enjoyed official success, with election to the Légion d'Honneur, the Order of Leopold (Belgium), and the Académie des Beaux-Arts.

68 *Grand Trianon* c. 1905
Oil on canvas, 70.5 × 94.5 cm
Bequest of Katherine Dexter McCormick (68.567)

Provenance
Alan Hardy, Paris (?); Galeries Georges Petit, Paris, nos. 3224, 8554; Katherine Dexter McCormick, Santa Barbara, Calif.; bequeathed by Katherine Dexter McCormick to the Museum of Fine Arts, Boston, September 11, 1968.

Selected Exhibitions
1905 Paris, Salon de la Société Nationale des Beaux-Arts, no. 805.
1989 *From Neoclassicism to Impressionism* (not in catalogue).

Selected References
Farinaux-LeSidaner 1989, no. 197; "Le Sidaner" 1912; Mauclair 1928, p. 94; Murphy 1985, p. 166.

Paul Signac

Paris 1863–1935 Paris

Spurning the profession of architect that his family wanted him to follow, Signac was largely self-taught as a painter. He met Georges Seurat (1859–1891) in 1884, and Seurat's ideas about a scientific approach to painting, based on the aesthetic theories of Charles Henry, had a transforming effect on Signac's art. After the death of Seurat, Signac assumed the leadership of the loose group of painters called Neo-Impressionists, in part because of his writings, which included *D'Eugène Delacroix au néo-impressionnisme* (1898) and, with Henri-Edmond Cross (1856–1910), a translation of parts of John Ruskin's *Elements of Drawing* (1889). To ally his paintings with the language and traditions of music (a common goal among artists and writers in the late nineteenth century), between 1887 and 1893 Signac assigned his paintings *opus* numbers. In 1892, he moved to Saint-Tropez on the Mediterranean where he could indulge his favorite subjects – marines and views of ports. While he adhered to the theory, Signac did not paint in a consistent divisionist style throughout his career. Instead, his touch loosened and became quite free, especially in the studies, often in watercolor, that he made outdoors. Signac was an active member of the Société des Indépendants, formed in 1884, and he exhibited his work throughout Europe as well. His bright, mosaic-like brushstrokes of about 1904 informed the early Fauvist paintings of Henri Matisse (1869–1954).

69 *View of the Seine at Herblay* late 1880s
Oil on canvas, 33.2 × 46.4 cm
Gift of Julia Appleton Bird (1980.367)

Provenance
Edmond and Lucie Cousturier, Paris, late 1880s (?); Hugo Moser, New York, by March 1960; Hammer Galleries, New York, until March 1960; Mrs. Charles Sumner Bird (Julia Appleton Bird), East Walpole, Mass., March 1960; given by Mrs. Charles Sumner Bird to the Museum of Fine Arts, Boston, October 15, 1980.

Selected Exhibitions
1989 *From Neoclassicism to Impressionism*, no. 79.

Selected References
Murphy 1985, p. 263.

70 *Port of Saint-Cast* 1890
Oil on canvas, 66.0 × 82.5 cm
Gift of William A. Coolidge (1991.584)

Provenance
Victor Boch, Brussels, by 1891; Léon Marseille, Paris; A. Zwemmer, London;
A. Ehrman, London; Marlborough Fine Arts, Ltd., London; William A.
Coolidge, Boston, 1958; given by William A. Coolidge to the Museum of
Fine Arts, Boston, 1991.

Selected Exhibitions
1891 Brussels, February, *Huitième exposition annuelle des XX*, as *Op. 209,*
 Saint-Cast (Côtes-du-Nord), Mai, 1890.
1891 Paris, March 20–April 27, *Exposition des artistes indépendants*,
 no. 1112.
1930 Paris, Berheim-Jeune, May 19–30, *Paul Signac*, no. 11.
1932 Paris, Braun et Cie., February 25–March 17, *Le Néo-Impressionnisme*,
 no. 25.
1934 Paris, February 20–March 14, *Cinquantenaire de la Société des*
 Artistes Indépendants, no. 4106.
1958 London, Marlborough Fine Arts, Ltd., April–May, *La création de*
 l'oeuvre chez Paul Signac (catalogue by P. Gay), no. 217.
1958 London, Marlborough Fine Arts, Ltd., summer, *XIXth and XXth*
 Century European Masters, no. 64.
1963–64 Paris, Musée du Louvre, December 1963–February 1964, *Signac*
 (catalogue by Marie-Thérèse Lemoyne de Forges), no. 35.
1992 *Crosscurrents*

Selected References
Besson 1954, pl. 44; Cachin 1971; Christophe 1891, p. 100; Geffroy 1891;
Krexpel 1891, p. 381; Leclercq 1891, p. 298; Rewald 1956, p. 135; Sutton
1995, pp. 96–101.

References Cited

The following works are cited in abbreviated form in the notes and under Selected References. Abbreviated forms are also used for some of the Selected Exhibitions; see "Note to the Reader" on page 9.

"A Boon for Cazin" 1890
"A Boon for Cazin." *The Collector*, vol. 1, no. 16 (July 1, 1890), p. 131.

About 1866
About, E. *Le Petit Journal*. Paris, 1866.

Adams 1994
Adams, Steven. *The Barbizon School and the Origins of Impressionism*. London, 1994.

Alexandre 1908
Alexandre, Arsène. "Claude Monet: His Career and Work." *The Studio*, March 1908.

Allen 1937
Allen, Josephine L. "Paintings by Renoir." *Bulletin of the Metropolitan Museum of Art*, vol. 32, no. 5 (May 1937).

Alphant 1993
Alphant, Marianne. *Claude Monet: Une vie dans le paysage*. Paris, 1993.

Andersen 1967
Andersen, Wayne V.. "Cézanne, Tanguy, Choquet." *The Art Bulletin*, vol. 49, no. 2 (June 1967).

André 1931
André, Albert. *L'atelier de Renoir*. Paris, 1931.

Ballu 1877
Ballu, R. "Les artistes contemporains: Diaz." *Gazette des Beaux-Arts*, ser. 2, vol. 2, no. 15 (March 1877).

Bareau 1998
Bareau, Juliet Wilson. *Manet, Monet, and the Gare Saint-Lazare*. New Haven and London, 1998.

Barnes 1990
Barnes, Rachel, ed. *Renoir by Renoir*. New York, 1990.

Barnes and de Mazia 1935
Barnes, Alfred C., and Violette de Mazia. *The Art of Renoir*. New York, 1935.

Berhaut 1978
Berhaut, Marie. *Caillebotte: Sa vie et son oeuvre. Catalogue raisonné des peintures et pastels*. Paris, 1978.

Bernard 1926
Bernard, Émile. *Souvenirs sur Paul Cézanne: Une conversation avec Cézanne*. Paris, 1926.

Bernard 1986
Bernard, Bruce. *The Impressionist Revolution*. London, 1986.

Berson 1996
Berson, Ruth. *The New Painting: Impressionism, 1874–1886. Documentation*. 2 vols. San Francisco, 1996.

Besson 1946
Besson, Georges. *Sisley*. Paris, 1946.

Besson 1954
Besson, Georges. *Paul Signac*. Paris, 1954.

Biermann 1913
Biermann, Georg. "Die Kunst auf dem internationalen Markt: Gemälde aus dem Besitz der modernen Galerie Thannhauser München." *Der Cicerone*, May 1913.

Bizardel 1974
Bizardel, Yvon. "Théodore Duret: An Early Friend of the Impressionists." *Apollo*, vol. 100, no. 150 (August 1974).

Bodelsen 1968
Bodelsen, Merete. "Early Impressionist Sales 1874–94, in the Light of Some Unpublished 'Procès-verbaux.'" *Burlington Magazine*, vol. 110, no. 783 (June 1968).

Boggs 1962
Boggs, Jean Sutherland. *Portraits by Degas*. Berkeley and Los Angeles, 1962.

Boggs 1998
Boggs, Jean Sutherland. *Degas at the Races*. Washington, 1998.

Boime 1971
Boime, Albert. *The Academy and French Painting in the Nineteenth Century*. London, 1971.

Boisdeffre et al. 1966
Boisdeffre, Pierre de, et al. *Cézanne*. Paris, 1966.

Bonnici 1989
Bonnici, Claude-Jeanne. *Paul Guigou, 1834–1871*. Aix-en-Provence, 1989.

Boston 1921
Museum of Fine Arts, Boston. *Catalogue of Paintings*. Boston, 1921.

Boston 1931
"Exhibition of French Paintings Lent by Mr. John T. Spaulding." *Bulletin of the Museum of Fine Arts* (Boston), vol. 29, no. 173 (June 1931).

Bouret 1972
Bouret, Jean. *L'école de Barbizon et le paysage français au XIXe siècle*. Paris, 1972.

Bouret 1973
Bouret, Jean. *The Barbizon School and 19th-Century French Landscape Painting*. New York, 1973.

Brettell 1990
Brettell, Richard R. *Pissarro and Pontoise: The Painter in a Landscape*. New Haven and London, 1990.

Brettell et al. 1984
Brettell, Richard R., et al. *A Day in the Country: Impressionism and the French Landscape*. Los Angeles, 1984.

Brettell et al. 1988
Brettell, Richard R., et al. *The Art of Paul Gauguin*. Washington, 1988.

Brown 1978
Brown, Marilyn Ruth. *The Image of the "Bohémien" from Diaz to Manet and Van Gogh*. Ann Arbor, Mich.: University Microfilms, 1978.

Buhler 1985
Buhler, Hans-Peter. "Rückkehr zu den Mannen: Jean-François Millet." *Weltkunst*, September 5, 1985.

Burty 1877
Burty, Philippe. *Maîtres et petits maîtres*. Paris, 1877.

Cabanne 1948
Cabanne, Pierre. *Edgar Degas*. Paris, 1948.

Cachin 1971
Cachin, Françoise. *Paul Signac*. Greenwich, Conn., 1971.

Cahen 1900
Cahen, Gustave. *Eugène Boudin: Sa vie et son oeuvre*. Paris, 1900.

Callen 1982
Callen, Anthea. *Techniques of the Impressionists*. Secaucus, N.J., 1982.

Cartwright 1896
Cartwright, Julia M. *Jean-François Millet: His Life and Letters*. London, 1896.

"Cazin in America" 1893
"Cazin in America." *The Collector*, vol. 4, no. 19 (October , 1893).

Champa 1973
Champa, Kermit S. *Studies in Early Impressionism*. New Haven and London, 1973.

Charivari 1844
Le Charivari, no. 84, March 24, 1844.

Christophe 1891
Christophe, J. "Le néo-impressionnisme à l'exposition des artistes indépendants." *Journal des Artistes*, April 12, 1891.

Chronique des Arts 1890
La Chronique des Arts, no. 23 (June 8, 1890).

Chronique des Arts 1974
La Chronique des Arts, no. 1261 (February 1974).

Claretie 1875
Claretie, Jules. *L'Art* [Paris], October 4, 1875.

Claretie 1876
Claretie, Jules. *L'art et les artistes français*. Paris, 1876.

Clark 1973
Clark, Kenneth. *The Romantic Rebellion: Romantic versus Classic Art*. London, 1973.

Clarke 1991
Clarke, Michael. *Corot and the Art of Landscape*. London, 1991.

"Claude Monet Exhibit Opens" 1905
"Claude Monet Exhibit Opens." *Boston Post*, March 15, 1905.

Clement and Hutton 1879
Clement, Clara Erskine, and Laurence Hutton. *Artists of the Nineteenth Century and Their Works: A Handbook Containing Two Thousand and Fifty Biographical Sketches*. 2 vols. Boston, 1879.

Cogniat 1939
Cogniat, Raymond. *Cézanne*. Paris, 1939.

Coke 1964
Coke, van Deren. *The Painter and the Photograph*. Albuquerque, N.M., 1964.

"Collection de tableaux de M. Charles Leroux" 1888
"Collection de tableaux de M. Charles Leroux." *La Chronique des Arts*, no. 9 (March 3, 1888).

Colvin 1872
Colvin, Sidney. "Review of the Fifth Exhibition of the Society of French Artists." *Paul Mall Gazette*, November 8, 1872.

Constable 1955
Constable, W. G. *Summary Catalogue of European Paintings: Museum of Fine Arts*. Boston, 1955.

Cooper 1954
Cooper, Douglas. "Two Cézanne Exhibitions – II." *Burlington Magazine*, vol. 96, no. 621 (December 1954).

Cormack 1986
Cormack, Malcolm. *Constable*. Oxford, 1986.

Courthion 1946
Courthion, Pierre. *Corot raconté par lui-même et par ses amis*. 2 vols. Geneva, 1946.

Cunningham 1939a
Cunningham, Charles C. "From Gainsborough to Renoir: Boston Exhibits Its New Bequest of the J. C. Edwards Collection." *The Art News*, vol. 38, no. 10 (December , 1939).

Cunningham 1939b
Cunningham, Charles C. "The Juliana Cheney Edwards Collection." *Bulletin of the Museum of Fine Arts* (Boston), vol. 37, no. 224 (December 1939).

Cunningham 1976
Cunningham, Charles C. *Jongkind and the Pre-Impressionists: Painters of the École Saint-Siméon*. Williamstown, Mass., 1976.

Daulte 1959
Daulte, François. *Alfred Sisley: Catalogue raisonné de l'oeuvre peint*. Lausanne, 1959.

Daulte 1971
Daulte, François. *Auguste Renoir: Catalogue raisonné de l'oeuvre peint. I: Les Figures, 1860–1890*. Lausanne, 1971.

De Gail 1989
De Gail, Sylvie Lamort. *Paul Guigou: Catalogue raisonné*. Paris, 1989.

De la Faille 1928
De la Faille, J. B. *L'oeuvre de Vincent Van Gogh: Catalogue raisonné*. 4 vols. Paris, 1928.

De la Faille 1939
De la Faille, J. B. *Vincent Van Gogh*. New York and Paris, 1939.

De la Fizelière et al. 1874
De la Fizelière, Albert, Jules Champfleury, and Frédéric Henriet. *La vie et l'oeuvre de Chintreuil*. Paris, 1874.

Dewhurst 1904
Dewhurst, Wynford. *Impressionist Painting: Its Genesis and Development*. London, 1904.

Dormoy 1926
Dormoy, M. "La collection Schimitz à Dresde." *L'Amour de l'Art*, vol. 7 (1926).

Dunlop 1979
Dunlop, Ian. *Degas*. London, 1979.

Durand-Gréville 1887
Durand-Gréville, E. "La Peinture aux États-Unis." *Gazette des Beaux-Arts*, ser. 2, vol. 2, no. 36 (July 1887).

Durbe and Damigella 1967
Durbe, Dario, and Anna Maria Damigella. *La scuola di Barbizon*. Milan, 1967.

Duret 1916
Duret, Théodore. *Vincent Van Gogh*. 2d ed. Paris, 1916.

Duret 1937
Duret, Théodore. "L'exposition: 'La vie et l'oeuvre de Van Gogh.'" *L'Amour de l'Art*, vol. 18, no. 4 (April 1937).

Edgell 1949
Edgell, George Harold. *French Painters in the Museum of Fine Arts: Corot to Utrillo*. Boston, 1949.

Erpel 1958
Erpel, Fritz. *Welt der Kunst:Paul Cézanne*. Berlin, 1958.

Estienne 1953a
Estienne, Charles. *Gauguin*. Geneva, 1953.

Estienne 1953b
Estienne, Charles. *Vincent Van Gogh*. Geneva, 1953.

Farinaux-LeSidaner 1989
Farinaux-LeSidaner, Yann. *Le Sidaner: L'oeuvre peint et gravé*. 1989.

Feaver 1985
Feaver, William. "The Elusive Renoir." *The Art News*, vol. 84, no. 10 (December 1985).

Fell 1991
Fell, Derek. *Renoir's Garden*. London, 1991.

Fermigier 1977
Fermigier, André. *Millet*. Geneva, 1977.

Feuillet 1923
M. Feuillet. "Revue des ventes de la semaine." *Le Figaro*, art supplement, no. 1, May 31, 1923.

Fezzi 1972
Fezzi, Elda. *L'opera completa di Renoir nel periodo impressionista, 1869–1883*. Milan, 1972.

Fidell-Beaufort and Bailly-Herzberg 1975
Fidell-Beaufort, M., and J. Bailly-Herzberg. *Daubigny*. Paris, 1975.

Florisoone 1938a
Florisoone, Michel. *Renoir*. Translated by George Frederic Lees. Paris, 1938.

Florisoone 1938b
Florisoone, Michel. "Renoir et la famille Charpentier." *L'Amour de l'Art*, vol. 19, no. 2 (February 1938).

Fonteney 1991
Fonteney, Monique le Pelle. *Léon Augustin Lhermitte (1844–1925): Catalogue raisonée*. Paris, 1991.

Forges 1962
Forges, Marie-Thérèse de. "*La Descente des Vaches* de Théodore Rousseau au Musée d'Amiens." *La Revue du Louvre et des Musées de France*, vol. 12, no. 2 (1962).

Fosca 1930
Fosca, François. *Corot*. Paris, 1930.

Fosca 1961
Fosca, François. *Renoir*. Paris, 1961.

Geffroy 1891
Geffroy, Gustave. *La vie artistique*. Paris, 1891.

Geffroy 1920
Geffroy, Gustave. "Claude Monet." *L'Art et les Artistes*, November 1920.

Geffroy 1922
Geffroy, Gustave. *Claude Monet: Sa vie, son temps, son oeuvre*. Paris, 1922.

Geffroy 1924
Geffroy, Gustave. *Monet: Sa vie, son oeuvre*. Paris, 1924.

Georgel 1999
Georgel, Pierre. *Claude Monet: Waterlilies*. Milan, 1999.

Geist 1975
Geist, Sidney. "The Secret Life of Paul Cézanne." *Art International*, vol. 19, no. 9 (November 20, 1975).

Gensel 1902
Gensel, Walther. *Millet und Rousseau*. Bielefeld and Leipzig, 1902.

Goldstein 1979
Goldstein, Nathan. *Painting: Visual and Technical Fundamentals*. New Jersey, 1979.

Goldwater 1938
Goldwater, Robert. "Cézanne in America." *The Art News*, vol. 36, no. 26 (March 26, 1938).

Goldwater 1958
Goldwater, Robert. "Renoir at Wildenstein." *Art in America*, vol. 46, no. 1 (Spring 1958).

Gordon and Forge 1983
Gordon, Robert, and Andrew Forge. *Monet*. New York, 1983.

Gowing 1956
Gowing, Lawrence. "Notes on the Development of Cézanne." *Burlington Magazine*, vol. 98, no. 639 (June 1956).

Grappe 1911
Grappe, Georges. *E. H. Degas*. London, Berlin, and Paris, 1911.

Grate 1959
Grate, Pontus. *Deux critiques d'art de l'époque romantique: Gustave Planche et Théophile Thoré*. Stockholm, 1959.

Gray 1972
Gray, Christopher. *Armand Guillaumin*. Chester, Conn., 1972.

Greenberg 1961
Greenberg, Clement. "The Late Monet." In *Art and Culture: Critical Essays*. Boston, 1961.

Guérin 1931
Guérin, Marcel, ed. *Lettres de Degas*. Paris, 1931.

Hamilton 1992
Hamilton, Vivien. *Boudin at Trouville*. London, 1992.

Hawes 1919
Hawes, Charles Henry. "*La Seine à Chatou* by Pierre-Auguste Renoir." *Bulletin of the Museum of Fine Arts* (Boston), vol. 17, no. 104 (December 1919).

Hefting 1975
Hefting, Victorine. *Jongkind: Sa vie, son oeuvre, son époque*. Paris, 1975.

Hellebranth 1976
Hellebranth, Robert. *Charles-François Daubigny, 1817–1878*. Paris, 1976.

Herbert 1979
Herbert, Robert. "Method and Meaning in Monet." *Art in America*, vol. 67, no. 5 (September 1979).

Herbert 1988
Herbert, Robert L. *Impressionism: Art, Leisure, and Parisian Society*. New Haven and London, 1988.

Herbert 1994
Herbert, Robert L. *Monet on the Normandy Coast: Tourism and Painting, 1867–1886*. New Haven and London, 1994.

Hertz 1929
Hertz, Henri. *Degas*. Paris, 1929.

Hoffmann 1958
Hoffmann, Edith. Review of Renoir exhibition at Wildenstein, New York. *Burlington Magazine*, vol. 100, no. 662 (May 1958).

Holmes 1909
Holmes, C. J. "Two Modern Pictures." *Burlington Magazine*, vol. 15, no. 74 (May 1909).

House 1986
House, John. *Monet: Nature into Art*. New Haven and London, 1986.

House 1988
House, John. *Renoir, 1841–1919*. Guernsey, 1988.

House 1995
House, John. *Impressions of France: Monet, Renoir, Pissarro, and Their Rivals*. Boston, 1995.

House and Distel 1985
House, John, and Anne Distel. *Renoir*. London, 1985.

Huet 1911
Huet, René Paul. *Paul Huet (1830–1869), d'après ses notes, sa correspondance, ses contemporains: Documents recueillis et précédés d'une biographie par son fils René Paul Huet*. Paris, 1911.

Hughé et al. 1960
Hughé, René, et al. *Gauguin.* Paris, 1960.

Hulsker 1980
Hulsker, Jan. *The Complete van Gogh: Paintings, Drawings, Sketches.* New York, 1980.

Huth 1946
Huth, Hans. "Impressionism Comes to America." *Gazette des Beaux-Arts,* ser. 6, vol. 29 (April 1946).

Ikegame 1969
Ikegame, C. *Cézanne.* Tokyo, 1969.

Isaacson 1978
Isaacson, Joel. *Observation and Reflection: Claude Monet.* Oxford, 1978.

Isaacson 1980
Isaacson Joel. *The Crisis of Impressionism 1878–1882.* Ann Arbor, 1980.

Isaacson 1984
Isaacson, Joel. "Observation and Experiment in the Early Work of Monet." In *Aspects of Monet: A Symposium on the Artist's Life and Times,* edited by John Rewald and Frances Weitzenhoffer. New York, 1984.

Isaacson 1992
Isaacson, Joel. "Pissarro's Doubt: Plein-Air Painting and the Abiding Questions." *Apollo,* vol. 136, no. 369 (November 1992).

Jamot 1918
Jamot, Paul. "Degas." *Gazette des Beaux-Arts,* ser. 4, vol. 14, no. 695 (April–June 1918).

Jamot 1924
Jamot, Paul. *Degas.* Paris, 1924.

Jean-Aubry 1968
Jean-Aubry, Gérard. *Boudin.* Paris, 1968.

Jean-Aubry and Schmit 1987
Jean-Aubry, Gérard, and Robert Schmit. *Eugène Boudin: La vie et l'oeuvre d'après les lettres et les documents inédits.* Neuchâtel, 1987.

Jenks 1927
Jenks, A. "Carriage at the Races." *Bulletin of the Museum of Fine Arts* (Boston), vol. 25, no. 147 (February 1927).

Jewell 1944
Jewell, Edward A. *Paul Cézanne.* New York, 1944.

Joyes et al. 1975
Joyes, Claire, et al. *Monet at Giverny.* London, 1975.

Kapos 1991
Kapos, Martha, ed. *The Impressionists: A Retrospective.* London, 1991.

Katalog 1916
Katalog der modernen Galerie Heinrich Thannhauser in München. Munich, 1916.

Keller 1987
Keller, Horst. *Auguste Renoir.* Munich, 1987.

Kendall 1987
Kendall, Richard, ed. *Degas by Himself.* London, 1987.

Kendall 1988
Kendall, Richard, ed. *Cézanne by Himself.* London, 1988.

Kendall 1989
Kendall, Richard, ed. *Monet by Himself.* London, 1989.

Kerr 1954
Kerr, John O'Connell. "Renoir at the Tate." *The Studio,* vol. 147, no. 730 (January 1954).

Krexpel 1891
Krexpel, J. "Les XX." *La Revue Blanche,* March 1891.

Küster 1992
Küster, Bernd. *Monet: Seine Reisen in den Süden.* Hamburg, 1992.

La Farge 1903
La Farge, John. "The Barbizon School." *McClure's Magazine,* vol. 21, no. 2 (June 1903).

La Farge 1908
La Farge, John. *The Higher Life in Art.* New York, 1908.

Lafond 1918
Lafond, Paul. *Degas.* 2 vols. Paris, 1918.

Langdon 1986
Langdon, Helen. *Impressionist Seasons.* Oxford, 1986.

Lecaldano 1977
Lecaldano, Paolo. *L'opera pittorica completa di Van Gogh.* Milan, 1977.

Leclercq 1891
Leclercq, J. "Aux Indépendants." *Mercure de France,* May 1891.

Lemoisne 1912
Lemoisne, Paul-André. *L'Art de notre temps: Degas.* Paris, 1912.

Lemoisne 1924
Lemoisne, Paul-André. "Artistes contemporains: Edgar Degas, à propos d'une exposition récente." *Revue de l'Art,* vol. 46 (June 1924).

Lemoisne 1946–49
Lemoisne, Paul-André. *Degas et son oeuvre.* 4 vols. Paris, 1946–49.

Leroi 1887
Leroi, Paul. "Salon of 1887." *L'Art,* vol. 43, no. 2 (1887).

Leroy 1874
Leroy, Louis. "L'exposition des impressionnistes." *Le Charivari,* April 25, 1874.

Lewis 1989
Lewis, Mary Tompkins. *Cézanne's Early Imagery.* Berkeley, Calif., 1989.

Lhôte 1939
Lhôte, André. *Traité du paysage.* Paris, 1939.

Lhôte 1958
Lhôte, André. *Traité du paysage et de la figure.* Paris, 1958.

Liebermann 1918
Liebermann, Max. *Degas.* Berlin, 1918.

Lindsay 1969
Lindsay, Jack. *Cézanne: His Life and Art.* New York, 1969.

Loyrette and Tinterow 1994
Loyrette, Henri, and Gary Tinterow. *Impressionnisme: Les origines, 1859–1869.* Paris, 1994.

MacClintock 1989
MacClintock, Lucy. *From Neoclassicism to Impressionism: French Paintings from the Museum of Fine Arts, Boston.* Hokkaido Shinbunsha, 1989. In Japanese.

Malingue 1943
Malingue, Maurice. *Claude Monet.* Monaco, 1943.

Malingue 1948
Malingue, Maurice. *Gauguin: Le peintre et son oeuvre.* Paris, 1948.

Malraux 1952
Malraux, André. "Auvers vu par les peintres." *L'Amour de l'Art,* vol. 31, no. 64 (1952).

Manson 1927
Manson, J. B. *The Life and Work of Edgar Degas.* London, 1927.

Mantz 1887
Mantz, Paul. *Catalogue descriptif des peintures, aquarelles, pastels, dessins rehaussés, croquis et eaux-fortes de J.-F. Millet*. Paris, 1887.

Marcel 1901
Marcel, H. "Quelques lettres inédites de J.-F. Millet." *Gazette des Beaux-Arts*, ser. 3, vol. 26, no. 529 (July 1901).

Mauclair 1903
Mauclair, Camille. *The Great French Painters*. London and New York, 1903.

Mauclair 1928
Mauclair, Camille. *Le Sidaner*. Paris, 1928.

McBride 1937
McBride, Henry. "The Renoirs in America: In Appreciation of the Metropolitan Museum's Exhibition." *The Art News*, vol. 35, no. 31 (May 1, 1937).

McMullen 1984
McMullen, Roy. *Degas: His Life, Times, and Work*. Boston, 1984.

Meier-Graefe 1921
Meier-Graefe, Julius. *Vincent van Gogh*. 2 vols. Munich, 1921.

Meier-Graefe 1923
Meier-Graefe, Julius. *Degas*. London, 1923.

Meier-Graefe 1929
Meier-Graefe, Julius. *Renoir*. Leipzig, 1929.

Meynell 1908
Meynell, Everard. *Corot and His Friends*. London, 1908.

Michelet 1908
Michelet, Victor-Émile. *Maufra: Peintre et graveur*. Paris, 1908.

Miquel 1980
Miquel, Pierre. *Eugène Isabey, 1803–1886*. Maurs-la-Jolie, 1980.

Moffett et al. 1974
Moffett, Charles S., et al. *Impressionism: A Centenary Exhibition*. New York, 1974.

Moffett et al. 1986
Moffett, Charles S., et al. *The New Painting: Impressionism, 1874–1886*. San Francisco, 1986.

Moffett et al. 1998
Moffett, Charles S., et al. *Impressionists in Winter: Effets de Neige*. Washington, 1998.

Mollet 1890
Mollet, John W. *The Painters of Barbizon*. London, 1890.

Moreau-Nélaton 1921
Moreau-Nélaton, Étienne. *Millet raconté par lui-même*. Paris, 1921.

Moreau-Nélaton 1924
Moreau-Nélaton, Étienne. *Corot*. Paris, 1924.

Mothe 1987
Mothe, Alain. *Vincent Van Gogh: Auvers-sur-Oise*. Paris, 1987.

Murphy 1984
Murphy, Alexandra R. *Jean-François Millet: Seeds of Impressionism*. Boston, 1984.

Murphy 1985
Murphy, Alexandra R. *European Paintings in the Museum of Fine Arts, Boston*. Boston, 1985.

Murphy et al. 1977
Murphy, Alexandra R., Lucretia H. Giese, and Elizabeth H. Jones. *Monet Unveiled: A New Look at Boston's Paintings*. Boston, 1977.

Naeling 1984
Naeling, Bernard. "Vincent van Gogh: Der Herbst eines Lebens." *Pan*, vol. 9 (September 1984).

Nemeczek 1981
Nemeczek, Alfred. "Die letzten Wochen des Malers van Gogh." *Art* [Hamburg], February 1981.

New England Magazine 1892
New England Magazine, no. 6 (February 1892).

Noon 1991
Noon, Patrick. *Richard Parkes Bonington: "On the Pleasure of Painting."* New Haven, 1991.

Novotny 1960
Novotny, Fritz. *Painting and Sculpture in Europe, 1780–1880*. Baltimore, 1960.

Orlando 1980
Orlando, Enzo. *Guido alla pittura di Renoir*. Milan, 1980.

Peacock 1905
Peacock, Netta. *Millet*. London, 1905.

Pepper 1948
Pepper, Charles, H. *The Collections of John Taylor Spaulding, 1870–1948*. Boston, 1948.

Perry 1927
Perry, Lilla Cabot. "Reminiscences of Claude Monet from 1889 to 1909." *The American Magazine of Art*, vol. 18, no. 3 (March 1927).

Petrie 1979
Petrie, Brian. *Claude Monet: The First of the Impressionists*. Oxford, 1979.

Pica 1912
Pica, Vittorio. "Artisti contemporanei: Henri Le Sidaner." *Emporium*, vol. 35, no. 210 (June 1912).

Piedgnel 1876
Piedgnel, Alexandre. *J.-F. Millet*. Paris, 1876.

Pissarro 1996
Pissarro, Joachim. *Monet in the Mediterranean*. Fort Worth, 1996.

Pissarro and Venturi 1939
Pissarro, Ludovico R., and Lionello Venturi. *Camille Pissaro: Son art, son oeuvre*. Paris, 1939.

Pope 1930
Pope, Arthur. "French Paintings in the Collection of John T. Spaulding." *The Art News*, vol. 28, no. 30 (April 26, 1930).

Poulet and Murphy 1979
Poulet, Anne L., and Alexandra R. Murphy. *Corot to Braque: French Paintings from the Museum of Fine Arts, Boston*. Boston, 1979.

Ratcliff 1992
Ratcliff, Floyd. *Paul Signac and Color in Neo-Impressionism*. New York, 1992.

Rathbone et al. 1996
Rathbone, Eliza E., et al. *Impressionists on the Seine: A Celebration of Renoir's "Luncheon of the Boating Party."* Washington, 1996.

Raynal 1922
Raynal, Maurice. "Renoir Nachlass." *Der Cicerone*, July 1922.

Raynal 1954
Raynal, Maurice. *Cézanne*. Geneva, 1954.

Reidemeister 1963
Reidemeister, Leopold. *Auf den Spuren der Maler der Ile de France*. Berlin, 1963.

Reuterswärd 1948
Reuterswärd, Oscar. *Monet*. Stockholm.

Rewald 1946
Rewald, John. *The History of Impressionism*. New York, 1946.

Rewald 1956
Rewald, John. *Post-Impressionism from Van Gogh to Gauguin*. New York, 1956.

Rewald 1961
Rewald, John. *The History of Impressionism*. Rev. ed. New York, 1961.

Rewald 1963
Rewald, John. *Camille Pissarro*. New York, 1963.

Rewald 1973
Rewald, John. *The History of Impressionism*. 4th rev. ed. New York, 1973.

Rewald 1996
Rewald, John, with Walter Feilchenfeldt and Jayne Warman. *The Paintings of Paul Cézanne: A Catalogue Raisonné*. New York, 1996.

Rewald and Weitzenhoffer 1984
Rewald, John, and Frances Weitzenhoffer, eds. *Aspects of Monet*. New York, 1984.

Rich 1951
Rich, Daniel Catton. *Degas*. New York, 1951.

Rilke 1985
Rilke, Rainer Maria. *Letters on Cézanne*. Edited by Clara Rilke. Translated by Joel Agee. New York, 1985.

Riviere 1935
Rivière, Georges. *Degas: Bourgeois de Paris*. Paris, 1935.

Robaut 1905
Robaut, Alfred. *L'oeuvre de Corot*. Paris, 1905.

Roger-Milès 1896
Roger-Milès, Léon. *Album classique de chefs-d'oeuvre de Corot*. Paris, 1896.

Roger-Milès 1920
Roger-Milès, Léon. *La collection Ferdinand Blumenthal*. Paris, 1920.

Rolland 1902
Rolland, Romain. *Millet*. London, 1902.

Rosenblum 1989
Rosenblum, Robert. *Paintings in the Musée d'Orsay*. New York, 1989.

Roskill 1970
Roskill, Mark. *Van Gogh, Gauguin, and the Impressionist Circle*. Greenwich, 1970.

Rostrup 1956
Rostrup, Haavard. "Gauguin et le Danemark." *Gazette des Beaux-Arts*, ser. 6, vol. 47, no. 1044 (1956).

Roth 1994
Roth, Michael S., ed. *Rediscovering History: Culture, Politics, and the Psyche*. Stanford, Calif., 1994.

Rouart et al. 1972
Rouart, Denis, et al. *Monet: Nymphéas*. Paris, 1972.

Russoli and Minervino 1970
Russoli, Franco, and Fiorella Minervino. *L'opera completa di Degas*. Milan, 1970.

Scharf 1962
Scharf, Aaron. "Painting, Photography, and the Image of Movement." *Burlington Magazine*, vol. 104, no. 710 (May 1962).

Scheffler 1921
Scheffler, Konrad. "Die Sammlung O. Schmitz in Dresden." *Kunst und Künstler* (1921).

Scherjon 1932
Scherjon, W. *Catalogue des tableaux par Vincent van Gogh décrits dans ses lettres. Périodes: Saint-Rémy et Auvers-sur-Oise*. Utrecht, 1932.

Scherjon and De Gruyter 1938
Scherjon, W., and Joseph De Gruyter. *Van Gogh's Great Period: Arles, St. Rémy, Auvers-sur-Oise*. Amsterdam, 1938.

Schmit 1973
Schmit, Robert. *Eugène Boudin, 1824–1898*. Paris, 1973.

Schneider 1985
Schneider, Cynthia P. "Renoir: Le peintre de figures comme paysagiste." *Apollo*, vol. 122, no. 281 (July 1985).

Seiberling 1981
Seiberling, Grace. *Monet's Series*. New York and London, 1981.

Seitz 1956
Seitz, William C. "Monet and Abstract Painting." *College Art Journal*, vol. 16, no. 1 (1956).

Seitz 1960
Seitz, William C. *Claude Monet: Seasons and Moments*. New York, 1960.

Sensier and Mantz 1881
Sensier, Alfred, and Paul Mantz. *La vie et l'oeuvre de J.-F. Millet*. Paris, 1881.

Shiff 1984
Shiff, Richard. *Cézanne and the End of Impressionism*. Chicago, 1984.

Shinoda 1957
Shinoda, Yujiro. *Degas, der Einzug des japanischen in die französische Malerei*. Tokyo, 1957.

Sickert 1905
Sickert, Bernhard. "The Pre-Raphaelite and Impressionist Heresies." *Burlington Magazine*, vol. 7, no. 26 (May 1905).

Silvestre 1856
Silvestre, Théophile. *Histoire des artistes vivants français et étrangers*. Paris, 1856.

Silvestre 1874
Silvestre, Armand. "Chronique des beaux-arts: Physiologie du refusé – L'exposition des révoltés." *L'Opinion Nationale*, April 22, 1874.

Silvestre 1878
Silvestre, Théophile. *Les artistes français*. Paris, 1878.

Simpson 1993
Simpson, Marc. "Reconstructing the Golden Age: American Artists in Broadway, Worcestershire, 1885 to 1889." 3 vols. Ph.D. dissertation, Yale University, 1993.

Stechow 1966
Stechow, Wolfgang. *Dutch Landscape Painting of the Seventeenth Century*. Ithaca, N.Y., 1966.

Sterling and Adhémar 1958–61
Sterling, Charles, and Hélène Adhémar. *Peintures: École française, XIXe siècle* (Musée du Louvre). 4 vols. Paris, 1958–61.

Stevens 1992
Stevens, MaryAnne, ed. *Alfred Sisley*. London, 1992.

Strahan 1879
Strahan, Edward. *Art Treasures of America*. Philadelphia, 1879.

Stranahan 1888
Stranahan, Clara Harrison. *History of French Painting*. New York, 1888.

Stuckey 1985
Stuckey, Charles F., ed. *Monet: A Retrospective*. New York, 1985.

Stuckey 1995
Stuckey, Charles F. *Claude Monet, 1840–1926.* Chicago, 1995.

Sturrock 1955
Sturrock, Alec. "Artists at the Seaside." *Scottish Art Review,* Summer 1955.

Sutton 1984
Sutton, Denys. "Degas: Master of the Horse." *Apollo,* vol. 119, no. 266 (April 1984).

Sutton 1987
Sutton, Peter C. *Masters of Seventeenth-Century Dutch Landscape Painting.* Boston, 1987.

Sutton 1991
Sutton, Peter C. *Boudin: Impressionist Marine Painting.* Salem, Mass., 1991.

Sutton 1995
Sutton, Peter C. *The William Appleton Coolidge Collection.* Boston, 1995.

Tabarant 1942
Tabarant, Adolphe. *La vie artistique au temps de Baudelaire.* Paris, 1942.

Thiébault-Sisson 1900
Thiébault-Sisson, François. "Claude Monet par lui-même." *Le Temps,* November 6, 1900.

Thiébault-Sisson 1918
Thiébault-Sisson, François, ed. "L'homme et l'oeuvre." *Le Temps,* May 18, 1918.

Thomas 1980
Thomas, David. *Renoir.* London, 1980.

Thoré 1844
Thoré, Théophile. "Salon of 1844." Translated in *The Triumph of Art for the Public: The Emerging Role of Exhibitions and Critics,* edited by Elizabeth Gilmore Holt. Garden City, N.Y., 1979.

Tinterow and Loyrette 1994
Tinterow, Gary, and Henri Loyrette. *Origins of Impressionism.* New York, 1994.

Tinterow et al. 1996
Tinterow, Gary, Michael Pantazzi, and Vincent Pomarède. *Corot.* New York, 1996.

Tomson 1905
Tomson, Arthur. *Jean-François Millet and the Barbizon School.* London, 1905.

Traz 1954
Traz, Georges de. *Degas.* Geneva, 1954.

Tucker 1982
Tucker, Paul Hayes. *Monet at Argenteuil.* New Haven and London, 1982.

Tucker 1989
Tucker, Paul Hayes. *Monet in the '90s: The Series Paintings.* Boston / New Haven and London, 1989.

Updike 1989
Updike, John. *Just Looking: Essays on Art.* New York, 1989.

Van Dovski 1950
Van Dovski, Lee. *Gauguin.* Olten and Bern, 1950.

Van Gogh 1929
Van Gogh, Vincent. *Further Letters of Vincent van Gogh to His Brother, 1886–89.* London, 1929.

Van Gogh 1958
Van Gogh, Vincent. *The Complete Letters of Vincent van Gogh.* 3 vols. London, 1958.

Venturi 1936
Venturi, Lionello. *Cézanne: Son art, son oeuvre.* Paris, 1936.

Venturi 1939
Venturi, Lionello. *Les archives de l'Impressionnisme.* Paris, 1939.

Venturi 1978
Venturi, Lionello. *Cézanne.* Geneva, 1978.

Vollard 1937
Vollard, Ambroise. *Paul Cézanne: His Life and Art.* New York, 1937.

Wadley 1987
Wadley, Nicholas. *Renoir: A Retrospective.* New York, 1987.

Wagner 1981
Wagner, Anne M. "Courbet's Landscapes and Their Market." *Art History,* vol. 4, no. 4 (December 1981).

Waldman 1927
Waldman, Emil. *Die Kunst des Realismus und Impressionismus.* Berlin, 1927.

Wall 1884
Wall, George A. *An Illustrated Catalogue of the Art Collection of Beriah Wall.* Providence, R.I., 1884.

Watson 1925
Watson, Forbes. "American Collections: no. 2 – The John T. Spaulding Collection." *The Arts,* vol. 8, no. 6 (December 1925).

Watson 1928
Watson, Forbes. "Recent Exhibitions." *The Arts,* vol. 13, no. 1 (January 1928).

Weisberg et al. 1975
Weisberg, Gabriel, et al. *Japonisme: Japanese Influence on French Art, 1854–1910.* Cleveland, 1975.

Weitzenhoffer 1986
Weitzenhoffer, Frances. *The Havermeyers: Impressionism Comes to America.* New York, 1986.

White 1984
White, Barbara Ehrlich. *Renoir: His Life, Art, and Letters.* New York, 1984.

Wildenstein 1964
Wildenstein, Georges. *Gauguin.* Paris, 1964.

Wildenstein 1974–91
Wildenstein, Daniel. *Claude Monet: Biographie et catalogue raisonné.* 5 vols. Lausanne, 1974–91.

Wildenstein 1996
Wildenstein, Daniel. *Monet: Catalogue raisonné.* Cologne, 1996.

Wilenski 1940
Wilenski, R. *Modern French Painters.* New York, 1940.

Wolff 1883
Wolff, Albert. *Cent chefs-d'oeuvre des collections parisiennes.* Paris, 1883.

Wolff 1886
Wolff, Albert. *Notes upon Certain Masters of the Nineteenth Century.* New York, 1886.

Zafran and Boardingham 1992
Zafran, Eric M., and Robert J. Boardingham. *Monet and His Contemporaries: Masterpieces from the Museum of Fine Arts, Boston.* Tokyo, 1992. In Japanese.

Zafran and Piussi 1995
Zafran, Eric M., and Anna Piussi. *The Real World: Nineteenth-Century European Paintings from the Museum of Fine Arts, Boston.* Boston, 1995. In Japanese.

Zola 1959
Zola, Émile. *Salons.* Edited by Hemmings and Niess. Paris, 1959.

Zola 1974
Zola, Émile. *Le bon combat: De Courbet aux impressionnistes.* Paris, 1974.

Index of Works in the Exhibition